MADE
in
BRITISH COLUMBIA

MADE
in
BRITISH COLUMBIA

EIGHT WAYS OF MAKING CULTURE

Maria Tippett

HARBOUR PUBLISHING

Harbour Publishing Co. Ltd.
P.O. Box 219, Madeira Park, BC, V0N 2H0
www.harbourpublishing.com

Cataloguing information available from Library and Archives Canada
ISBN 978-1-55017-729-9 (cloth)
ISBN 978-1-55017-730-5 (ebook)

Edited by Lucy Kenward
Jacket design by Carleton Wilson
Text design by Mary White
Index by Brianna Cerkiewicz
Printed and bound in Canada

Harbour Publishing acknowledges the support of the Canada Council for the Arts, which last year invested $157 million to bring the arts to Canadians throughout the country. We also gratefully acknowledge financial support from the Government of Canada through the Canada Book Fund and from the Province of British Columbia through the BC Arts Council and the Book Publishing Tax Credit.

For Peter Clarke

Contents

Foreword by Tom Berger 1

I. The Imperial Garden of Eden
 FRANCIS MAWSON RATTENBURY (1867–1935) 5

II. Butchering the Garden of Eden
 MARTIN ALLERDALE GRAINGER (1874–1941) 30

III. "The Life of the Trees," Emily Carr's Forest
 EMILY CARR (1871–1945) 51

IV. Defining the Canon, The Self-Made Man of Letters
 GEORGE WOODCOCK (1912–1995) 78

V. Social Commentator or Social Rebel?
 GEORGE RYGA (1932–1987) 103

VI. "Music is My Life"
 JEAN COULTHARD (1908–2000) 130

VII. A Contested Reputation
 BILL REID (1920–1998) 161

VIII. Beyond Provincialism
 ARTHUR ERICKSON (1924–2009) 192

Epilogue 231

Acknowledgements 239
Index 241

Foreword

BY TOM BERGER

BRITISH COLUMBIA evokes an image of forests, water and mountains, of European settlement from the nineteenth century and of the long history of First Nations before that. Our surroundings and our history have inspired artists and intellectuals—people who paint, who write, who design, who build. What they have achieved represents a distinctive contribution to the way we in this province think about ourselves. Their books, their sculpture, their music, their plays and their buildings—these illuminate the cultural history of the province.

Maria Tippett has chosen to write about the lives and work of eight culture makers, men and women who have left their mark on our minds and memory. Their work is found in our galleries, museums, libraries and in our built environment. Maria's cultural producers include a novelist, a painter, a musician, an editor and writer, a playwright, a sculptor and two architects. Some of them—Emily Carr, Arthur Erickson and Bill Reid—are well known today. Some of them are not, but they deserve to be better known.

Who, you may ask, was Martin Grainger? He came from London, England, worked in the BC woods in the early days of hand-logging, got to know well the rough life of men in the camps along the BC coast, and in 1908 wrote a novel entitled *Woodsmen of the West*. He knew the forest

industry and he could write, and such were the opportunities available in those days in a province on the frontier that he became the secretary to the Royal Commission on Forestry in 1909 and wrote the report that resulted in the establishment of the BC Forest Service.

Francis Rattenbury, a recent arrival from England, obtained in 1892, at the age of twenty-five, the commission to design British Columbia's Parliament Buildings. Yes, I realize that we may have heard of him because he was later murdered by his eighteen-year-old chauffeur, his wife's lover. But we ought to remember also that he designed other familiar landmarks: the old Vancouver Courthouse, the Nelson Courthouse and, perhaps best-loved of all, Victoria's Empress Hotel.

George Woodcock, like Grainger and Rattenbury, also came from Britain. Woodcock was an author and editor of renown, a mentor to a multitude of writers and a midwife to literary scholarship in British Columbia. He was a one-man cultural industry.

Jean Coulthard was a composer whose life illustrates that, although British Columbia was not a musical wasteland (after all, the first piano arrived in Victoria in 1853), it was not easy for a woman, in the middle of the twentieth century, to obtain an audience for the performance of her compositions.

In 1967 the opening of George Ryga's play *The Ecstasy of Rita Jo*e shocked those who attended the opening night in Vancouver. Suddenly, through art, we were made to realize the reality of life for Native women on the streets of our cities. Ryga's play had something of the impact of Wally Oppal's Missing Women Commission of Inquiry today.

As for those subjects whom we know well: Emily Carr's paintings of the forest and Native villages can be seen everywhere today. So also the houses and buildings that Arthur Erickson designed. Though they were the product of a lifetime of study around the world, they also take their inspiration from British Columbia's landscapes and seascapes. As for Bill Reid, his carvings, jewellery and sculpture represent at one and the same time a recollection and a renaissance of British Columbia's Native heritage.

Maria has not written a complete cultural history of the province. The definition of culture is as expansive as it is difficult to pin down. But

in this book she has provided us with a history of leading figures in British Columbia's cultural history during the twentieth century. In its own way, *Made in British Columbia* provides us with a real sense of how we have come to think about ourselves and the history of the province itself.

The Imperial Garden of Eden
FRANCIS MAWSON RATTENBURY (1867–1935)

A

T THE BEGINNING of the twentieth century, there was no more eminent British Columbian than Francis Mawson Rattenbury. He had already acquired fame as the man who designed British Columbia's magnificent Legislative Building, and this achievement has lasted well. But his name also retains an unavoidable sense of notoriety because he was to be murdered—and by his wife's lover, in circumstances that were nothing if not melodramatic. The extraordinary story that his life ended clearly demands initial attention, if only because it sadly threatens to eclipse his reputation. For the real Frank Rattenbury, or "Ratz" as he was alternatively known throughout his life, was much more than the architect of British Columbia's most prestigious edifice and arguably of his own demise.

Persistently unlucky in love, the young Frank Rattenbury had met his future wife Florence Eleanor Nunn shortly after arriving in Victoria from England in 1892. Known as Florrie, she struck many people as stout, plain, unassuming—in short, not a great catch for an up-and-coming architect in his mid-twenties. Nonetheless Ratz and Florrie married in 1898 and had two children, Francis Burgoyne and Mary. The family lived in style—they had six servants—in a half-timbered Arts and Crafts–style house, Iechinihl, designed by Rattenbury and occupying a fine site

next to the ocean in the soon-to-become fashionable suburb of Oak Bay. Today Iechinihl is the core building of Glenlyon Norfolk School.

Perhaps the early years promised better, but the atmosphere in the Rattenbury household soon became bitter. Certainly by 1918 Frank had become estranged from Florrie. They were now living at separate ends of Iechinihl and communicating by letter. Although he was then only in his early fifties, Frank was feeling his age. He was conscious of going bald. He suffered from bouts of depression and fatigue, made worse by the amount of alcohol he was consuming. He was a fixture at the Union Club in Gordon Street, for which he had designed the handsome extension at the rear of the building. Indeed this august gentlemen's club had become his unofficial home, where the convivial architect hobnobbed with the political and business elite of Victoria.

In 1923, by now fifty-five years old, Frank met Alma Victoria Clarke Dolling Pakenham. She was everything that Florrie was not: fashionable, musically talented and—although twenty-eight years younger than Frank—already twice-married, having lost her first husband in the First World War. Alma's subsequent affair with the province's leading architect not only ended Frank's marriage to Florrie but would also end his residence in British Columbia. His spirits initially boosted, Rattenbury flaunted his relationship with the youthful but questionable Alma before the staid Victoria public. Members of the club raised eyebrows; their wives liked the liaison even less. All of this made Florrie's life intolerable. After having earlier refused to divorce her errant husband, she agreed in 1925 (and was herself to die only four years later).

Frank was thus free to marry Alma and did so in 1927. As Rattenbury's son Francis Burgoyne recalled, "We knew that disaster was ahead from the first time my father met Alma."[1] The son may not have been an impartial witness but there is evidence of a life of even heavier drinking and possible cocaine taking. First the affair with the extravagant Alma, and then their rackety marriage, had the effect of isolating Ratz from his former business associates, his colleagues in the government and his friends at the Union Club. After 1923 he received few architectural commissions.

1. *Vancouver Sun,* 17 April 1935.

Frank and Alma decided to leave town, taking their infant son, John, with them. When they left Victoria for England in 1930, only Francis Burgoyne Rattenbury saw off his father, stepmother and stepbrother at the Canadian Pacific dock. The urban landscape around Victoria's Inner Harbour was now dominated by not only the impressive Legislative Building, but by the colonnade of the Canadian Pacific terminal itself and the handsome facade and roofline of the Empress Hotel—all designed by Rattenbury. These were among the architectural landmarks left behind by the lonely figure who had become a pariah in the place where he had made his reputation.

And then from bad to worse. Following a six-month tour of the Mediterranean, Frank and Alma settled in the genteel English seaside town of Bournemouth. Seeking to trade on his many achievements in British Columbia, Rattenbury attempted to win commissions. But, like the rest of the world, Britain was caught up in the Great Depression, and Frank's professional work plummeted. Initially he channelled his energy into helping Alma establish her musical career in England. Soon, however, depression and heavy drinking were again the pattern. Alma's extravagant spending habits ceased to be amusing and became appalling. And Frank's suicidal tendencies were fuelled by suspicions that his wife was not faithful.

On 23 March 1935, four years after settling in England, Francis Mawson Rattenbury, aged sixty-seven, was bludgeoned to death in his surprisingly modest Bournemouth home, the Villa Madeira. George Percy Stoner, the family's eighteen-year-old chauffeur-gardener, with whom Alma, then aged thirty-nine, had started an affair, had murdered him. The sexual passions, the age discrepancies, the financial tangles and the atmosphere of betrayal and the proliferating scandal all invested Stoner's trial with melodrama, further enhanced by Alma's suicide upon learning that her lover had been sentenced to be hanged. The subsequent commutation of the death penalty, and the reduced sentence served by Stoner, kept alive a story that was to become the subject of plays and novels, operas, poems and study cases for budding lawyers. Yet this is surely not the only way that we should remember British Columbia's most famous architect of the province-building era from the 1890s to the end of the First World War.

JUST UNDER SIX FEET TALL, the red-haired Yorkshireman always had exceptional amounts of energy and drive. In his heyday, everyone who was anyone in Victoria knew Ratz. He was elected as Reeve of Oak Bay. He stood out as someone who could win over a government minister, building contractor or fellow architect to his way of thinking—or throw them into a rage. He had, above all, what every imperialist who arrived in British Columbia at the end of the nineteenth century needed in order to succeed: ambition. As he told his daughter, Mary, in 1920: "The greatest game in life is to set out to do something, strive against all difficulties, and win."[2]

During his childhood and apprenticeship as an architect Rattenbury had witnessed the rebuilding of London, then the largest city in the world, through the restoration of the Houses of Parliament, the erection of the Natural History Museum, the additions to the National Gallery, and the construction of grand hotels and ornately decorated arcades. Frank's hometown of Leeds, located in the heart of industrial Yorkshire, also possessed grand civic buildings especially its Town Hall, opened by Queen Victoria in 1858. As outward symbols of public government embodying dignity and beauty, these buildings were not in the architectural tradition of the aristocracy's country houses that adapted classical models to domestic living on a grand scale. Rather, the civic gospel of the new industrial towns celebrated the bourgeois ethic. And their architects appropriated diverse styles—vernacular and Gothic as well as classical— from the proud public buildings in Italy, the Netherlands and Germany.

And this is what young Ratz saw before him in Leeds and in the neighbouring town of Bradford. That city's majestic town hall, designed by Rattenbury's uncle William Mawson and his partner Henry Lockwood not only suited the tastes of the Victorian middle class. Its massive clock tower, inspired by the Palazzo Vecchio in Florence, along with the building's façade featuring thirty-five statues of England's rulers from the Norman Conquest to Victorian Britain, spoke alike to the Italian Renaissance and to British nationalism.

2. Anthony A. Barrett and Rhodri Windsor Liscombe, *Francis Rattenbury and British Columbia: Architecture and Challenge in the Imperial Age* (Vancouver, 1983), 4.

When Frank entered Leeds Free Grammar School in 1878, his parents John and Mary (née Mawson) had no idea that their son would become an architectural apprentice seven years later. Devoted to preparing its students for entrance to Cambridge or Oxford universities, Leeds Free Grammar School had seen one pupil become the keeper of London's National Gallery and another the agent general for New South Wales in Australia. Edward Gawler Prior, another former pupil, had carved out a career in British Columbia that combined entrepreneurship and politics. Initially a Member of Parliament for Victoria, Prior later became the province's premier during Rattenbury's crucial early years in the city.

Frank was not, however, being groomed at Leeds Free Grammar School for admission into one of Britain's great universities or for a career in the civil service. The plan was for him to take the place, vacated by his father (who had turned to painting shortly after his son's birth), in Mawson and Dewhirst's thriving woollen firm. On leaving grammar school, Frank therefore entered the Yorkshire College of Science. Established in the mid-1870s in response to growing foreign competition, primarily from Germany, the college gave its students the technical and cultural skills to become England's captains of industry. But it quickly became apparent that Frank was unsuited for a career in business. Sensing that her son was more like his artistic father than the entrepreneurs in her family, Mary Rattenbury pulled him out of Yorkshire College and arranged to have him apprentice with her two architect brothers, William and Richard Mawson, whose offices were in Bradford.

Called Mawson and Mawson when Frank began his apprenticeship, the firm had known better days as Mawson and Lockwood. Versatile and adaptable, William Mawson and Henry Lockwood had not only designed Bradford's monumental town hall but, drawing on the Italianate Classical style, had also created the model town of nearby Saltaire. By the time Frank had entered the business in 1885, however, Lockwood was dead and William Mawson was about to retire. Again renamed, this time as Mawson and Hudson upon William's death in 1889, the firm continued to seek inspiration equally from the Italian Renaissance, Flemish, Gothic and Romanesque eras. It also embraced new trends like the Queen Anne style, inspired by the seventeenth-century architecture of the Netherlands.

But Mawson and Hudson found decreasing scope for their ambitions. Projects like the town hall in the nearby town of Cleckheaton, were less prestigious. And with the local economy in a slump, commissions were fewer. The creative flame that had once made Mawson and Lockwood one of the most successful architectural firms in the north of England had flickered out.

Frank nevertheless gained a sound training during his six-year apprenticeship. He learned how to create a set of drawings. He learned about the utilitarian aspects of planning and structural design. He learned how to prepare a proposal for an architectural competition. And he learned how to adapt historic and contemporary styles to the tastes of his clients. Outside of the office, he watched his flamboyant bachelor uncles and their assistant, Robert Hudson, guide contractors, skilled workers and labourers through a project. He also discovered that commercial and institutional commissions were more lucrative—and drew more public attention—than domestic ones.

Within five years of beginning his apprenticeship, twenty-two-year-old Frank Rattenbury showed that he had promise when he was shortlisted for one of the most prestigious architectural awards in the country. Overseen by the Council of the Royal Institute of British Architects (RIBA), the competition for the Soane Medallion was open to British apprentices and students alike. Candidates were invited to submit a set of drawings and plans for a building of the council's choice, and in 1890 that building was to be a public day school. Rattenbury's submission offered a "dignified and picturesque structure" that gave, in his own words, "ample light and air to every part of the building."[3] Along with the functional layout and the detailed consideration he gave to heating and ventilation, Frank chose the fashionable Queen Anne style.

Rattenbury's submission won the coveted Soane Medallion. His plans for a public day school were published in the leading architectural journal, *The British Architect*, and with prize money for an architectural study tour of Europe, Frank set out for the Continent in 1890.

With fifty pounds—up to eight thousand dollars in today's money—in his pocket, Frank visited various cities and towns in Italy and the

3. *The British Architect* (April 1890).

Netherlands and a number of châteaux in France. He thus enhanced at first hand his knowledge of the continental-based styles that he had seen imported to buildings in London and Leeds, in Bradford's civic buildings, on the drawing board in his uncle's firm and in the plans and illustrations reproduced in *The British Architect*. As a result Frank Rattenbury's confidence—and some might say his arrogance—was boosted. By the end of the European tour he was more determined and more confident that he could make a name for himself. But where was he to do this?

Frank saw little future in remaining in his Uncle Richard's declining firm. On the other hand, he lacked the money to set up a practice of his own. Moreover, while winning the Soane Medallion might have enabled him to enter a more prosperous firm, during the 1890s there were too many British architects for the work available. It is not surprising, therefore, that the restless Ratz glimpsed prospects on the west coast of Canada, where every newcomer, so the immigration brochures assured him, could find more hopeful chances.

SOME MIGHT ATTRIBUTE Rattenbury's success in Canada to timing. After all, when he arrived in British Columbia in the spring of 1892 many citizens wanted Victoria to assert its status as capital of the province and to establish its civic identity not only in Canada but in the rest of the Empire. Hence the support for the government's proposal to finance a handsome range of public buildings. Likewise, the business community was eager to invest in the province's newfound wealth, along with the funds it could attract from eastern Canada and Britain, to construct banks, houses and churches, railway hotels and amusement centres. Just like Victoria's newly laid-out sewer and lighting systems, streetcar rails and telephone lines, such buildings were symbols of wealth and status. Constructing them, however, meant high-risk work for the builders. Amid conditions of economic uncertainty, a contractor could go bankrupt or make a fortune. And designing buildings could make—or destroy—the reputation of an ambitious architect.

But timing alone does not fully explain how a twenty-four-year-old immigrant from Leeds so quickly made his mark. Within a few weeks of

arriving in British Columbia, Rattenbury opened an office on Cordova Street in downtown Vancouver. Though he was still doing some work for Mawson and Hudson back in Leeds, he desperately needed fresh commissions in British Columbia. He therefore placed a notice in the *Vancouver Daily World* on 5 July 1892, announcing that he was open for business. In it he claimed to have been working as an architect for ten years with "the well-known firm of Lockwood and Mawson." Not only was the prestigious Lockwood name long since defunct, if it had been true that Rattenbury had joined the firm in 1882 he would have been a young teenager. He likewise went on to claim a hand in designing Bradford's town hall and Saltaire's model city: both of these projects had been completed when Frank was a youth.

This was not the first or the last time that Ratz embellished his credentials. It was easy for him to falsify his past. There were no long-distance telephone lines or websites where his story could be checked. Frank knew that Leeds was a long way from British Columbia; and his fellow Yorkshireman, Edward Prior, was hardly the sort to blow the whistle. In 1896 Prior lost his seat as a Member of Parliament for election irregularities and in 1903 he was dismissed as the province's premier for awarding an important public construction contract to his own business. Such ethical laxity was easy to live down in an era when a gentleman was as good as his word—or as good as what he claimed to be in the newspaper. But it worked. Shortly after placing his advertisement, Rattenbury got his first commission: to design a residence for the German-born bookbinder Gustav A. Roedde in the West End of Vancouver.

Many people in British Columbia took the debonair Ratz to be older and more experienced than he was, and accepted him at his own valuation. After all, architecture was a young profession in Canada. It was only during the decade following 1885 that professional codes of ethics were established, that architectural federations were formed, that a professional journal, *Canadian Architect & Builder*, was launched and that degree-granting schools of architecture were founded at McGill University and at the University of Toronto. Indeed many architects in Vancouver, New Westminster and Victoria had come to their profession through the building trades. Few had served an apprenticeship in an architect's office.

And most of them, arriving in British Columbia via the United States, had never designed anything more demanding than the uninspired two-storey brick buildings, now replacing the fragile wood-frame structures that had enabled first Victoria then later Vancouver to call itself a town. Even so, by 1891 British Columbia had an Association of Architects, which in 1892 became the British Columbia Institute of Architects. This was the body that set an architects' fee at 5 per cent on any project above $2,500.

On the same page of the same newspaper that carried Rattenbury's advertisement on 5 July 1892, a more momentous architectural announcement was published. Posted by the Chief Commissioner of Lands and Public Works, it invited architects both in Canada and abroad to submit preliminary drawings for a Provincial Legislature or Parliament Building, which the government had voted to construct in March 1892. It was to be sited in Victoria's Inner Harbour and to comprise four blocks: one for administration offices, one for the legislature and two more for the Queen's Printer and the Land Records Office. The building's size was limited to 600,000 square feet; its cost was not to exceed $600,000. It was to be fireproof and, whenever possible, to be constructed from local materials. The building was to be completed in time for Queen Victoria's Diamond Jubilee in 1897.

The government's building specification required that the new legislative building be sited on the space behind six wood-framed government buildings known as the Birdcages. Located on the south side of the Inner Harbour, these original colonial administrative buildings looked across to the site of the recently demolished Fort Victoria and over the mud flats to the wooden bridge that connected the residential area of James Bay with the town. The Birdcages also stood within sight of the Songhees Indian Reserve.

Virtually no one saw any problem in appropriating this land around Victoria's Inner Harbour. When James Douglas had chosen a site for the Hudson's Bay Company's fort in 1843, he proclaimed the area on the tip of Vancouver Island to be "a perfect 'Eden,' in the midst of the dreary wilderness of the Northwest coast."[4] Likewise, when H.O. Tiedemann

4. James Douglas to James Hargrave, 5 February 1843, in G.P. de T. Glazebrook, ed., *The Hargrave Correspondence, 1821–1843* (Toronto, 1938), 420–21.

designed and oversaw the construction of the colonial-style Birdcages in 1859, the issue did not arise. Nor did it in 1892. This was largely because the civil servants associated with the imperialist project considered every inch of the province to be available for their own use.

But was the area around present-day Victoria an "Eden," a *tabula rasa*, as Douglas saw it? In fact, the wilderness areas of what was to become British Columbia—where Europeans had traded for furs, set up forts, panned for gold, established farms, dug mines, cut down trees, laid railway tracks and built towns and cities—was never virgin territory. It was, and still remains, a contested site: an area of dispossession. The Lekwammen Coast Salish people had no fewer than ten village sites on the southern tip of Vancouver Island. These were a people whose men and women had helped clear the ground, provide the building materials and the labour that built Fort Victoria. Their reward was to find themselves moved from the area outside of the fort in 1850 to Pallatsis—literally "place of cradles," or as the settlers called it, the Songhees Reserve. Sixty years later its inhabitants would be moved out of the city altogether because the good citizens of Victoria no longer needed nor wanted Native peoples on their doorstep.

Thus Rattenbury did not view the site for his building as a contested space that had dispossessed the Lekwammen people. He was focused on winning the greatest architectural competition in British Columbia's history, claiming a position of prominence for Victoria on the map of the British Empire. Getting onto the shortlist would give him a much-needed foothold in the province as an architect. It might even lead to further government commissions.

The government, too, was focused on the competition. It knew that such competitions were popular with the public because they were ostensibly fair—all submissions were supposedly anonymous. Large construction projects also provided jobs, especially needed during periods of depression. Moreover, since architects had to finance all of the costs associated with their submissions, government officials could claim that the competition cost the taxpayer nothing. It thus fell upon Rattenbury to cover the expense of preparing his preliminary drawings and seeing to it that they were delivered to the Chief Commissioner of Lands and Public Works in Victoria.

Apart from the Chief Commissioner, the other two judges of the competition were an architect from Ontario and another from Quebec. They made it clear to the competitors that they wanted a set of plans that would rival the legislative buildings that had been erected in Quebec in 1880, in Manitoba in 1884 and in Ontario in 1886. They wanted a building that would commemorate British Columbia's entry into Confederation, achieved in 1871; celebrate its connection to the rest of the country by the Canadian Pacific Railway fourteen years later; and signal its considerable wealth as a result of gold rushes, mining booms (whether coal, silver, lead or zinc) and the exploitation of the province's other natural resources. This is certainly what the citizens of Victoria wanted: a building that would confirm their city's status and importance. This was all the more important because there were signs by 1891 that Vancouver was eclipsing Victoria in size. The fear was that the terminal city was taking over as the centre of the province's fishing, mining, lumber and export industries, and that Victoria's neighbour would progress, by the turn of the century, from a resource-based to a service-based industry.

By the time the architectural competition closed in September 1892 the judges had received sixty-five sets of plans from sixty-two architects. There were submissions from architectural firms in Chicago, San Francisco and New York. There were submissions from Toronto and Montreal, Winnipeg and Ottawa. Inexperience or lack of qualifications did not deter nineteen of British Columbia's own architects from responding: eleven of them from Victoria and eight (including Rattenbury) based in Vancouver or New Westminster.

Among the entries from Victoria was one from the city's most successful architect, the former mining engineer John Teague. Since his arrival in the 1870s, this British-born architect had designed an addition to St. Ann's Academy, Victoria's City Hall, the Masonic Temple, as well as schools and churches and several two-storey commercial buildings. Though less prolific, another British-born and British-trained architect who entered the competition, Thomas Charles Sorby, had designed fashionable residences and the Five Sisters Block in the centre of the city. These two men, along with three other architects from Victoria (Thomas

Hooper, Edward Mallandaine and A. Maxwell Muir), were naturally seen as the seasoned favourites to win the competition.

Rattenbury knew this. He also knew that his submission had to do two things: speak to local pride and incorporate stylistic elements from a variety of sources. This is surely why he entered the first round of the competition with the *nom de plume* "B.C. Architect." It is why he chose local materials for the building's façade, thus affirming the grandeur of the British Columbia landscape. It is also why, in designing the building, he drew on a variety of historical architectural styles.

In November 1892, just two months after submitting his plans, Rattenbury found himself shortlisted. Just twenty-five, he was chosen alongside Thomas Sorby, some thirty years his senior, and three architectural firms from the United States. For the second stage of the competition, the judges wanted the five remaining candidates to refine their first submission by giving careful attention to the building's staircases and passages, to entrances, to light and air and to heating and ventilation. They also wanted a more detailed plan of the construction. Fulfilling this task in three months was a tall order. But Rattenbury did so, once again, at his own expense.

Entering the second round of the competition, Ratz played the cards in his hand with his customary shrewdness. In choosing a new *nom de plume*, "For Our Queen and Province," he was surely nudging the Canadian judges with an appeal to imperial pride against the American challengers, at a time when anti-American suspicions were easily excited. Rattenbury conceived a T-shaped building. The central block featured a magnificent entrance flanked by two towers, a grand rotunda, a sixty-one-foot-long legislative assembly and government offices. An east and west wing, connected to the central block by a classically inspired colonnade, completed his plan.

In his submission, Frank Rattenbury had chosen to deploy the whole gamut of contemporary and historical styles. Among them were Italian Renaissance, Richardsonian or American Romanesque, and Gothic Revival. Thus the finely detailed arch at the entrance of the central block owed its inspiration to the revered American architect Henry Hobson Richardson. The huge dome that rose ninety feet above the

Domical Hall had its roots in the buildings of the Italian Renaissance. The general layout of the buildings spoke to eighteenth-century English country houses as well as to medieval English cathedrals. And the use of Romanesque and Northern Renaissance elements to underpin the entire design could be paralleled in both London's Natural History Museum and Imperial Institute. Rattenbury called this mélange of architectural references "free classical style."

Rattenbury's overall conception of the Legislative Building would have pleased late Victorian aesthetes like John Ruskin who wanted buildings to conform to the picturesque through the application of surprise and irregularity. Ruskin had also demanded that buildings reflect the surrounding landscape. Not only would Rattenbury's proposal have pleased Ruskin: it pleased the judges, who found his plan "very dignified and effective."

On 15 March 1893 Rattenbury received a congratulatory telegram from the Deputy Chief Commissioner of Lands and Public Works. The young man had held off the Americans and bested Teague, Sorby and the rest of the province's established architects. Upon learning that he had won the commission, Frank closed his Vancouver office, packed his bags and sailed to Victoria. Initially he established residence in the city's most luxurious hotel, the newly built Driard Hotel. When this proved to be too expensive, he moved into a boarding house. In reluctantly scaling down his immediate accommodation, however, Ratz had certainly not scaled down his ultimate ambitions.

IT WAS ONE THING to design such a building as the legislature, another to complete it successfully. Rattenbury had agreed to meet the contractual requirement that local materials be used wherever possible. For the building's foundation he chose light grey granite from Nelson Island, located one hundred kilometres northwest of Vancouver. Andesite, known to be easy to carve, was chosen for the rest of the exterior and brought from a quarry on Haddington Island in the Broughton Strait. The slate used for the roof came from a rich quarry in Jervis Inlet. The sandstone was likewise taken from quarries on the Gulf Islands. The bricks too were locally

made. Douglas-fir was used for the construction work, and red cedar and maple for the interior of committee rooms: all of the wood from lumberyards on Vancouver Island. Even the kitchen range was manufactured locally by Victoria's Albion Iron Works Co.

Other building materials and hardware were imported. The marble used in the legislative assembly and in the rotunda came from quarries in Tennessee and Italy. Most of the stained glass came from London's E.W. Morris Co. and, at the architect's behest, from Powell Brothers of Leeds. The glass was variously decorated with quotations from such English writers as Francis Bacon and Samuel Johnson, adorned with figures from ancient Greece and Rome and inscribed in Latin or illustrated with pictorial symbols that paid homage to the arts and sciences. Many of these symbols and personages were more fitting for a public building in Europe than in British Columbia. But that, of course, was the point. It was as important for the young province to look back and connect with the Empire and Europe as it was to project to the future.

Just as Rattenbury attempted to use local materials, he also attempted to employ local people. His first contractor, Frederick Adams, was a Victoria resident. The fresco artist, Victor Moretti, who worked closely with Rattenbury on the interior decoration, was a recent immigrant from Italy. H. Bloomfield & Son of New Westminster provided the geometric mosaics of coloured glass that ornamented the skylights and screens in the central block. Albert Franz Cizek, an immigrant tinsmith and sculptor from Vienna, produced the gilded statue of Captain Vancouver that was erected on top of the central dome. E.C. Howell, who was the government's Superintendent of Works, himself carved the capitals on the pillars in the Legislative Assembly. And, although there were initial complaints in the local press that too many Americans were on the building site, the majority of carpenters and plumbers, bricklayers and stonemasons, electricians and plasterers, painters and steamfitters were permanent residents of British Columbia.

A project of this size must have made innumerable demands on a newly minted architect. After learning that he had won the commission, Rattenbury had to prepare more detailed drawings. This was done on a small table in his boarding-house bedroom. He also had to order the local

and imported materials. He had to work with a variety of personalities: from the contractor, the craftsmen and the labourers to government officials whose conception of the building often conflicted with his own.

Yet Ratz gave no indication in his letters to relatives back home in Leeds and Bradford that he was faced with difficult challenges and difficult decisions. Writing to his uncle, Richard Mawson, during the second year of the project, Frank claimed that he was spending a lot of time swimming, walking and, thanks to the purchase of a Peterborough canoe, admiring the rugged scenery as he paddled up the Gorge Inlet. Indeed, to Frank, that summer seemed "like one long holiday."[5] Frank also told his mother how it was a "great enjoyment to me when we were building the Parliament Buildings, to take it easy in the cool shade and watch a couple of hundred men pounding away for dear life at the hard stone."[6]

It is difficult to imagine Rattenbury in a recumbent pose on the building site during the height of construction. Or to picture him devoting an entire summer to taking in the scenic beauty of his new home. In fact it is difficult to imagine Frank as anything but busy—frantically busy—during the four years that he oversaw the building of the Parliament Buildings.

What his letters home did not reveal, however, was that from the moment construction began in the summer of 1893, Rattenbury discovered that government commissions were a messy business. As the chief architect on the project he had to please the general public, and the building contractor, as well as various government officials and ministers—not an easy thing for a man who always wanted his own way to achieve. He openly fought with his first contractor, Frederick Adams. Unable to keep to the fixed-price contract, Adams found himself unable to pay his men and went bankrupt. There followed several meetings with Rattenbury during which, to the government's embarrassment, many

5. Francis Mawson Rattenbury to Richard Mawson, 25 August 1894, cited in Anthony A. Barrett and Rhodri Windsor Liscombe, *Francis Rattenbury and British Columbia,* 53.
6. Francis Mawson Rattenbury to Mary Rattenbury, 25 August 1894, cited in Anthony A. Barrett and Rhodri Windsor Liscombe, *Francis Rattenbury and British Columbia,* 55.

insults were hurled between the two men. The matter was only resolved when the unfortunate Adams drowned in a boating accident.

Ratz did not always get his own way. Tempers flared again in 1897 when the government began removing a screen of trees in front of the Legislative Building. Writing to the editor of the *Colonist* newspaper, Rattenbury stated that it made him "heartsick to see each tree as it falls to the ground."[7] His appeal was of no use. The trees were cut down. On another occasion, Rattenbury threatened to resign when members of the executive council decided that the Land Records' Office, designated for the East Wing of the buildings, should be occupied instead by the Provincial Museum of Natural History. Though Rattenbury fought hard against the proposed change, the motley collection of stuffed-animal trophies was nevertheless moved into the East Wing of the building. But Rattenbury remained on the job.

In 1895 he encountered problems with the new Chief Commissioner of Public Works, A.G.B. Martin, a former cattleman from the interior of the province. Rattenbury had promised the previous Chief Commissioner that he would reduce expenses by cutting the imported marble from the budget. But it is clear that he had no intention of eliminating the material. He decided, instead, to wait for a more sympathetic Chief Commissioner to take the place of the old, penny-pinching one. There ensued a sharp exchange of letters between Rattenbury and Martin. The architect pleaded that if "cheaper imitation material" were used "the grandeur of the whole scheme would be absolutely ruined."[8] It worked. Rattenbury got his marble and the government got the finest two rooms—the Legislative Assembly and the Domical Hall—of any provincial parliament buildings in the country.

Rattenbury claimed that he could adhere to the government's request that the total cost of the project should not exceed $600,000. He also assured government officials that he would have no trouble meeting the deadline for completion in 1897. Neither estimate was realistic. The final bill came to over a million dollars and the building was not completed until 1898.

7. *Colonist* (Victoria), 18 December 1897.

8. Anthony A. Barrett and Rhodri Windsor Liscombe, *Francis Rattenbury and British Columbia,* 56.

There were many reasons why the completion date could not be met. At the outset the stonecutters delayed work by going on strike. Other time-wasting incidents arose when some workers, not surprisingly, balked at being unfairly subjected to piecework and speed-ups; and carpenters, who had been in a trade union since 1863, struggled to maintain an acceptable wage level and the nine-hour day. Time was also lost because Rattenbury altered his plans. This meant that when he rejected materials, the builders then had to wait for a new delivery of materials to arrive, often from abroad. Rattenbury also fought with government officials and his co-workers, all of which resulted in time-consuming correspondence and time-wasting public hearings.

Yet when the Lieutenant-Governor T.R. MacInnes presided over the opening of the Parliament Buildings in February 1898, everyone seemed to forget the delays, the contentious letters to the editor, the open hostilities and the threatened resignations. And no one now remembered—or acknowledged that they remembered—how difficult it had been to work with the arrogant, strong-willed and overbearing Ratz who had moved from being an apprentice to a master architect within the space of a few years.

Several months before the opening ceremonies, Rattenbury had been heartily congratulated by the provincial librarian. Bringing the "huge masses of gray stonework" into harmony with "the blue waters of James Bay" and "the glorious Olympic mountains" had been achieved, according to Richard E. Gosnell, "in a spirit of accordance with the materials to be obtained and in conformity with local requirements."[9]

Nor did the quality of the Parliament Buildings' interior go unacknowledged. After paying tribute to the "imposing and pleasing" overall structure of the buildings, a writer for the *Victoria Times* directed his attention to the interior. Of most interest to him was the well-proportioned two-storey-high Legislative Assembly. The Ionic marble columns, magnificently carved Speaker's throne, large and roomy galleries with four dome-shaped lanterns and side windows that provided sufficient illumination at all times of the day, combined to give British Columbians

9. Douglas Franklin in Martin Segger, eds. *The British Columbia Parliament Buildings* (Vancouver, 1979), 13–14.

"a chamber of which they have every reason to be proud." Rattenbury had not only managed to bring together "an architectural pot-pourri of Classical, Renaissance, and even Baroque features" in the Legislative Assembly, he had created a monument whose domes and turrets, majestic entrance and finely detailed, lavish interior were all in accordance with the grandeur of the landscape and an expression of the future ambitions of the province.[10]

The fact that the Legislative Building was not completed on time for the Jubilee celebrations in the spring of 1897 had one outcome that was more than temporary. The lighting contractor, Cunningham and Hinton, found a way to give the impression that the job was, in fact, finished. He instructed the workers to trace the contours of the building with hundreds of lights. Though this device suggested the artifice of a fairground rather than the majesty of a parliament building, the simple fact is that it did the trick magnificently. Once switched on, the lights were never removed and the Legislative Building continues to be illuminated in this manner to this day. It is, in fact, one of the building's most distinctive features, duly appearing in many photographs and on picture postcards.

One can only wonder what the Lekwammen people must have thought as they witnessed the large blocks of granite pile higher and higher until the building had reached its present form. Many of them could, of course, remember Fort Victoria. Some of the elders among them had probably helped to build it. The Legislative Building might have looked unfamiliar, might even have looked out of place. But standing proud by day, and then illuminated across the harbour by night, its very presence signified that the men and women who had come to British Columbia a little over two generations earlier were here to stay.

Rattenbury's original plans had called for the central dome to be crowned with a gilded statue of Britannia. The government disagreed. This time Rattenbury did not resist. As a result, it is Captain George Vancouver, the first European to have circumnavigated and surveyed Vancouver Island, who looks over the Inner Harbour and beyond it to

10. *Victoria Times*, 10 February 1898.

the distant Sooke Hills from the top of the dome. The imperial Garden of Eden lies at his feet.

RATTENBURY WAS NOT IN VICTORIA to receive the accolades that were bestowed upon the Parliament Buildings during the official opening. He was in London, where he and a business partner, Wellington J. Dowler, were attempting to raise money for their recently established Bennett Lake and Klondyke Navigation Company. Rattenbury and Dowler were attempting to persuade British businessmen to invest in the construction of steamers that would take gold-seeking miners across Lake Bennett to the Yukon. But the trip to Britain raised little money. When Ratz returned to Victoria, however, he found the necessary funds for this scheme among fellow members of the Union Club, from friends at the Masonic Hall and from other business acquaintances.

Three knock-down steamers were built. Contracts to transport men and goods across Lake Bennett to the goldfields were signed. But by the time the steamers were up and running, the miners were moving to richer lodes of gold in Nome, Alaska. Rattenbury's steamers had come too late, and in 1899 Bennett Lake and Klondyke Navigation Company folded.

This was neither the first nor the last time that Rattenbury took a financial risk. Shortly after settling in Vancouver, he had designed a prefabricated house with the hope of providing instant housing for his fellow immigrants. The only customers that he could find to buy it, however, lived on the Canary Islands! Later, during the construction of the Parliament Buildings, Rattenbury founded a decorating business, Melrose Paint and Decorating Co. Known today as Melrose Paint and Decorating Center, it was one of Rattenbury's few successful ventures— perhaps because he actually understood the business better.

Rattenbury had done financially well out of the Parliament Buildings—he had netted over $43,000 in fees (about a million dollars in today's money). In 1903 most of it went into the purchase of thousands of acres of land along the Nass, Bulkley and Nechako Rivers in northern British Columbia. This land abutted the projected route of the Grand Trunk Pacific Railway. Though the track linking Winnipeg and

Edmonton to Prince Rupert was completed by April 1914, the railway terminus on the coast never had enough volume of freight or passengers to make the railway viable. Not surprisingly, therefore, the branch lines leading to the areas of land that Rattenbury owned were never constructed and potential agricultural settlers could not be found. Moreover, the railway hotels and stations that Rattenbury designed in his capacity as the company's official architect were never built.

With few purchasers for its thousands of acres, Rattenbury & Co. Estates became a liability. Though Frank had sold some of his land before the First World War, he was still holding large portions of it after the conclusion of the hostilities. Things now got even worse for all concerned. In 1919 the Grand Trunk Pacific Railway declared bankruptcy and the Canadian National Railway took over their track. Then the government presented Rattenbury with a heavy tax levy on the remaining land that he had not developed. Unable to pay the taxes, he was forced to sell the land at a knock-down price to the government, which needed it for returning soldiers.

It was the Yukon story all over again. For if the gold rush in the Yukon had not petered out just as Rattenbury delivered his steamers to Lake Bennett, he might have built more than three steamers and thus made a considerable fortune from the transport of passengers and supplies. Likewise, if new settlers had purchased Rattenbury's land adjacent to the banks of the Nass, Bulkley and Nechako Rivers, he would have realized a great profit. If the Grand Trunk Pacific Railway had not gone bankrupt, Rattenbury's prefabricated houses, along with his designs for station houses and hotels, might have put his architectural stamp on wilderness areas in northern British Columbia. If…

Many other speculators in British Columbia had invested and lost money during the province's early boom-and-bust years. Yet Rattenbury seemed to have a knack for repeatedly getting things wrong. Good old Ratz could talk up his schemes at the Union Club but was a poor judge of character and often failed to do the arithmetic. Moreover, he was overly optimistic, a trait that led to self-deception. And, yes, he had singular bad luck in his investments. Even so, he continued to have high hopes for the province's future and his own ability to take part in its expansion.

"Speculations are fun for a year, but when the misery is drawn out over several years it is hard to see the point of the joke," he told his sister Kate, following the collapse of his Klondyke company in 1899. "At the same time," he wrote, "it is a curious feeling to be without any little ventures, as they certainly add a zest and excitement to life unless one burns one's fingers."[11]

However much Rattenbury enjoyed the frisson of adventure, his drive and ambition were best channelled into the profession for which he had been trained. It was when he undertook high-profile public architectural commissions that his personal fortune mounted and his reputation grew.

Even before the opening ceremonies of the Parliament Buildings, Rattenbury had undertaken a number of other public commissions. In 1895 he incorporated some of the design elements from the Parliament Buildings into a courthouse for the coal-mining town of Nanaimo. Around the same time, he drew on the less imposing wood frame–and–shingle Queen Anne style to design a courthouse for the town of Chilliwack in the Fraser Valley. And in 1897 he took on his first commission for the Bank of Montreal by drawing up the plans for its headquarters in Victoria. The success of this building led to further commissions from the Bank of Montreal in New Westminster, Vancouver, Calgary, Rossland and Nelson. In Victoria, the work was both copious and eclectic: in 1901–2 he designed the neo-Gothic Victoria High School and the lieutenant governor's residence, Cary Castle. The latter was designed in conjunction with the city's leading domestic architect, Samuel Maclure. Fashioned in both neo-Gothic and neo-Tudor styles, the building's destruction by fire in 1957 is thus particularly regrettable.

It was, above all, in the Kootenay towns of Nelson, and particularly in Rossland, known as the Johannesburg of British Columbia, that the scale and flair of Rattenbury's work, and its sheer eclecticism, flowered around the turn of the century. The three buildings that he designed in Nelson, which by 1899 had become the largest city between Vancouver and Winnipeg, gave the mining town an appearance of stability, permanence and solidity. The imposing, high-pitched mansard roof of the

11. Anthony A. Barrett and Rhodri Windsor Liscombe, *Francis Rattenbury and British Columbia*, 45.

courthouse was in the Château style, while the Bank of Montreal's high parapet along with its terracotta tile and intricate brickwork brought Italian classicism to the interior of British Columbia. Nelson's most elegant building, however, was the Burns Building commissioned by Rattenbury's friend, the Alberta cattle baron Patrick Burns. Intended for Burns' meat packing business, the building's decorative stylized foliage and terracotta panels, along with its clever use of brickwork, illustrated the extent to which Rattenbury could work on a small scale yet achieve a sense of grandeur.

In 1905, when the city of Vancouver needed a new courthouse, it was Francis Rattenbury, as the province's leading architect, who was chosen to design it. When extensions were projected, or renovations were needed, for such high-profile buildings as the Hotel Vancouver, the Château Lake Louise, Mount Stephen House in Field and the Banff Springs Hotel, it was Rattenbury whom the Canadian Pacific Railway (CPR) commissioned to do the job. And in 1903, when optimistic Victorians still hoped that their city would become the CPR's terminus, it was Rattenbury who designed the châteauesque-style Empress Hotel that emerged from the mud flats across the harbour from the Parliament Buildings. While Vancouver remained the CPR's terminus, the Empress Hotel did indeed bring to the West Coast some of the gravitas of the CPR's Château Laurier in Ottawa and Château Frontenac in Quebec City. It also helped to foster a new industry for Victoria that was to sustain the city during the following century—tourism.

In the winter of 1910 Rattenbury was at the top of his game as an architect. Yet his frequent trips to Europe left him discontented at living in "sleepy old Victoria."[12] Victoria was a useful base from which Rattenbury invested his money and designed buildings elsewhere in the province; but it was short of stimulation. Frank found himself longing for a radically different environment that might ignite new interests and renew his energy. He thought of setting up his architectural practice in London, or perhaps San Francisco, or even in Rome, which he had visited on his grand tour so many years earlier. But he was hard-headed enough

12. Francis Rattenbury to Mary Rattenbury, 2 December 1919, Francis Mawson Rattenbury Papers, Victoria City Archives, Victoria, BC.

to see that he had obligations that kept him in British Columbia; and in 1911 he received a commission that he could not refuse.

That year the provincial government voted $150,000 for further construction on the Parliament Buildings. A legislative library and two wings to the east and west of the Legislative Assembly for the rapidly growing administration were to be added to the central block. Rattenbury was not only the preferred architect. By now he seemed to be the inevitable architect to finish the job for which he was the most famous and sought to repeat his triumph. But Rattenbury did not work alone in fashioning the plans. Ethelbert O.S. Scholefield had replaced Richard Gosnell as the archivist and librarian and it was he, as much as Rattenbury, who gave shape and content to the layout of the Legislative Library.

At the time there were no institutions of higher learning in the province. Moreover, libraries were either private or under the purview of the Mechanics Literary Institutes. Very much aware of this lacuna, Scholefield wanted to build "a scholastic retreat for the student, the scholar and the historian."[13] He also wanted to create sufficient space for the province's archives. Rattenbury felt differently. His design called for a three-storey-high hall in the centre of the library, thus reducing the space for books, let alone for the province's archives.

Initially Rattenbury and Scholefield worked together well. Rattenbury accepted Scholefield's suggestions for the names of sixteen people—from Captains Cook and Vancouver to Simon Fraser and Judge Matthew Baillie Begbie—all of whom had helped shaped British Columbia. The sculptor Charles Marega, a recent immigrant from Trieste, Italy, produced three-foot maquettes of each figure. A stone carver turned the maquettes into nine-foot-tall figures, and these were placed in niches on the exterior walls of the library building. Not forgetting that the majority of British Columbian's settler community had their roots in Europe's culture, Scholefield also came up with the names of literary figures and philosophers, including Shakespeare, Dante and Sophocles, and Marega carved small medallions of their heads. But these were minor

13. Terry Eastwood, "R.E. Gosnell, E.O.S. Scholefield and the Founding of the Provincial Archives of British Columbia, 1894–1919," *BC Studies* 54 (Summer 1982), 57.

additions. When the provincial librarian repeatedly urged further changes, or what he thought of as improvements that would help to accommodate the archives, Rattenbury pressed his case—and won. A disappointed Scholefield nevertheless saw the parliamentary library completed within three years.

The coming of the First World War blighted Rattenbury's professional career as much as his financial investments; and in its aftermath he found building projects curtailed or even abandoned. Even so, he received two notable post-war commissions in Victoria, namely the new CPR Steamship Terminal and the Crystal Gardens, both designed in conjunction with British architect, Percy Leonard James. As with Scholefield, the collaboration quickly turned sour. James accused Rattenbury of not giving him enough credit for his contribution to both buildings. Though James did carry out much of the detail work on the plans, it was Francis Rattenbury who had been responsible for the design of both buildings. The Crystal Gardens, not finished until 1925, is less striking than the classically inspired CPR Steamship Terminal, finished in the previous year, with its elegant colonnade looking out on to the water. These were his last important commissions; both had come in 1923—the fateful year that Frank met Alma.

Rattenbury's buildings had given Victoria a tourist-attracting inner harbour, Vancouver a monumental courthouse and fledgling communities from Nelson to Nanaimo a sense of permanence and stability. Adapting local materials and new building techniques, deploying a stylistic vocabulary ranging from the American-inspired Richardsonian Romanesque to the Italian Renaissance and the English Gothic, Rattenbury had set new standards for his provincial contemporaries. At the same time he had raised the profile of his profession by serving as president of British Columbia's first professional association of architects. An early conservationist, Rattenbury had created Willows Park and saved Oak Bay's golf course from residential development. If his campaign to save the tall cedar and Douglas-fir trees that screened the Legislative Building had been a failure, he had the consolation of seeing his own handiwork thereby better exposed to public view. No stranger to taking financial risks, he

had invested—and lost—in schemes associated with, among others, the Klondike Gold Rush and the Grand Trunk Pacific Railway.

Francis Mawson Rattenbury was, in so many ways, typical of his era: an ambitious immigrant who was determined to make good; ready, if necessary, to cut corners; prepared to risk his fortune on the frontier of the Empire. It was all very far away from Leeds, yet he did not forget what he had learned there, instead turning his knowledge to good professional account by quickly seizing his opportunities. Almost all of his best work was done before middle age, within twenty-five years of arriving in British Columbia. Rattenbury did not create a "style" of his own. He turned a blind eye to new theories of architecture that, by the mid-1920s, were challenging the adaptation of historical models and applied ornamentation. Even so, during his heyday Rattenbury had been imaginative in reworking the conventional styles of the late Victorian era in a way that makes his buildings instantly recognizable, right across the province. Buildings designed by Rattenbury seem more solid, more consciously decorative and more graceful than the buildings surrounding them. No one more completely captured and defined the history of the province and its aspirations like Francis Rattenbury, whose buildings acknowledged earlier architectural styles yet evoked British Columbia's future prosperity.

Butchering the Garden of Eden
MARTIN ALLERDALE GRAINGER (1874–1941)

MARTIN ALLERDALE GRAINGER is known today as the man who wrote *Woodsmen of the West*.[14] The novel was published in London in 1908 when the author was thirty-three years old, and it was to be his only book. It has often been read less as a work of the imagination than as a documentary chronicle, drawing on its vivid reportage of the author's experiences in the rain forests of coastal British Columbia at the turn of the century. It was the book's republication by McClelland & Stewart in 1964, as part of the Toronto publisher's New Canadian Library series, that was to give Grainger's work a new life and a new status. Indeed it signified that *Woodsmen of the West* had been accepted into the canon of Canadian literature. The parallels between "Mart," the novel's central character, and its author, Martin Grainger, can only go so far since what we know of Grainger's actual lifetime is in many ways at odds with the posthumous reputation that has been constructed.

Admittedly, *Woodsmen of the West* contains much telling detail, with a verisimilitude reinforced, in the first edition, by photographs of some of the loggers with whom Grainger himself had worked. This, along with the graphic first-hand account of the logging industry in British

14. All quotations from Martin Grainger's novel are taken from *Woodsmen of the West* (Toronto, 1964).

Columbia, has made it tempting to put Grainger's novel in the category of creative non-fiction. True, when the book was first published, Grainger had recently spent time in a logging camp and, like the novel's protagonist Mart, he felt that he was lacking physical ability. Unlike Mart, however, the author himself was anything but shy. Most remember him as talkative and sociable, even as gregarious. The real Grainger was by no means "the delighted amateur" Mart, experimenting in the backcountry of British Columbia, whatever the artifice suggesting otherwise in his fictional account.

We need to remember that we are reading a novel that is a projection of carefully selected aspects of Grainger's own life and experience. He was British, born in London in 1874, and his friends indeed knew him as "Mart" just like the central character in his novel. Grainger was university educated, graduating from Cambridge in 1896. The family moved to Australia when Grainger was two years old, and when he reached school age he entered St. Peter's School in Adelaide. Naturally he acquired Australian intonation and an Australian vocabulary, which gave him a "peculiar accent." His accent was only modified after the boy was sent back to England for further education.

Ill during the early years of his life, Martin was regarded as a disappointment by his large and burly extrovert father. Henry William Grainger had vigorously pursued multiple careers as a stockbroker, a newspaper editor and also as a member of the Australian Parliament until he went bankrupt and was forced to resign. But he resurfaced in 1901 as the Agent-General for South Australia in London. With the family back in England, Henry Grainger had expected his son to go to Rugby School, the public school known for its tradition of muscular Christianity and made famous in Thomas Hughes' 1857 novel, *Tom Brown's School Days*. Instead, the sickly boy was awarded a scholarship to Blundell's School located in his mother's hometown of Tiverton in Devon. Then, after winning an exhibition (a competitive entrance scholarship) at King's College, Cambridge, he studied mathematics for his degree. In this subject the young man showed considerable aptitude in a challenging field in which Cambridge had excelled since the days

of the revolutionary seventeenth-century physicist and mathematician, Isaac Newton.

In Cambridge, Martin Grainger became a member of the left-leaning Fabian Society, which propagated an orderly vision of socialism that appealed to the professional classes. He also discovered the writings of the second-century Roman emperor and stoic Marcus Aurelius, whose philosophy of service and duty coupled with a reverence for nature would remain Grainger's spiritual touchstone throughout his life. Making his own way, the young man now flourished physically as much as intellectually. In spite of his slight frame, Grainger was a founding member of the Cambridge Boxing & Fencing Club. He also rowed for his college.

Far from leaving these influences behind, Grainger was to commend the stoicism, the pride in manual labour, the artistry and inventiveness, the professionalism and democracy that he found manifested among the loggers whom he later depicted in *Woodsmen of the West*. "One is made to think over the commonplaces about education, and to realize that a man can get well trained in his more generous character without troubling the books very much." He found the loggers' values more sympathetic than those of many of his own narrow-minded and class-bound countrymen: "There is a toleration [in the logging camps of British Columbia] that surpasseth all the understanding of the old-country English."

It was in this spirit that Grainger first headed to Western Canada. News of the Klondike gold rush of 1896 had reached him in England. He showed himself to be his father's son in responding to the lure of a quick fortune and adventure. And two of his Cambridge friends joined him in his enthusiasm. One was Lyndhurst Falkiner Giblin, a two-hundred-pound English international rugby player.[15] The other, a young man called Forster, was equally keen to temporarily set aside his ambitions for a steady career. The trio set out for northern British Columbia in 1897. They headed up the Stikine Trail towards the Yukon but could not join the thousands of men who were panning for gold because they ran out of money to finance the rest of their trip. What now became of Forster

15. Lyndhurst Falkiner Giblin was a fellow Fabian who would later become the chief economist of Australia and ultimately Governor of the Solomon Islands. See Douglas Copland, *Giblin: the scholar and the man* (Melbourne, 1960).

is not known, but Giblin and Grainger spent the next two years working at various jobs in the Upper Stikine River Valley and at Dease Lake in the Cassiar District on the border between British Columbia and Alaska. It was in this rugged landscape that Grainger learned about hydraulic mining, about building and operating a sluice, about hunting for and then cooking his food over an open fire. He also learned how to row a thirty-foot scow, to handle a dog team and to pit himself against minus-fifty degree weather. He learned how to survive a winter with only one book, sharing with Giblin a copy of George Meredith's novel *The Egoist* (1879). And he learned to wield an axe and handle a crosscut saw.

Grainger met a diverse range of individuals during his first years in northern British Columbia. There were prospectors representing almost every nation in the world. And there were Chinese labourers and Native peoples, officials from the Hudson's Bay Company and many others who would find a place in *Woodsmen of the West*. It was also in Cassiar, in 1899, that he met Leonard Higgs, a resident of the southern Gulf Islands. It was with Higgs that Grainger established the short-lived Thibert Alluvial Gold Company. And, some eight years later, it was Higgs who would become Grainger's brother-in-law.

Grainger's experience of living in central British Columbia for two years was unlike that of his fictional character Mart in *Woodsmen of the West,* who would never become a decent axe-man but remained "a mere butcher of wood." Looking through Fabian socialist eyes, Grainger saw for himself the devastating impact wrought in the Cassiar District by unchecked modern capitalism: the construction of instant mining towns and mines that ravaged the forests, the streams and the salmon habitat. He became aware of the suppression and displacement of the Aboriginal peoples and of the onerous tasks that Chinese labourers were forced to take on in the mines, the canneries and the railways if they wanted work. Grainger was mindful of the institutional racism towards these two groups, towards whom he was personally supportive, and mindful, too, of the destruction of the wilderness—all well before he arrived at the logging camp that he later made famous in his novel.

Just as it is wrong to suppose that the author of *Woodsmen of the West* was a newcomer to the woods, nor should Grainger be supposed a

raw novice when it came to writing. Years before composing his novel, Grainger had sent newspaper dispatches from the Front while serving in the Boer War (1899–1902). He had heard about the conflict in South Africa while working in the Cassiar District, and like the playwright Bernard Shaw and some other leading Fabians, Grainger supported the British imperial cause as standing for progress, pitted against the stubborn and reactionary South African Boers, and wanted to do his part. Grainger was initially rejected as a volunteer—probably because of his flat feet. He nevertheless worked his passage via New York City to South Africa where he managed to get himself attached to Lord Roberts' Horse division. As a mounted trooper—then as an officer in the Manchester Regiment— Grainger saw action that won him a six-bar South African medal. This surely confounded the low opinion of Grainger's physical ability, held alike by his father and the recruiting officer who had rejected him for service.

Moreover, rather than simply proving that Grainger was a man of action, the Boer War also gave him something to write about. Grainger's hard-hitting letters written to his old friend Lyndhurst Giblin, who had returned to England, found their way into two Liberal newspapers: London's *Daily News* and the *Westminster Gazette*.

Grainger's unsigned "Letters from the Front" and "Life at the Front" challenged what he called the "smug untruthfulness" of his fellow war correspondents (who included Winston Churchill, like himself aged twenty-six at the time, but reporting for the Conservative newspaper, the *Morning Post*). The British Army's transport arrangements were, Grainger wrote, "a sight to make the gods weep." Britain's troops, who were compelled to obey orders that they did not understand, seemed, he continued, like "hopeless amateurs" compared to the Boers. Above all, Britain's senior officers, so Grainger protested, lived in relative luxury while their troops lived on biscuits.[16] Such outspoken criticism would not be tolerated when, twelve years later, Britain was engulfed in the First World War. Even so, when that war did break out in August 1914,

16. Peter Murray, *Home from the Hill, Three Gentlemen Adventurers* (Ganges, BC, 1994) 142–43; also see Murray's profile of Martin Grainger in the 1994 edition of *Woodsmen of the West* (Victoria, 1994).

Grainger again rallied in support of the British Empire and was critical of those who did not join up.

Following his experiences in South Africa, Grainger returned to northern British Columbia in 1901. He first worked for the adventurer and speculator, Warburton Pike, at the Thibert Creek Mine Company near Dease Lake. Then Grainger, accompanied by Giblin who had rejoined him in British Columbia, moved south to the Gulf Islands in the Salish Sea. Pike had a house on Saturna Island. But Grainger's old friendship with Leonard Higgs led him to nearby North Pender Island. Here, from 1902 to 1903, Grainger and Giblin "worked and sweated like the bulls" hauling Douglas-fir and cedar into the water, notably at Wallace Point on the southwest approach to Bedwell Harbour.[17]

When they were not logging, the two men took part in tennis parties and afternoon teas and played scratch cricket on the adjacent South Pender Island. Grainger and Giblin not only made new social contacts with pioneer settlers like British-born Arthur and Lilias Spalding but also met Leonard Higgs's two sisters, Winifred and Mabel, who had first arrived on South Pender in 1897, and Winifred's husband, Ralph Grey, whom she had married in 1900. Martin Grainger and the five-year-older Mabel Higgs were likewise to marry—in the end. But whatever his feelings towards her were when they met around 1903, they were not strong enough to keep him from returning to England two years later.

ALMOST IMMEDIATELY upon his arrival in London, Grainger had a life-threatening illness. During his recovery he was swept up in the popular Japanese art of self-defence called jiu jitsu. The science of defeating brute strength by quickness and muscular ingenuity appealed to a man of Grainger's slim stature—and may have had something to do with his quick recuperation. "The art of softness," as jiu jitsu was called, was popular among military men and even among women. Grainger first demonstrated his skills at the official premises of his father, now the Agent-General for South Australia. He was so enthusiastic about the

17. "Early Days Out West," *Empire Forestry,* n.d. M.A. Grainger Papers, Royal BC Museum, Provincial Archives, Victoria.

sport that six months later, in October 1905, Grainger and two Japanese jiu jitsu masters founded a school called Ju-Jitsu Limited. In the summer of 1906, however, Grainger's venture came to a sticky end when his two associates absconded to Paris with the company's funds. Fortunately, Grainger had enough money in his pocket to pay his way back to British Columbia. With a view to making his living by his pen, he had a letter of reference from E.V. Lucas who had recently joined the magazine *Punch* as its deputy editor.

Convinced that England was "a good deal too small" for his old friend, Lucas felt that Grainger's "loyalty, his enthusiasm, and his adventurous gentlemanliness" were better suited to the New World. Though Grainger had written articles concerning, among other subjects, the hazards of immigration, for British publications like the *Pall Mall Gazette*, he had been unable to establish himself as a journalist in England. Even so, within months of returning to British Columbia, he set aside his literary ambitions and became a hand-logger working in a camp over one hundred kilometres north of Vancouver. Grainger's adventures in the logging camp, along with his investigation, during the late summer of 1907, of the purchase of timber leases in the company of Leonard Higgs, became the setting for *Woodsmen of the West.*

Grainger's fictional character Carter ran the logging camp located off Minstrel Island at the mouth of Knight Inlet. Black-eyed and dark-haired, this powerful man "had to talk or burst." Carter tells Mart how he had worked in lumber camps in eastern Canada, on a farm in Nova Scotia, in a mine in Montana and on rivers in Michigan; how he had trapped in the Cariboo, panned for gold, run a saloon, worked as a blacksmith in a logging camp in Puget Sound, all before achieving his present success in the logging camp. This self-made man is eager to show the educated Mart that he is reliant on no one and that he has created a small empire. "All mine," Carter says as he surveys his timber lease, "*my* donkey, *my* camps, *my* timber, *my* steamboat there! *Money* in the Bank, and *money* in every boom for sixty miles, and hand-loggers *working* for me, and me the boss of that there bunkhouse-full of men!"

At the time that Grainger was working in logging camps along the west coast of British Columbia, the inlets, bays and coves around Knight

Inlet were indeed the centre of hand-logging operations. "It was boom-time then up the coast," as Mart rightly observes in the novel, "and speculation was ballooning higher than men had ever known before." Logging was, of course, hardly a new activity. For centuries Native peoples had been felling cedar trees to build and carve their canoes, totem poles, ceremonial objects and community houses. They had also been stripping the tree's bark in order to make their clothing. When Captain Cook arrived at Friendly Cove (Yuquot) in March 1778 during his search for a northern route to China, one of the first things he did was to accompany his carpenters into the forest behind the Native settlement and choose spars for his ships, HMS *Discovery* and HMS *Resolution*. Almost a century after, James Douglas, then the Chief Factor of the Hudson's Bay Company and later governor of the Colony of Vancouver Island (1851) and of British Columbia (1858), hired the Lekwammen Coast Salish people to construct Fort Victoria in 1843 on the southern tip of Vancouver Island for the new Crown colony. (The Native peoples, whose land the Hudson's Bay Company had appropriated, were "paid" one blanket for every forty cedar pickets they supplied.) Commercial logging began in the 1860s but only expanded on a large scale in the 1890s when there were more export markets and, most importantly, more British capital.

Even though the federal government had retained Crown ownership over British Columbia's forests since 1865, the best timber had been leased for tax revenues and railway development. From 1870 to 1905, forest companies paid lease fees and were granted blocks of forest under various restrictions, the most significant being that the holder of a lease could not then sell it. From 1905 the government of Premier Richard McBride offered special timber licences that could subsequently be sold on the open market. This had the effect of immediately enhancing the speculative element for a man like Grainger's fictional camp boss Carter. Suddenly a lease on 160 acres could be bought for less than a dollar an acre.

Almost overnight a small army of timber speculators spread throughout the province securing leases, mostly along the coast. This was where hand-logger bosses and their crews felled Western red cedar and hemlock, spruce and Douglas-fir on the steep slopes around Knight Inlet and off Minstrel and Cracroft Islands. It is also where Grainger tells us

that Carter "set out to sack the woods, as medieval towns were sacked, by Vandal methods."

The Vandals, however, did not have an easy time of it. As Grainger makes clear in his novel, it was no simple task to get the trees from the steep wooded slopes to the mills in southern British Columbia. After making an undercut on a tree with an axe, two fallers climbed onto six-foot-long springboards wedged into either side of the tree. This precarious perch kept the fallers above the broad bole of the tree, above the pitch that clogged their seven-foot-long Swedish crosscut saws and above the tangled underbrush. When the fallers had dropped the tree to the ground, buckers removed the branches, bark and knots before sawing the tree into twenty-four- to forty-foot lengths. Then the hookers attached a long cable to a spar tree at the top of the slope and the log was ready to be dragged down a skidway—a track formed by horizontal logs—to the tideline. After the log hit the water, it was sorted and corralled into a log boom or raft and then floated south to mills up the Fraser River or in Burrard Inlet.

Bringing the monster trees to the ground—five men could stand shoulder to shoulder behind the stump of an old-growth Douglas-fir— and preparing the trees for the mill was physically challenging. Logging depended on men who were willing to work a long day, prepared to live in a shack poised on an unstable float, able to sleep on cedar slats in bunks three tiers high and ready to work in a highly competitive all-male environment for months on end. Hand-loggers could expect to eat well when the food was plentiful, and not so well when the supplies ran out. They had to risk life and limb, to endure the wet weather and the mud that went with it, to expect back and knee injuries, and to slave for a boss whose first concern was more often for the logs and their profitability than for his crew and their safety. Relations between one slave-driving boss and his men working in a logging camp on Vancouver Island became so tense that when the crew encountered their boss in Vancouver they allegedly "beat the hell out of him," and, as one eyewitness remembered, "walked on his face."[18]

18. Richard Somerset Mackie, *Island Timber* (Winlaw, BC, 2000), 80.

All the equipment that turn-of-the century hand-loggers needed was a good pair of hobnailed boots and some gloves. They also bene-fited, by the end of the nineteenth century, from two mechanical aids. The Gilchrist jack—or "Kill Christ," in loggers' parlance—weighed sixty pounds and had to be dragged up the hillside before it could begin nudging a pick-up-sticks pile of logs into place in preparation for their journey down the skidway. Another device, the steam donkey or donkey engine, was a powerful winch that also dragged the logs down the hill-side into the water with the help of cables that were attached to a spar tree. Whatever new mechanical aids were available to the hand-loggers, however, felling a tree essentially depended upon agility, speed and, above all, brute force.

Here was the raw physical challenge that faced Mart—and like-wise the literary challenge that faced his creator, Martin Grainger. The author makes his protagonist, Mart, younger than himself and totally new to logging practices and life in backwoods British Columbia. This is surely a literary device designed to induce Grainger's mainly British male readers to identify with Mart's self-deprecating manner and his insecurity. He was, Grainger writes of Mart, "a figure of hopeless incompetence." With his university education, his soft hands, his unconventional English accent and his slight physique, Mart seems unsuited to the rough and dangerous life of the hand-logger. Yet the fact that he imagines himself to be the laughing stock of the camp wins him empathy with his reader. Indeed, Grainger makes his readers feel that, like Mart, they are entering a logging camp for the first time, that they are working under a difficult boss, that they are being introduced to strange backwoods characters and that they are experiencing Mart's wonderment at the landscape as he first sails from Minstrel Island towards Knight Inlet.

In some ways Mart is portrayed as the kind of man that people do not have to get to know but feel comfortable with immediately. This was a bonus for a person who was not a talker but a listener. And since hand-loggers were "desperately anxious to talk," there is plenty for Mart to hear. But though Mart has skills that enable him to find a niche and to even win the respect of his fellow workers—and occasionally his demanding and unsympathetic boss, Carter—he never really fits in. He

does not gamble, though gambling was the primary amusement in a camp and hand-loggers would often lose a week's, a month's or even a year's earnings in an evening. Mart also has "a distaste" for liquor. And he is never up for a fight. When an insult from Carter infuriates him, his response is only in fantasy: "I would bash him in the face and put an arm lock on him, and a gloating thrill ran through me to think how I would listen for the crack of Carter's dislocated arm." Doing nothing, however, leaves Mart with the guilty feeling that he is "a fool."

The worst that could be said about a man in a logging camp was that he was lazy. And Mart set out to prove that he was anything but that. Much to the amusement of his fellow hand-loggers who are waiting for a ride to Carter's camp, Mart splits wood at the back of the Hanson Island Hotel for something to do while the other men pass their leisure time in the bar. Moreover, when the landlord offers to reimburse Mart for his effort, he refuses payment. Later, during a monumental trip in which Mart pits his rowing skills against two other men, he wins when their boat sinks and he has to rescue them. Thus Mart undertakes every task as though it is a game. "There is still the great pleasure of working up the *intensity of effort*, trying (vulgarly) to beat time, or to beat some other man's performance, or simply to see how long one's own endurance will hold out; playing games with one's work and with one's own body and character."

Grainger's central character demonstrates how the resourcefulness of an amateur gentleman can triumph over nature, over his own lack of skill and even over some of his fellow workers. Unskilled as a faller, bucker, hooker or cutter, Mart takes on a variety of tasks in an adaptable spirit. He dresses a fellow hand-logger's festering leg and nurses another man's infected eye. He puts his mathematical aptitude to good use by offering to keep Carter's books. And, much against his instinct for self-preservation, he agrees to row a leaky and unstable rowboat sixty miles up the treacherous inlet in order to get much-needed supplies. On another occasion, Mart also keeps his nerve when the boat that he is skippering, the *Sonora*, runs into difficulties: "I felt so superior to the man who had entertained despair; I felt I could show him how to keep cool and competent."

For Grainger the hand-loggers were proof that mere education paled besides the virtues of physical activity, self-reliance and independent thinking. He did not find it difficult to admire his fellow workers, with their "boyish craving for *efficient* performance, feeling for sound, clean work, and the very moderate care for consequences." Often thoughtful and witty, always tolerant and self-deprecating, Mart scorns the "conscious mental superiority" of the educated man. But he nevertheless maintains his upper-middle-class status as a gentleman, and by the end of the book he chooses to return to civilization, to take his place in the class system that he has so criticized. He does so, moreover, in order to uphold the moral obligation to his betrothed—"Farewell to loggers and my youth! / Farewell to it all: marriage is better."

All of this was very true to life. From British Columbia, Grainger had proposed by cable in 1907 to Mabel Higgs who had herself returned to England. When he received an affirmative reply, he quickly joined her. It was during the next few months of courtship over the late autumn and winter of 1907–8 that, drawing on his memory and on the letters that he had written to Mabel, Grainger wrote *Woodsmen of the West*.

Family legend has it that the book was written in two weeks—and out of necessity. It is certainly true that Martin Grainger needed to raise funds for his passage back to Canada, and the three hundred dollars raised from the sale of the copyright was enough to pay his passage home. In the spring of 1908 Martin and Mabel sailed on the same ship: he in steerage and she in first class. The couple were married in June of that year on Mayne Island, British Columbia, and then settled in the suburb of Esquimalt in Victoria. After taking various manual jobs, Grainger found a position more suited to his academic qualifications: teaching mathematics at the city's prestigious private school, St. Margaret's School for Girls.

WOODSMEN OF THE WEST had a friendly reception from British critics when it was published in London in 1908 by Edward Arnold Publishers, and for understandable reasons. First, Grainger was in good company on his publisher's new list, which included E.M. Forster's classic novel *A Room with a View*. Second, Edward Arnold set the tone by promising his

readers "a vivid and graphic account of an adventurous life." And, third, Grainger had interwoven his amateur photographs of the unpopulated landscape and work-worn hand-loggers into the text. It is no wonder that reviewers in the *Spectator*, the *Graphic* and the *Westminster Gazette* praised *Woodsmen of the West* as a realistic first-hand narrative rather than an infusion of selected experiences with a heavy dose of artistic imagination. Few of the critics seem to have doubted that this was anything but "life—rough, strong and genuine, the real thing." More ambivalently, the reviewer in the *Chicago Record Herald*, who was unique in referring to the book as a novel, found "art in his ingenuous artlessness." And Grainger's own university's magazine, the *Cambridge Review,* talked up the literary merits of the book in its extravagant claim: "What Mark Twain did for the steam-boat life on the Mississippi, Mr. Grainger has done for the camp on the shores and inlets of British Columbia."[19]

In his protagonist Mart, Grainger had created the sort of man that immigration officials, late nineteenth-century adventurer-visitors and travel writers were encouraging to settle in British Columbia. That such a man could pit his slim frame against the most robust of woodsmen resonated with commentators who feared that Britain was losing its vitality and its competitive edge. Its "national efficiency," as the Fabians liked to put it, was being impaired by the physical weakness of the supposedly imperial race. Some said that a city-bound male population that had few physical challenges was drawn too much into the female world and into situations that challenged their moral values. What some modern writers have called a crisis of masculinity saw the founding, during the late nineteenth and early twentieth centuries, of youth movements and outdoor clubs, notably Robert Baden-Powell's Boy Scout movement. These groups were devoted to an ideal of hard work and discipline within a masculine world that could only flourish outside of the city.

Grainger thus spoke to this concern by creating a character who finds himself in the wilderness. It was a wilderness, however, that was firmly within the Empire. And although Mart is among strangers, they remain nevertheless British subjects. It was not just the strictures of life in England that

19. Newspaper clipping files, Grainger Papers, Royal BC Museum, BC Archives, Victoria.

prompted such a man to exchange Cambridge for the backwoods of British Columbia. For many Englishmen, the Canadian West served as a synonym for freedom. Nor was this sense of liberation confined to working-class immigrants. Grainger's new brother-in-law, Leonard Higgs, had exchanged a comfortable life in England—he and his two sisters had been raised in an imposing country house near Hastings—for the freedom of eking out a living on South Pender Island and, subsequently, on the even more remote Samuel Island. Higgs's neighbour on South Pender, Arthur Spalding, spent forty-seven years clearing his land: "Sixty or seventy acres / That's all a lifetime clears."[20] For immigrants of all classes, therefore, opportunity beckoned in British Columbia. One did not have "to submit to anything—not even from public opinion," as Mart puts it. "If one's work, or one's boss, or one's food, or one's surroundings displease one," he continues, "one can move at once elsewhere, provided times are reasonably good—as they usually are."

For many in Grainger's British audience, Western Canada was seen as a field of opportunity and a land of plenty. In *Woodsmen of the West* we see Mart successfully engaged in exploiting British Columbia's natural resources, notably minerals, fish and timber, which many British visitors to the Northwest Coast from the late nineteenth century on described as "one of the roughest, wildest countries on the face of the earth."[21] Indeed, the woods in which Mart toils were among the largest and most valuable unexploited forests in the world. Here was a situation bristling with opportunities for those ready to forsake "a genteel job in England" in favour of tackling the challenge of this natural endowment. "There is definite work to be done," Grainger writes, "Nature and natural obstacles to be struggled against (and not one's fellow-men)…"

The fact is that *Woodsmen of the West* achieved more popularity among readers in Britain than it did in British Columbia. The few copies of the book that made their way to the West Coast did not ignite much interest,[22] perhaps because, as one local writer admitted, Victoria's citizens

20. Arthur Spalding, "Near the End" in *Put That Damned Old Mattock Away,* David J. Spalding, ed. (Victoria, 2013), 162.

21. R. Byron Johnson, *Very Far West Indeed* (London, 1872), 266.

22. Newspaper clipping files, Grainger Papers, Royal BC Museum, BC Archives, Victoria.

knew too little of the hand-loggers' "struggling lives." The paradox is worth exploring, since all forms of logging remained the dominant industry in the province, providing jobs and enabling astute businessmen like H.R. MacMillan to build industrial empires.

Above all, wood was to be seen everywhere in turn-of-the-century British Columbia. In rapidly expanding cities like the former colonial capital of New Westminster, for example, virtually every house was built out of wood. The picket fences surrounding that city's trim gardens were built out of wood. The lych-gate and belfry of Saint Mary the Virgin's church, which was constructed by the Royal Engineers in 1865, were made of wood. The two-storey Old Vicarage and the palatial Archdeacon's house with its four imposing chimneys were made of wood. The sidewalks that were treacherously slippery when it rained, and the steps leading from the town down to the sawmills, the canneries and the fishing boats at the mouth of the Brunette Creek, were made from wide cedar planks. Even New Westminster's roads were constructed out of small blocks of wood (and some survive to this day). The crosses in the Native peoples' cemetery and the fences surrounding their graves were made out of wood. New Westminster's residents burned mill ends in their furnaces and fireplaces. Lumber companies burned sawdust and other wood-waste in conical burners known as haystacks. The thick black smoke from these towers floated across the Fraser River as far as Lulu Island. And wood was burned in unintentional ways too. In 1898 a wood fire had reduced the town of New Westminster to ashes.

Yet in rapidly expanding cities like New Westminster, so largely made of and by wood, lumber was not the stuff of literature. Few people in British Columbia wanted to read about life in a remote logging camp or about the hand-loggers who were destroying or, as Grainger put it, "conquering" the landscape. The sort of British Columbians who had the leisure to read books often wanted their landscape to remain pristine, wild and untouched. By the turn of the century, hikers were ascending the mountains in the newly established forest reserves and soon-to-be-created provincial parks. (In 1911 Strathcona Park on Vancouver Island became British Columbia's first provincial park.) Less adventurous people were building substantial summer cottages in Burrard Inlet or setting up summer camps in the

unlogged parts of Vancouver Island or pitching tents in remote areas of the province that had become accessible by automobile and railway.

Loggers were certainly not the stuff of romance. The logging industry was responsible for the smoke that many in the book-reading class saw spewing from the furnaces in the lumber mills. Likewise, when they passed through the east side of the city they saw rowdy loggers raising hell while spending their hard-earned money during a trip south to Vancouver. Hand-loggers had a reputation for being foolhardy, undisciplined and hard-drinking. They could only be heroes in most people's mind if, like the woodsmen in Ralph Connor's *Black Rock: A Tale of the Selkirks* (1898), they submitted to the preacher who had warned them that "without Him you'll never be the men you want to be."[23]

If the public wanted romantic backwoods characters, they could find them in Robert Service's tales of the Klondike, which were first published in *Songs of a Sourdough* in 1907, a year before *Woodsmen of the West*. If they wanted physical evidence of the life in gold-mining towns like Barkerville, with their hurdy-gurdy girls, operas and rowdy clientele, they could find that too. And if the general public wanted romanticism, they could have plenty of it in wilderness romances, woodland poems, wild animal stories, sportsmen's tales and in the poetry of Pauline Johnson whose poems embraced the Native and white worlds. Virtually all of these romantic writers extolled the untouched wilderness but ignored or denigrated the Native peoples to whom the lands belonged.

Thus hand-loggers, with their rough ways, were not the stuff for fiction writers in early twentieth-century British Columbia. And the smokestack at the lumber mill and the logged-over hillside were not subjects for visual artists either. Since the late nineteenth century, artists from Ontario and Quebec had painted pristine images of the last six hundred kilometres along the newly built Canadian Pacific Railway to British Columbia. In the early twentieth century, immigrant artists, like Charles John Collings and Thomas Fripp, had pushed their way above the forest and the snowline to render a landscape "untouched by the hand of man." Even twenty-five years later when Emily Carr produced such paintings as *Loggers Leavings* and *Scorned as Timber, Beloved of the Sky*, the

23. Ralph Connor, *Black Rock: A Tale of the Selkirks* (London, 1898), 17.

visual imagery and literature of logging camps still encountered derision and resistance.

It was not the tangled wreckage on the foreshore below a skidway in a hand-loggers' camp that had obvious visual appeal. Nor were "butchering" images of the landscape of aesthetic interest to the artist and public alike. Yet the frontispiece of *Woodsmen of the West* shows a stark image of a man—possibly Grainger himself—standing on a twelve-foot-high stump with the crude caption "Conqueror" written below it.

THE BRILLIANT CONSERVATIONIST and novelist Roderick Haig-Brown would later characterize the first fifty years of logging in the province as "an affair of heedless devastation. Flats and benches and hill slopes were stripped clear of timber without the slightest consideration for the other values of land or water. Fires usually followed the logging, getting good hold in the waste of limbs and treetops and other debris, and burned the soil to powder. Creeks were filled with trash and logs were dragged across spawning gravels."[24] All of this was true. Three-quarters of the wood standing in the forest was ignored and only 40 per cent of what was felled ever reached the shoreline. The government of British Columbia badly needed to regularize the large revenues it was getting from the timber leases. It needed to control the forest fires. It needed to develop new markets. And, above all, it needed to find a balance between exploitation and conservation. In 1909 a Royal Commission of Inquiry on Timber and Forestry attempted to do something about all of this.

Grainger was, of course, an obvious choice to help the commission: he had worked in the camps in coastal and interior British Columbia as a boom-man, hand-logger, cook, hook tender, steamboat skipper and accountant. He had cruised up Knight Inlet with Leonard Higgs in search of timber leases. As a mathematician he knew something about statistics. And as a published author he knew how to put his thoughts into words. In 1910 he was made chief of records and secretary to the Royal Commission and in this capacity Grainger addressed such matters as trespass, timber tenures, rights-of-way, timber charges, scaling, timber

24. Roderick Haig-Brown, *Fisherman's Fall* (Toronto, 1964), 27.

marking, forest protection, rules and regulations and penalties, and land resource surveys—all concerns associated with the publicly owned provincial forests. His recommendations included creating a provincial Forest Branch and aligning its policy to conservationist principles. Grainger further proposed establishing a regulatory system to protect British Columbia's forests and to provide perpetual timber supply for the industry. The Forestry Act, which became law in February 1912, saw the creation of the British Columbia Forest Service.

Though the federal government's concern about the wasteful use of resources had led to the creation of a Commission of Conservation in 1909, this was the first time the government of British Columbia acknowledged the principle of forest conservation. The Forestry Act thus paved the way for the 1945 Sloan Commission's actions by establishing "reforestation" and "sustained yield" as important concepts, by regulating the rate of timber harvested to assure a steady supply of wood and by creating a form of forest tenure that enabled and encouraged the growing of timber crops.

In 1912 Grainger persuaded Ontario resident and businessman H.R. MacMillan to become the province's first Chief Forester, while he himself became head of the Forest Branch Records Office. Three years later when MacMillan left his government position to form a lumber company, the Alberni Pacific Lumber Company at Port Alberni, Grainger became the province's deputy forester. Two years after that he stepped into MacMillan's shoes. During his term as the province's Chief Forester, Grainger made a survey of British Columbia's forests; he also promoted and developed export markets.

Grainger worked intensely, if erratically, during his four years as Chief Forester. He was capable of fanatical outbursts of energy. He was disorganized. He was irreverent to his superiors. And, above all, he displayed an infectious sense of humour. In some ways he was a comical figure, increasingly given to eccentricity. Crippled in 1914 by fallen arches as a result of a long trek through the forest, Grainger was forced to wear flat shoes. His preferred choice of footwear was beaded moccasins. A new pair was made for him every year and he wore nothing else—even when he was dressed in black tie and, on one occasion,

presented to the King. Equally idiosyncratic were the methods Grainger used to quit smoking. Believing that the object was to get as much distance as possible between himself and the tobacco, he took to rolling foot-long cigarettes.

Though Grainger might have been the best man to write the Forestry Act, he was ill suited to a desk job. He also found that "conservation goals and scientific resource management were incompatible with large-scale capitalist development of the forest."[25] Yet we should not jump to the conclusion that he now simply sided with conservation against capitalism. In 1920 he left the civil service and moved to Vancouver, where he became the director of the Timber Industries Council of British Columbia. As the head of this powerful lobby group, Grainger found himself *defending* some of the logging practices he had criticized when he helped to write the Forestry Act. This was, paradoxically, the man who had written in *Woodsmen of the West* that "It was held to be shameful that great tracts of country should be closed against the *bona fide* logger and lie idle for the future profit of speculators..." Two years later, in 1922, Grainger followed MacMillan into private industry, becoming the chairman of the Alberni Pacific Lumber Company and then owner of Timberland Investment and Management Company.

Even before the onset of the Depression in the 1930s, Grainger's business involvement had decreased. He had become "distrustful of his own judgment." He was plagued by "indigestion, ill-health, and an neurasthenic slant."[26] And even though he told his brother-in-law Ralph Grey in 1923 that British Columbia was "a country for the young," by 1931 he was "gradually escaping from the barbarian temple [of commerce] through a love of exercise and (consequently) of horses."[27] By 1936, at the age of sixty-two, Grainger had escaped from business altogether and was retired.

25. Stephen Gray quoted in "Afterword," *Woodsmen of the West* (Toronto, 1996), 213.

26. Martin Allerdale Grainger, "Notes on a case of investments," 7 February 1928, M.A. Grainger Papers, Royal BC Museum, Provincial Archives, Victoria.

27. Martin Allerdale Grainger to Ralph Grey, 28 December 1923, M.A. Grainger Papers, Royal BC Museum, Provincial Archives, Victoria.

In retirement Grainger did not stop writing but did more of it. British and Australian newspapers published his articles. Grainger's letters to the editor appeared at regular intervals in the local press. And he wrote several essays supporting the exclusion of Asians from the province and, more benignly, extolling the virtues of horse trekking along the old fur-brigade trails lying between Hope and Princeton in the Cascade Mountains.

Grainger had got to know the area in 1919 during his tenure as Chief Forester. His first, non-working, visits to the Cascades were confined to the weekends then increasingly extended. He built a cabin, which he named Arcadia, on the ranch of his friend Bert Thomas. Grainger's wife, Mabel, rarely accompanied her husband to the Princeton area. She preferred the company of her sister Winifred, long married to the ardent socialist Ralph Grey, and her two nieces, Evelyn (Evie) and Constance, on whom the childless woman doted.

Woodsmen of the West was the only book by Grainger to be published in his lifetime. But the body of the letters and essays that Grainger wrote between 1928 and 1931 were later brought together in one volume by Peter Murray. *Riding the Skyline* was published in 1994 long after Grainger's death.[28] This collection of writings reinforced the notion that Grainger was not a joiner—despite the time that he spent in the Union and Vancouver Clubs with men whose only goal, in his view, was to accumulate more wealth. Grainger's later writings also reveal the extent to which he was often frustrated by having a desk job that kept him from being outdoors.

Conversely, in the wilderness Grainger was in a place where, except for the going and the coming of light, time ceased to exist. It was a place where simple living and eating, along with physical exertion, enabled him to live, like his classical mentor Marcus Aurelius, a just and pious life. Grainger's need for physical activity, along with his conservationist leanings, led him into a final enterprise with his old friend H.R. MacMillan. Fearing that the wildlife would be spoiled by the construction of a highway over Allison Pass between the towns of Hope and Princeton, Grainger and MacMillan lobbied politicians and journalists to preserve

28. Peter Murray, ed., *Riding the Skyline* (Ganges, BC, 1994), 74.

the area. It may be an irony that both men had themselves participated in destroying British Columbia's forests, but they were now determined to build on the interest that established the nation's national park bureau in 1919: the Dominion Parks Branch. At first the area was made into a reserve, then in June 1941 the provincial government set aside the land as a provincial park. Manning Park was named for the Chief Forester, Ernest Manning, who had recently been killed in a car crash. Everyone agreed, however, that it was Grainger's energy and Grainger's enthusiasm that had prompted the government to make the region into a provincial park.

Martin Allerdale Grainger died from a heart attack in October 1941 at the age of sixty-six. He had lived to see the creation of Manning Park. He was remembered in British Columbia as the author of the province's Forestry Act and as its second Chief Forester. His alma mater, King's College at Cambridge University, created a studentship in his honour, remembering him as an outstanding mathematician. Neither in Grainger's native England nor in his adopted British Columbia was he hailed as the author of *Woodsmen of the West*, which had not sold particularly well in Britain or in Canada.

By the time his novel was rediscovered and republished by Toronto publisher McClelland & Stewart, Grainger had been dead for twenty-three years. Moreover, any romanticism associated with being a logger in the British Columbia wilderness had been replaced by the reality of the job. As Vancouver poet Helen Potrebenko wrote so poignantly in *Career Woman*: "When I was young I thought I'd be a logger / hiking over high hills in heavy boots -/ above the ocean, below the sky -/ hiking among tall trees in heavy boots." But, she concluded, "The loggers I know are dead now / the loggers I know are crippled."[29]

29. Helen Potrebenko, *Life, Love and Unions* (Vancouver, 1987), 5.

"The Life of the Trees,"
Emily Carr's Forest
EMILY CARR (1871–1945)

FROM THE EARLY 1930S until her last sketching trip in 1942, Emily Carr spent virtually every spring and autumn painting the woods in the environs of Victoria. She captured the gaping caverns of the gravel pits and the immense arching sky above it at Metchosin. She sketched first- and second-growth areas of forest in Mount Douglas Park and on the Goldstream Flats, at the Esquimalt Lagoon and in rain-drenched Sooke. And closer to Carr's home in James Bay and during all seasons of the year, she painted the log-strewn seashore and wide scoop of the Salish Sea below the Dallas Road cliffs.

Balancing her sketching board on her lap, Carr would smoke a cigarette, sing her work song and then, striking out with her arm and wrist, depict the scene before her in great sweeping strokes. Using a quick-drying, oil-on-paper medium for sketching, she admirably captured the nuances of colour, light and mood of the West Coast landscape. It was from such oil-on-paper sketches that, over the winter of 1935–36, Emily Carr painted the monumental canvas *Reforestation* (1936).

Reforestation is different from any other work produced by Carr's contemporaries in British Columbia. It is unlike anything painted by

the Ontario-based Group of Seven. And it bears no resemblance to what Carr's American counterparts south of the border were painting in their studios and exhibiting in public and private art galleries up and down the West Coast. Painted at a time when she could whirl any bit of forest or shore onto paper or canvas, *Reforestation* represents a breakthrough in the artistic perception of the British Columbia landscape. And when she painted it, Emily Carr was sixty-four years old.

FOR MOST OF HER LONG CAREER as an artist, Carr had portrayed British Columbia's coastal landscape in a very different way. A child of British immigrant parents—Richard Carr and his wife, Emily, had arrived in Victoria in 1863—she was born in 1871. During her formative years Emily had an inimical relationship to the forest and shore. She watched settlers struggling to fell trees. When the Carr family picnicked at Millstream on the outskirts of the city, Emily and her four sisters and brother, Richard, ignored the forest and clung to the edge of the stream. And when, at the age of twenty-four, Emily made an excursion through the forest wilderness by bicycle from Duncan to Cowichan Lake, she put into words her negative view of the forested landscape around her. The trees that she and her friends encountered were "tall and somber" and, she continued, the densely wooded forest was "dark, lonesome, silent, and gruesome."[30]

Emily Carr's negative response to the forest wilderness was only to be expected. It was in keeping with the eighteenth-century notion of the sublime, which imbued the wilderness landscape with fear and related that fear directly to God. Her perception of the wilderness was equally in line with how British Columbia's settlers were coming to grips with their fear of the forest by making it a source of communal wealth by transforming it into farmland and lumber. Emily's view of the landscape was equally conditioned by living among Victoria's gently rolling meadows and its benign hills, which were covered with small, unthreatening Garry oaks. And the way in which she painted the settled areas around the city of Victoria was in accordance with the English Romantic Realist tradition

30. Emily Carr, "Lake Cowichan Sketchbook, 1895," Private Collection.

of landscape painting, which was passed on to her by her first art teachers, Emily Henrietta Woods and Eva Withrow.

The subjects that Carr chose to depict during the early years of her career—beached canoes on the nearby Songhees Reserve, documentary views of Victoria and pastoral scenes—were little different from those of her contemporaries and even of her distant predecessors. John Webber, who had accompanied Captain James Cook to Vancouver Island's Friendly Cove (Yuquot) in 1778, was less interested in capturing the wilderness landscape than in documenting—and romanticizing—the First Nations peoples. Fifty years later, the artists who attached themselves to overland expeditions, to military surveys or to the Royal Navy made topographical drawings of fledgling settlements and encampments and sketched Aboriginal villages and Native peoples' artifacts, thereby giving visual evidence of their conquest and ownership over Aboriginal territory. The first contingent of female painters, like Hariot, Lady Dufferin—wife of Governor-General, the Earl of Dufferin—Sara Crease and Eleanor Fellows were no different from their more adventurous predecessors. Nor were the artists from Central Canada who visited the province towards the end of the nineteenth century. In their sketches, oil paintings and watercolours, they either ignored the forest altogether or rendered it as smudged side-wings that framed the subject that interested them more: the mountains.

Emily Carr's aversion to the unsettled areas of British Columbia's landscape was, therefore, an understandable part of her upbringing. And her outlook did not change when, in 1890, at the age of nineteen she pursued more formal art training at the California School of Design in San Francisco. Modelled on the traditional art schools in Europe, the California School of Design set Emily drawing in charcoal from replicas of antique sculpture. She progressed to painting still-life assemblages, though modesty kept her from working from the nude model in the life class. True, moving to landscape at the beginning of her third year of study, Carr found a more elusive subject than the well-defined contours of the objects that she had been copying in the classroom. But she had little opportunity to pursue this theme because she was recalled to Victoria. Richard Carr had died in 1888, his wife two years earlier, and

the apparent mismanagement of the Carr family estate, along with the general economic downturn, ended Emily's study abruptly in 1893.

Twenty-one years old when she returned to Victoria from San Francisco, Emily possessed a generous but far from stout figure. She pulled her dark brown hair into a fashionable chignon at the nape of her neck, allowing some curly wisps of hair to frame her handsome face. This was how the grey-eyed teacher appeared alike to her young art students and to her less attractive—and always disapproving—maiden sisters, Edith, Lizzie and Alice. It also explains how she attracted an unidentified man with whom she fell in love "with a thoroughness that was terrible"— only to discover that he was "just a flirt."[31]

After returning from San Francisco, Emily made a summer excursion to the remote Nuu-chah-nulth village of Ucluelet (Hi'tats'uu) on the west coast of Vancouver Island where a family friend was a missionary. Setting aside the prejudices shared by most of the settler community Emily became friends with a Native elder who gave her the name Klee Wyck, "the one who tends to laugh." She also became acquainted with several other people in the village. This experience reinforced what she had read in Alexander Pope's *Essay on Man* (1734), namely that Indigenous people possessed untutored minds, were intimate with nature and had a natural religion. However, while Carr believed at this time that Native peoples communed with the forest, she did not make the forest wilderness surrounding the village of Ucluelet the subject in her minute watercolour sketches. Indeed, the forest remained a silhouetted backdrop to the Native peoples and their community or "big houses."

For most female artists living in Victoria at the end of the nineteenth century, art was little more than an agreeable pastime. The more ambitious women exhibited their work in local venues such as the Willows Agricultural Fair. Some became art teachers and passed on their skills to children. But if they had any further ambition and the money to support it, like Emily's childhood sketching partner, Sophie Pemberton, they travelled to Europe in search of professional training. This is exactly what Emily herself chose to do in the summer of 1899.

31. "Love," [undated], Emily Carr Papers, Royal BC Museum, BC Archives, Victoria.

In old age, Carr wrote with some disgruntlement—and exaggeration—about the prolonged spell she spent in England. "Five years and a half in London! What had I to show for it but struggle, just struggle…"[32] Enrolled in the overcrowded classrooms at London's Westminster School of Art, Emily spent two years repeating much of the course work she had taken at the California School of Design in San Francisco. She also ended a relationship with an admirer, Mayo Paddon, who had travelled all the way from Victoria to London, only to have his offer of matrimony rejected. Towards the end of Emily's English sojourn, things got worse when nervous strain, repeated migraine headaches, news of the death of her brother, Richard, and dissatisfaction with her studies caused her to suffer what her sister Lizzie described in her diary as "a bad nervous breakdown."[33] This condition, which had brought Lizzie to England, landed Emily in a sanatorium in East Anglia, where she remained for over a year.

The fact of the matter was that Emily was not just suffering from headaches and bereavement. Nor was she simply disappointed that she was not making more progress in her art. She was, above all, still suffering from a traumatic incident that had occurred between herself and her father, Richard Carr, during her early teenage years and that would continue to have an impact throughout her life.

Emily only talked and wrote about what she called "the brutal telling" a few years before her death.[34] "I couldn't forgive Father, I just couldn't," she wrote in her journal, "for spoiling all the loveliness of life with that bestial brutalness of an explanation filling me with horror instead of gently explaining the glorious beauty of reproduction."[35] Whether or not the sexually charged encounter with her father was real or imagined, it drove a wedge between Emily and her family. It surely played some part in prompting her to identify with Native peoples who, she felt,

32. Emily Carr, *Growing Pains: The Autobiography of Emily Carr* (Toronto, 1946), 193.

33. Elizabeth "Lizzie" Carr Diary, 16 December 1902, Emily Carr Papers, Royal BC Museum, BC Archives, Victoria.

34. Emily Carr to Ira Dilworth, "Tuesday" n.d. [1942–43], Emily Carr Papers, Royal BC Museum, BC Archives, Victoria.

35. Journals, "Easter Monday," 22 April 1935, Emily Carr Papers, Royal BC Museum, BC Archives, Victoria.

were outsiders like herself; likewise it prompted her to turn to animals—domestic or wild—for affection. It made her sexually frigid—her suitor Mayo Paddon had "demanded more than I could have given."[36] And, ultimately, this formative experience helped make her into an artist. Without "the brutal telling," Emily would not have devoted her life to her art and thereby become one of Canada's finest painters.

DESPITE THE NEGATIVE EXPERIENCE of the months that Carr spent in the East Anglia Sanatorium, she made a positive breakthrough in her perception of the forest during her time in England. It was not only surprising that this happened in England, but that it occurred in the virtually treeless, rock-strewn Cornish village of St. Ives in Cornwall. When Emily climbed the steep hill above St. Ives' harbour to the small deciduous forest known as Tregenna Wood, she was not in search of a new subject for her art. She wanted to find shelter from the glare of the sun on the beach, which triggered her severe migraine headaches. She also wanted to avoid her teacher, Julius Olsson, who along with curious villagers and tourists would peer over her shoulder while she was at work in the town itself. Much to Carr's surprise, Tregenna Wood offered more than privacy and more than a refuge from the glaring sun. Setting up her easel in the centre of the wood, Carr discovered that there were mysterious, unfathomable depths in the greenery of the solemn, ivy-draped trees. She also found a subject that was not only well suited to her Romantic Realist style of painting but one that could be transported to the west coast of British Columbia.

When Carr returned to Victoria in the autumn of 1904 she saw the town with new eyes—and with a new sense of her own identity. She now smoked cigarettes, albeit in the cow shed. She was more openly rebellious towards the strict and outdated Victorian conventions of her elder sisters. She had a new motif for her art that was to deepen and strengthen during the rest of her career. Fortified by nostalgia during her time in England, she had become a staunch Western Canadian. And having recovered from

36. Emily Carr, *Hundreds and Thousands, the journals of Emily Carr* (Vancouver, 2006), 302.

her nervous breakdown, she had the confidence to embark on a career as a professional artist and teacher. Resolved to escape from the suffocating atmosphere of her judgmental sisters, restless at the limited opportunities available to her as a professional artist living in Victoria, Emily moved to the mainland.

The population of "the Liverpool of the Pacific," as Vancouver was known in 1905, had surpassed Victoria's. Its economy, based on the lumber, fishing and mining industries, was thriving. And even though the city had a reputation for being a place "where the quest for the dollar . . . [left] no time for the quest for the beautiful," the young city had a long-established Art, Historical and Scientific Association and a Ladies' Art Club.[37] Cultural life also flourished on a professional level. During Carr's four-and-a-half years in the city, the dancers Vaslav Nijinsky and Anna Pavlova from the famed Ballet Russes performed at the Opera House on Granville Street, as did pianist Jan Paderewski and actor Sarah Bernhardt.

Carr established her studio in the centre of town and gave art lessons there. She took a job as a cartoonist for the local paper, *The Week*. This was a serious, professional occupation, which, together with the money she received from teaching upwards of seventy-five children a week, earned her enough money to purchase five city lots in Vancouver's new Rosedale area, which lay within the Hastings Townsite. When Emily was not teaching or drawing cartoon sketches, she would walk down Georgia Street, cross the Coal Harbour Bridge and enter Stanley Park. Setting up her easel in the midst of the city's thousand-acre forest, she likened it to the nave of a Gothic cathedral. Its mysterious atmosphere, redolent of the fear that she had long felt to be present in British Columbia's forests, also revived her feelings of painting in Tregenna Wood. The solemnity, majesty and silence were now transferred to her large watercolour paintings of Stanley Park's forest. The experience of doing this was, she later recalled, "the Holiest thing I ever felt."[38]

While in Vancouver, Carr exhibited her forest paintings alongside the work of more established artists like Thomas Fripp and Charles John

37. *Daily News-Advertiser* (Vancouver), 16 October 1904.
38. Journals, n.d. Emily Carr Papers, Royal BC Museum, BC Archives, Victoria.

Collings at the Studio Club. Unlike these artists, she had not scaled a mountain before opening her sketchpad. Or joined the Alpine Club, whose various members had ascended every peak within view of the city. Nor had she pushed her way through densely tangled underbrush in order to reach giant-boled coniferous trees. Though many of the Douglas-firs, spruce, arbutus and cedars that Carr painted were first-growth trees, Stanley Park was only a step away from the centre of town.

It would be wrong to claim that Emily Carr had a monopoly on the forest interior as a subject for her work. Twenty years earlier the Ontario painter of mountains, Lucius Richard O'Brien, had set up his easel in the middle of the forest on the outskirts of Vancouver. Carr's contemporary and fellow exhibitor at the Studio Club, Grace Judge, was adapting an idiom derived from the English illustrator Arthur Rackham to the interior of the coastal rain forest. And while the experience of painting in Stanley Park helped Carr "to see a glimmer of something beyond objectivity," it would be wrong to claim too much originality in her work at this time.[39] Her style remained captive to the Romantic Realist tradition. Moreover, her handling of the watercolour medium was often less accomplished than her fellow exhibitors in the Studio Club.

In 1907, Carr's exploration of the forest motif was interrupted. Accompanied by her sister Alice, she boarded the ss *Princess Royal* in Seattle and sailed up the West Coast to Sitka in Alaska. It was a splendid trip. The women sailed past mile upon mile of forested shore, past snow-capped mountains that rose out of the sea and past fiords that bit deep into the coastline. From the deck of the ship they saw villages inhabited by Native peoples, fish canneries bustling with activity, log booms floating by and lumber camps full of rowdy loggers. And when they arrived at their destination in Alaska, Emily viewed the totem-pole paintings of an unidentified American artist from New York City.

During her brief visit to Sitka, Emily took a stab at painting the Haida and Tlingit totem poles that had been relocated to the town's Indian River Park. During the return voyage, the ss *Dolphin* stopped at, among other villages, the Kwakwa̱ka̱'wakw village of Alert Bay ('Ya̱lis) on

39. Journals, n.d. Emily Carr Papers, Royal BC Museum, BC Archives, Victoria.

the west side of Cormorant Island. Emily had just enough shore time to sketch the broad-planked community houses embellished with boldly painted, spread-winged thunderbirds. She also took the opportunity to sketch the tree-hung coffins and the totem poles, the newer ones covered with gaudy house paint and the older, delicately faded poles leaning precariously towards the beach.

The watercolour paintings from Emily's Alaska trip, like her paintings of Stanley Park's forest, may seem unremarkable in themselves. But meeting the American artist, and viewing his work, prompted the thirty-five-year-old Emily Carr to make a decision. "I shall come up every summer among the villages of BC," she wrote, "and I shall do all the totem poles & villages I can before they are a thing of the past."[40]

Carr's painting now had a mission, if not a distinctive style. Over the course of the next few years she painted Native peoples' villages up and down the coast and, to a lesser extent, in the interior of the province. She learned more about First Nations people by studying the carvings on display in Vancouver's city museum and by reading all the anthropological literature that she could borrow from Vancouver's Carnegie Library on Hastings Street. Continuing to shun the social conventions and ignore the racial prejudices of her upbringing, she also cultivated a relationship with a Native woman. A member of the Squamish community at the North Vancouver (Ustlawn) Mission, Sophie Frank enjoyed a lifelong friendship with "My Friend, Emily the lady who goes all over to paint."[41]

When Carr embarked on her visual "salvage mission" in 1907, the forest, which had been a central motif in her work since painting in Stanley Park, became a backdrop to the totem poles and community houses. Equally, her long-held view that a frightening and overpowering God resided in the forest was tempered by her belief that Native peoples imbued nature with spiritual significance through their art and culture. Approaching the forest through what she perceived to be the Native peoples' special relationship to it was, of course, both an oversimplification and an exaggeration. Even so, it helped to erode Emily's fear of the

40. Emily Carr, *Growing Pains,* 211.
41. Journals, n.d. Emily Carr Papers, Royal BC Museum, BC Archives, Victoria.

forest wilderness that she, like the majority of her non-Native contemporaries, possessed.

It was both inevitable and intentional that Carr was eager to apply ideas from the modernist school of painting to her documentation of the Native peoples and their villages. Her friend Sophie Pemberton had been adapting high-pitched colours to the landscape around Victoria since returning from study at the Académie Julian in Paris. Another friend, Theresa Wylde, had displayed "a fearless manipulation of colours" following her study at London's Slade School.[42] Both Pemberton and Wylde now prompted Emily to adopt a brighter palette and to give less attention to detail in her own work. Determined to learn more about this new school of painting, Carr held an auction of her Native-inspired work at her Granville Street studio. The show was a success, allowing Emily to raise enough money to finance a year's study in France.

Carr's fifteen-month visit to France exposed her to the full force of the Post-Impressionist movement, then in the heyday of its international influence. The expatriate artists from England, Scotland and even New Zealand with whom Carr studied taught her with missionary zeal. They prompted her to adopt hatched brush strokes, to juxtapose bright patches of primary colour, to set aside detail, to simplify the rendering of her subjects and to use a bold, dark outline—some of the techniques, of course, that were characteristic of her earlier cartoon sketches and hallmarks of Post-Impressionism.

Employing these stylistic devices released Carr from the drudgery of producing an accurate transcription of visual fact as demanded by the Romantic Realist style of painting. Her exposure to the French modernist school of painting enlivened her palette. Above all, the encouragement she received from teachers like Frances Hodgkins, John Fergusson and Phelan Gibb convinced Carr that her newly acquired Post-Impressionist style was well suited to the portrayal of British Columbia's Native peoples.

42. *Victoria Times,* 28 September 1910.

IN 1912, less than a year after returning from France, Carr made a seminal trip to northern British Columbia. She did so with the financial assistance of the vessels and trains owned by the Grand Trunk Pacific Railway. Missionaries and cannery bosses gave her accommodation. And Aboriginal guides took her to remote and otherwise inaccessible villages. Her goal was to apply her new style to the totem poles and community houses located in Native villages on the Queen Charlotte Islands (Haida Gwaii) and in the Gitxsan communities along the Upper Skeena River. It was a momentous trip that saw Carr travel by canoe and in leaky gas-powered boats, sleep in vacant schoolhouses, camp on the beach and suffer attacks by mosquitos.

When she returned to Vancouver several weeks later, the newspapers welcomed her home with flattering comments. It was "a matter for congratulations that an artist of Miss Carr's ability should have undertaken to make a record for posterity of these things of grandeur, of an age that is passing."[43] And when she showed the public some of her modernist-inspired paintings at the Studio Club's annual exhibition in Vancouver a few weeks later, a critic for the *Sun* newspaper found them to be "perhaps the most striking series in the hall."[44] During an interview given after returning from Paris, Carr had prepared her public for what they were about to see. As she told the interviewer, "a picture should be more than meets the eye of the ordinary observer." She also made it clear that she had aligned herself with the French Modernists who were using "pure colour, more light" and "a bold use of line" to help them render "the bigger things in nature."[45]

It had proved difficult, however, when travelling north during the summer of 1912, to reconcile her ambition of making a historically accurate record of the Native villages with her new artistic ambition of adhering to the "bigger, freer work" of the Post-Impressionists.[46] Thus, while Carr firmly believed that her old style of painting had been

43. *Daily News-Advertiser* (Vancouver), 15 September 1912.
44. *Vancouver Sun,* 10 October 1912.
45. *Province* (Vancouver), 27 March 1912.
46. Journals, n.d., Emily Carr Papers, Royal BC Museum, BC Archives, Victoria.

revitalized through its contact with Post-Impressionism, she was not, like so many of her modernist contemporaries, willing to distort the Native peoples' totem poles and community houses for art's sake. Despite her exposure to the modernist school of painting, Carr's work remained largely descriptive and documentary.

Buoyed by the positive reception to her work following her trip to northern British Columbia in 1912, Carr approached the provincial government. She asked them to purchase her paintings for display in the newly constructed Provincial Museum. She also asked the government to sponsor further painting excursions so that she might complete her documentary record of the province's Native villages.

In this, she asked too much. For since the end of the nineteenth century British Columbia's government had let foreign museums remove carvings from Native villages, an activity that in many cases was little more than licensed robbery. The curator of the fledging Provincial Museum was more interested in collecting and exhibiting exotic stuffed animals than in displaying Native carvings. The priority of Premier Richard McBride's Conservative government was not to protect the culture of Aboriginal peoples but to annihilate it in the name of progress—by implementing the residential school and reserve system, by encouraging missionary work in Native communities and by enforcing the anti-potlatch law, which inhibited traditional cultural production. Under the circumstances, then, it was not surprising that the government showed no interest in accumulating Emily Carr's depictions of what she herself called "a passing race."[47] It was even less keen to finance the artist's northern excursions.

Undaunted by the government's rejection, Carr rented the Drummond Hall near her Vancouver studio and, in April 1913, mounted a solo exhibition. Comprised of over two hundred sketches, oil paintings and watercolours, it was enormous in scale and unprecedented in the short history of painting in British Columbia. During the weeklong exhibition, Carr gave two public lectures. She discussed the technique of carving and erecting a totem pole. She described the legends that she felt that they depicted. And she emphasized the urgency of recording

47. Emily Carr to Henry Esson Young, n.d. [1913] Royal BC Museum curatorial files, Royal BC Museum, BC Archives, Victoria.

them. "These poles are fast becoming extinct," Emily pleaded. "Every year sees some of their number fall, rotted with age, bought & carried off to museums in various parts of the world, others alas are burned down for firewood." Addressing the prejudice that the majority of her fellow citizens felt towards Native peoples' art, Carr told her audience: "These things should be to us Canadians what the ancient Britons' relics are to the English."[48]

Only the *Province* newspaper reviewed Carr's exhibition. Their critic praised her for assembling "a very valuable record of a passing race" but said nothing about the artistic qualities of the work itself.[49] Disheartened, Emily closed her studio, packed up her work and moved back to Victoria.

THIS WAS A LOW MOMENT. Now forty-one years old, Emily Carr, like many female artists of her generation, was discovering some hard truths. While women had dominated the art schools in Canada and abroad, while they had walked off with many prizes at the end of their training, they nevertheless found it difficult to establish themselves as professional artists. Women were, moreover, barred from membership in most of the country's professional art organizations. Even when a few token women were elected to these august bodies, they were rarely given voting privileges. True, the female artists who lived in Central Canada had formed their own semi-professional exhibition societies, but those living on the fringes of the country were limited to exhibiting with local amateur groups. Above all, most women could only live as full-time artists if a spouse supported them. For those who had to earn their own living or were occupied with children or were running a household, painting always took second place to these "more important" activities.

This was Emily Carr's dilemma. Despite her training abroad and despite the critical success of her exhibitions, she could not make a living from her art—especially in 1913 when the province fell into an economic depression. The provincial government was unwilling to purchase her

48. "Lecture on Totems," April 1913, Emily Carr Papers, Royal BC Museum, BC Archives, Victoria.

49. *Province* (Vancouver), 16 April 1913.

work and to support further excursions to the villages of First Nations people so that she might produce more of it. Nor could she expect to receive support from the general public. As Emily's old friend Flora Hamilton Burns later recalled, most people regarded Native peoples' art as "strange" and consequently "found it difficult to understand why she was interested in it."[50]

Up to this point, Emily's life had been subservient to her art. She had been emotionally and spiritually dependent on it for her self-expression, perhaps even for her sanity. After 1913, however, the harmony of her life and her art was disrupted. Her plan to document, then to sell her paintings of Native villages had to be abandoned. Her plan to run a successful teaching studio in Vancouver was quashed by the economic downturn. And her prospects for marriage were unpromising, especially given how the "the brutal telling" had made it difficult for her to have a "normal" relationship with any prospective suitor.

While Emily was resigned to joining the ranks of her three maiden sisters, she was not dependent on them for a living. Despite the initial mismanagement of his estate, Richard Carr had, as his youngest daughter recalled, "left us comfortable." (This is evident from the fact that his estate included not only land, which was an appreciating asset, but also $50,000 in trust, which would be worth well over a million dollars today.) Emily had also profited from the sale of her Vancouver property. These funds enabled her to build a summer cottage on land that she purchased at McNeill Bay—also known as Shoal Bay—on the outskirts of Victoria. And there was enough money left over to allow Emily to construct a four-suite apartment house. Later romanticized in her own literary work under the name "The House of All Sorts," Hill House was Emily's home for the next twenty-three years. Both property investments stood Emily in good stead. One saved her from any real pinch of poverty. The other gave her a place of refuge from her sometimes-difficult tenants.

Emily was nothing if not versatile after her return from Vancouver. Unafraid to get her hands dirty, she opened a dog kennel and became a well-known breeder of Belgian griffons and English bobtail sheep

50. Flora Hamilton Burns, interview by Imbert Orchard, 18 May 1962, Oral History tapes, Royal BC Museum, BC Archives, Victoria.

dogs, which she exhibited in local dog shows and at the Pacific National Exhibition in Vancouver. She marketed her handmade pottery, digging the blue-grey clay from the Dallas Road cliffs, decorating it with Native peoples' crests and baking it in a homemade kiln in her backyard. And she wove rags into rugs, likewise sold through an agent to tourists in Banff. In 1916–17 she spent eight months in San Francisco, painting a mural at St. Francis Hotel. And she continued to produce witty cartoons and verse, that were published in Vancouver's *Western Woman's Weekly*.

The First World War affected everyone in the country. But it did not have the decisive impact on Carr that it had on male artists who were either conscripted into the ranks or, less frequently, commissioned as war artists. Carr's annual painting excursions were, it is true, curtailed for the duration of the hostilities. And when she did resume them in 1920, they took her to the Okanagan and the Cariboo in the interior of the province as well as to settled areas on Vancouver Island. Although Carr had little time or inclination to continue her documentation of Native villages, she studied the Native carvings housed in the Provincial Museum. And in 1926 when she heard that Marius Barbeau, an ethnographer with the Victoria Memorial Museum in Ottawa, was giving a series of lectures on First Nations people in Vancouver, she invited him to view her Native-inspired art if and when he visited Victoria. Barbeau did not take up Carr's offer. Conversely, when the British Columbia Art League invited her to exhibit and to give a talk focused on her Native-inspired work in Vancouver the same year, she declined. Still smarting from what she perceived to be the public rejection of her work in 1913, she replied with "thanks and regrets."[51]

Had Carr agreed to show her work at the Art League in 1926, she would have found a very different city than the one she had left in 1913. The newly founded Vancouver School of Decorative and Applied Art had hired several inspiring artist-teachers: J.W.G. "Jock" Macdonald had joined the staff in 1925 and, a year later, the equally dynamic Group of Seven artist F.H. Varley became a teacher. While more traditionally bound artists like Thomas Fripp were still active, the majority

51. British Columbia Art League "Minute Book," 9 December 1926, Vancouver City Archives.

of Vancouver's artists favoured a modernist approach to painting. Their work could be seen at the Palette and Chisel Club, the Studio Club, the British Columbia Art League as well as at the British Columbia Society of Artists. Indeed, Carr's former student Statira Frame, whom she had introduced to Post-Impressionism, was dominating Vancouver's local exhibitions with her highly keyed palette and imaginative compositions making her one of the most exciting artists in the province.

Carr might have been unwilling to exhibit her Native-inspired work because, by 1926, she had dropped that theme and returned to the landscape. In fact, she had been painting on the Dallas Road cliffs near her home since 1914. She had even exhibited some of her landscape paintings with the city's Island Arts and Crafts Society.

EMILY CARR'S RESOLVE to adapt Post-Impressionism to the local landscape was reinforced when two artists, Ambrose and Viola Patterson, came into her life in the early 1920s. These art teachers from Seattle helped Emily take the first step towards creating her monumental painting, *Reforestation*, in 1936. As so often in her life, however, the route by which Carr travelled was by no means straight or direct but always liable to unforeseen deviations and distractions.

Ambrose and Viola had been looking for a place to spend their weekends and summers when they came across a sign advertising rooms for rent in Hill House in the early 1920s. Soon after taking a room, the young artists realized that they had a lot in common with their landlady. Though Viola Patterson recalled that Emily was "rather like her little dogs, snappy and cranky," they got on well.[52] Like Emily, they had studied in Paris. Like her, they were working in the Post-Impressionist idiom. And like her again, they were attempting to develop a style that would celebrate the uniqueness of the West Coast landscape.

Viola and Ambrose not only reinforced Carr's belief that the modernist style was adaptable to the landscape of the Pacific Northwest, they encouraged her to transfer more of her energy from landlady chores, dog-raising duties and craft-making activities to her art. More

52. Author's interview with Viola Patterson, Seattle, 5 October 1973.

significantly, they introduced her to the writings of art historian Jan Gordon.

Gordon's *Modern French Painters* (1923) advised artists to avoid making "an accurate imitation"—as Emily had attempted to do in her portrayal of Native villages. In a chapter devoted to the work of Paul Cézanne, he introduced Carr to the notion that the artist's "first and most important task" was to reveal the underlying structure of a subject in order to expose the "sensation of rhythmical movement of lines and ordered sensations of depth."[53] After reading Gordon's book, Carr self-consciously focused on the chaotic rhythm in nature. Using a medley of primary colours and working in oil, watercolour and chalk, she gave structure to the wild-armed arbutus trees, the scraggy underbrush and the sweeping limbs of the conifers that were all within walking distance of Hill House.

Impressed by their friend's new work, Viola and Ambrose Patterson invited Carr to exhibit with them at Seattle's annual Pacific Northwest Exhibition in 1924. A year later, they saw to it that their friend's landscape paintings were shown with the San Francisco Art Association at the California Palace of the Legion of Honor. And the Pattersons also introduced Carr to their friends, most notably to the dynamic artist and teacher Mark Tobey who would have a significant impact on her own career a few years later. All of this renewed Emily's confidence and exposed her work to a wider audience.

IN AUGUST 1927 Carr's career trajectory and recognition were to change crucially. That month Eric Brown, the director of the National Gallery of Canada, paid a visit to her studio before giving a public lecture in Victoria. After viewing Carr's canvases and watercolour paintings, Brown authoritatively told his audience that evening that Emily Carr's work was "as good as anything that is being done in the country."[54] Brown's feeling

53. Jan Gordon, *Modern French Painters* (London, 1923) 31, 33. Emily Carr's copy is inscribed "M. Emily Carr, Victoria, BC January–March 1924," private possession.

54. *Daily Colonist* (Victoria), 14 September 1927.

of discovery was all the greater because Carr told him that she had been forced to stop painting in 1913 because her work had been "hated," "ridiculed" and "dishonoured."[55]

This was, of course an exaggerated and one-sided account. But it made a good, simple, heart-rending story. It fit into the myth of the abused but heroic artist. And Eric Brown, who had, a few years earlier, witnessed the Group of Seven's own struggle-story—partly created by themselves and their supporters—now bought Carr's story too, hook, line and sinker.

If Carr was less than candid with Brown, he was likewise less than candid with her. He did not tell her that he had heard of her work six years earlier through the Vancouver photographer and art collector Harold Mortimer Lamb. Or that after viewing a few poor snapshots of her Native paintings, he had told Lamb that Miss Carr's work would be of more interest to a provincial or national museum than to an art gallery. Nor did Brown now tell Emily that he had passed up an opportunity to view her paintings on a previous visit to Victoria. And when he finally agreed to see Carr's work, he did not reveal that he was unsympathetic to the French Modernist school of painting that she had so fully embraced.

But Brown was willing to put aside his prejudices. He was equally willing to change his attitude towards painting that drew its inspiration from the art of Native peoples. Nor was he alone in this thinking. The Canadian government had long attempted to eradicate Native peoples' culture by assimilating it into the culture of English-speaking or Francophone Canada. Believing that First Nations culture was dead, Marius Barbeau had purchased, "restored," then put many of the deteriorating totem poles on display in Central Canadian museums. Barbeau and Eric Brown had also encouraged members of the Ontario art establishment to record what remained of Native peoples' totem poles and community houses in British Columbia.

Accordingly, when Brown walked into Carr's studio in 1927, he and Barbeau were in the final stages of organizing an exhibition at the National Gallery of Canada that would "mingle for the first time the art

55. Emily Carr to Eric Brown, 1 November 1927, Archives, National Gallery of Canada Ottawa.

work of the Canadian West Coast tribes" with that of the "more sophis-
ticated [non-Native] artists."[56] To Brown's surprise, it turned out that
Carr had produced more Native-inspired work than any other artist in
the country. He immediately invited her to contribute to the *Exhibition
of Canadian West Coast Art, Native and Modern*. He made sure that she
would attend the opening in Ottawa by giving her a free pass on the
Canadian National Railway. And he encouraged the National Gallery and
the Victoria Memorial Museum to purchase some of her work.

During Carr's six-week visit to Central Canada in the autumn
of 1927, she met members of the Ontario Group of Seven and their
followers. She was introduced to the influential Toronto writer F.B.
"Fred" Housser, who had just published *A Canadian Art Movement*
(1926) extolling the work of the Group of Seven. She travelled to
Montreal where she met female artists like Annie Savage, and to Toronto
where she viewed the paintings of Bess Housser and Isabel McLaughlin.
These contacts brought Emily Carr into the heart of the Canadian art
establishment. It also changed the course of her life.

Lawren Harris was the Group of Seven artist who had the most impact
upon Carr during her trip to Central Canada. After viewing his paintings
of the Northern Ontario landscape, which blended elements of German
Romanticism with Art Nouveau and Scandinavian Symbolism, Carr
was dumbfounded. "Oh, God, what have I seen?" she wrote in her jour-
nals, "Where have I been? Something has spoken to the very soul of me,
wonderful, mighty, not of this world." Harris's paintings took Emily "into
serene, uplifting planes, above the swirl into holy places." They struck deep
"into the vast lovely soul of Canada; they plumbed to her depths, climbed
her heights and floated into her spaces." His paintings were, she further
recorded in her journal, "a revelation, a getting outside of oneself and
finding a new self in a place you did not know existed." Believing that the
Group of Seven possessed a divinely inspired vision of the vastness of the
Canadian landscape, Carr was now prompted to think that "perhaps I shall
find God here, the God I've longed and hunted for and failed to find."[57]

56. *Exhibition of Canadian West Coast Art, Native and Modern*, (Ottawa, 1927).
57. Journals 17–18 November 1927, Emily Carr Papers, Royal BC Museum,
BC Archives, Victoria.

Following Carr's visit to Central Canada, her paintings began to receive national recognition. She had met the major artists in Canadian painting and had linked herself to the nucleus of the Canadian art establishment. As a result of her ensuing relationship with Lawren Harris and F.B. Housser, she was reading the poetry of Walt Whitman and Ralph Waldo Emerson and exploring the esoteric religion, Theosophy, which professed a direct and mystical apprehension of God.

After 1927 Carr projected her Western-ness into the Canadian-ness of the Group of Seven. She shared their ambition to create a new art for Canada. And she believed that she could express the essence of the land by returning to the Native motif. "I feel you have found a way of your own wonderfully suited to the Indian spirit," Harris told Carr in a letter.[58] Here was new inspiration to return to her old subject matter with a new vision. "Next time I paint the Indians," she wrote in her journals, "I'm going off on a tangent tear."[59]

And this is exactly what Carr did, though initially with disappointing results. During the summer after she returned from Central Canada, she travelled north to Haida Gwaii and to the Nisg̱a'a and Gitx̱san communities along the Nass and Skeena Rivers. Her six-week-long journey was far from successful. The weather was poor. She lost a lot of sketching time waiting for transportation. She did not get to all of the villages she intended to visit. And, although some Native artists were continuing to produce canoes, masks and totem poles for their own community and performing their illegal traditional winter ceremonies, Carr wrongly concluded that the Native artist was now only "carving to please the tourist and to make money for himself, not to express the glory of his tribe."[60]

She did, however, manage to execute thirty large watercolour paintings and sketches on this trip. It was from these works that she produced a few oil canvases when she returned to Victoria. But she did not have enough material to keep her busy all winter. She was therefore forced to work from her 1912 watercolour paintings, as well as from photographs

58. Emily Carr, *Growing Pains,* 237.
59. Emily Carr, 14 November 1927, *Hundreds and Thousands,* 24.
60. Emily Carr, *Growing Pains,* 237.

that had been taken of the remote villages on Haida Gwaii several years earlier by the amateur botanist and ethnologist C.F. Newcombe. After the high point of meeting Eric Brown and the Group of Seven in 1927, this was another anticlimax. Her ambitions, aesthetic and spiritual alike, were not fully realized—at least for the moment.

SHORTLY FOLLOWING Carr's 1928 trip to northern British Columbia, the American artist Mark Tobey gave an art class in her studio. Having just returned to Seattle from France, Tobey had been infected by the Cubism of Pablo Picasso and Georges Braque. Imparting his enthusiasm for these artists to Carr, who was still working in the Post-Impressionist style, was no easy task. "I had to battle with her," Tobey recalled years later.[61] At the end of three weeks, however, he won the war. By sheer force of personality, Tobey had convinced Carr to dramatize the spirit that she felt resided in the totem pole. And she did this by reducing the totem poles to primary geometric shapes, which enhanced the inner tension that seemed to expand, or press against, the surface of the totem pole. She cast a strong interior light across the surface of the canvas. And she replaced her earlier high-keyed colours with a subtle medley of greys and browns.

Moreover, she took two further steps. Wrongly convinced that Native peoples' culture was not just dying but was actually dead, she eliminated human beings from her paintings of First Nations villages. This was a fruitful misconception, since it led her to pay as much attention to the forest vegetation as to the totem poles and community houses. Thus, for the first time the forest vegetation, which had previously been a backdrop to the Native motif, became an intricate part of the painting.

In 1930 the public in Victoria had an opportunity to see what Carr was doing when she put over fifty paintings, including this new work, on show at the Crystal Gardens. The response to her Native-inspired paintings was largely positive. But this posed a dilemma. A year earlier Lawren Harris had suggested—in line with the Group of Seven's own project— that she set aside explicitly Native subject matter and portray the West

61. Mark Tobey to Donald Buchanan, n.d. [received 15 April 1957], Archives, National Gallery of Canada, Ottawa.

Coast landscape instead. This was because Harris felt that the spirit of British Columbia, as he told Carr, resided "in the exotic landscape of the island and coast."[62]

Carr had already come to feel that she was "copying the Indian idiom instead of expressing my own findings."[63] Moreover, the previous spring and summer of 1929 when she had travelled into Nuu-chah-nulth territories at Friendly Cove (Yuquot) where Captain Cook had made landfall in 1778 and to neighbouring Port Renfrew (Pacheedaht), she had focused on the landscape. While Carr would return occasionally to the Native motif, from 1930 her goal was to express her relationship to God through the forested landscape of British Columbia. Or, as she eloquently put it in her journals, portraying "the seeing beyond the form to the spiritual reality underlying it."[64]

In order to accomplish this, Carr turned her back on Harris's Theosophy and explored other esoteric religions before returning to the Christianity of her youth. She absorbed the ideas of the art historian Mary Cecil Allen whose essay in *Painters of the Modern Mind* (1929) told Carr how she could reduce nature "to a rhythmic series of light and dark patches" that gave a painting a "synthesis so closely knit and so organic that it obliterates the impression of the several parts of movements and presents one complete living structure."[65] Carr also looked at the work of other artists. On a trip to New York she saw the *Jack-in-the-Pulpit* series of flower paintings by Georgia O'Keeffe. She visited the art connoisseur Katherine Drier, whose wide-ranging private collection included works by the Russian Constructivists and the German Expressionists as well as by artists belonging to the modernist school of painting in Paris. And Carr became a regular contributor to exhibitions in Central Canada, in the United States as well as in her own province.

By the early 1930s Emily had won the approval of her generally disapproving sisters, Alice and Lizzie. (Edith and her only married sister, Clara,

62. Lawren Harris to Emily Carr [1929], Emily Carr Papers, Royal BC Museum, BC Archives, Victoria.

63. Emily Carr, *Growing Pains,* 254.

64. Journals, 29 January 1934, Emily Carr Papers, Royal BC Museum, BC Archives, Victoria.

65. Mary Cecil Allen, *Painters of the Modern Mind* (New York, 1929), 61–64.

had died in 1919.) Now that the three remaining Carr sisters had reached middle age, their relationship was cemented by tradition, common memories and blood. They loved one another dearly and fretted over each other's well-being. Even so, they were too entrenched in their own lives to take a much wider interest in one another. Alice and Lizzie had often found it difficult to consider painting as anything more than a hobby. So it was all the more gratifying when, after Alice saw Emily preparing her work for shipment to an exhibition in Edmonton in 1933, she told her sister that her oil-on-paper sketches were "beautiful"—and then added—"No that's not quite it. They're wonderful."[66] A year later Lizzie also admitted for the first time to recognizing something in Emily's painting that she liked.

Alice was right to admire her sister's oil-on-paper sketches. They marked the beginning of Carr's independence from the heavy, static elements that pervaded the forest paintings she had produced under the influence of Mark Tobey and Lawren Harris. The oil-on-paper medium that she embraced entailed adding large quantities of turpentine to white house paint, which Emily then mixed with Cambridge oil paints. This new medium gave Carr the best of both oil and watercolour. Unlike watercolour, the oil-on-paper medium did not dry a lighter hue but retained the same intensity of colour. Unlike oil, which took hours to dry, it dried immediately. The oil-on-paper medium unleashed one of Emily's greatest gifts as an artist: her spontaneity. It enabled her to do three oil-on-paper sketches a day, whereas it took her several days, even weeks, to complete one oil canvas. The new medium also saved Emily money because the Manila paper, the turpentine and the house paint—though not the Cambridge oil paints—were inexpensive. As Emily recalled, she was thus "unafraid to slash away because material scarcely counts."[67]

IN 1934 Emily Carr proudly wrote in her journal that she was painting her "own vision now, thinking of no one else's approach, trying to express my own reactions."[68] This was certainly true. Using the full sweep of her

66. Emily Carr, October 1933, *Hundreds and Thousands*, 97.
67. Emily Carr, 5 April 1934, *Hundreds and Thousands*, 155.
68. Emily Carr, 24 April 1934, *Hundreds and Thousands*, 164.

arm and squinting her eyes so that the trees were slightly out of focus, Emily could whirl any bit of forest, shore or sky on to canvas or paper. By employing a series of short vertical strokes, she drew her viewer from the clearing into the interior of the forest. By rendering the forest vegetation in S-curves, chevrons and interlocking rings, she created that surging rhythm of which Jan Gordon and Mary Cecil Allen had written. By connecting one brush stroke to another, she infused the sky, the trees and the shore with an energizing force that satisfactorily expressed one thing to Emily: God in all. The visual vocabulary that she had developed through the oil-on-paper medium thus enabled her to sort out the apparent chaos of the forest growth and to enter "into the life of the trees."[69]

Helping her to obtain the peace and quiet that enabled her to commune with nature, Carr purchased, in 1933, a caravan and had it towed to the settled outskirts and wilderness parks around Victoria. This semi-mobile vehicle, which she called The Elephant, was hauled to the Esquimalt Lagoon, Telegraph Bay, Metchosin, Sooke, Albert Head, Goldstream and Mount Douglas Parks—all within an hour's drive from the centre of town. Surrounded by her menagerie of animals, and without her apartment-house chores, Emily achieved the sort of isolation and propinquity that enabled her to reach a level of consciousness where she was no sex, no age, just a mindless part of the scents, the smells, the silence and the colours of the forest.

Carr had begun recording Native peoples' legends—taken largely from the writing of anthropologists—in 1912, and had written short stories about her northern excursions in 1926. It was not until 1930, however, that "trying to find equivalents for things in words" helped her to find "equivalents in painting."[70] Writing in her journal, she described the small young pines as the forest's children; the towering elephant-legged cedars were their matrons. The loggers, whom she saw racing through the woods, were the tree's executioners. Carr not only gave the trees human characteristics in prose. In such paintings as *Scorned as*

69. Journals, 8 April 1936, Emily Carr Papers, Royal BC Museum, BC Archives, Victoria.

70. Emily Carr, 26 November 1930, *Hundreds and Thousands*, 46.

Timber, Beloved of the Sky (1935) she also invested her beloved trees with anthropomorphic drama.

When Emily painted *Reforestation* from two or perhaps three oil-on-paper sketches during the winter of 1935–36, she had come to terms with her art and her life. She acknowledged that she had received "lots of recognition" but was "wasteful of it." She admitted to having been so embarrassed by praise that she had wanted to hide. As she wrote in her journals in 1936: "You've got to meet success half-way. I wanted it to come all the way, so we never shook hands."[71] Above all, she knew that she had forgotten her fellow female artists: "It's them I ought to be upholding."[72]

Paintings like *Reforestation* grew out of Emily Carr's inner spiritual condition, out of her realization that her paintings must express that condition and out of her discovery of a style, a medium and an appropriate subject matter to express that spiritual condition. Her early alienation from her father and her family following "the brutal telling" required that she come to terms with her life through the inner spirit.

Emily Carr's spiritual quest had begun with her perception of the landscape, both through the British settlers' eyes and through what she believed to be the Native peoples' unique relationship to the forest. Her spiritual quest had continued through her study of Theosophy and other esoteric religions, and then it culminated in her return to Christianity. The means through which she sought to express that inner condition began when Emily first painted in Tregenna Wood in St. Ives, and later in Stanley Park. But it was only realized when she saw how Lawren Harris was expressing his spirituality and the spirit of the land through his art. The development of a style appropriate to that expression began in France when Emily was introduced to Post-Impressionism. It was continued through her contact with the Pattersons, Mark Tobey and the Group of Seven and through the writings of Mary Cecil Allen and Jan Gordon. The conditions that allowed all of these causes to come to fruition through

71. Journals, 9 February 1936, Emily Carr Papers, Royal BC Museum, BC Archives, Victoria.

72. Journals, 6 April 1937, Emily Carr Papers, Royal BC Museum, BC Archives, Victoria.

the act of painting were, among other things, the restructuring of her life to fit the primacy of her art by subordinating landlady chores, achieving isolation in the forest by purchasing her caravan and by discovering the oil-on-paper medium for sketching.

Sadly, Emily Carr had less than a decade during which these causes and conditions that enabled her to produce monumental works like *Reforestation* fully operated. In January 1937 she had her first heart attack. Two years later she had the first of several strokes. Though she was able to make a few painting excursions to the forest following her heart attack, it was always in the company of a maid, and she now lived in in a cottage rather than in her beloved Elephant. Under these conditions it was not easy for Carr to imbue her paintings of the forest with the mystery that she had once observed in Stanley Park. It was equally diffi-cult for her to capture the rhythm and energy that first emerged in her 1920s' oil canvases or to convey in her oil-on-paper sketches the delicacy, joy and rhythm that united every element of the forest, sky and shore. She took increasingly to writing, in which she received help from her loyal "listening ladies" and from the Canadian Broadcasting Corporation producer Ira Dilworth. Indeed, writing became the main outlet of her artistic expression during the last five years of her life and earned her a Governor General's Award in 1941 for her book *Klee Wyck*.

In 1936 Emily felt that she had "gone further this year," seeing "things a little more as a whole, a little more complete." Nevertheless she feared becoming feeble and passé in her work and she did not want "to trickle out."[73] Even more aware of her posterity, she wrote a few days before her death on 2 March 1945 that she imagined that the next generation might consider her "trash" and "scoff" at her honours—she had just learned that the University of British Columbia was awarding her an honorary degree.[74] And in this, she was right. Beginning in the mid-1990s, some critics accused Carr of appropriating Native peoples' art for her own use. She was charged with lacking sincerity towards or knowledge of the province's First Nations people. It was said that she turned a blind eye to

73. Emily Carr, 23 September 1936, *Hundreds and Thousands,* 351.

74. Emily Carr to Ira Dilworth, n.d. [1945], Emily Carr Papers, Royal BC Museum, BC Archives, Victoria.

the government's treatment of its Indigenous peoples. And above all, she was pilloried for assuming that Native art was dead, when Native artists like Willie Seaweed (Kwaxitola) and Mungo Martin (Nakapenkem) were keeping it very much alive. But the life and art of Emily Carr cannot be considered according to our own value judgements. Her oeuvre must surely be assessed within the context of the era in which she lived.

What remains undeniable is that many creative artists, writers, choreographers, playwrights and composers, before and after the 1990s, have been inspired by her work. Acknowledging in the early 1950s that painting in British Columbia was shaped by both international and national influences, the late artist Joe Plaskett said of Emily Carr that she "used the resources of modern art to interpret the mystery and power of her environment." By so doing, he maintained, "she founded West Coast art and her achievement is our example. Not by copying her, for already her form is inadequate for us, but by reading her spirit."[75] Anyone venturing into the West Coast rain forest—which is still evident on the fringes of the city or in the few remaining wilderness areas of the province—will find their experience enriched when they see straight from-the-shoulder Douglas-firs or note how the younger "feminine" cedars "swirl and dance."[76] We still look at this landscape through Emily Carr's eyes.

75. Joe Plaskett, "The Subject and the Object," [typescript] n.d., private collection.
76. Emily Carr, 5 June 1934, *Hundreds and Thousands,* 185.

Defining the Canon,
The Self-Made Man of Letters
GEORGE WOODCOCK (1912–1995)

H E MAY WELL HAVE BEEN British Columbia's most prolific author. Certainly by the time of his death George Woodcock had published some 145 books and pamphlets. Among them were travel books, not only on his home territory of the West Coast, but also on India and Mexico. There were historical works about Great Britain, which he had left at the age of forty, about Canada, his adopted country, and also about Persia. His political commentaries ranged equally widely, showing his own interest in anarchism and pacifism and reflecting his aesthetic concern with state funding for the arts and with the decline of the Canadian Broadcasting Corporation (CBC). He published multiple volumes of poetry. There were dozens of radio and television scripts, as well as full biographies of such internationally recognized figures as Aldous Huxley, George Orwell and Gabriel Dumont; and the subjects of his essays included not only a wide array of Canadian writers but also artists like Jack Wise, B.C. Binning, Jack Shadbolt and Toni Onley. It was a literary output distinguished alike for its sheer volume, for its diversity and—at its best—for its high quality.

When he was not writing, George Woodcock taught intermittently at both the University of British Columbia (UBC) in Vancouver and at the

University of Washington in Seattle. He founded charities: the Tibetan Refugee Aid Society, the Canada India Village Aid and the Writers Development Trust (now the Writers' Trust of Canada). He and his wife, Ingeborg ("Inge"), gave dozens of dinner parties bringing together artists and writers throughout the country. Above all, Woodcock was an ambitious and painstaking literary editor.

During the seventeen years that Woodcock edited *Canadian Literature* he put British Columbia's writers on the national map and Canadian writers on the international stage. Based in British Columbia, *Canadian Literature* challenged Central Canada's dominance over literary journals and literary activity in English-speaking Canada, at once establishing and reassessing literary reputations. Hence, as one commentator claimed, Woodcock "virtually created Canadian literature through the journal he founded under that name."[77] Likewise, his editorship earned him his sobriquet as Canada's "first man of letters." Yet the story is more complex than these simple claims imply.

GEORGE WOODCOCK WAS ALWAYS PROUD of the fact that he was born in Winnipeg, even though his parents, Arthur and Margaret, returned to their English roots in Shropshire shortly after his birth in 1912. He evidently became well known during his early career in England for trading on this accident of birth. "You're a Canadian, aren't you George?" the London-based editor of *Poetry Magazine,* Muriel Spark, teased him in 1947. "Isn't it time that you read what your own people are doing?" Spark asked Woodcock when requesting that he review a new volume by the British Columbia poet Earle Birney.[78]

Woodcock could well have told Muriel Spark that, yes, he was familiar with the poetry of the Ontario writer and critic A.J.M. Smith whose work had appeared in Britain's *New Verse*, where he had been published himself.

77. Peter Hughes, *George Woodcock* (Toronto, 1974), 49.

78. Earle Birney, *The Strait of Anian* (Toronto, 1948); George Woodcock, *Letter to the Past*, (Don Mills, 1982), 251. (For an earlier account of this conversation see George Woodcock, "Poetry Magazines of the Thirties: A Personal Note" in *A George Woodcock Reader,* Douglas Fetherling, ed. (Ottawa, 1980), 23.

He might have added that, as a child, he had been enthralled by Frederick Niven's *The Lost Cabin Mine* (1908), which followed the congenial gold-seeking train and bank robber "The Apache Kid" through the interior of British Columbia. But Woodcock's knowledge of Canadian literature, and specifically that of British Columbia, did not go much further. When he arrived on the West Coast himself, a couple of years after Muriel Spark's tongue-in-cheek inquiry, he pronounced the province's literary scene to be as bleak "as a Winnipeg winter."[79]

If Woodcock had taken the time to look at what had already been written by British Columbia's authors, he would have discovered that there were more writers than Frederick Niven and that Earle Birney was not a solitary pioneer. It had been more than forty years since Martin Grainger had produced one of the best pieces of writing in the province, *Woodsmen of the West*, in 1908. A year earlier Robert Service had published the first of his sourdough poems celebrating eccentric characters in the Klondike. Earlier, from the late eighteenth century onwards, maritime and overland explorers had given vivid—if romanticized and frequently ghostwritten—descriptions of the landscape and the Native peoples in published journals. Conversely, the remarkable Arthur Wellington Clah had kept a day-by-day account of what it was like to be caught between the Tsimshian and European worlds from the middle of the nineteenth century to the early years of the next century.[80]

Other writers living during the first half of the twentieth century had also made British Columbia the subject of their work. Ralph Connor (Reverend Charles Gordon) and C.L. Cowan both wrote moralistic novels. Pauline Johnson made her paddle sing by recasting Native "legends" in her sentimental poetry. Hilda Glynn-Ward published a notable, though alarmingly racist novel, *The Writing on the Wall* (1920), which targeted the Japanese and Chinese peoples. At the other end of the political spectrum, Dorothy Livesay and Irene Baird each wrote sensitively in their poetry and fiction about Vancouver's factory workers and

79. George Woodcock, "Massey's Harvest," *Canadian Literature* 73 (Summer 1977), 2.

80. Arthur Wellington Clah's diaries, Archives, Wellcome Institute in London, England.

the brutal treatment of the chronically unemployed who occupied the Vancouver Art Gallery and the post office in 1938. Livesay also wrote about the expulsion of Japanese-Canadians into the interior of the province during the Second World War.

There were plenty of semi-autobiographical, rough-and-ready adventure stories published by authors like Richmond P. Hobson during the first half of the twentieth century. Hubert Evans and Howard O'Hagan wrote popular novels that attempted to explore, through realism and myth, the condition of First Nations people. The province's most prominent environmentally conscious nature writer, Roderick Haig-Brown, emerged in the 1930s. His novels, written for both children and adults, blended fact and fiction, taking as his subjects the salmon and the cougars, the rivers and the loggers, of central Vancouver Island.

Nor did the quality of the literature produced in the province go unrecognized in Central Canada. In 1941 British Columbia had its first Governor General's Award winner. Just five years after Governor General Lord Tweedsmuir, himself famous as the fiction writer John Buchan, had established the award, Emily Carr received it for her stories in *Klee Wyck*. A year later the journalist Bruce Hutchinson picked up the non-fiction award for *The Unknown Country* and Earle Birney the prize for poetry. (It had taken Birney two years to find a publisher for *David and Other Poems*.) In 1944 Dorothy Livesay likewise received Canada's most prestigious award for poetry for her volume *Day and Night*.

It is not surprising that poetry was popular in British Columbia. In the mid-1940s Alan Crawley, a former corporate lawyer, and Earle Birney, now with an academic position at UBC, established a programme that encouraged poets to read their work to Vancouver's schoolchildren. Crawley had already begun setting high standards for British Columbia's—and Canada's—poets in 1940 when he launched the journal *Contemporary Verse*. It challenged the monopoly of cultural magazines and journals, like the *Canadian Forum*, the *University of Toronto Quarterly* and *Queen's Quarterly*—all based in Central Canada. This prompted the province's few bookstores to display *Contemporary Verse* proudly, alongside the largely foreign and Central Canadian books on their shelves.

The role played by UBC in encouraging Canadian literature would have been recognized by anyone familiar with the province during the generation before Woodcock's own arrival. From the 1920s, prominent Central Canadian writers like Wilson Macdonald, Bliss Carman and Charles G.D. Roberts visited the campus on their cross-country reading tours. The university's budding writers and poets—including Earle Birney and the future non-fiction writer Pierre Berton—had a venue for their poetry and prose in the student magazine, *Ubyssey*. The enthusiastic professor of English, Garnett Sedgewick, hosted an informal writing group for would-be writers in the 1920s. And when Earle Birney joined the Department of English in 1946, he established the country's first course in creative writing.

Following the Second World War there was, as novelist Ethel Wilson observed, "an uprush of writing, or perhaps more truly, of aspirations to write." The Vancouver-based novelist modestly acknowledged that "our talents are fairly mediocre, while our aspirations are considerable."[81] The year 1947 saw the publication of Wilson's first novel, *Hetty Dorval*. The same year Malcolm Lowry published the epic novel *Under the Volcano* and began writing early drafts of the unfinished novel *October Ferry to Gabriola* (1970). The footloose Lowry had been living in a shack in Dollarton near Vancouver since 1939. Around the same time another itinerant, the Ottawa writer Elizabeth Smart, took up residence on the Sunshine Coast near Vancouver. It was there that she wrote early drafts of her long prose poem *By Grand Central Station I Sat Down and Wept* (1945).

Despite all of this activity, however, most writers in British Columbia took a bleak view of the literary scene. "Why," Malcolm Lowry asked Dorothy Livesay in the early 1940s, "haven't we any serious prose writers?" After all, he reflected, "there is so much to write about in BC; there is everything."[82] Ethel Wilson echoed this sentiment when, a few years later, she asked why the province's literary critics were so "insipid

81. Ethel Wilson to John Gray, 10 January 1952, in David Stouck, *Ethel Wilson, A Critical Biography* (Toronto, 2003), 167.
82. Dorothy Livesay, *Journey With My Selves* (Vancouver, 1991), 167.

and uninformed."[83] Similarly, Earle Birney who proposed in 1948 that the government subsidize the arts wondered why the country's magazines and publishers had "to please big advertising corporations and [cater to] the lowest level of public taste?"[84]

Such comments speak to a sense that writers in British Columbia were not fulfilling their potential, in part because of a lack of critical stimulation. In 1949 Earle Birney was to find in George Woodcock, fresh off the boat from England with his impressive prefabricated literary credentials, an ideal collaborator in remedying the situation.

WOODCOCK HAD GROWN UP in the Shropshire town of Market Drayton, and then in Marlow, a small town in the Thames Valley west of London, where he attended the Sir William Borlase Grammar School. Top of the class at school, George faced not only personal loss when his father died but also a crisis in his education. His prosperous grandfather, Sam Woodcock, offered to finance his grandson's study at Oxford University, but only on the condition that the boy would agree to become an Anglican clergyman. But George had other plans. Turning down his grandfather's offer was a principled stand, which reinforced Woodcock's lifelong sensitivity to the fact that he lacked a university education.

From the age of nine, Woodcock had shown a facility for writing prose. By his early teens he was editing and publishing his poems in the Borlase Grammar School's literary magazine. Such ambitions were deferred when, after leaving school at the age of sixteen in 1929, Woodcock followed his late father by taking a job at the London office of the Great Western Railway. He hoped to save enough money, by the age of forty, to establish himself as a full-time writer. Woodcock was seventeen years old when he made this decision.

It is difficult to imagine this man, who would become as addicted to writing as an alcoholic is to drink, spending the next eleven years as a

83. Ethel Wilson, "A Cat Among the Falcons," *Canadian Literature* 2 (Autumn 1959),18.

84. Earle Birney, *Spreading Time, Remarks on Canadian Writing and Writers, Book I: 1904–1949* (Montreal, 1980), 124.

lowly railway clerk. Not surprisingly, Woodcock was bored and frustrated. He hated the daily commute that took him down the Thames Valley from Marlow to London's Paddington station. "I can remember months on end," he later recalled, "during which I returned home of an evening so dispirited that I would sit down after dinner with a pack of cards and play patience for hours on end because I had no urge to do anything else."[85]

But there were compensations for working in London. George discovered the delights of the Russian ballet at Covent Garden and—more accessible within his limited means—the free public museums and galleries in South Kensington and Bloomsbury. He fell under the spell of the First World War writers Wilfred Owen and Siegfried Sassoon and of the modernist poetry inspired by T.S. Eliot. Woodcock was also ambivalently impressed by the work of W.H. Auden and Stephen Spender, the precocious left-wing poets of the 1930s who were only a few years older than himself but each of them with an Oxford degree and a homosexual orientation. He absorbed the lively essays that the British philosopher and critic Herbert Read wrote for the weekly magazine *The Listener*, which had been recently established by the British Broadcasting Corporation (BBC). The young autodidact also read the European classics, published in affordable editions by Everyman and, from the mid-1930s, by the new imprint of Penguin Books. In response to the evangelistic religious training of his youth, along with his suspicion of government institutions and his belief in voluntary co-operation among individuals, he embarked on a study of anarchism and socialism.

In 1932, at the age of twenty, Woodcock became a published author when his Audenesque poems "Nocturne" and "Stephane" appeared in the highly regarded literary magazine *New English Weekly*. Three years later Woodcock's literary world expanded when he met Charles Lahr, the Anglo-German bookshop owner and publisher. Lahr brought out Woodcock's *Six Poems* (1938) in his Blue Moon Press. He encouraged the aspiring poet to submit his poems to *New Verse*, *The Serpent* and *Twentieth Century Verse*. A committed anarchist, Lahr also introduced his young protégé to the dynamic Italian anarchist Marie Louise Berneri, through whom George met his future wife, Ingeborg Linzer Roskelly

85. George Woodcock, *Letter to the Past,* 152.

(1917–2003). And since Lahr's Blue Moon Bookshop was a gathering place for writers during the inter-war years, he opened "a gateway," as Woodcock later acknowledged, "into the world of letters."[86]

Woodcock rightly perceived that he himself "would be at best a poet's poet."[87] With the publication of his first poems in the 1930s, he began to meet a congenial group of young poets who were loners. They stood apart from the fashionable literary cliques to which Auden and Christopher Isherwood belonged. Instead, like Woodcock himself, his was a group of lower-middle-class young men with no university degrees but intent on self-education. They met at the Duke of York pub in Bloomsbury, where they exchanged their poems, discussed the Spanish Civil War and the impending Second World War. They reinforced one another's belief that literature mattered and that society and politics could only be understood through the literary imagination. Above all, they held to the ethic of the "men of letters" of an earlier generation, affirming that any writer worth his or her salt could write effectively on any subject.

Not wholly surprisingly, upon the outbreak of the Second World War in 1939, Woodcock, like many of his new friends, became a conscientious objector to conscription. During the war he continued to write poetry. In 1940 Fortune Press brought out his book of poems entitled *The White Island*. Woodcock also built on his earlier interest in anarchism by writing a series of essays and pamphlets. And in 1944 Freedom Press published his first book of prose, *Anarchy or Chaos*.

An abrupt change in his circumstances occurred in 1940 when Woodcock came into an inheritance. He later sought to suggest that the sum involved was small, but it was clearly large enough to enable him to quit his railway job more than twelve years before planned and to devote his time solely to literature, at least until the money ran out. The inheritance also left him with sufficient funds to establish a literary magazine, *Now*, which proclaimed itself devoted to good writing and gave a harbour to writers with anarchist tendencies. A year following the launch of *Now*, Woodcock fused his interest in modernist poetry with militant pacifism

86. George Woodcock, *Letter to the Past*, 177.

87. George Woodcock, "Fragments from a Tenth-Hour Journal" in *A George Woodcock Reader*, 14.

by taking on the joint editorship of *War Commentary* (published from 1945 as *Freedom*).

As a conscientious objector, Woodcock worked on the land for the War Agricultural Committee in lieu of completing his military service. This arrangement was congenial in itself, since it tallied with his romantic conception of anarchism as a path to self-sufficiency through manual labour. "The sufficiency that will allow men to be free—that is the limit of the anarchist demand on the material world," he wrote later.[88] Moreover, many of his fellow conscientious objectors were literary men. Thus far from being alienated from the literary community during the Second World War, George was drawn further into it through his personal acquaintance with writers like Herbert Read, whom he had long admired.

At the end of the war an air of optimism and idealism resided over Sir Stafford Cripps's otherwise austere Britain of the late-1940s. The British Arts Council had now been established, the BBC was flourishing and plans were being laid for the Festival of Britain, which was to celebrate Britain's post-war achievements in the arts as well as industry in 1951.

Convinced that the arts had a place in the post-war reconstruction of Britain, Woodcock resumed writing scripts for the BBC, an activity that he had begun in 1942. He became a regular book reviewer for the *Times Literary Supplement* and *The New Statesman*. From 1945 to 1948 he wrote a "London Letter" for the American anarchist magazine *Retort*. He became secretary of the Freedom Defence Committee, an organization that helped pacifists and anarchists who had been victimized during the Second World War. He re-launched his journal *Now*, which embraced the American writers Henry Miller and Dwight Macdonald, as well as George Orwell, of whom Woodcock was later to write an admiring and award-winning biography.[89]

In the 1940s Woodcock also published more books of his own. He wrote biographies of the late-eighteenth-century libertarian thinker William Goodwin and of the seventeenth-century writer Aphra Behn,

88. George Woodcock, *Anarchism: A History of Libertarian Ideas and Movements* (London, 1962), 25.

89. In 1966, Woodcock received the Governor General's Literary Award for *The Crystal Spirit: A Study of George Orwell* (London, 1966).

who was later hailed as a pioneer feminist. Woodcock wrote a book of essays that explored the relationship between writers and politics; and he commenced the research and writing for two further biographies, one on Oscar Wilde and the other on Peter Kropotkin (whose conception of anarchism was close to the author's heart).[90] None of these works, however, produced enough money to provide the steady income that Woodcock clearly needed to supplement his residual savings. Thus Woodcock had good reason to become an editor of Porcupine Press.

Woodcock was by now professionally employable in such a capacity. He succeeded in getting plenty of work during the post-war years because he could be relied upon to meet a deadline and to see the next issue of a magazine through the press. According to his friend, the writer Julian Symons, George was also an inspiring, if somewhat overly idealistic, colleague. "His gentleness of manner," in Symons' view, "was belied by a square pugnacious face, his serious and, at times solemn conversation was starred by flashes of wit and, bursts of outrageous exaggerative fantasy."[91]

Woodcock was driven, during these years following the Second World War, by the need to make up for lost time—years wasted as a railway clerk and years during which his energies had been diverted from literature while he was a conscientious objector. He still felt a need to compensate for his lack of university education. Nevertheless writing, editing and committee work were compensation. They enabled Woodcock to fulfill his political commitment to pacifism and anarchism. All of these various activities saw him working a sixteen-hour day and writing more words in a year than most people would have read in that time.

On the positive side, George garnered a great deal of satisfaction from earning his living by his pen. He enjoyed the knowledge that he could turn his hand to any facet of literary endeavour, be it producing radio scripts for the BBC or writing poems, reviews, polemical articles or books. He had thus achieved the literary status he craved. Yet some

90. George Woodcock, *William Goodwin* (London, 1946); George Woodcock, *The Incomparable Aphra: A Life of Mrs. Aphra Behn* (London, 1948); George Woodcock, *The Writer and Politics: Essays* (London, 1948).

91. Julian Symons, "George Woodcock: A Portrait" in *A Political Art, Essays and Images in Honour of George Woodcock*, William H. New, ed. (Vancouver, 1978), 176.

palpable sense of frustration, amounting to claustrophobia, prompted him to make a big decision. As he later recalled, "even Britain seemed an island too small to be endured."[92] Approaching forty in 1949, Woodcock decided that it was the right time to immigrate to Canada—or, as he frequently put it, to return to the country of his birth.

George Woodcock longed to succeed as an immigrant where his father had failed. He wanted to live in a country where he would not be so sharply defined by his lower-middle-class background. Moreover, following the example of his hero George Orwell, who was living a kind of Tolstoyan existence in Scotland's Hebrides, Woodcock wanted, in true anarchist fashion, to try blending physical labour with literary endeavour.

Most of Woodcock's friends thought that he was foolish to attempt to do so. Why throw up everything he had so painfully achieved? How, they wondered, could bookish George carve out a name for himself while scratching a living on the fringes of the Empire? Woodcock's plan to set up a market garden on Vancouver Island, while attempting to pursue his literary career at the same time, was in Symons's view, "a visionary, slightly risible, project."[93] Crucially, George Orwell was the only one to approve of the plan. "I think it's the sort of country that could be quite fun for a bit," he told Woodcock, "especially if you like fishing."[94]

THE MODEST PIECE OF LAND that a Canadian anarchist, Doug Worthington, offered to George and Inge for settlement was situated on the west coast of Vancouver Island, a little over an hour's drive north of Victoria. During Woodcock's first year of living in the logging community of Sooke, he continued to write articles for the anarchist publications *Freedom* and *Libertarian League*. He saw his biographies of Wilde and Kropotkin, already largely written in England, through the press.[95] A Guggenheim Fellowship in 1950 allowed him to spend a year in Europe

92. George Woodcock, *Letter to the Past,* 310.
93. Julian Symons, "George Woodcock: A Portrait," 179.
94. George Woodcock, *Letter to the Past,* 82.
95. George Woodcock, *The Paradox of Oscar Wilde* (London, 1950); George Woodcock with Ivan Avakumovic, *The Anarchist Prince: A Biographical Study of Peter Kropotkin* (London, 1950).

researching a biography of the French anarchist Pierre-Joseph Proudhon. The book was not to be published, however, until 1956 (and again in England).

Meanwhile the newly arrived man of letters energetically sought to make himself known in British Columbia. Within a few weeks of arriving on Vancouver Island, Woodcock began reviewing books and also reading his own work on the Canadian Broadcasting Corporation (CBC). Producing scripts for the CBC's *Critically Speaking* and *Wednesday Night* programmes gave him a modest source of income. It also forced George to Canadianize his vocabulary and to break down the didactic style of his prose. Above all, working for the CBC brought George into personal contact with other writers, most notably Earle Birney.

Shortly after arriving in Canada, Woodcock began to gather material for a study on anarchism in Canada by visiting the Doukhobor community in Hilliers, north of Nanaimo. The book that eventuated, *The Doukhobors* written in collaboration with Ivan Avakumovic, was not to be published until 1968. In order to learn more about the province, and also about neighbouring Alberta and southern Alaska, Woodcock managed to arrange free transportation on the coastal vessels and the Canadian Pacific and Canadian National railways. Combining his love of travel with his interest in Native peoples resulted in *Ravens and Profits: An Account of Journeys in British Columbia, Alberta and Southern Alaska*. Brought out by a British rather than by a Canadian publisher, the book appeared in 1952.

Despite all of this activity, George and Inge's first three years in Canada were financially difficult. The British pound was devalued, thus diminishing their income from England by nearly one-third. In any case, living outside of literary London, George now received fewer requests for articles and reviews. The market garden that he had started shortly after arriving in Sooke consumed a large part of his energy without making much of a contribution to his income. In order to make ends meet, he dug ditches and house foundations. He and Inge also picked strawberries and sold Christmas trees. By 1953 Woodcock's plan to blend his physical and intellectual labours and thereby avoid the man-made rules and institutions that threatened his freedom had become financially and socially untenable. Lonely and lost in Sooke, he later acknowledged the stern

reality of their situation: "We had decided we were really urban people."[96] The Arcadian adventure a failure, George and Inge moved to Vancouver.

Almost at once George's prospects improved. It was Birney who made the necessary introductions to the nascent literary community in Vancouver. Woodcock might not have approved of Birney's fierce socialism or agreed with his view that creative writing could be taught and enhanced through literary groups. However, when his friend invited him to give a lecture on contemporary British poetry at UBC in January 1950—and offered him an honorarium of fifty dollars—he jumped at the chance.

For Woodcock was probably the most qualified person in the province to give a lecture on "British Poetry Today." He had personally known big-name writers like George Orwell and Herbert Read; he knew well-established literary editors and poets like Julian Symons; he had hobnobbed with the notorious Welsh poet Dylan Thomas at London's Café Royal. Woodcock had himself published his poetry in Britain's leading poetry magazines and journals, and he had been a frequent contributor to the BBC. These were institutions and names that Woodcock's university-educated audience revered. It was not surprising that they seized the chance to "pump" him for his own opinions and for insider gossip about the young British poets and novelists in whose circles he had so recently moved.[97]

In turn, on that cold winter evening in January 1950, at the reception following his talk, Woodcock was introduced to many leading figures in the Vancouver cultural milieu. He met Birney's colleagues—Stanley E. Read and Roy Daniells, among others—from the university's Department of English. He was also introduced to the artists and teachers B.C. Binning and Jack Shadbolt who were at the forefront of the modernist movement of painting in Vancouver.

Birney continued to play a significant role in Woodcock's life, introducing his new friend to poets Dorothy Livesay, Phyllis Webb, Marya Fiamengo, Anne Marriott and to artists Bruno and Molly Bobak, John

96. George Woodcock, *Beyond the Blue Mountains, An Autobiography* (Toronto, 1987), 44.
97. George Woodcock, *Beyond the Blue Mountains,* 5.

Koerner and Gordon Smith. Birney also saw to it that Woodcock became a contributor to the highly regarded Toronto-based journal *Northern Review*. Nor did Earle Birney's sponsorship stop there. He brought his protégé into a Vancouver literary circle known as Authors Anonymous. And though Woodcock remained adamant that writing was a private act and felt uncomfortable having his work openly assessed by his fellow writers, it was through Authors Anonymous that he got to know Ethel Wilson, as well as other local writers.

Moreover, in the mid-1950s it was Birney's recommendations that made it possible for Woodcock to secure lectureships at two universities, despite his own lack of academic credentials. In 1954–55 George taught a course for the Department of English at the University of Washington in Seattle. At the end of the academic year he was offered a permanent lectureship. When he returned to Washington State following the summer vacation to take up his position, however, American immigration officials denied him entry into the country. The fact that Woodcock had severed his connection with anarchist groups when he left England made no difference: in this Cold War context, he was deemed a security threat.

Once again Birney stepped in to help his new friend. He arranged for Woodcock to teach a course in composition and European classics in translation for the Departments of Continuing Studies and English at UBC. Thus, in 1956, Woodcock became a university lecturer, a position that he held for the next ten years. Admittedly, he came to feel that preparing lectures threw him into "states of nervous tension and profound discouragement."[98] Giving them also made him talk out several books. Even so, his contact with students offered stimulation, if not a lot of work. In these years too, Woodcock became a familiar voice on the CBC, and in 1958, less than ten years after immigrating to Canada, he was included in the commemorative volume, *Anthology of British Columbia*, celebrating the province's centenary.

Woodcock had joined the Department of English not because he liked to teach but because he saw it as a means to an end. He also hoped to establish a university-funded journal devoted to Canadian literature. When Roy Daniells, Basil Stuart-Stubbs, Inglis Bell and a few others at

98. George Woodcock, *Beyond the Blue Mountains,* 70.

the university were planning to found *Canadian Literature*, Woodcock emerged as their obvious choice to edit it. Woodcock did not need much persuading, especially since the new job meant cutting his teaching duties in half.

"I was there at the right time," as Woodcock later put it, "with the editorial experience and the appropriate attitude of slightly distracted objectivity."[99] His experience in the London literary world now seemed like an apprenticeship that qualified him to play a key role in Vancouver and, indeed, in Canada. The colleagues who appointed him knew they were getting someone who was both hard-working and congenial. And Woodcock knew himself that, having tried and abandoned three novels, he "had acquired the primary equipment of a critic: to know the pains of creation, the reasons for failure."[100] The failed market-gardener was also readily convinced that the development of a country's literature required a critical counterpart—and that, as a newcomer, he possessed a critical perspective that home-grown critics clearly lacked.

THE FIRST ISSUE of *Canadian Literature* appeared in the summer of 1959. In his first editorial, Woodcock made it clear as to what kind of journal he wanted it to be: "Good writing, that says something fresh and valuable on literature in Canada."[101] He wanted the journal to give Canadian literature the critical infrastructure that he felt it lacked. He wanted it to include both English and French-Canadian writers and critics, just as Quebec's literary and artistic journal *Le Nigog* had attempted to do in 1918. He wanted *Canadian Literature* to include contributions from full-time writers and critics as well as from academics. He wanted it to avoid literary cliques. And, above all, he wanted it to be accessible to "the curious reader."[102]

99. George Woodcock, *The World of Canadian Writing, Critiques & Recollections* (Vancouver, 1980), 11.

100. George Woodcock, "Fragments from a Tenth-Hour Journal" in *A George Woodcock Reader,* 3.

101. George Woodcock, "Editorial," *Canadian Literature* 1 (Summer 1959), 4.

102. George Woodcock, "Editorial," *Canadian Literature* 1 (Summer 1959), 3.

The early issues of *Canadian Literature* featured some of the editor's friends: Earle Birney, Dorothy Livesay and the poet P.K. Page. The journal offered a refreshingly critical view of established Canadian writers, from Duncan Campbell Scott and Stephen Leacock to Gabrielle Roy and Gratien Gélinas. It invited authors like Ethel Wilson, Roderick Haig-Brown, Hugh MacLennan and Mordecai Richler to write about writing and others like Gilles Marcotte to write about literary criticism.

During its formative years *Canadian Literature* devoted articles to a wide range of subjects: to biography and travel writing, to children's literature, to history and radio drama. In Woodcock's own editorials, articles and reviews, he discussed censorship and literary awards; he paid tribute to other literary journals; and in order to raise the journal above the parochial, he discussed writers from outside of Canada. To complement the content, Woodcock produced a visually attractive journal. Robert Reid did the make-up typesetting and page layout; George Kuthan produced stunning black-and-white woodcuts for the early issues. Not surprisingly, *Canadian Literature* won an Award of Distinctive Merit at the annual exhibition of Canadian printing: Typography '60.

However successful in other ways, *Canadian Literature* failed to become a bilingual journal. Woodcock found that the Francophone writers in Quebec were looking elsewhere. "I soon learned that their compasses were mostly set towards Paris" and, he acknowledged later, that his journal was out of tandem with the "rising separatist sentiment."[103] Nor did *Canadian Literature* maintain the hoped-for balance between full-time writers and academics. Non-academic writers found it increasingly difficult to compete, when the incentives of winning tenure, promotion and research grants spurred many university academics to produce an article or two for *Canadian Literature*—itself testimony to the fact that it had now become the country's leading literary journal.

The experience of editing *Canadian Literature* augmented rather than diminished Woodcock's own writing career. He acquired a standing in the literary and academic community that he would not otherwise have had. He later claimed to have been "happy to play a notable role in the

103. George Woodcock, *Beyond the Blue Mountains*, 85.

post-1950s naissance of a genuine Canadian literary tradition."[104] He thus helped the country's literature through its growing pains. Indeed, a year after the first issue appeared Woodcock proudly wrote that "present-day writing in Canada is something more than the product of the remittance men of European traditions, something more than the shadow of literature in America."[105]

What did it mean, then, to be a Canadian writer? It was Ethel Wilson who observed in 1955, "I used to find it faintly irritating when I saw Malcolm Lowry . . . referred to as "a Canadian novelist" just because he sometimes lived in Dollarton, a sort of place up the north arm of Burrard Inlet. I would not see that that made him a Canadian novelist."[106]

Indeed, Lowry never did become a Canadian. He declined to take out Canadian citizenship simply in order to receive a grant from the Canada Council. "They can't very well let me think I'm being bribed as it were by a fellowship to become a citizen," as he put it, and he refused, in an era when it would have been necessary to renounce his British citizenship, "to give up that old blue passport, that emblem of freedom."[107] It was obviously an issue to which Woodcock brought his own personal experience, declaring: "I did not then think of Lowry, any more than I thought of myself on first returning, as a Canadian writer."[108] Yet he was inconsistent here, and by 1961 Woodcock himself was ready to pronounce Lowry a Canadian and, above all, a British Columbia writer, agreeing to edit essays on his work that would set off a virtual "Malcolm Lowry industry" among academics.[109]

Woodcock always knew his own mind (even when he changed it). In his many essays he showed himself unafraid to offer his opinion

104. George Woodcock, *Beyond the Blue Mountains*, 20.

105. George Woodcock, "Summer Thoughts," *Canadian Literature* 5 (Summer 1960), 6.

106. Ethel Wilson to John Gray, 14 April 1955 in David Stouck, ed., *Ethel Wilson: Stories, Essays, and Letters* (Vancouver, 1987), 195.

107. Malcolm Lowry to Albert Erskine, [early summer] 1953, Harvey Breit and Marjorie Bonner Lowry, eds. *Selected Letters of Malcolm Lowry,* (London, 1967), 336–37.

108. George Woodcock, *The World of Canadian Writing,* 11.

109. George Woodcock, ed., *Malcolm Lowry: The Man and His Work* (Vancouver, 1971).

on Canada's established writers. Thus the novels of Montreal's Hugh MacLennan were deemed by Woodcock to be nationalistic, "unashamedly didactic" and "moralistic in tone." The poetry of Newfoundland's E.J. Pratt was conservative. Toronto writers fared no better in Woodcock's view: Morley Callaghan wrote prose that was verbose and flabby, and the critics Northrop Frye and Marshall McLuhan were "audacious prose fantasists."[110] These were bold judgements, boldly offered and often influential in setting the tone for others.

The hands-on mechanics of editorship were all part and parcel of Woodcock's life. Working from home, he put together each issue of *Canadian Literature* with help from Donald Stephens, his associate editor. Dressed in a shirt, tie and frequently wearing a decorative Mexican vest, Woodcock worked with Stephens during long afternoons at the dining table. "Each of us would have a pair of scissors, and we would begin," Stephens recollected. "I would count the lines and cut the galleys, and George would paste the cut portions on to the page; while he was numbering the pages and doing the titles, I would be cutting for the next page."[111]

When Stephens knocked off in the early evening, he well knew that Woodcock's own day was far from over. At this point, editorial duties completed, Woodcock retreated to his sunroom-cum-office where he set to work again, through the night, this time producing his books, poetry and articles and often continuing his own writing until five or six in the morning. This was an established routine, and those who knew George and Inge well would never call them before 11:00 a.m.

By the late 1970s George pined for release from this double shift. He came to feel that he "could not continue the task of giving an original context to the writing of other people."[112] He had become weary of making annual grant applications to the Canada Council and the Leo and Thea Koerner Foundation in order to keep *Canadian Literature* afloat.

110. George Woodcock, "Of Place and Past" in *A George Woodcock Reader,* 223; see also A.J.M. Smith, *Masks of Fiction* (Toronto, 1961), 129.

111. Donald Stephens, "'Man as Pattern' Recollections of George Woodcock" in W.H. New, ed. *A Political Art*, 193.

112. George Woodcock, *Walking Through the Valley, an autobiography* (Toronto, 1994), 21.

He was tired of struggling with a succession of university administrators to maintain the autonomy of the journal. He was now impatient both with writers who complained when they got a bad book review and with those who failed to meet a publication deadline. He bristled at "the xenophobia" that Robin Matthews and other stridently nationalistic academics displayed when they "attacked good scholars from abroad."[113] Moreover, by the middle of the 1970s other literary magazines and journals like *The Journal of Canadian Fiction, Essays on Canadian Writing* and *Mosaic* had emerged.

In British Columbia itself the TISH collective, inspired by the American-born University of British Columbia literary theorist Warren Tallman, became a focal point for emerging writers like George Bowering, Frank Davey, Fred Wah and Daphne Marlatt. In 1978 Fred Wah introduced a writing programme at David Thompson University Centre in Nelson. All of these courses, writers and groups looked to the United States rather than to Great Britain for their inspiration. This marked a departure from traditional ways of considering literature in Canada and in British Columbia.

It was no surprise to those who knew George Woodcock when he handed over the reins of *Canadian Literature* to UBC English professor William New in 1977. This was an inspired choice. Far from following the trend to look south—particularly to the poets based in Southern California—New chose to consider Canadian writing within the context of Commonwealth literature. Confident that *Canadian Literature* was in good hands, Woodcock was now free to clear off the dining room table and spend all of his time in the word-factory sunroom.

DURING THE SEVENTEEN YEARS that Woodcock was at the journal's helm, he had managed to write a number of books. These included, most notably, his groundbreaking study: *Anarchism: A History of Libertarian Ideas and Movements* (1962) and *The Crystal Spirit: A Study of George Orwell*, for which Woodcock received a Governor General's Award in 1966. He had also returned to writing lyric poetry. He had written several

113. George Woodcock, *Beyond the Blue Mountains,* 70.

travel books resulting from his trips to the Andes, Japan, India and Tibet. He had produced dozens of articles on the visual arts for prestigious journals like New York's *Arts Magazine* and Toronto's *Artscanada* (later known as *Canadian Art*). Drawing on his experience as the editor of the leading literary journal in the country, he had written on specific writers such as Mordecai Richler, as well as on Malcolm Lowry. He had also edited collections of literary essays on past and present novelists, critics and poets.[114]

Woodcock had also indefatigably produced books on Canadian Confederation, on the Hudson's Bay Company and on Canadian nationalism. Convinced that Canada's history and its geography disposed it to regionalism, and that nationalism would "harden our country into a single centralized and authoritarian state," Woodcock suggested that the provinces become autonomous political entities, thus turning the country into a federation in the manner of the Swiss.[115] This was, of course, consistent with his continuing commitment to an anarchist ideal of society.

Following his editorship of *Canadian Literature*, George became more of a political activist. Casting his libertarian gaze on the regional-federal debate, he maintained in *Confederation Betrayed* (1981) that British Columbia had the resources to separate from the rest of Canada. He also voiced his concern over the deterioration of cultural programming on the CBC and questioned the government's conservative policy towards censorship.

It was not the expectation of making lots of money that had prompted Woodcock to give up editing *Canadian Literature* in order to write full time. Nor was he interested in the fame that sometimes comes—if relatively seldom in Canada—from being a successful writer. Shy and reserved, Woodcock was not really interested in seeking out other writers and academics. This is not to suggest that he did not have friends, but he was not naturally gregarious. When someone arranged for Woodcock to

114. See, for example, George Woodcock, *The Canadian Novel in the Twentieth Century* (Toronto, 1975); George Woodcock, *The Sixties, Writers and Writing of the Decade* (Vancouver, 1969).

115. George Woodcock, *Beyond the Blue Mountains,* 188–89.

meet Malcolm Lowry at a downtown pub, it was noted that "the authors mostly ignored each other, leaving their wives to manage forced conversation."[116] Many of his friends, like Roderick Haig-Brown and David Watmough were autodidacts and British-born writers like himself, or else artists, like his closest friend, Jack Shadbolt, and the artist's curator-wife, Doris. Indeed, Woodcock proudly recalled that he spent "more time with visual than with literary artists."[117]

Woodcock wrote because he gained an enormous satisfaction from expressing his ideas clearly and from communicating those ideas to others. Like the English writer of an earlier generation, V.S. Pritchett, who would spend long hours with a pastry board resting on the arms of his chair while he scrawled page after page, Woodcock simply enjoyed writing, in itself and for itself, though his own preferred medium was a standard manual typewriter rather than a fountain pen. Even if he had been unable to get his work published, George would probably have continued to write anyway. Writing was both a pleasure and an obsession. Like Rudyard Kipling he could have said, "the mere act of writing was, and always had been, a physical pleasure to me."[118]

It was not unusual for George to bring out three books in one year. But however much Woodcock remained physically aloof from the literary world, he was desperate for the approval of his fellow writers. And he usually got it. Indeed, the range of subjects on which he wrote and the quantity of writing that he produced, astonished reviewers and readers alike. What he did not like was criticism. Yet some of his books naturally attracted it, especially when he brought his libertarian and anarchist ideas to a wider audience, or argued that all pre-European societies were somehow linked.

116. George Woodcock Literary Achievement Awards, *BC Bookworld Media Kit*. I once held a reception for the American writer Ursula Le Guin, and Woodcock had expressed mutual admiration. Towards the end of the evening, Ursula asked me if Woodcock had been detained at which point I took her to the other side of the room and introduced her to George.

117. George Woodcock, *Beyond the Blue Mountains*, 47.

118. Rudyard Kipling, *Something of Myself* (London, 1937), 206.

WOODCOCK HAD JUST LEFT *Canadian Literature* and was enjoying what he called his "creative liberation" when a lengthy and brutal review of his book *Peoples of the Coast* (1977) appeared in *BC Studies*.[119] Woodcook had published an earlier account of First Nations people, *Ravens and Profits*, which had been well received. But that book had been published in 1952 for a British audience. Moreover, it did not claim to be much more than a travel book. *Peoples of the Coast* was, however, considerably more ambitious and more authoritative. It dug deeper into the history of First Nations people who had lived on the northwest coast of North America for more than seventeen thousand years. It was produced for a Canadian audience. And, above all, it was published at a time when scholarship and specialism had greatly developed.

Peoples of the Coast had been given for review by the journal *BC Studies* to two ethnologists at the British Columbia Provincial Museum: Robert D. Levine and Peter L. Macnair, the latter the son of George's old friend Dorothy Livesay. The reviewers' first paragraph proclaimed the book to be "one of the worst discussions of this subject matter available." *Peoples of the Coast* was, in their view, "shot through with basic errors." Its author had "misunderstood or failed to assimilate the contents of his sources." Woodcock had mislabelled photographs, misunderstood indigenous languages, ignored recent books on the subject and thereby distorted the history of the province's Native peoples. These accusations made the reviewers ask: "How was it possible for such a book to get published and, even more important, *why* was it published?"[120]

Woodcock hit back at the pedants from the Provincial Museum and raided his own locker of allusions. He employed the rhetoric of the pre–First World War poet Ezra Pound and the painter Wyndham Lewis who had founded the magazine *Blast*. Levine and Macnair were depicted as "Bombardiers" who had aimed "the great popgun of theirs rather wildly, and the result is a number of damaging misrepresentations." While conceding that there might be errors in his book, Woodcock defended

119. George Woodcock, "On Editing *Canadian Literature*: Recollections in 1977" in *The World of Canadian Writing*, 10.

120. Robert D. Levine and Peter L. Macnair, "George Woodcock's *Peoples of the Coast*: A Review Article," *BC Studies* 40 (Winter 1978–79), 57–70.

the captions accompanying the illustrations. If there were wrong attributions it was because the museums themselves and other institutions had given him incorrect citations. He insisted that he had used, and thereby benefited from, the work of ethnologists, which the reviewers accused him of ignoring. And, as a final salvo, Woodcock noted the reviewers' own dearth of publications by invoking Bernard Shaw's famous remark: "Those who can, do; those who can't, criticize."[121]

Such criticism, much of it justified, heralded a new area of professionalism and asserted the dominance of academics and specialists. Yet Woodcock was incensed at the suggestion that writing about First Nations people should be left to the social scientists. This struck a sour note for a man who had always believed that a good writer could turn his hand to any subject, and that a man of letters could earn both his own living and other people's respect while working outside of the academic institutions. His career had been built on the confidence that he could work on two or three different books at a time. That he could write on any subject. That he could write quickly with virtually no revision. And that he had the energy to do so.

A lot was at stake. He had given up the reins of *Canadian Literature* in order to embark, at the age of sixty-five, on writing as a full-time occupation. He had decided to publish his work exclusively in Canada and to write on more Canadian subjects. Undeterred by Levine and Macnair's harsh criticism, this is what Woodcock did until his death in 1995. He continued to write about libertarian and anarchist thinkers as well as about Canadian literature and history. He took a third unsuccessful stab at writing a novel. And his and Inge's travels also produced more books.

Though no longer the editor of *Canadian Literature*, George Woodcock continued to celebrate Canadian writing.[122] He produced the volume *BC: A Celebration* (1983), which featured both artists and writers. He also continued to write for *Canadian Literature*. In 1992, three years before his death, Woodcock celebrated female writers like Sheila Watson,

121. George Woodcock, "Counterblast by George Woodcock," *BC Studies* 40 (Winter 1978–79), 71–75.

122. George Woodcock, *The World of Canadian Writing*; George Woodcock, *Northern Spring* (Vancouver, 1987).

whose only novel, *The Double Hook* (1959), had, in his view, "wielded an immense influence on later Canadian fiction" by showing "younger Canadian writers that they could go safely beyond the romantic realism that had earlier characterized most Canadian fiction..."[123] (Oddly, he failed to mention his friend and openly gay writer Jane Rule whose 1964 novel, *Desert of the Heart*, had been turned into a popular feature film.)[124]

Woodcock also found the time to complete the last two volumes of his autobiography, though his wish to keep his marriage and his private life off the page makes for rather dry reading. Even illness—George had had the first of several heart attacks in 1966—did not prevent him from spending most of his waking hours in his converted sunroom at the back of his house or, when he was ill, working in the hospital bed. Despite his heart disease and debilitating arthritis by the time of his death in 1995, Woodcock had good eyesight and was in possession of all of his mental faculties. Indeed, when he died he was in the midst of translating the writings of Marcel Proust.

The legacy remains. Today anyone wanting to know about anarchy and pacifism can still turn to George Woodcock's biographies of Proudhon, Gandhi, Goodwin and to his classic study, *Anarchism: A History of Libertarian Ideas and Movements* (1962). His award-winning book *The Crystal Spirit* remains basic reading for an understanding of George Orwell. And, above all, an understanding of the development of Canadian literature from the late 1950s to the 1970s can be charted through the forty or so issues of *Canadian Literature* that appeared under Woodcock's editorship.

Woodcock belonged to a literary world that we have lost. The days of the sage, who writes on a variety of subjects for an intelligent, non-specialized audience, has all but disappeared. Rather like Lionel Trilling and Edmund Wilson in the United States, or V.S. Pritchett and Herbert Read in England, Woodcock began his literary career at the right time. He had a chance, during the 1930s and 1940s, to participate in the literary

123. George Woodcock, "Balancing the Yin and the Yang," *Canadian Literature* 133 (Summer 1992), 4.

124. It was not until George Woodcock left the editorship of *Canadian Literature* that the journal published work by Jane Rule.

political culture in Britain. And he left London in time to partake in the burst of literary nationalism in Canada during the 1960s and 1970s. As he wrote in retrospect, *Canadian Literature* "flourished because of the growing number of new critics, and the growing volume of new books, quantitatively and eventually rich."[125] What George Woodcock modestly did not mention was the extent to which he had himself contributed to the growth and the development of literature in Canada. Perhaps it did not need mentioning at the time—but it deserves to be recalled today.

125. George Woodcock, *Walking Through the Valley*, 55.

Social Commentator or Social Rebel?
GEORGE RYGA (1932–1987)

O N THE EVENING of 23 November 1967, during Canada's centennial year, history was made at the Playhouse Theatre in Vancouver. The usual accoutrements associated with the theatre were absent. There was no plush red velvet curtain and no elaborate stage set behind it—just a circular ramp and a cyclorama depicting a mountain and a cityscape. There was no dimming of the house lights, no grand entrance by the actors at the beginning of the play. The actors simply appeared at the side doors and from the back of the 670-seat auditorium then took their positions on the stage. It was only at this moment that the house lights were dimmed and Act One of George Ryga's play began with the words: "The first time I tried to go home I was picked up by some men who gave me five dollars. An' then they arrest me."[126]

Few among the largely white, middle-class audience anticipated what they would experience over the next two hours. They would be dragged through seedy rooming houses in the city's Downtown Eastside. They would share the anguish of some ten thousand Native people, many of whom were out of place in the white urban culture as much as on their

126. George Ryga, "The Ecstasy of Rita Joe" in *Modern Canadian Plays,* Jerry Wasserman, ed. (Vancouver, 1985), 27–54. All other quotations from the play are taken from this volume.

own reserves. And they would be invited to empathize with a woman who was guilty of shoplifting, assault, drunkenness, prostitution and vagrancy, and whose life would end in rape and murder.

The Ecstasy of Rita Joe was a play with no plot, no storyline and no logical sequence. It shifted between the present and the past, between dream and fantasy and between reverie and memory. Even more surprisingly, the play began when the protagonist, played by the Toronto actor Frances Hyland, was already dead. Few in the audience initially realized that they were witnessing the beginning of a new era in Canada's theatre history.

THE AUTHOR OF THE PLAY, George Ryga, and the director, George Bloomfield, had used both old and new theatrical devices and techniques to thrust the audience into the world of Rita Joe. Shafts of soft and harsh light suggested the bars of a prison cell at one moment and the starkness of a Vancouver courtroom at the next. Menacing shadows allowed Rita Joe's rapist-murderers to retreat and appear at will. Searing spotlights emphasized the Native actors' isolation from Vancouver society. The magical barrier that divided the actors from the spectators was only dissolved when Rita Joe's lover, Jaimie Paul, spoke directly to the audience: "Hey, mister, you know me. You think I'm a dirty Indian."

Language and class, as much as light, divided the actors. The standard, authoritative English of the magistrate, the priest, the teacher, the policeman and the community organizer grated against the disarmingly idiomatic, and frequently poetic, lines spoken by Rita Joe. The magistrate's attempt to instruct Rita Joe on the due process of the court prompted her to respond: "Can I bum a cigarette someplace?" The refrain sung by Ann Mortifee's off-stage voice—"God was gonna have a laugh / An' gave me a job in the city"—captured the bitter irony of Rita Joe's hope for a better life by moving there. The presence of the actor Chief Dan George (Tswahno), hereditary chief of the Tsleil-waututh First Nation reserve in Burrard Inlet, invested the character of David Joe with authority and *gravitas*.

At the end of the first act on opening night there was no clapping and virtually no reaction from the audience. They quietly exited the auditorium, leaving the director wondering if they would return for the second act. The audience did come back; and, at the end of the play, they broke into a thunderous applause. The cast did not take any curtain calls on that first-night performance. By the time the audience had vacated the playhouse, the actors, as artistic director Joy Coghill recalled, were "up the road having a beer at the Alcazar."[127]

It had been a very different story during the making and rehearsing of the play. There was a tug-of-war between the director and the playwright. Bloomfield wanted to turn the script into a documentary. Ryga wanted to establish a "dream-nightmare type of movement and mood" that charted a young Native woman's "odyssey through hell."[128]

The actors added their own perspectives during the rehearsals. The sixty-eight-year-old Chief Dan George, who played Rita's father, incorporated his experience as logger-longshoreman-cum-actor and, before that, as a pupil at St. Paul's Boarding School on the North Vancouver reserve, into the character David Joe. He revelled in having an opportunity to deliver some lines in his Native tongue. "I am a chief," he observed a few years later, "but my power to make war is gone, and the only weapon left to me is speech."[129] At the same time, Chief Dan George was surprisingly uncomfortable with the play's criticism of the Roman Catholic Church. "Go tell your God. . . when you see him. . .," Rita Joe ordered the Roman Catholic priest, "Tell him about Rita Joe an' what they done to her! Tell him about yourself too! . . That you were not good enough for me, but that didn't stop you tryin'!"

There was only one other First Nations actor among the cast. Of Mohawk descent, August Schellenberg played Rita Joe's angry young lover, Jaimie Paul, who did not just want a box of cornflakes—he wanted "the whole store." During one rehearsal, Jaimie Paul asked Rita Joe's

127. Joy Coghill quoted in James Hoffman, *The Ecstasy of Resistance: A Biography of George Ryga* (Toronto, 1995), 179.

128. Christopher Innes, *Politics and the Playwright: George Ryga, The Canadian Dramatist,* vol. 1 (Toronto, 1985), 46; James Hoffman, *The Ecstasy of Resistance,* 167.

129. Chief Dan George, *My Heart Soars* (Saanichton, 1974), 91.

father, David Joe: "Where you gonna be when they start bustin' our heads open an' throwing us into jails right across the goddamned country?" As Schellenberg began to recite these words to Chief Dan George, he saw his own grandfather standing before him. Overwhelmed, he "just couldn't say the lines. I had to stop."[130]

Joy Coghill sensed the emotional toll that the play was exacting from the actors after their first reading of the script. "When the reading was over, the cast came out and, as they passed me, they seemed deeply moved, some had tears in their eyes; something special had happened in there."[131] During the ensuing three weeks of rehearsal, the off-stage singer Ann Mortifee enjoyed sitting quietly with Chief Dan George. "Just being in his presence," she recalled, "taught me the value of silence and stillness."[132] Pat Gage, who played Rita Joe's sister, Eileen, "wept for hours." And in the title role as Rita Joe, Frances Hyland was "unable to sleep."[133]

MOST BRITISH COLUMBIANS were not accustomed to this kind of hard-hitting "entertainment." The first performance of a play on the Northwest Coast seems to have taken place in 1853 aboard the HMS *Trincomalee*, which was anchored off the outskirts of Fort Victoria. During the ensuing colonial period, local amateur theatrical groups and professional touring companies from the United States offered their audiences a moral tale or, more frequently, an escape from everyday life through comedy, melodrama or farce. Things did not really change after Governor General Lord Bessborough established the Dominion Drama Festival (DDF) in 1932. The amateur actors who travelled to Ottawa from virtually every province in the country in order to partake in the annual competition staged largely conservative, tradition-bound plays and, above all, plays written by British or American playwrights.

130. *Province* (Vancouver), 17 November 1967.
131. Joy Coghill quoted in James Hoffman, *The Ecstasy of Resistance*, 176.
132. Ann Mortifee quoted in Peggy Stortz and Susan Woods, *Mentors in Our Midst: Leading Ladies of the North Shore* (West Vancouver, 2004), 102.
133. Christopher Innes, *The Canadian Dramatist*, 50.

It was not until the 1930s that a small group of left-leaning actors and dramatists, comprising workers, university students, teachers, New Canadians and the unemployed, bucked this trend. They infiltrated the DDF and, like the members of Vancouver's Progressive Arts Club, they satirized the capitalist system and introduced themes associated with the working class and the poor. Their efforts to move the theatre away from the drawing room and the conventional stage and to engage with politically and socially charged subjects proved short-lived.

It was no different for the director Sydney Risk and the actors associated with Vancouver's Everyman Theatre. In 1953 they offered their audiences a different kind of challenge by staging a sexually frank play called *Tobacco Road*. Written by the American playwright Jack Kirkland in 1933, the play was too realistic for some members of the public. Denounced as obscene by the local authorities, *Tobacco Road* was shut down and Sydney Risk, along with some members of the cast, was thrown in jail.

The Ecstasy of Rita Joe was neither escapist theatrical entertainment nor a morality play nor overtly left wing. Its provocative rape scene did not prompt the authorities to close the play down. Nevertheless, like John Osborne's play *Look Back in Anger* which startled British audiences in 1956, *The Ecstasy of Rita Joe* guaranteed its audience a new experience. Ryga had not only managed to challenge his audience's preconceptions but, working in the tradition of George Bernard Shaw and Oscar Wilde, he had shocked them. Moreover, like Eugene O'Neill whose play *The Emperor Jones* offered a racially integrated cast in 1920, Ryga had made the social and cultural condition of contemporary Native peoples in British Columbia the central theme of his play. And, like picking at a scab, *The Ecstasy of Rita Joe* had "peeled a cicatrice [*sic*] off Canadian society and showed the bleeding flesh beneath."[134] As a writer for the *Christian Science Monitor* who reviewed a performance of the play in Washington, DC, rightly observed: "The Canadians are second to none on this continent in their guilt-feelings concerning the Indians."[135]

134. Jack Richards, *Vancouver Sun*, 24 November 1967.
135. "The Ecstasy of Rita Joe: A drama of American Indian Life," *Christian Science Monitor*, 11 June 1973.

Watching *The Ecstasy of Rita Joe* was "an exhausting emotional experience" for the Vancouver *Province*'s critic James Barber. [136] Likewise, Jack Richards did not know whether the play was great, but as he told his readers in the *Vancouver Sun*, "If the role of the stage is to communicate, and I believe it is, Ryga and director George Bloomfield have accomplished their purpose."[137]

Less impressed than the province's local newspaper critics was the *Toronto Star*'s Nathan Cohen. He pronounced Ryga's script weak and Bloomfield's staging of it pedantic. "A non-production of a non-play," was the influential drama critic's verdict. [138] A commentator for the Canadian Broadcasting Corporation (CBC) agreed: *The Ecstasy of Rita Joe* "was not a play." But, he admitted, the play was "an act of communion in which our own participation is inescapable."[139]

The Ecstasy of Rita Joe was no less unsettling for the group of hardboiled politicians who attended opening night at Ottawa's National Arts Centre two years later. By 1969 Native peoples had possessed the federal vote, albeit only since 1960. They had been voting in British Columbia's provincial elections since 1949. And two years later the federal government had rescinded the anti-potlatch law of 1884, which had made the practice of First Nations cultural traditions illegal. Even so, inequities still remained: British Columbia's provincial government had still not settled Native land claims; they were still subjecting many Native children to the devastating residential school system; they had still done little to reduce the large number of Native peoples who flooded the prisons; and they had still done virtually nothing to alleviate the poverty that most of British Columbia's Native peoples experienced both on and off the reserves.

It was British Columbia's premier, W.A.C. Bennett, in Ottawa for a constitutional meeting, who encouraged the other provincial premiers to accompany him to the National Arts Centre's performance of *The Ecstasy of Rita Joe* in 1969. Bennett was no theatregoer, and this was reportedly

136. *Province* (Vancouver), 25 November 1967.

137. *Vancouver Sun*, 24 November 1967.

138. *Toronto Star*, 25 November 1967.

139. Christopher Innes, *The Canadian Dramatist*, 51.

the first time he had ever attended a play. Although he must have had some prior knowledge of what to expect, he found himself deeply moved. During the reception following the performance, he sought out Chief Dan George and spoke to him sympathetically.

Bennett had also brought Ryga's play to the attention of federal politicians, whom he encouraged to attend the play with him. The Minister of Indian Affairs, Jean Chrétien, along with the Justice Minister, John Turner, were therefore in the audience, as was Pierre Elliott Trudeau. The prime minister made it clear that he had been unimpressed by the direction, lighting and set design. Even so, he told a reporter for the *Montreal Star* that he had been "profoundly moved."[140] So had John Turner, who asked Bennett, his fellow British Columbian: "What do we do? Something must be done."[141]

The Ecstasy of Rita Joe did not offer the politicians any solutions as to how they might help Native peoples regain their self-respect by taking possession of their ancestral lands and thereby reconnect with their culture. Nevertheless, Ryga did show everyone who attended his play how Rita Joe was "much more than just another skid row casualty": she represented an immense cultural loss that went beyond class and ethnicity.[142] And while Ryga had put the country's political, judicial, educational, religious and welfare systems on trial, he only allowed Rita Joe to achieve "ecstasy" through her violent death.

THE VANCOUVER PLAYHOUSE had taken a considerable risk in asking George Ryga to write a play for its centennial celebration. An unknown figure to the Lower Mainland theatre community, the author lived in the small town of Summerland on the shores of Okanagan Lake. Ryga had written a couple of novels, several short stories, radio plays, television scripts and a self-published volume of poetry. But he had never previously

140. James Hoffman, *The Ecstasy of Resistance*, 199.

141. Malcolm Page, "Fourteen Propositions about Theatre in British Columbia" in Ginny Ratsoy, ed. *Theatre in British Columbia,* Critical Perspectives on Canadian Theatre in English, vol. 6, (Toronto, 2006), 28.

142. James Hoffman, *The Ecstasy of Resistance*, 180–81.

written a stage play.[143] This became apparent during the rehearsals when he had to be reminded which was "stage right" and "stage left." Nor had Ryga been raised in a traditional Canadian Anglophone or Francophone community. Moreover, he had once been a member of the Communist Party.

George Ryga was born on 27 June 1932, in a two-room log cabin on a barely viable 160-acre farm a hundred miles north of Edmonton in northern Alberta. Called Deep Creek by the locals and named Richmond Park by the mapmakers, the nearest town to the Ryga homestead was Athabasca—some twenty miles northeast by dirt road.

George Ryga senior and his wife, Mary (née Kolodak), were part of the second wave of Ukrainian immigrants who had left the Soviet Union in the late 1920s and settled in rural areas across Western Canada. They joined an existing Ukrainian community, thus ensuring that their language and their culture would survive. Ukrainian, therefore, remained their first language—and in the case of Mary, it remained her *only* language. Ukrainian folktales and ballads, notably the poetry of the martyr and founder of the Ukrainian language, Taras Shevchenko, were the cultural touchstones of their community. Ukrainian nationalism, the Orthodox or Catholic Church—depending on whether they came from eastern or western Ukraine—along with socialism, formed their spiritual and political base. George senior and Mary worked hard on the family farm and expected their children to do so too, after receiving a rudimentary education. This was the future that awaited the children of most Ukrainian settlers, including George and his younger sister, Anne.

As a child, Ryga was thus steeped in Ukrainian history and litera-ture—some of which he had learned by sitting on the periphery of his father's reading circle. He was proud that his ancestry went back to the Mongolian and Russian Cossacks. And although his grandfather had died before he was born, Ryga was equally proud of his ancestor's staunch atheism and military exploits.

143. George Ryga's novels—*Hungry Hills* (Toronto, 1963) and *Ballad of a Stonepicker* (London, 1966)—and book of poetry—*Song of My Hands: and other poems* (Edmonton, 1956).

The boy did not speak English until he began elementary school. During the course of mastering his second language, however, he realized that his English was different from that of "the ticket seller at the railway station, the social worker, the postmaster, and the old prick who fought in the First World War and now walked around town at night with a club in his hand in his capacity as town constable." From the beginning, therefore, Ryga felt himself to be an outsider: "It was as clear-cut as that—there was 'them' and there was 'us.'"[144] Whether he saw this in terms of class or of ethnicity, this gut feeling informed George Ryga's worldview—and continued to do so, in different ways, throughout his later career as a writer.

Despite his initial lack of proficiency in the English language, Ryga was a good student. By the age of twelve he had completed Grade 8—having skipped two grades—and thereby exhausted all of the schooling available to him in Deep Creek's one-room schoolhouse. At the age of thirteen, however, he began working on the family farm. In his spare time he immersed himself in the poetry of Robert Burns and Percy Bysshe Shelley, both of whom were politically radical in their day. He also read the poems of Omar Khayyam (in the Fitzgerald translation) and, indeed, anything else he could get his hands on. In the late 1940s he began writing romantic, pastoral poems in English, and he published some of them in the region's weekly newspaper.

George also took correspondence courses with a view to completing his high school education. The sixteen-year-old's essays in English literature impressed one of his tutors, Nancy Thompson, who encouraged her young student to write more. And in 1949 she prompted him to enter a province-wide writing competition, sponsored by the Alberta Writers Conference and the Imperial Order Daughters of the Empire (IODE). Ryga's submission, a short story about pioneer settlers in northern Alberta titled *Smoke*, won him a coveted scholarship to attend the Banff School of Fine Arts, in the mountains of southern Alberta. Suddenly, the shy and frequently stuttering seventeen-year-old farm boy from Deep Creek had the break that he needed to fulfill his ambition to become a writer.

144. George Ryga, "Contemporary Theatre and Its Language," *Canadian Theatre Review* 14 (Spring 1977), 6.

From its founding in 1933, the Banff School of Fine Arts had brought distinguished dramatists to the Canadian Rockies. Gwen Pharis Ringwood, Alberta's leading playwright, worked there as registrar. In 1938 Frederick Koch, the American director of the University of North Carolina's prestigious drama department, had introduced Canadian students to the concept of the folk play. Eleven years after that, when Ryga arrived at the school, other American dramatists had joined the staff. He took classes in playwriting and the short story from E.P. Conkle, whose plays, just like those of his more famous student Tennessee Williams, captured the humour, language and folk-wisdom of small-town America.

Ryga also studied the novel and drama with the charismatic theatre director, Burton James. A Marxist who had worked in the Soviet Union at the Moscow Art Theatre, James introduced Ryga to the dramatic value that could be achieved by using regional and peasant dialects. He also encouraged the budding dramatist to put whatever he wrote into a historical, political and social context.

During his summer in Banff, Ryga saw his first play: Sophocles' Athenian tragedy, *Oedipus Rex*, written in 429 BCE. He met and made friends with the largely Canadian contingent of drama students. He also made connections with the school's Canadian staff. There were two professors from the University of Alberta, J.T. Jones and W.G. Hardy. There was the Toronto actor Mavor Moore, who ran the CBC's foreign-service drama department. And there was also Sydney Risk, the veteran director of Everyman Theatre, who had been jailed for his production of *Tobacco Road*.

At the end of the summer, Ryga returned home. Writing was temporarily displaced by his duties on the farm. With the help of his former correspondence course tutor, Nancy Thompson, however, he read even more widely than the previous year. "Coming into contact with literature and becoming aware of its dignity, beauty and severe discipline was probably the kind of challenge I needed at the time."[145] The following year Ryga entered—and won—the IODE's creative writing competition once again. This took him back to the Banff School of Fine Arts.

145. George Ryga interviewed by Peter Hay, "George Ryga: Beginnings of a Biography," *Canadian Theatre Review* (Summer 1979), 40.

Over the course of the summer, Ryga resumed his acquaintance with Burton James. More significantly, this time he studied radio writing and radio technique with the American playwright, author and dramatist Jerome Lawrence. Ryga not only attended Lawrence's classes, "I stayed with him in his cottage," he recalled, "and the workday began at seven in the morning and didn't end till midnight every night."[146] A director for the Columbia Broadcasting System in New York City and in Hollywood, Lawrence remembered his eighteen-year-old student from Alberta as "an absolute original" who possessed "a gold-mine of stories and legends not only of the rugged Northern Alberta farm-country, but of the Indians, and his own rich Ukrainian heritage."[147]

By the end of his second summer in Banff, Ryga had learned much. Lawrence had taught him how to write radio plays. Burton James had encouraged his socialist leanings. And his sponsor, the IODE, had shown him the cost of voicing his political views. After reading one of his poems criticizing the Korean War, IODE officials informed him that he would not be considered for a further scholarship.[148]

UNSHAKEN IN HIS POLITICAL OUTLOOK, George returned to the family farm more determined than ever to express his political views through his art. At the end of the harvest in the autumn of 1950, his socialist commitment was reinforced when he was hired to help build a bridge across the Athabasca River, thus giving residents in Deep Creek easier access to the provincial capital, Edmonton. It was while working as a labourer for Alberta Public Works that Ryga met fellow worker David Stirling. The older man not only shared George's commitment to left-wing politics, he introduced him to the American Beat poets. And he listened sympathetically to Ryga's ambitions to become a writer—"aspirations beyond those which most Athabasca farm boys had at the time."[149]

146. George Ryga quoted in Peter Hay, "Beginnings of a Biography," *Canadian Theatre Review* (Summer 1979), 41.

147. Jerome Lawrence quoted in James Hoffman, *The Ecstasy of Resistance*, 50.

148. It should be noted that the IODE never awarded the scholarship to an applicant for more than two years.

149. David Stirling quoted in James Hoffman, *The Ecstasy of Resistance*, 53.

During Ryga's first season working for Alberta Public Works the temperature fell to forty degrees below zero. The work was demanding. And, as Ryga discovered when he lost three fingers on his right hand, it was dangerous. However traumatic this industrial accident must have been, it put an end to Ryga's work on the construction site and, for the moment at least, on the family farm. It thus took him away from Deep Creek, leaving George free to test his skills as a professional writer in the nearest major city: Edmonton.

Armed with credentials from two summers' study at Banff, Ryga secured a job as a copywriter at one of Edmonton's leading radio stations, CFRN. From 1951 to 1953 he wrote commercials and news items. He took on extra work producing radio scripts, sometimes featuring his favourite poets, for CFRN's Sunday evening cultural programme, *Reverie*. And he had interesting colleagues like the folksong collector Omar Blondahl, who introduced him to Canadian folk music.

When Ryga was not working at CFRN, he took non-credit courses in philosophy, drama and psychology from the University of Alberta's Extension Department. He also studied Marxist-Leninist theory. Influenced by his reading, as well as by David Stirling, by his former teacher Burton James and by his father who was steeped in progressive, populist, agrarian politics, George became a member of the Communist Party. He helped the party organize cultural events at rallies and meetings. And he submitted politically inspired poems to the left-leaning Toronto-based magazine *New Frontiers*.

Ryga's affiliation with the Communist Party—which had been repeatedly outlawed by the federal government—cost him his job at CFRN. In the spring of 1953 George was asked to leave the station after the manager learned that his young employee had given a speech at a rally supporting Ethel and Julius Rosenberg, the American couple who had been accused of passing information about the construction of the atomic bomb to the Soviet Union. (They were subsequently executed.) The rally itself was actually organized by the Co-operative Commonwealth Federation, thus under socialist rather than explicitly Communist auspices. George returned again to the family homestead and worked there until the autumn of 1954, when he got another scriptwriting job in Camrose,

Alberta. After Ryga had spent a few months working for CFCW, however, the owner of the station learned that his new employee was a member of the Communist Party. Once again, George was dismissed.

Despite losing two jobs in a row, by 1955 Ryga had made what must have seemed like a small fortune to an Alberta farm boy. He duly bought his parents their first tractor. Until then, horses had pulled the family's plough. He was also able to finance a year-long visit to Europe.

Ryga claimed that the main purpose of the trip was "information gathering."[150] But the year he spent in Europe was more than that. The budding twenty-three-year-old writer fulfilled his ambition to visit the ancestral home of Robert Burns. The Scottish poet's colloquial language, poverty, closeness to the land and populist values had long appealed to Ryga. More significantly, in the context of the Cold War he attended three international peace conferences set up through Soviet-front organizations that recruited the participation of young people, intellectuals and well-known cultural figures.

During the summer of 1955 Ryga and his travelling companion, the Edmonton carpenter Mike Omelchuk, got a crash course in international politics at the World Assembly for Peace conference held in Helsinki. There the two men heard the prominent peace activists Bertrand Russell and Jean-Paul Sartre voice their opposition to the Korean War, to nuclear bombs and to the re-armament of West Germany. After Helsinki, Ryga and Omelchuk left for Warsaw to participate in the World Festival of Youth and Students for Peace and Friendship, which had an attendance of thirty thousand. Sponsored by the London-based World Federation of Democratic Youth, the festival's ostensible aim was to encourage all nationalities and ethnicities to participate in global politics with a view to promoting world understanding and international solidarity. Following the two-week conference in Warsaw, George and Mike accepted another invitation, and this time they travelled to Bulgaria.

It was in Bucharest, at the international youth camp that George met, and fell in love with, the dissident Iranian poet Lobat Vala. Tortured and imprisoned for her criticism of the repressive regime, Vala had recently fled from Teheran. When Ryga met her, the young

150. George Ryga quoted in James Hoffman, *The Ecstasy of Resistance*, 66.

poet was in poor health and would die within a year. Along with the American Communist poet Martha Millet, with whom George had experienced an intense relationship a few months earlier, Vala attracted him for more than purely romantic reasons. He saw both women, like his literary hero Robert Burns, as committed poets of the left who spoke for the people.

Back in London following his summer in Eastern Europe, Ryga took various jobs in order to extend his European sojourn. He found employment as a bus conductor, he took a job in a bank and—more professionally relevant—he worked for an agency of the British Broadcasting Corporation (BBC) where he reviewed such shows as *Coronation Street*, the long-running soap opera set in working-class Manchester. It was in the British capital that George built on his interest in Canadian folk music through his contact with the folklorist and singer Ewan MacColl and with the American folk-music specialist Alan Lomax who had discovered and popularized the song *Home on the Range*. It was in London, too, that George wrote drafts of his first three novels—*Hungry Hills*, *The Bridge* and *Ballad of a Stonepicker*. And it was also here that he made the decision to become a full-time writer.

RYGA HAD NO TROUBLE getting a job as a copywriter with the Baldwin Advertising Agency when he returned to Edmonton in the spring of 1956. But the stress, resulting from his employment, gave him migraine headaches. Moreover, the sheer volume of work left him little time to revise the novels that he had drafted in London. Ryga left the agency after just six months and took a number of less-demanding jobs, the best of which was working as a night clerk at the down-at-heel Selkirk Hotel. Relatively free of stress, he devoted more time to his fiction.

It was through writing that Ryga now expressed his political views. In 1956 he self-published forty-three poems in *Song of my hands: and other poems*. Although the slim volume did not receive the national attention Ryga would have liked, The *Athabasca Echo* praised the collection for highlighting the "unceasing battle of man and the elements; the farmer

and his toil, and the dignity of honest labor."[151] In the autumn of 1956 when the Soviet Union invaded Hungary, Ryga gave up his membership in the Communist Party. That he was nevertheless determined to demonstrate his empathy for the ordinary worker became apparent when, early in 1957, he published *A Canadian Short Story*—his first exercise in this genre—in *The Ukrainian Canadian*.[152] Though he made another visit to Great Britain in 1959, Ryga again returned to Edmonton, and it was there that his life took a significant new twist that brought him to British Columbia.

Norma Barton was a native of Nova Scotia whom George had first met in 1956 in London. Now recently divorced, she had moved to Edmonton with her two young children in order to live with her sister, Millie. Norma and George renewed their friendship and soon fell in love. Much to the disapproval of Ryga's parents and his sister, George and Norma became common-law partners before they married in 1959.

Norma, who loved literature, the theatre, music and politics—in equal measure, worked as a medical photographer at the University of Alberta. Her income gave the couple and their children just enough money to live on. Norma's confidence in George as a writer, along with her ability to keep him on track when he "ran around or lost direction," provided the stability that he had lacked during his years as a bachelor.[153] Now free to write full time, Ryga pulled the drafts of his three novels into shape. And in 1962 Longmans agreed to publish his first novel, *Hungry Hills* (1963).

MANY PLAYWRIGHTS, novelists and short story writers across the country had launched their careers on the airwaves. Private radio stations had been broadcasting Canadian plays on the radio since the early 1920s. With the founding of the CBC in 1936, there were a host of programmes

151. The article was published on 16 September 1956. See James Hoffman, *The Ecstasy of Resistance*, 95.

152. The article was published on 15 February 1957. See James Hoffman, *The Ecstasy of Resistance*, 97.

153. Ann Kujundzic, ed., "Introduction," *Summerland* (Vancouver, 1992), 23.

devoted to the work of local and international playwrights. Within ten years, unlike the situation in amateur and professional theatre companies across the country, 80 per cent of the plays broadcast on the CBC in the weekly drama series *Wednesday Night* and *Stage 44* were by Canadian authors. It was hardly an exaggeration to claim that from the mid-1930s until the late 1950s the country's National Repertory Theatre was to be found on CBC Radio.

George Ryga had listened to the plays of fellow Albertan Gwen Pharis Ringwood, whom he knew from Banff days, on the CBC. Her work gave dramatic voice to the prairie experience during the Depression. In 1960 Ryga sold his short story, *High Noon and Long Shadows*, to the CBC in Winnipeg, and a short time later began writing plays for the radio. It was on CBC's newly established television service, however, that he would enjoy his first nationwide success.

Ryga had seen Edward Albee's *The Zoo Story* on the CBC's experimental drama series, *Q for Quest*. The American playwright's confrontational two-person drama exploring loneliness, social disparity and dehumanization inspired Ryga to adapt one of his own short stories, *The Pinetree Ghetto*, into a half-hour television script. The CBC in Winnipeg had earlier rejected the short story because the producer felt that it was too political. However, when Vancouver's CBC television drama producer, Daryl Duke, received the television script of *The Pinetree Ghetto*, he felt differently.

This proved to be crucial. Duke was so well disposed to this work that he agreed to produce it, retitled as *Indian*. And he showed the script to Ken Lefolii, the editor of *Maclean's* magazine, then at the peak of its influence as Canada's leading weekly. One week before Ryga's thirty-minute television drama was broadcast on CBC's *Q for Quest* in November 1962, Lefolii published the entire script of *Indian* in his magazine. "Well, this was my big breakthrough," Ryga told *The Ukrainian Canadian* in an interview, "because when it was aired it had a fantastic reaction right across the country. *Maclean's* magazine picked it up and published it and suddenly I found new possibilities open to me."[154]

154. George Ryga, interviewed by Jerry Shack in "George Ryga—Poet, Playwright, Novelist" in *The Ukrainian Canadian* 514 (June 1969), 37.

As a boy, Ryga had encountered Cree and Métis peoples during harvest time. As a young man he had worked alongside First Nations people on the construction site. George had long felt that Native peoples "were pretty much on the same level" as members of the Ukrainian community. "We were struggling exactly the same way," he believed, "to get out of the ghetto."[155] As the unnamed Native person in *Indian* tells a Department of Indian Affairs agent at the end of the play: "I got nothing . . . nothing . . . no wallet, no money, no name. I got no past . . . no future, nothing."[156]

Looking back, theatre critics and scholars rightly acknowledge that *Indian* gave "a harsh vision of the prairie landscape characterized by close-up camera shots of rural debris—among which a nameless, homeless Native man was seen hammering in fence posts on a white man's farm."[157] Little wonder that the television play received a mixed reception at the time. A critic for the *Toronto Star* praised the CBC for producing "a perceptive study of the Canadian Indian in modern life."[158] But the Edmonton-based (and non-Native) Friends of the Indians Society felt that Ryga had distorted the image of Native peoples and thereby done them considerable harm. "Had I created an image of an Indian that people evidently would have wished to have seen," Ryga wrote in his defence, "I would have denied the plight of the Indian race in North America today."[159]

THE CREATOR OF RITA JOE, it might seem, had found his métier and his own distinctive voice. In doing so, Ryga was challenging a very long tradition. Indeed, on the stage, white actors had almost invariably depicted Native people. The first play to be written about the Northwest

155. Peter Hay, "George Ryga: Beginnings of a Biography," 40.

156. James Hoffman, ed., *George Ryga: The Other Plays* (Vancouver, 1962), 33.

157. James Hoffman, "George Ryga's *The Ecstasy of Rita Joe*: Hauntingly True and Healing," in Ginny Ratsoy, ed., *Theatre in British Columbia*, 3.

158. James Hoffman, *George Ryga: The Other Plays*, 23.

159. *Edmonton Journal*, 24 January 1963 cited in James Hoffman, *George Ryga: The Other Plays*, 23.

Coast, *Nootka Sound; Or, Britain Prepar'd,* had no Native actors. Written following Captain Cook's visit to Nootka Sound in 1778, the play was performed at the Theatre Royal in London. The "Aboriginal" actors were not really performers; they served as part of the setting, standing in the side-wings just as they had been portrayed in the eighteenth-century drawings and watercolours of the Cook expedition's official artist, John Webber.[160]

Even when Ryga's play, *Indian,* was televised in 1962, Canadian audiences were not accustomed to seeing Native peoples on the stage, except in highly sanitized roles.[161] Indeed, most white people in British Columbia viewed Indigenous peoples as inferior and their artistic achievements as belonging to the past. This trivialized the rituals and traditions associated with the carving of totem poles and masks and with dancing and singing. It was a different matter, however, to show a living tradition—a harder job, only tackled with difficulty. Prior to the Second World War, Anthony Walsh, who taught at the Inkameep Indian Day School near Oliver in the Okanagan Valley, helped his students resurrect their traditional songs and dances and took a small group of them on tour around the province. Following the Second World War, Frank Morrison and Cecil West set the Thunderbird and Killer Whale legends of Vancouver Island's Cowichan/Quw'utsun' peoples into an opera, *Tzinquaw.* In spite of an all-Native cast starring the singer and dancer Abel Joe, the music was an uneasy blend of traditional Native songs and nineteenth-century English liturgical music. Moreover, there was little evidence of the songs and dances, the storytelling and oratory, the elaborate costumes and stage settings that were an integral part of the Quw'utsun' people's traditional winter

160. James Hoffman, "Political Theatre in a Small City: The Staging of the Laurier Memorial in Kamloops," in Ginny Ratsoy, ed., *Theatre in British Columbia,* 197.

161. One exception was the *Laurier Memorial (1910),* a dramatized 3,000-word petition about the "increasingly troubled relations between the First Nations peoples and the immigrant/settlers" presented by Shuswap, Okanagan and Thompson First Nation chiefs to the visiting Canadian prime minister, Sir Wilfrid Laurier, through Father Jean-Marie Raphael Le Jeune. James Hoffman, "Political Theatre in a Small City: The Staging of the Laurier Memorial in Kamloops," in Ginny Ratsoy, ed., *Theatre in British Columbia,* 187.

ceremonies. *Tzinquaw* was entertainment not ritual. Above all, the opera was produced for a largely non-Native audience.

At the end of the First World War, the modernist playwright Carroll Aikins founded the country's first Little Theatre. Known as the Home Theatre, it was established above a fruit-packing plant in the small Okanagan community of Naramata. The small group of amateur actors, set designers and playwrights offered a challenge to the British and American theatre companies that monopolized the professional stage. Aikins himself wrote several plays, one of which was loosely based on legends from Native peoples living in the Okanagan region.[162] His melodramatic and far from historically accurate play, *The God of Gods* (1918), had been premiered at the Birmingham Repertory Theatre in England during the First World War. Almost forty years later Aikins helped the Penticton Ladies Choir produce an equally stylized and historically flawed folk opera, *Ashnola: A Legend of Ashnola's Singing Water* (1954), for the local white community.

Little wonder that a new generation of articulate Indigenous figures protested at such caricatures. As Chief Dan George proclaimed in his 1967 centennial address, *Lament for Confederation*, given before a crowd of 35,000 people at Vancouver's Empire Stadium a few months before the opening of *The Ecstasy of Rita Joe*: "Oh Canada, how can I celebrate with you this Centenary, this hundredth year?" By asserting "I was ridiculed in your plays and motion pictures," he was simply voicing the experience of his own people.[163] Ethel Wilson had been among the few non-Native writers to deplore this implicit gulf in perceptions. "If you are an Indian, do you begin thinking from a totally different premise?" she asked in her 1956 novel, *Love and Salt Water*. "Do you then see the world and people differently and differently conditioned?"[164]

Here was Ryga's challenge and his opportunity. Once the CBC accepted *Indian* for production in 1962, he felt empowered to take up

162. "A Theatre on a Farm" [typescript] 1923, William Deacon Papers, Thomas Fisher Rare Book Library, University of Toronto.

163. Chief Dan George (Tswahno), "Lament for Confederation" in Jeannette C. Armstrong and Lally Grauer, eds., *Native Poetry in Canada* (Peterborough, 2001), 2–3.

164. Ethel Wilson, *Love and Salt Water* (Toronto, 1956),138.

this cause, and to do so in British Columbia. His fee for *Indian* enabled him to buy a house and a few acres of land in the Okanagan Valley. The move from Edmonton to Summerland was ideal for a family on a low income. The Okanagan was warmer than northern Alberta. One could live cheaply—this was important with another baby on the way—and George and Norma could live off their small acreage.

Within a few months of settling in Summerland, "there was a steady stream of people dropping by for a coffee, staying for a few days, months or in some cases years—potters, writers, musicians, artists, local raconteurs," as one Okanagan friend has recalled. "All of this involved gallons of coffee, many cigarettes and conversation that ranged all over the map—literature, social policy, politics, horticulture, Canadian history—you name it."[165]

Despite the coming and going of so many people, Ryga continued to write. His son Campbell has fond memories of hearing the tap of his father's typewriter late into the night. "I don't believe that sound represented a source of security for any of us in the traditional sense," he recalled, aware of the precarious nature of his father's finances. "The sound," he continued, "was a by-product of the medium in which he transcended his emotions and anxieties."[166] Predictably, one CBC producer suggested that the struggling author could do better by moving to Toronto. Ryga responded by insisting that if the CBC was not satisfied with his location, they should find better ways of working with writers outside of Toronto and Montreal.[167] The fact that his stories and plays continued to be published and aired on the CBC was a self-conscious demonstration that a writer could survive living on the fringes of the country.

It was Ryga's identity as a British Columbia writer that led to his most significant commission when Malcolm Black, the artistic director of the Playhouse Theatre in Vancouver, asked him to produce a play for the centennial year. Black had seen a newspaper clipping reporting the death of a young Native woman on the Downtown Eastside of Vancouver. He approached the local playwright Beverley Simons with the idea of writing

165. Linda Charles, in correspondence with the author, 25 June 2010.
166. Ann Kujundzic, ed., *Summerland,* 12, 14.
167. James Hoffman, *The Ecstasy of Resistance*, 163.

something on that theme. She was not interested. But Simons did suggest that Black contact the man who had written the play *Indian* that had so impressed her on television.

THE ECSTASY OF RITA JOE had an impact that made it a transforming cultural event. It was to be performed around the world, thereby challenging the notion that, as one American critic put it, "Canadian" and "playwright" were as incongruous as "Panamanian hockey-player" or "Lebanese fur-trapper."[168]

Within a year of its opening night, *The Ecstasy of Rita Joe* had been translated into French by the renowned Quebec playwright Gratien Gélinas and, a year after that, it was staged in Montreal. The play was made into a film and transformed into a ballet by Norbert Vesak for the Royal Winnipeg Ballet. It also became part of the Canadian high school and university curriculum. In 1981 Winnipeg's Prairie Theatre Exchange put on a production with an all-Native cast and took it on a tour that ended at the Vancouver East Cultural Centre exactly fourteen years after its first production in 1967. *The Ecstasy of Rita Joe* has become part of the repertoire for theatre companies across the country.

None of this success guaranteed that any subsequent play by Ryga would be a hit—or even be performed. A second commission from the Playhouse Theatre in 1969 resulted in *Grass and Wild Strawberries*. Ryga's second play combined film projection, rock music, dance and song to celebrate the counterculture youth of the 1960s. However, few of the older members of the audience were prompted to join the company's actors on stage and dance to throbbing rock music during the play's finale. Though clearly a favourite with the Playhouse's younger audience, *Grass and Wild Strawberries* was not a critical success. Moreover, the experimental nature of the play made the board of directors require that in the future two of its members vet every script.

This proved to be a disastrous move for a politically committed playwright like Ryga. His third commission from the Playhouse was inspired

168. *The New York Times*, 13 May 1973; Christopher Innes, *The Canadian Dramatist*, 52.

by the Front de Libération du Québec's (FLQ) kidnapping of the British diplomat James Cross and its abduction and murder of Québec's Labour Minister, Pierre Laporte, which resulted in the implementation of the War Measures Act in 1970. A play that pitted an FLQ commander against his captive, a diplomat, was felt to be too political—after all, the Quebec Crisis was less than a year old—and the production of Ryga's *Captives of the Faceless Drummer* was vetoed by the Playhouse board. The Vancouver Art Gallery's board members were less inhibited. The gallery premiered *Captives of the Faceless Drummer* in April 1971, and theatres in Toronto and Lennoxville, Quebec, followed suit.

Though it can be claimed that the Vancouver Art Gallery's production "provoked debate that spilled beyond the lobby and into the street," Ryga felt snubbed by Vancouver's theatre establishment.[169] Being censored was difficult for a man who was committed to addressing, as he put it, "the larger issues of life confronting us."[170] After 1971 Ryga found himself cut off from the mainstream of theatrical production. His plays were subsequently commissioned and produced only by the small professional theatres that had emerged during the 1960s and 1970s, often with the help of federal, provincial and municipal funding (largely from the Canada Council). Ryga's play *Sunrise on Sarah* was, for example, commissioned and staged at the School of Fine Arts at the Banff Centre in 1972 and *A Portrait of Angelica* in the same venue a year later. *Ploughman of the Glacier* was commissioned by the Okanagan Mainline Regional Arts Council and performed in 1976 by the Western Canada Theatre Company of Kamloops. The University of Alberta's Studio Theatre presented Ryga's *Seven Hours to Sundown* the same year. In 1978 Victoria's Kaleidoscope Theatre commissioned *Jeremiah's Place* for production in the province's schools.[171] And in 1980 Ryga's most autobiographical play, *A Letter to My Son*, was commissioned and produced by Thunder Bay's Kam Theatre Lab in northern Ontario.

169. James Hoffman, *The Ecstasy of Resistance*, 212.

170. George Ryga, "Theatre in Canada: A Viewpoint on Its Development and Future," *Canadian Theatre Review* 1 (Winter 1974), 30.

171. Though the play was scheduled to tour the province's schools for a year, it was withdrawn from production after only a few performances.

Being blacklisted by major theatre companies and institutions across the country spurred Ryga to become a cultural activist. When he learned of the sale of the long-standing Ryerson Press to an American company in 1970, Ryga asked the Secretary of State, Gerard Pelletier, to propose legislation "to forbid outright sale or controlling-interest purchase of Canadian book publishing houses by foreign interests," in order "to assist the publishing of low-cost books and periodicals for the widest general distribution" all with a view to safeguarding the country's "culture and identity."[172] Writing in the first issue of the *Canadian Theatre Review* four years later, Ryga wondered why Canada's major dance companies, like the National Ballet and the Royal Winnipeg Ballet, had not incorporated the country's folk dances into their repertoire. He asked why Canada's major theatres allowed themselves to be dominated by boards of directors who dictated policy, who were empowered to hire and fire artistic directors and who thus determined what would be produced. And he refused "to endorse the cheap, divisionary and divisive tactics of the Canada Council and the regional theatres [in order] to delight their book-keepers in announcing vast numbers of productions of Canadian works—when in reality, nothing more than public rehearsals occur."[173]

Ryga predicted—wrongly—that the "quaint, elitist and reactionary" attitude of the Stratford and Shaw Festivals would, just like the Dominion Drama Festival before it, lead to their demise.[174] Even the Banff School of Fine Arts, which had given Ryga his start in 1949, was not spared his scorn. He accused the school of commissioning one of his plays simply to give "credence and dignity" to an institution that had previously given "racial and social policies" no attention.[175]

In 1974 Ryga attempted to persuade W.A.C. Bennett's son Bill, who would become the premier of British Columbia the following year, to re-evaluate the province's cultural industries in order to give cultural producers more control over their work. Nothing happened. A year later

172. George Ryga to Gerard Pelletier, 12 November 1970, cited in Ann Kujundzic, ed., *Summerland*, 183–84.

173. George Ryga, "Theatre in Canada: A Viewpoint On Its Development and Future," 28–32.

174. George Ryga, "Theatre in Canada," 28–32.

175. George Ryga, "Theatre in Canada," 30.

he spoke to the Learned Societies Conference in Edmonton about the use of language and the contemporary theatre in Canada. Talking in 1977 to a sympathetic group at the Arts Club Theatre in Vancouver, Ryga called for the re-examination of Canadian culture. A few years later he voiced his concerns outside of the country when he joined a delegation of Canadian playwrights with a view to promoting Canadian theatre in Australia and New Zealand. And in 1983 he examined the role of the playwright in contemporary society at a UNESCO conference in Bordeaux, France.

Though a steady income was no longer coming to him from major theatre companies, other opportunities opened up. In 1977 Ryga wrote a film script for the American television series *The Bionic Woman*, produced by Universal City Studios in Hollywood. He earned a professorial salary that same year as writer-in-residence at Simon Fraser University, and likewise, three years later, at the University of Ottawa. He also received an income from productions of his work abroad—especially in Germany—as well as royalties from the publication of his plays by Talonbooks, which had been founded in 1967. And although Ryga continued to criticize the Canada Council, there was a steady flow of grants from Ottawa.

It was not until 1986, almost twenty years after the production of *The Ecstasy of Rita Joe*, however, that the Vancouver Playhouse agreed, at the last minute, to premier Ryga's new play, *Paracelsus*. Sadly, however, the play's performance during Expo 86 was a flop. Excuses were proffered by friends. It was said that there was "insufficient time for the necessary rewriting." Or there was "insufficient time for cast selections." Above all, "insufficient time for the 'workshopping' required—it had never yet been staged, and it was a play of complexities, textually and visually."[176]

Ryga's last screenplay, *A Storm in Yalta*, dealt with the final years of the Russian writer Anton Chekhov's life. Ryga had completed the draft of the film script in late spring of 1987, but his own health, like that of Chekhov's in the film script, was deteriorating. At the same time, George's wife, Norma, who had been suffering from a rare eye disease since 1971, lost her sight. Consequently, *A Storm in Yalta* was never produced. And

176. Ann Kujundzic, ed., *Summerland*, 30.

George, who was diagnosed with abdominal cancer, would himself die within months.

IT WAS FITTING that the friends, critics and relatives who came together to pay tribute to the art and life of George Ryga in December 1987 did so at the site of his first triumph: the Vancouver Playhouse Theatre. His work will always be remembered in the context of the writing and the reception of *The Ecstasy of Rita Joe*. Nor has it ceased to be highly controversial with the passage of time; it retains its power to engage different interpretations.

As literary critic Richard J. Lane observed in 2006, *The Ecstasy of Rita Joe* had shifted "from being a play that opens up debates about BC's First Nations to being a play about the appropriation of First Nations' perspective, subjectivity and voice," all of which makes it "a work of ventriloquism."[177] True, from the perspective of the 1990s, the Native writer Agnes Grant could well argue that the tone and cadence of Chief Dan George's lines as Joe David—some of which were spoken in his Native Coast Salish tongue—were linguistically inauthentic. Even so, she was willing to concede that "the message of the play was so important that Dan George chose to give theatre-goers what they were looking for."[178] The obvious fact is that Ryga addressed the Native people's condition within a non-Native cultural paradigm. In his own terms, he was identifying "us" and "them," as he always had, with a broader sense of empathy that transcended race, ethnicity and class. Yet as the late expatriate theatre producer John Juliani reflected during a visit to Canada in 1994, cultural appropriation and self-censorship had "terrorized" the country's most prominent cultural institutions. As he rightly observed: "George Ryga probably couldn't have written *The Esctasy of Rita Joe* today.

177. Richard J. Lane, "Performing History: The Reconstruction of Gender and Race in British Columbia Drama," in Ginny Ratsoy, ed., *Theatre in British Columbia*, 143.

178. Agnes Grant, "Native Drama: A Celebration of Native Culture, in *Contemporary Issues in Canadian Drama* (Winnipeg, 1995), 103–15.

Why? Because he was of Ukrainian stock—and how dare he voice the concerns of the native community?"[179]

Ryga's own daring has not lacked posthumous recognition from those for whom he sought to speak. For the Native writer Lee Maracle, the experience of watching *The Ecstasy of Rita Joe* had been "tremendously healing for all of us."[180] Chief Dan George's son, also named George, had "found it very profound that George Ryga, who, you might say, would be on the opposite end of where an Indian is, would come along and write something so powerful . . . and my father was in there, living it out with the other actors."[181]

A few days after the opening night performance of *The Ecstasy of Rita Joe*, a critic for the *Canadian Forum*, Irene Howard, hoped that Ryga's work would prompt other playwrights to produce work in which "Indians will be allowed as complex beings."[182] It certainly did. The themes that were so much a part of Ryga's plays—the alienation of the individual from society, from the land and from one's roots; intergenerational conflict; and the dignity of ordinary people—would be addressed by the end of the twentieth century by a number of First Nations playwrights, from Tomson Highway to Marie Clements. Moreover, other previously marginalized dramatists, whether gay or feminist, whether of Chinese, Italian or Sikh ethnicity—also began to speak for and about their communities. This has resulted in the kind of drama that Ryga envisioned. A theatre that would be inclusive and representative of all people in society. A theatre that would explore the social, political and economic realities. And a theatre that would challenge the dominant myths of English-Canadian society.

Ryga appreciated, more than most Canadians, the extent to which the country was caught between its historic role as a colonized society with its ties to Great Britain (and the neo-colonizing US) and its own role as a colonizer of First Nations people. He knew, too, that the country's

179. John Juliani, "Coming Home," *Canadian Theatre Review* (Summer/Fall 1994), 69.

180. *Vancouver Sun,* 6 June 1992.

181. Leonard George quoted in Ann Kujundzic, ed., *Summerland,* 13.

182. Irene Howard, "Vancouver Theatre Diary," *The Canadian Forum* (February 1968), 254.

mythology was based on the major historical players—mostly male—in Canada's history. "Some came to this continent as empire-builders, traders, officers, priests," he wrote, conscious that not all immigrants were of this "superior class" but were themselves among the exploited: "What of the people who came in the holds of ships like cattle to build a country?"[183]

Ethnicity and class always remained two sides of the same coin for Ryga. He never forgot that everything had come to him "on the basis of other people who run machines, grow grain, dig coal; everything that comes out of human labour to which I'm not directly contributing." His vision was inclusive and informed his own mission: "I think that I have an obligation to make sure that those people who made my life possible are remembered, and are treated with respect and dignity."[184]

Ryga's career helped demonstrate that Canada had credible playwrights and competent actors to perform their work. He showed that British Columbia's theatregoers did not have to rely on foreign imports for their entertainment, or use the theatre for mere escape. Later dramatists like John Gray, Sherman Snukal, Margaret Hollingsworth, John Lazarus, and so many others, did not have to make a name for themselves outside of the country before being accepted at home. There is no place here for triumphalism or complacency. But the fact that British Columbia has an indigenous theatre, if no longer a Playhouse Theatre, is part of the fragile heritage of that first performance of *The Ecstasy of Rita Joe* in 1967.

183. George Ryga, interviewed by Jill Martinex, July 1980, cited in Ann Kujundzic, ed., *Summerland*, 34.

184. George Ryga, interviewed by Jill Martinex, July 1980, cited in Ann Kujundzic, ed., *Summerland*, 34.

"Music is My Life"
JEAN COULTHARD (1908–2000)

OULD A MUSICIAN in British Columbia not only be a brilliant performer but also a renowned composer, as well as an inspirational teacher and a cultural activist too? Could such a person obtain due recognition not only in the province but across Canada and internationally? Could a woman achieve all of this and do so without emigrating permanently to Toronto or to New York or even to London? These are challenging questions, and the career of Jean Coulthard does not supply easy answers to them.

Coulthard wrote her expansively lyrical compositions in all musical genres throughout eight decades. She taught students who would go on to be among the country's leading generation of composers and teachers. She was a founding member of the Canadian League of Composers (1951), an organization that promoted the professionalization of Canadian composers. She also participated in music festivals and taught in summer schools throughout Western Canada.

In all of this Jean Coulthard remained true to her own star. In an era when the modernist school of atonal music developed by the Austrian composer Arnold Schoenberg had its vogue among the avant-garde, she declined to jump on the bandwagon. As a result, throughout most of Coulthard's career her unabashedly melodic compositions for piano,

voice, string quartet, ensemble and orchestra were largely ignored by the musical establishment. It was only in the 1970s when musicologists responded to the fusion of modernism with older musical traditions that some of Coulthard's French-inspired "conservative" compositions were seized upon as examples of a newly fashionable Postmodern or Neo-romantic musical genre.

The slow recognition of Jean Coulthard's work had as much to do with her being female as with the supposedly conservative music she composed. Yet Coulthard never let her role as wife and mother interfere with the strict regime she imposed on herself as a composer, teacher and student. In this sense, she was a true professional. Her constant mission was to introduce the work of Canadian composers to a public that could not see beyond the three "Bs"—Beethoven, Bach and Brahms—and the big "M"—Mozart. She was well aware that the musical education of most British Columbians lacked sophistication—and did so for understandable historical reasons.

DURING THE NINETEENTH CENTURY and the first half of the twentieth, the province's music makers had been predominantly amateurs. It was not unusual for overland explorers to hear the sound of a fiddle, a voice or a tin whistle around a campfire. Or for sailors on board their Royal Navy vessels that were anchored in Esquimalt, near Victoria Harbour, to enjoy a musical evening. But it took the first generation of British female settlers, some of whom brought their pianos with them around Cape Horn as early as 1853, to set the standard for more formal music-making. By the end of the nineteenth century, European settlers waltzed, or danced the one-step and the polka, in makeshift community halls to the beat of a fiddle or a concertina. In Victoria's Canton and Shanghai Alleys, Chinese immigrants attended performances of Cantonese operas in the five-hundred-seat Sing Kew Theatre. And when First Nations children were forced into residential schools following the Indian Act in 1876, they exchanged the songs that had been sung for generations by their elders for Western tunes that they now learned to play on the violin, piano or trumpet.

Religious organizations did not only make Western music a part of the acculturation or "civilizing" process of the Native students in their residential schools. The construction of churches also brought professional British and Central Canadian musicians to the province to conduct choirs and play the organ or the piano. A church, moreover, unlike a saloon, offered a respectable, female-friendly environment. The rapid growth of British Columbia's population from the late nineteenth century into the early twentieth saw the formation of church bell-ringer clubs alongside secular brass bands, jazz ensembles and philharmonic and choral societies. Sanctioned by its familiar religious overtones, the annual performance of Handel's *Messiah* (1741) in small towns across the province was often the only musical event of the year.

Much of what happened in British Columbia followed the musical tradition in Britain where the town halls that Francis Rattenbury and his uncles had helped to build were famous for such performances. In the same way, when the Ontario-based First Cycle of Music Festivals reached Vancouver in 1903, people were introduced to the choral music of largely British and German composers. Indeed, by 1913 there seemed to be so much musical activity in British Columbia that the Vancouver musician and composer J.D.A. Tripp proudly noted in *The Year Book of Canadian Art* that it was "a source of wonder" that music-making in the province had reached "such an advanced stage."[185]

Music was not only heard around the campfire, in the church and parlour and at the residential school, Chinese Opera House and community hall. During the early decades of the twentieth century, sponsorship from David Spencer's department stores, Home Gas, Simpson's and BC Electric saw the formation of amateur symphony orchestras, choirs, bands and operatic societies. Participation in such groups (and sometimes in a company's morning singsong) was thought to enhance morale, increase work productivity and create a social and cultural environment that was conducive to the overall health of the company and its employees.

The Canadian Pacific Railway (CPR) was no less involved in these activities. The company installed radio transmitters in its dining cars so

185. J.D.A. Tripp, "Music in British Columbia" in *The Arts and Letters Club of Toronto, The Year Book of Canadian Art* (London, 1913), 139.

that anyone who boarded one of its trains could hear performances by Toronto, Saskatoon and Montreal's symphony orchestras. And with a view to fostering national unity and assimilating non-English-speaking Canadians into the dominant Anglo-Canadian community, the CPR sponsored a series of nationwide festivals that celebrated the songs, dances and games of the country's Native peoples and non-British immigrants. In 1933 the city of Vancouver launched its own folk festival during which various groups performed, according to one commentator, as "Canadian citizens of a country which is brilliant, and distinctly North American."[186]

Many "New Canadians," as recent immigrants were called, had been performing their traditional songs, operas and dances since arriving in British Columbia. The Mennonite community in Fraser Valley's Yarrow was famous for its 1,300-voice-strong congregational choir. The choir sang not only in four-part harmony. They performed the more difficult descant and six-voice polyphonies. And this was not all that made this Fraser Valley town north of Vancouver a cultural oasis. Yarrow had an accomplished violin-maker in its community too. Russian-born, like many of the first Mennonite settlers who had founded Yarrow in 1928, Heinrich Friesen had studied at the Moscow Institute of Music before training as an instrument-maker in Mittenwald, Germany. Friesen may not have been as well known as Victoria's violin-maker, Justin Gilbert. But a "blind" comparison of his violin with a seventeenth-century Stradivarius and a Guarneri at a concert in Victoria saw the audience deem Friesen's sonorous violin to be the best instrument.

In 1922 British Columbia's largely amateur musicians had an opportunity to reach out to a wider audience when the first licensed broadcasting stations were established. In an effort to fill airspace, radio stations from Vancouver, Chilliwack and Kamloops to Victoria gave air-time to local church and school choirs, to talent-show contestants, to amateur classical musicians as well as to dance bands like Mart Kenney and his Western Gentlemen and Dal Richards' popular orchestra. With the founding of the Canadian Radio Broadcasting Commission in 1932—it was to become the Canadian Broadcasting Corporation (CBC)

186. Margaret R. Gould, "Toronto Folk Festival," *Canadian Forum* (July 1947), 86.

four years later—Vancouverites also got to hear the Vancouver Symphony Orchestra (VSO) on the air. And from 1934 they could also attend live performances of the VSO in Stanley Park's Malkin Bowl.

SUCH WAS THE DIVERSE MUSICAL LIFE of the city in which Jean Coulthard spent her formative years. In later life she insisted that she never consciously chose to become a composer—"I think I *always* was one."[187] Wolfgang Amadeus Mozart had begun composing at the age of five, under the tutelage of his father. Jean Coulthard began composing on the piano at the age of seven, under the eye of her mother, who helped her daughter transcribe—or score—the simple tunes she composed onto paper. In 1919 one of the eleven-year-old's first compositions appeared in the educational magazine *The Educator of Canada*. Young Jean's sense of herself as a composer was, therefore, developed at an early age.

Jean's mother, born Jean Blake Robinson in New Brunswick, was herself an accomplished musician, having studied voice and piano at the New England Conservatory of Music in Boston. Marriage in 1904 to a physician from Ontario, Dr. Walter Coulthard, duly enhanced her career. The couple moved to Vancouver, and by the time their daughter Jean was born in the stylish and central West End district of the city in February 1908, Mrs. Walter Coulthard, as she was invariably known, was a much sought-after teacher of voice and piano. Her number of pupils grew exponentially when the family moved, in 1913, to a palatial residence in the newly established Shaughnessy Heights. So did her circle of middle- and upper-class acquaintances who appreciated music, considered playing an instrument to be a social asset and were willing to pay her to teach their sons and daughters.

Referred to as "the gracious lady of Vancouver music" in the local press, Mrs. Walter Coulthard was also in demand as a singer and pianist.[188] She introduced her audiences to compositions by French

187. Quoted in William Bruneau and David Gordon Duke, *Jean Coulthard, A Life In Music* (Vancouver, 2005), 24.

188. Quoted in William Bruneau and David Gordon Duke, *Jean Coulthard*, 29.

Impressionist composers like Claude Debussy, whose music reflected the painterly imagination of artists like Claude Monet. She also helped establish the British Columbia Music Teachers' Federation and the Vancouver Women's Musical Club (1905). She was a founding board member of the Vancouver Symphony Orchestra. And, in her role as the city's unofficial impresario, she helped bring internationally known performers like Anna Pavlova, Kathleen Parlow and Walter Damrosch to the West Coast.

Investing time, energy and money in musical activities not only enhanced Mrs. Coulthard's own social standing: it raised the social capital of other women. The Rogers' Sugar Refinery heiress, Mrs. B.T. Rogers, was a notable supporter of the vso.[189] Likewise, European émigrés, among whom were Walter and Thea Koerner, Imant Raminsh, Hans Gruber, Otto Lowy, Ernst and Elisabeth Friedlander, brought an Old World bourgeois sense of the importance of the classical musical tradition to British Columbia.

This was the milieu in which Jean Coulthard developed as a musician; in a sense she never left it. Her mother gave her, and later Jean's younger sister, Margaret ("Babs"), their first piano and voice lessons. She introduced the girls to the harmonic inventions and irregular scales of the French composers Maurice Ravel, Erik Satie and Claude Debussy. She took her daughters to the eastern seaboard of the United States where, over the winter of 1918–19, she herself studied voice in New York. Back home in Vancouver, Mrs. Coulthard saw to it that Jean and Babs performed at musical soirées, entered local and provincial music festivals and acquired appropriate qualifications with other musicians in the city. In an effort to raise the standards of music throughout Canada, the Toronto Conservatory of Music had established a nationwide system to award certificates in practical and theoretical music. Inspired by Mrs. Coulthard, Jean and Babs now worked their way through the conservatory's examinations.

189. The first symphony orchestra in Vancouver was founded in 1897 by Adolf Gregory—it disbanded after three concerts. The second Vancouver Symphony existed from 1919 to 1921. A third orchestra was founded in 1930 and exists to this day.

Through her various musical activities, Mrs. Walter Coulthard showed her daughters that partaking in musical activity was not just a means of improving one's social standing or of catering to nostalgic sentiment. It was more, too, than offering well-informed audiences an alternative to the stream of foreign operatic and music-hall touring companies that had been drawn to Victoria, New Westminster and gold rush towns in the Cariboo since the 1860s. Being a professional female musician, Mrs. Coulthard demonstrated to Jean and Babs, could be combined with marriage and motherhood.

However well-qualified she was as a music teacher, Mrs. Coulthard knew her own limitations. And when it became clear that she had a gifted daughter on her hands, she asked Dr. Frederick Chubb, the British-trained organist and choirmaster at Vancouver's Christ Church Cathedral, to instruct young Jean in musical theory. It was with Chubb's assistance that eighteen-year-old Jean obtained the Toronto Conservatory of Music's diploma for piano in 1926.

But Jean required further training if she was to fulfill her virtually innate ambition to become a composer. She could, of course, have studied at the Toronto Conservatory of Music or entered McGill University's music department in Montreal. However, she felt that "there was not enough possibility to assimilate new musical ideas in Canada during these early years."[190] This is, in fact, why Jean applied to the Vancouver Women's Musical Club, which had established a travelling scholarship for young musicians, and why when she won it, that Frederick Chubb advised her to study composition and piano at London's Royal College of Music.

This was good advice. Jean had an uncle in London with whom she could live. There was no language barrier that would have been the case if she had studied on the Continent. Moreover, since the college's founding in 1883 it had been devoted to encouraging and promoting music not only in Britain but throughout the Dominions.

When Jean joined the college in 1928, there were leading performers, music theorists and conductors on its staff making the Royal College of

190. Jean Coulthard, "Canadian Music in the 1930s and 1940s," Queen's University, Kingston, Ontario, November 1986, 36.

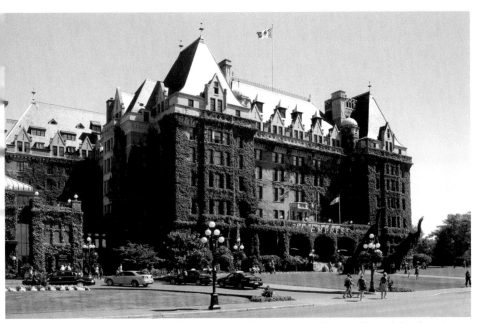

In 1903, when a site for a landmark hotel was chosen in Victoria, many residents still hoped that their city would become the terminus of the Canadian Pacific Railway. Five years later the chateauesque-style Empress Hotel designed by Francis Rattenbury emerged from the mudflats to become the emblem of a new industry that was to sustain the city throughout most of the century: tourism. TONY HISGETT/FLICKR PHOTO

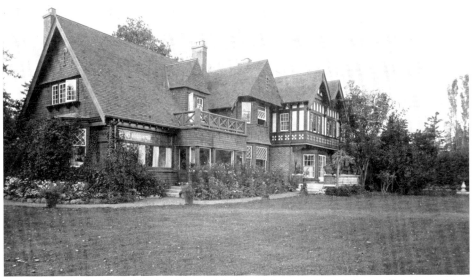

Rattenbury built Iechinihl, a half-timbered Arts and Crafts–style house on Beach Drive, as a fittingly prestigious home for himself, as Victoria's foremost architect. It survives today, externally little altered, as the main building of the Glenlyon Norfolk School. IMAGE D-03003 COURTESY OF THE ROYAL BC MUSEUM AND ARCHIVES

Crowds thronged the civic reception for the Governor General and his wife, the Duke and Duchess of Connaught, in Vancouver at the courthouse in 1912. Designed by Francis Rattenbury, it would subsequently become the home of the Vancouver Art Gallery in 1983. IMAGE G-00255 COURTESY OF THE ROYAL BC MUSEUM AND ARCHIVES

The distinctive red hair of Francis Rattenbury is unfortunately not captured in this monochrome photograph, taken shortly after his arrival in British Columbia in 1892—and shortly before he beat well-established local and international architects to win the commission to design the Parliament Buildings. IMAGE B-09502 COURTESY OF THE ROYAL BC MUSEUM AND ARCHIVES

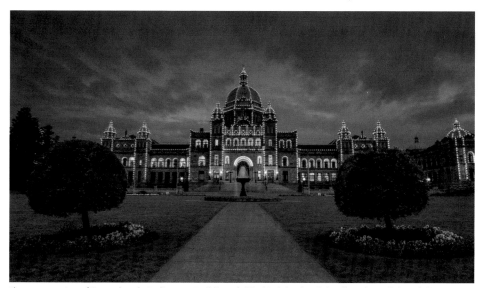

The construction of Rattenbury's Parliament Buildings fell behind the fixed deadline date of the Jubilee Celebrations in 1897. But, with brilliant improvisation, the contours of the unfinished buildings were traced with hundreds of lights to give the impression of completion. So successful was this device that the lights survive to this day. JIRIVONDROUS/THINKSTOCK PHOTO

Martin Grainger called this photograph The Conqueror and used it as the frontispiece for *Woodsmen of the West*. It is possibly Grainger himself standing on top of the twelve-foot-high stump at Knight Inlet, where he worked as a hand-logger in the early years of the twentieth century. REPRINTED FROM MARTIN GRAINGER, *WOODSMEN OF THE WEST*, EDWARD ARNOLD PUBLISHERS (LONDON, 1908)

A steely image of Martin Allerdale Grainger—a photograph taken just after his marriage on Mayne Island to Mabel Higgs in 1908 and nine years before his appointment, following H.R. MacMillan, as the Chief Forester of British Columbia. IMAGE C-05657 COURTESY OF THE ROYAL BC MUSEUM AND ARCHIVES

"An affair of heedless devastation" was how, in 1964, the environmentalist Roderick Haig-Brown described the first fifty years of logging in British Columbia. Here is Martin Grainger crossing Lakelse River on a logjam, taken in 1914 near the present-day town of Terrace. IMAGE H-05554 COURTESY OF THE ROYAL BC MUSEUM AND ARCHIVES

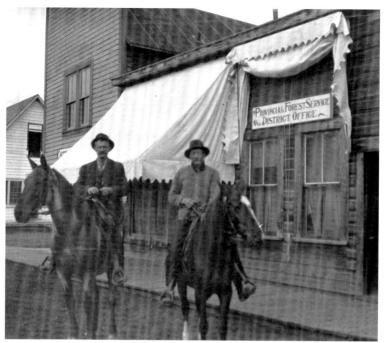

Martin Grainger had just been appointed head of the Forest Branch Records Office and is shown here, accompanied by a forester called Latham, on his first survey of British Columbia's forests around Hazelton. IMAGE H-05547 COURTESY OF THE ROYAL BC MUSEUM AND ARCHIVES

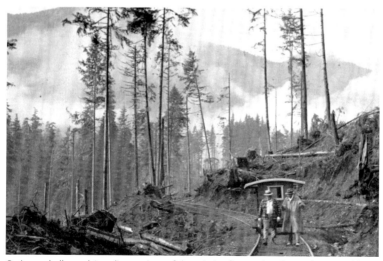

Grainger challenged Arcadian notions of the pristine forest when he made scenes like this "the stuff of literature" in *Woodsmen of the West*. The exact location and date of this photo is not known but the authenticity of the scene speaks for itself. IMAGE C-07510 COURTESY OF THE ROYAL BC MUSEUM AND ARCHIVES

In 1893 Emily Carr's studies at San Francisco's California School of Design ended abruptly when, aged twenty-one, she was summoned back to Victoria due to the mismanagement of the Carr family estate. This studio photograph of her taken on her return to Victoria may reflect her mixed feelings. IMAGE H-02813 COURTESY OF THE ROYAL BC MUSEUM AND ARCHIVES

In 1936 the Vancouver photographer Harold Mortimer Lamb photographed Emily Carr in her Beckley Street home. Behind her is her dynamic oil-on-paper painting, *Sunshine and Tumult* (1938) now in the Art Gallery of Hamilton. IMAGE D-06009 COURTESY OF THE ROYAL BC MUSEUM AND ARCHIVES

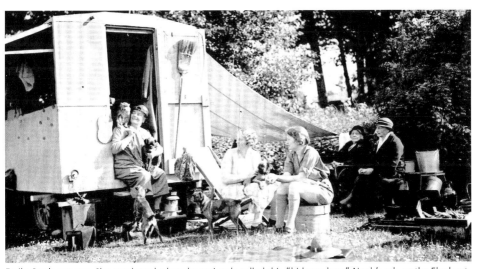

Emily Carr's caravan. She purchased what she variously called this "hideous box," Noah's ark, or the Elephant, for $166 in 1933 to enable her to camp in the forested areas around Victoria. Here she is with monkey Woo on her shoulder and with a group of visitors, including Dorothy Morley and Joyce Maynard. IMAGE B-09610 COURTESY OF THE ROYAL BC MUSEUM AND ARCHIVES

A vibrant reproduction of Emily Carr's *Reforestation* (1936). With its rising spirals, s-curves, chevrons and interlocking rings, her painting offers a new vision of the coastal forest of British Columbia. COURTESY THE MCMICHAEL CANADIAN COLLECTION, KLEINBURG, ONTARIO

Scorned as Timber, Beloved of the Sky, painted by Emily Carr in 1935, was her visual response to the destruction of the British Columbia forest wrought by the loggers whom she called "executioners." EMILY CARR, *SCORNED AS TIMBER, BELOVED OF THE SKY*, 1935, OIL ON CANVAS, COLLECTION OF THE VANCOUVER ART GALLERY, EMILY CARR TRUST. PHOTO: TREVOR MILLS, VANCOUVER ART GALLERY

Painted along the Dallas Road cliffs, this oil-on-paper sketch, *Sea and Sky* (c. 1936) expressed what Emily Carr felt was the "divinity and oneness with the Creator." COURTESY ART GALLERY OF GREATER VICTORIA

George Woodcock, pictured here as a young boy, showed a facility for writing prose from his boyhood in England, though his work was to flower most abundantly after his emigration to British Columbia. QUEENS UNIVERSITY ARCHIVES, GEORGE WOODCOCK FONDS, LOCATOR #2303.22, BOX 9, FOLDER 14, PHOTOGRAPHS

Woodcock had high aspirations as an essayist, as an editor and as a poet. But, shown here as a young man in London during the 1940s, his time had not yet come. QUEENS UNIVERSITY ARCHIVES, GEORGE WOODCOCK FONDS, LOCATOR #2095, BOX 39, FOLDER 13, PHOTOGRAPHS

According to one critic, George Woodcock "virtually created Canadian literature"—a striking claim about his contribution to the impact of the literary journal *Canadian Literature*, which he founded in 1959. By the time this photograph was taken, he was clearly enjoying his status as an eminent man of letters. UNIVERSITY OF BRITISH COLUMBIA ARCHIVES, [UBC 41.1/204]

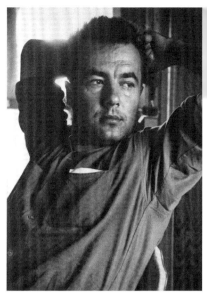

A tense moment between Rita Joe (Columpa Bobb) and the Magistrate (Dwight McFee) in Vancouver's Firehall Arts Centre 1992 production of George Ryga's play *The Ecstasy of Rita Joe.* BRIAN KENT/*VANCOUVER SUN* PHOTO

The thirty-year-old George Ryga, taken just before leaving Edmonton, Alberta, for Summerland in the Okanagan. His play *Indian* had recently been televised by the CBC in 1962. NORMA RYGA PHOTO

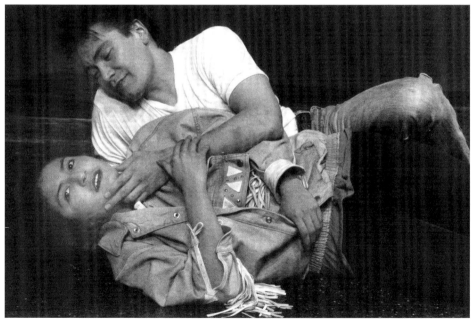

Rita Joe (Columpa Bobb) and her lover Jaimie Paul (Michael Lawrenchuk) in the 1992 Firehall Production of *The Ecstasy of Rita Joe.* PETER BATTISTONI/*VANCOUVER SUN* PHOTO

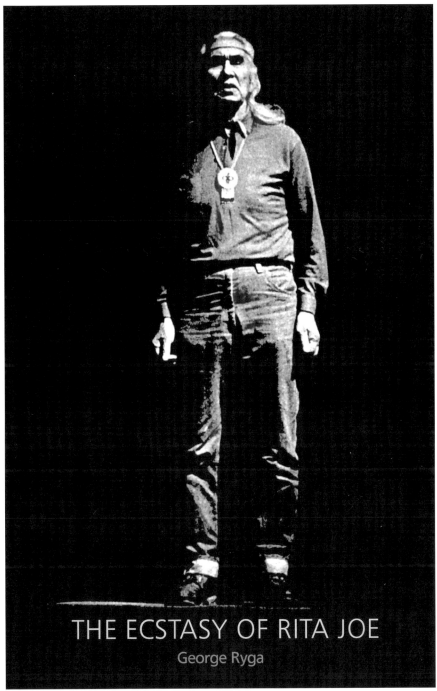

THE ECSTASY OF RITA JOE
George Ryga

Chief Dan George (Tswahno) as Rita Joe's father, David Joe, in George Ryga's *The Ecstasy of Rita Joe.* The authenticity of his performance inevitably reflected his own life experience. COURTESY TALONBOOKS

Jean Coulthard in her cottage garden in Vancouver shortly after her marriage on Christmas Eve in 1935 to the interior designer Donald Adams. UNIVERSITY OF BRITISH COLUMBIA ARCHIVES, JEAN COULTHARD FONDS, BOX 13, FOLDER 18

In 1978 and 1979 Jean Coulthard taught master classes in composition at the Banff Centre in Banff, Alberta. LIBRARY AND ARCHIVES CANADA/WALTER CURTIN FONDS/ E010698558

Jean Coulthard rehearsing for a concert at the Banff Centre with fellow teacher, the British-born pianist George Brough. The intensity of her concentration is surely expressed in her body language. LIBRARY AND ARCHIVES CANADA/WALTER CURTIN FONDS/E010698559

Bill Reid literally inhabits his best-known carving, *Raven and the First Men* (1980). Its graphic depiction of the Haida creation myth of the raven's discovery and subsequent release of five male creatures from a clam shell made a strong impact, and it is now housed in the Museum of Anthropology at the University of British Columbia. UNIVERSITY OF BRITISH COLUMBIA ARCHIVES, [UBC 44.1/2840]

Bill Reid received a record-breaking three million dollars for *The Jade Canoe*. Installed at the Vancouver International Airport, this sculpture welcomes visitors to British Columbia. TONY HISGETT/FLICKR PHOTO

One of the totem poles for the Haida House complex that Bill Reid created in 1961–1962 with the assistance of 'Namgis artist Douglas Cranmer in the grounds of the Museum of Anthropology.
VANCOUVER PUBLIC LIBRARY 85817A

Inspired by a memorial figure that he had seen at the Provincial Museum in Victoria, Bill Reid carved *Sea Wolf* in 1962, with the assistance of Douglas Cranmer. UNIVERSITY OF BRITISH COLUMBIA ARCHIVES, [UBC 41.1/2512]

Bill Reid and Douglas Cranmer are seen working together, carving the frontal board for the Haida Mortuary Pole at the Museum of Anthropology.
UNIVERSITY OF BRITISH COLUMBIA ARCHIVES, [UBC 1.1/13183]

xiv

Arthur Erickson and his architectural partner Geoffrey Massey (left) with Gordon Shrum (right) on Burnaby Mountain 31 July 1963, the day the two young architects learned that their proposal had won the competition to build Simon Fraser University. Shrum was chair of the project. COURTESY SIMON FRASER UNIVERSITY ARCHIVES

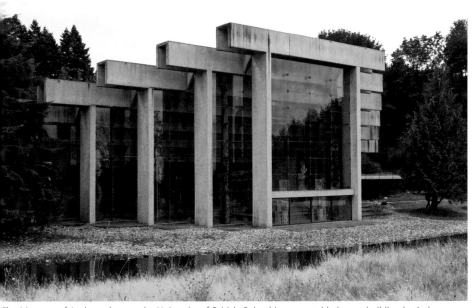

The Museum of Anthropology at the University of British Columbia—a notable legacy building by Arthur Erickson. He used fifty-foot-high pre-cast posts and post-tensioned cross-beams—some up to 180 feet long—in his design. DAILYMATADOR/FLICKR PHOTO

At the height of his career Arthur Erickson maintained offices at various times in Vancouver, Toronto and Montreal, as well as in Saudi Arabia, Kuwait and Los Angeles. UNIVERSITY OF BRITISH COLUMBIA ARCHIVES, [UBC 1.1/15731]

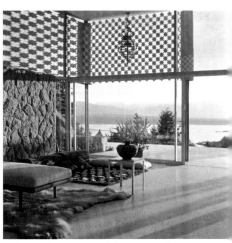

Arthur Erickson designed the Robert Filberg House in 1958 in the Mediterranean Baroque style. Sadly the owner committed suicide shortly before moving into the luxurious retreat near Comox, British Columbia. COURTESY ERICKSON ESTATE COLLECTION

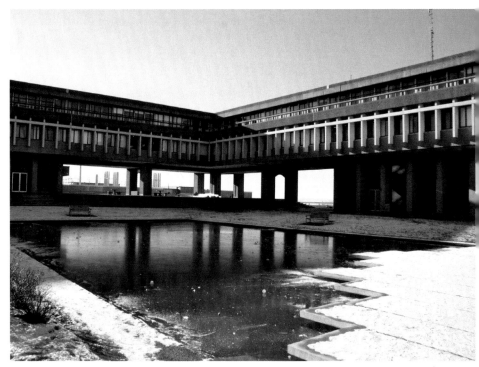

Simon Fraser University stands as a monument to the work of Erickson and Massey. Arthur Erickson felt that the linear construction of the academic quadrangle located on the summit of Burnaby Mountain gave "the building complex its characteristic of classical repose." MARK BURGE/FLICKR PHOTO

Music one of the best music schools in Europe. Most important for Jean, the college offered its students an opportunity to conduct one of its three orchestras. Jean also took further lessons on the piano with Kathleen Long who, like Mrs. Walter Coulthard, was devoted to modern French composers. She studied music theory with R.O. Morris whose book, *Contrapuntal Technique in the Sixteenth Century* (1922), gave her a thorough grounding in the history of composition in Western music. She enrolled in the recently established course in conducting. And she studied composition with one of Britain's leading composers, Ralph Vaughan Williams.

When Jean became his student in the winter of 1929, Vaughan Williams had already completed some of his most powerful work. This included three highly lyrical and melodic symphonies as well as the popular *The Lark Ascending* (1920)—a piece that would inspire Coulthard to write *The Bird of Dawning Singeth All Night Long* (1962) more than forty years later. Along with many other English composers of his generation, Vaughan Williams eschewed "the eruptions of musical harmony and language taking place in Europe" in an effort to break England's dependence on Continental music. No chauvinistic nationalist—before the First World War he had studied orchestration with Maurice Ravel in Paris—he nevertheless incorporated English folk music into his work. Convinced that most composers were incapable of conveying a worldwide message, he urged his students to address their own people and to write the music that they felt was in them.

Ralph Vaughan Williams was no teacher. Many of his students found him to be disorganized and ineffectual. For her part, Jean "never felt the thrill of inspiration at his lesson," in which she plainly felt patronized by his avuncular manner. On a couple of occasions Vaughan Williams patted Jean on the back "like any old man might! And would say, 'Now you are beginning to do well.'" He seemed more concerned to compliment her dress sense than to appraise her compositions, and Jean remembered "wishing fervently my music had called forth a few remarks instead of my spring frock." She also regretted that "there was never time for him to

do any of his compositions over with me: Half an hour and my time was up!"[191]

Jean Coulthard surely had good reason to expect better. After all, Vaughan Williams had previously taught two female composers, Elizabeth Maconchy and Ina Boyle, and helped establish their careers. Like Mrs. Walter Coulthard, he admired contemporary French composers. He might have been more willing to teach Jean the basic forms of composition if she had been more confident of her own ability. Apparently she did not even show him her compositions, and her low morale was shown in her homesickness for British Columbia. London was exciting, but vast and anonymous. Conversely, Vancouver now seemed like a small city where she had always known everyone who mattered.

Of more immediate significance to Jean's professional development was the music of other composers. In London she was exposed to the modernist compositions of Arnold Schoenberg, Béla Bartók and France's *Les Six*—Darius Milhaud, Francis Poulenc, Arthur Honegger, Georges Auric, Louis Durey and Germaine Tailleferre. Unlike Vaughan Williams in so many ways, they were nonetheless like him in reacting against the Romanticism of German composers like Richard Strauss and Richard Wagner and even against Debussy and Ravel.

If modernism was one issue to grapple with, feminism was another. Jean was well aware of the paucity of female composers and conductors in the history of music. Admittedly, Sappho had composed choral poetry in the seventh century BC. The Benedictine abbess Hildegard von Bingen had written music for her morality plays in the twelfth century. Female troubadours wrote songs; nuns wrote madrigals and motets; a few female composers from the Renaissance onwards produced music for carnivals, or composed operas for the court. Some of them had even begun to publish their music. Among those who had not studied music in a religious order, a trickle of female composers had been the daughters, sisters, wives, lovers or pupils of famous male composers. Overwhelmingly, however, like the nineteenth-century Romantic German composer Clara Schumann, women were celebrated for their performances not for their compositions.

191. Jean Coulthard, "Diary of a Young Composer," in William Bruneau and David Gordon Duke, *Jean Coulthard,* 38.

During the early part of the twentieth century, a few composers like Cécile Chaminade in France and Amy Marcy Beach in the United States were occasionally allowed to conduct their own music. Moreover, Jean had a potential example near at hand. In London, Ethel Smyth was an unforgettable figure. Now nearly seventy, she could be seen at concerts, "striding up the gangway in coat and skirts and spats and talking at the top of her voice," as her friend Virginia Woolf recalled.[192] Smyth had a colourful record as a pre-war suffragette: her "March of the Women" was their battle song. She also had the distinction of having her opera, *The Wreckers*, performed first in Leipzig, Germany, in 1906 and then in London three years later. But Smyth was no innovator as a composer. She sought to emulate not just Brahms but the operatic music of Arthur Sullivan—whom the young Coulthard would have found laughably Victorian in the late 1920s. So although she was a woman, Smyth, with her impatient rejection of the avant-garde, was no model for Jean Coulthard.

Instead, Jean watched the young conductor Adrian Boult—seen by Smyth as an enemy—and also the not-so-young Sir Henry J. Wood, both conducting music composed by her teacher Vaughan Williams. She also listened to works composed by the flamboyant Russian Igor Stravinsky and heard performances of works by the French composers Gabriel Fauré, Maurice Ravel and Frederick Delius (whom Ethel Smyth particularly loathed). On a trip to Germany she attended a performance of Paul Hindemith's recently composed opera *Cardillac*. And in July 1929 when Jean conducted the Royal College's third orchestra, her interpretation of a concerto by Mozart received praise in London's *Daily Express*. This was surprising recognition for a young music student to receive in the best-selling British popular newspaper of its day. The fact that it was owned by the Canadian Lord Beaverbrook and edited by another Canadian, Beverley Baxter, may have helped. Just like her mother, Jean Coulthard never lacked the right social connections.

192. Hermione Lee, *Virginia Woolf* (London, 1996), 586.

WHEN JEAN RETURNED to Vancouver in the early autumn of 1929, the cachet of having studied at the Royal College of Music stood her in good stead, as did her firsthand exposure to so many of Britain's and Europe's leading composers, conductors and musicians. Oblivious of the impending financial crisis that was to strike Wall Street within a few weeks, Jean successfully embarked on a teaching career, with private students at home as well as pupils at Queen's Hall School for Girls and St. Anthony's College. She launched her career as a professional pianist, performing with the city's newly revived Vancouver Symphony Orchestra in 1930. Two years after her début performance she gave a seminal concert recital in the Oak Room at the Hotel Vancouver. During the first half of her recital, Jean played work by modernist composers, among whom were Claude Debussy and Manuel De Falla. Then, during the second half of the concert, she surprised her audience. Accompanied by the soprano Avis Phillips and violinist Charles E. Shaw, Jean played some of her own compositions.

This was one of the last occasions on which Mrs. Walter Coulthard heard her daughter perform. Within seven months she was dead. For Jean and her musically gifted sister, Babs, the premature death of their mother, who had been the girls' "inspiration, comfort and the light of our house," was emotionally devastating.[193] Though both women continued giving private lessons in their Shaughnessy Heights music studio, their old family life ended and their father, now increasingly an invalid, did not long outlive his wife.

Before her mother's death, Jean had felt that "there was an initial joyous feeling of a 'spring of the arts' in the West—a tremendous sensation of hope that everything in the creative arts was about to burgeon forth." Now, as the reality of the Great Depression seeped into her upper middle–class life, she increasingly came to feel that "there was really nothing for the young composer."[194] Getting her music performed was a major problem. The Dutch-born conductor of the Vancouver Symphony Orchestra, Allard de Ridder, turned a blind eye to any contemporary pieces except his own, firmly shutting out Canadian composers. And he was not alone. Conductors—with the notable exception of the Toronto conductor

193. William Bruneau and David Gordon Duke, *Jean Coulthard,* 48.
194. Jean Coulthard, "Canadian Music in the 1930s and 1940s," 37.

and composer Sir Ernest MacMillan—were reluctant to put Canadian music on their concert programmes until well after the Second World War. And even as recently as 1993, Toronto composer Murray Adaskin would complain, "You can only recognize music because you have heard it before and Canadian music is not being heard enough." This was—and continues to be—a deep-seated, longstanding problem for every composer in Canada. Adaskin placed the blame on conductors who did not "know or care about Canadian music, and on orchestra committees who produce programs and are thinking more about marketing than about music."[195]

In order to hear her own compositions performed, Coulthard became the conductor of the Vancouver Little Theatre Orchestra in the mid-1930s. This was a significant achievement. Canadian women were rarely invited to step onto the conducting podium, as the founding of the Montreal Women's Symphony Orchestra in 1940 testified. There were intermittent breakthroughs, as when Coulthard's composition *Portrait* (1936) was chosen by Pennsylvania's Reading Symphony Orchestra in its search for music by young North American composers. And after the CBC established the Radio Symphony Orchestra in 1938, Coulthard occasionally heard her work—or performed it herself—on the airwaves. But this fell far short of what Coulthard had envisioned for herself as a composer when she returned from England.

Despite these personal and professional setbacks, Coulthard maintained an active life during the 1930s. She resumed her lessons in theory with Dr. Chubb. She took advanced training on the piano from Jan Cherniavsky of the internationally acclaimed Cherniavsky Trio, who was now settled in Vancouver. She also undertook a heavy teaching schedule, as well as occasionally performing her own music. She gave a series of recital-lectures on the CBC. And she continued to compose music. "I had in my mind a certain amount of musical repertoire that I wanted to write for my own satisfaction" and, she recalled in 1989, "I expect that's what kept me going."[196]

195. Ray Chatelin, "Murray Adaskin," *Canadian Composer* (Winter 1993), 18.

196. David Duke, "A Conversation with Jean Coulthard," *Music Scene* 379 (November/December 1989), 14.

Two years after the death of Mrs. Walter Coulthard, Jean married Donald Marvin Adams. He was an interior designer who later showed considerable entrepreneurial flair; in the 1950s and 1960s, his business became highly profitable in marketing modern furniture with a Scandinavian inspiration. But in the 1930s and 1940s the newlywed couple had to watch their money, and Jean's own earning power was important to them.

Don was an amateur pianist whose own contacts with contemporary American composers, dating from his studies in California, proved professionally helpful to Jean. In 1937 during a visit to New York, for example, Don encouraged his young wife to show her work to the soon-to-become-famous American composer Aaron Copland. At this time she was still under the influence of French modernist composers. While Copland gave Jean and Don tickets to concerts in New York and appeared to take her seriously as a composer, he was unimpressed by her work. Though Copland had himself studied in France, he had now turned his back on European composers like Debussy and Arnold Schoenberg. Rather, Copland was drawing on American folk-tunes and American jazz for inspiration. By using vernacular sources for his compositions, Copland hoped to engage a broader sector of the American public. For all of their differences, however, Coulthard and Copland agreed on one thing: whatever they composed must engage the audience and could only do this if their compositions reflected their country's cultural, geographic and political environment.

Jean introduced her new husband to the cultural life of Vancouver into which she had always been so well integrated through her mother's influences. The couple's social life revolved around the students and faculty at the Vancouver School of Decorative and Applied Arts and around the Department of English at the University of British Columbia (UBC). It took them into the studios of the avant-garde photographer John Vanderpant; the former member of the Group of Seven, Lawren Harris, and his artist-wife, Bess, who had moved to Vancouver in the early 1940s; and other artists, including Jack Shadbolt, B.C. (Bert) Binning and even Emily Carr, from whom Don and Jean bought a painting in 1936.

The outbreak of the Second World War brought Jean and Don into contact with the British-Australian conductor and composer Arthur Benjamin. Seeking a refuge from hostilities in Europe, Benjamin had come to Vancouver ostensibly as a music adjudicator. Like Coulthard, however, he was first and foremost a composer. Indeed, during his time in Vancouver he wrote a piece for orchestra—*North American Square Dance Suite*—several songs for the piano along with an opera, *The Devil Take Her*. From 1941 to 1946 Arthur Benjamin conducted Vancouver's CBC Radio Symphony Orchestra.

Benjamin's local impact, however, came mainly through his formation of the Vancouver Promenade Symphony Orchestra (VPSO) as a rival to the established Vancouver Symphony Orchestra. Whenever Benjamin conducted the VPSO, the programme included music from the classical repertoire as well as from contemporary composers. Within a period of three years the orchestra performed Coulthard's three-movement suite for orchestra, *Canadian Fantasy* (1939); five-movement ballet suite, *Excursion* (1940); her work for large string orchestra, *Ballade: "A Winter's Tale"* (1942); and *Convoy*, also known as *Song to the Sea* (1942).

Benjamin not only introduced Coulthard's work to a wider audience. He showed her compositions to well-connected Central Canadian musicians like Sir Ernest MacMillan. Indeed, MacMillan was so impressed by Coulthard's *Convoy* that he not only performed it in the concert hall but also made a recording of it with the Toronto Symphony Orchestra. Benjamin's influence on Coulthard was immense. He encouraged her to compose larger orchestral works. And he gave her confidence by assuring her that her music created a "web of sound" that evoked the feeling of the British Columbia coast.[197]

This compliment struck a chord. As a child Jean and her family had travelled to the interior of the province and up and down the west coast. *Song to the Sea* and other pieces that Jean composed during Benjamin's residence in Vancouver evoked the "rippling lyrical nature of sunlight glinting on the watered stone of a small brook" and, she added, the

197. Jean Coulthard, "Biographical Sketches" cited in Vivienne W. Rowley, "The Solo Piano Music of the Canadian Composer Jean Coulthard" (Ph.D. thesis, Boston University, 1973), 4.

"depth of one's being reflected in the deep fiords of our west coast."[198] Jean's *Two Songs of the Haida Indians* (1942) may be viewed as "somewhat naïve" and clichéd depictions of First Nations peoples' traditional music.[199] But the two fragments of Coast Salish music woven into her later orchestral suite *Canadian Mosaic* (1974) offer a subtle rendering of the half and quarter-tones and rhythmic cadence characteristic of First Nations peoples' traditional music.

Poetry was equally important in Coulthard's creative process during the years that Benjamin resided in Vancouver. "You go through a lot of verse," she remarked in an interview, "and I think very often poetry helps you to start a musical idea."[200] An admirer of the poems of her friend Earle Birney, she composed the choral work "Québec May" (1948), "This Land" (1967) for solo for voice and orchestra, and *Vancouver Lights: A Soliloquy* (1980)—all inspired by his poems.

Finding an intelligent musical supporter like Arthur Benjamin was a wonderful boon to Jean Coulthard. Alas, it proved short-lived. His Vancouver Promenade Symphony Orchestra provided unwelcome competition for the Vancouver Symphony Orchestra, whose board members were much better connected to the right social circles. Virtually hounded out of town by his rivals, Benjamin returned to London after the Second World War. His presence, his encouragement and his patronage had been important to Jean emotionally and also professionally, not least in giving her works local recognition and performance. She never again enjoyed such strong support in the city of her birth.

DURING THE SECOND WORLD WAR, it seemed as though any significant European composer you could name was likely to be living in the United

198. Jean Coulthard cited in Ian L. Bradley, *Twentieth Century Canadian Composers* (Agincourt, Ontario, 1982), 7.

199. Coulthard was helped by University of British Columbia ethnomusicologist Ida Halpern, who had collected over 340 hereditary songs in the 1940s before First Nations peoples' claim to "primary authority" and the ban on potlatching was rescinded. Glenn David Colton, "The Piano Music of Jean Coulthard" (Ph.D. thesis, University of Victoria, 1996), 25.

200. David Duke, "A Conversation with Jean Coulthard," 15.

States. Igor Stravinsky, Arnold Schoenberg and Darius Milhaud were all on the West Coast, having found refuge from the war in California. The acclaimed French music teacher Nadia Boulanger was living on the West Coast, as was the notorious Alma Mahler who had been successively married to the composer Gustav Mahler, the Bauhaus architect Walter Gropius and the novelist Franz Werfel.

During the summer of 1942, Coulthard approached Darius Milhaud, whose work she had known since her interest in *Les Six* during her London days, and Arnold Schoenberg, the early advocate of twelve-tone music. It was probably Copland who told Jean that Milhaud was now living in Oakland on the outskirts of San Francisco and might be willing to look at her compositions. A professor at Mills College, Milhaud was a prodigious and wide-ranging composer. While in the United States he wrote classical pieces for the well-known New Brunswick violinist Arthur LeBlanc and concertos for popular musicians like the clarinetist Benny Goodman, as well as music for Hollywood films. Milhaud also conducted his own compositions with the San Francisco and Chicago Symphony Orchestras. A kind and thoughtful teacher, Milhaud adhered to the watchword: "Learn your technique, because through technique you will be free."[201] Technically proficient herself, Coulthard was sympathetic to such an approach, and also to Milhaud's advice that his students ignore his own work and derive their inspiration, as Copland had, from their immediate environment.

Later, travelling south to Los Angeles, Coulthard also showed her compositions to Milhaud's friend Schoenberg, who was teaching at the University of California. Like Milhaud, Schoenberg was known for his generosity and for adjusting his teaching to his students' varied artistic expressions. Far from trying to persuade Coulthard to abandon tonality and adopt the twelve-tone system of atonal music for which he was himself so famous, Schoenberg encouraged her to pursue her own individuality as a composer. When she was later teaching at UBC, Coulthard followed Milhaud and Schoenberg in encouraging such freedom in her own students.

201. Roger Nichols, *Conversations with Madeleine Milhaud* (New York, 1996), 61.

Jean's education continued in 1943 when her husband was posted to Saint John, New Brunswick, as an officer with the Royal Canadian Navy. Accompanied by her baby daughter, Jane, Jean moved to New York, where she stayed with Grandma Robinson (her mother's mother). Again Jean seized her chances. Rather than simply lapsing into domesticity and childcare, she decided to study at the Juilliard School of Music.

The Dutch-born composer Bernard Wagenaar had been a violinist with the Philharmonic Orchestra before taking a post at the premier academy of music in North America. As the saying went, "You don't go to Juilliard to get an education, you go to Juilliard to be discovered."[202] Coulthard decided to go there in 1944. But the anti- modernist Bernard Wagenaar, who had a reputation for encouraging his female students, gave Jean private lessons. Over the course of six months, Wagenaar clarified Coulthard's outlook with a rigorous approach to the formal organization of her materials. He broadened her understanding of harmony, he expanded her tonal vocabulary and he prompted her to adopt some aspects of atonal music, rather than simply rejecting it outright. Having helped her in these technical ways, he encouraged Jean to write a string quartet. It was through Wagenaar—with whom she was to study briefly again in 1945 and 1949—that Coulthard cultivated her highly lyrical voice as a composer, evident in such pieces as *Music on a Quiet Song* (1946). As she later recalled: "Of all the eminent teachers I've had, I truly believe that no one reached me as deeply as Wagenaar was able to do."[203]

Coulthard did not work solely with Wagenaar during her stay in New York City but also sought out the Hungarian composer Béla Bartók. A generation older than Coulthard, Bartók had fled to New York in 1940. He was, of course, more famous than Wagenaar. Indeed, Bartók had already been admitted to the canon of twentieth-century musical innovators. And when Jean met him, he was in the midst of writing his *Sonata for Unaccompanied Violin* as well as his *Concerto for Orchestra*. It was probably the complex rhythms and rich range of harmonies for which he was so famous that made Coulthard think that his music showed

202. Andrea Olmstead, *Juilliard, A History* (Chicago, 2001), 2.
203. David Gordon Duke, "The Orchestral Music of Jean Coulthard: A Critical Assessment" (Ph.D. dissertation, University of Victoria, 1993), 33.

composers "a way into the future" and thus led her to him.[204] Although teaching composition held a low priority for someone who was reluctant to speak about his own compositional methods, Bartók agreed to look at Coulthard's work in 1944.

But things did not go smoothly. Meeting Jean Coulthard face-to-face for the first time, Bartók expected a man—like the Finnish composer Jean Sibelius, perhaps—and showed himself less than sympathetic to the idea of teaching a female composer. Moreover, Bartók was unhappy with his life in New York; he was short of funds and he already had leukemia, from which he died the following year. During Coulthard's few sessions with Bartók, he chose to concentrate on aural training and, though she had a good ear, she recalled that "he didn't feel I was quick enough in perceiving complicated rhythms."[205] Even so, when she later incorporated Scottish, Inuit and French-Canadian songs into her compositional language, Coulthard was building on Bartók's blending of folk and classical music as well as on his rhythm and on his demanding approach to traditional forms of composition.

The end of the war in 1945 brought a welcome return home for Jean, Don and their daughter, Jane. Now settled in distant Vancouver, Coulthard was culturally isolated. She was not part of the group of musicians who, like John Weinzweig, had links with the Toronto Conservatory of Music. Equally obviously, she was not one of the Central Canadian composers who had become closely linked with both the CBC and the Canadian Film Board during the war, at a moment when the arts acquired greater public sponsorship. True, from 1944 Coulthard benefited from a few commissions from the CBC, in its efforts to introduce Europeans to Canadian music by broadcasting their work on its International Service. This is when the Toronto Symphony Orchestra, conducted by Sir Ernest MacMillan, recorded Jean's compositions on large sixteen-inch discs. She was in good company. With the founding of the CBC's Transcription Service in 1947, such artists as the pianist Glenn Gould and the vocalists Maureen Forrester and Lois Marshall made their first recordings. The

204. David Duke, "A Conversation with Jean Coulthard,"14.
205. Jean Coulthard, "Biographical Sketches," cited in David Gordon Duke, "The Orchestral Music of Jean Coulthard," 33.

CBC thus played a significant role in helping these and other musicians to cultivate their international reputations.

And Coulthard's own reputation? It would be an exaggeration to say that her work went unrecognized in Canada. In 1952 the music publisher BMI Canada made Coulthard's music available in print. In 1953, when CBC's *Wednesday Night* presented a number of programmes celebrating the coronation of Queen Elizabeth II, Coulthard was among those commissioned to commemorate the event. This was the origin of her *Prayer for Elizabeth* (1953). The 1950s also saw Coulthard become somewhat better known outside of the country. She was awarded a substantial grant from the American Learned Society and was commissioned to write a symphony by the Australian Broadcasting Commission. And she won prizes for her compositions at the Olympiads in 1948 and 1952, in London and Helsinki respectively.

Yet, despite sporadic recognition of this kind, Coulthard could not have supported herself as a full-time composer. "If you're a composer," Murray Adaskin observed in old age, "you really have to be lucky to survive. It is not possible to make a living by composing. You have to do other things—teach, play in an orchestra or work for the CBC."[206] In 1947 Coulthard chose the first of these options.

JEAN COULTHARD WAS NO ACADEMIC. She had spent one year, 1925–26, studying English at the University of British Columbia. However, she had earned her licentiate from the Royal College of Music and, following that, she had studied with Bernard Wagenaar, who was respected as an eminent music theorist in his field. In addition to this, she had had her work appraised by composers as internationally renowned as Copland, Milhaud, Bartók and Schoenberg. Coulthard was thus fully qualified to teach music theory and composition. And these were the subjects that Harry Adaskin, brother of the composer Murray and head of the fledgling music department at the University of British Columbia, needed to balance the popular musical appreciation courses that had been started by

206. Ray Chatelin, "Murray Adaskin," 18.

ethnomusicologist Ida Halpern in 1940 and were now being taught by him.

Jean was, by all accounts, a good teacher. She insisted that her students study the classical as well as the contemporary repertoire. She made them pay close attention to the structural design of a composition. She insisted that they have a solid grounding in musical technique and in all forms of music, be it the fugue, madrigal or sonata. She made her students—among whom were future composers Ka Nin (Francis) Chan, Michael Conway Baker and Sylvia Richard—aware of Canadian composers while never turning them into clones of her own music. And she used her social connections in the city, and increasingly across Canada, to help her students establish their careers. For Coulthard, technique was not an end in itself. She encouraged her students to listen to their own instinct and to be aware of the environment in which they worked. "I think when you get an idea you follow it through and simply, absolutely forget about any technique," was how she put it to her former music student David Duke, adding: "Just get the musical idea down and then apply the technique to it when you go over it."[207]

Two years after Coulthard joined the music department, the appointment of Barbara Pentland increased the staff to three. Jean and the Winnipeg-born Pentland had much in common. They were both female composers in a field dominated by men. They had received criticism from Copland and taken lessons in composition from Wagenaar. And both women took their inspiration from the British Columbia landscape as well as from poetry and the traditional music of the province's Indigenous peoples.[208] Yet Coulthard and Pentland were never to become close friends. Coulthard's neo-classical romantic music was so very different from Pentland's sharp-textured, twelve-tone compositions. And while Adaskin organized recitals featuring the compositions of both women, it was Pentland whom he favoured and Pentland who, unlike Coulthard,

207. David Duke, "A Conversation with Jean Coulthard," 14.

208. In 1954 Barbara Pentland collaborated with the poet Dorothy Livesay in the production of her one-act chamber opera, *The Lake,* which was set in the Okanagan and Similkameen Valley.

had strong affiliations with the Toronto music establishment. Moreover, when Adaskin allegedly needed to make budget cuts to the music department in 1951, it was Coulthard whom he attempted to dismiss. (Using her lifelong connections with the Vancouver establishment, Jean successfully mobilized support from the university's president, Norman ("Larry") MacKenzie, to overrule Adaskin.)

During Coulthard's long teaching career—it lasted from 1947 until 1973—she was never promoted beyond the rank of Senior Lecturer. Even when "the energetic and bumptious" Adaskin left the department in 1973, things did not improve.[209] The new department head, the American composer G. Welton Marquis, recruited teachers from the United States who were not only advocates of the contemporary music style evident in his own compositions, but also represented a new kind of academic professionalism. They showed little interest in the classical tradition, let alone in music composed in Canada. Coulthard would have been equally out of place at the newly opened university just over city boundaries in Burnaby. In 1965 Simon Fraser University had hired R. Murray Schafer, an environmental soundscape composer who wove outdoor sounds, notoriously including snowmobiles, into his compositions. Open-minded as she was, Jean Coulthard would never have composed music for a snowmobile. Shunning experimentation for experiment's sake, she believed that a composer's language should be instinctive, natural and personal. She could never accept the notion, as she put it in 1976, "that originality is present only when the musical work becomes an utterance that either astounds or agitates."[210]

Despite her marginalization in the University of British Columbia's music department, which must have taken some personal toll on her, Coulthard maintained that her teaching career never interfered with composing. It is certainly true that being a member of a university music department increased her national and international reputation

209. William Bruneau, "Music and Marginality: Jean Coulthard and the University of British Columbia, 1947–1973" in Elizabeth Smyth et al., eds. *Challenging Professions: Historical and Contemporary Perspectives on Women's Professional Work* (Toronto, 2001), 100.
210. Jean Coulthard to Keith MacMillan, 12 March 1976 cited in Colton, "The Piano Music of Jean Coulthard," 103.

exponentially. Moreover, it was only after her appointment to the music department that she began to write music on a grand scale. She imbued her work with a formal logic that helped centre "the harmonic language in an appropriately modern idiom."[211] And she demonstrated that there was nothing to prevent a composer from expressing "a simple idea or even an old idea in a new, original way."[212]

Teaching also gave Coulthard a steady income that could be put towards travel and further study, at a time when Don's retail marketing of new design furniture had yet to take off. In 1949, Jean's own earnings made it possible for her to make her first post-war visit to Europe. The previous year, during an evening at Lawren and Bess Harris's home, she had met the English composer, pianist and folksong collector Elizabeth Poston. Coulthard had heard Poston's songs performed at the Royal College of Music during her student years, but it was only in 1948 that she met the composer.

Ten years older than Coulthard, Poston was certainly well connected as the director of music for the British Broadcasting Corporation and as president of the Society of Women Musicians. Poston was, above all, a fierce advocate of music written by contemporary British composers. Jean's developing friendship with the older woman took her back to England during many summers. Poston introduced her not only to the Aldeburgh Festival of Music and the Arts on the Suffolk coast but also to its founder, the leading British composer Benjamin Britten. With Poston, too, Jean attended the Cheltenham Music Festival in the west of England, where they heard premieres of compositions by younger British composers. Committed to getting the work of contemporary composers on the air and onto the concert platform, Poston invited Coulthard to represent Canada at a conference of British Women composers in London. And having introduced Coulthard to *her* France and to *her* Venice, she also took Jean to her own evocative country home. Once owned by the novelist E.M. Forster, it had been the inspiration for his novel *Howards End* (1910), wherein the Schlegel sisters had affirmed their passionate commitment to shared artistic values.

211. David Gordon Duke, "The Orchestral Music of Jean Coulthard," 39.
212. Jean Coulthard to Keith MacMillan, 12 March 1976, 103.

After winning a fellowship from the Royal Society of Canada in 1955, Coulthard was able to spend an entire year in Europe. During the late 1940s and 1950s, many other musicians, artists and writers from British Columbia were making similar journeys, aided by grants from the newly established Canada Council or by scholarships from the Royal Society of Canada or from the Emily Carr Trust. The painters Joe Plaskett, Jack Shadbolt and B.C. Binning, along with the poet Earle Birney, all went to live in Europe and then—with the exception of Plaskett who remained in Paris—returned to British Columbia with renewed vigour and with a determination to apply what they had learned abroad to the British Columbia scene.

Coulthard put her own sabbatical year to good use. She began an opera, based on Thomas Hardy's *The Return of the Native*, and made an arrangement of the poems of Emily Dickinson, *Five Long Songs*, for baritone and piano. Before moving from Paris to Menton in the south of France, Coulthard briefly studied composition with her first and only female teacher, Nadia Boulanger, who had been holding classes in musical analysis on Wednesday afternoons at her Paris apartment in rue Ballu since 1921.

This distinguished, somewhat mannered teacher was impervious to developments in contemporary music. Instead, she remained wedded to a style of teaching that depended on her ability to project her own passion for music onto her students. Coulthard was not impressed: "She was *not* a composer and there is the great difference in comparison with others I have worked with." On the other hand, Coulthard was thrilled when the famous French conductor Gaston Poulet included her composition *Ballade: "A Winter's Tale"* (1942) on the programme in a performance at the Théâtre des Champs-Elysées in 1956. A number of friends whom she had made in Paris attended the concert, and afterwards Poulet, who had been the last musician to perform with Claude Debussy, told Coulthard: "You write beautiful music." Coulthard was deeply moved by this fine gesture. As she later put it, "it was a case of 'my cup runneth over.'"[213]

213. Jean Coulthard quoted in William Bruneau and David Gordon Duke, *Jean Coulthard*, 98.

A later sabbatical in 1965–66 gave Coulthard—now approaching sixty—a further opportunity to expand her musical horizons. At the University of London she indefatigably attended lectures on early music given by Thurston Dart, whose book *The Interpretation of Music* (1934) was familiar to her. She also took private lessons with the British theorist Gordon Jacob, who had been a teacher during her years at the Royal College of Music and whose *Concerto for Viola and Orchestra* (1925) she had heard, conducted by Adrian Boult.

Jacob had definite ideas about what a good piece of music entailed: imagination, clarity, sensitivity, with a touch of showmanship and a sense of drama. He demanded that a composer have a sound knowledge of the traditional techniques in harmony, counterpoint and fugue.[214] He had clear guidelines on what the composer should avoid: using contrasted groups of instruments in turn; treating the brass and drums simply as noisemakers; and letting a chorus swamp the orchestra.[215] Coulthard's "lessons" with Jacob took the form of a friendly discussion. This was only appropriate, given her professional standing. Showing humility in seeking to learn from him, she later acknowledged that he gave her "a very good basis" for exploring more complex orchestral techniques.[216]

Coulthard's lyrical and traditionally orchestrated compositions were undeniably out of step with the music produced by most contemporary composers in Canada. This had already become evident when the First Symposium on Canadian Contemporary Music was held in Vancouver in the spring of 1950. Though Coulthard was among the thirty largely English-Canadian composers who attended the event and later wrote of the symposium with great enthusiasm, it was Barbara Pentland along with John Weinzweig, Harry Somers and Harry Freedman, who were setting the trend in the new music with their atonal compositions. Coulthard's tonal music was likewise out of step with other pieces performed at a concert at the Vancouver Art Gallery in 1953 and organized by the Canadian League of Composers, of which she had been a founding member in 1951. It is also notable that she was not among

214. Gordon Jacob, *The Composer and His Art* (London, 1955), 3, 4.
215. Gordon Jacob, *The Elements of Orchestration* (London, 1962), 26.
216. David Duke, "A Conversation with Jean Coulthard," 15.

the twenty-two Canadian composers (only one of them a woman) who attended the International Conference of Composers held in Stratford, Ontario, in August 1960. Nor did she play a major part in founding the Canadian Music Centre in 1959, an organization that aimed to encourage the publication, recording and distribution of Canadian music.

This is not to suggest, however, that Coulthard did not care or was never involved in organizations that furthered the interests of composers and performers. The appointment of a Royal Commission on National Development in the Arts, Letters and Sciences (the Massey Commission) was an important cultural landmark in 1949, and Jean duly submitted a brief that dealt with the problems facing Canadian composers. In a letter to the Canadian Music Council around the same time, she called for the founding of a Canadian League of Composers that would promote Canadian music.[217] Moreover, she supported the establishment of a Vancouver branch of the Canadian Music Centre and was gratified that from 1965 everything that she wrote was deposited into the centre's archives. However this, like virtually every other national cultural organization in the country, was Toronto-based and run by members of the Toronto music establishment.

In Vancouver it was not until the 1980s that conductors like Mario Bernardi of the CBC's Radio Orchestra took up where Arthur Benjamin had left off in the 1940s. He performed *and* recorded Coulthard's orchestral work on a regular basis. On the other hand, although the Vancouver Symphony Orchestra's conductor Meredith Davies had commissioned Coulthard to write a choral symphony to celebrate the country's centennial several years earlier, the resulting work, *Choral Symphony,* (1967), was never performed by the orchestra. Unable to get sufficient support for the performance of contemporary music, Davies resigned in 1970 after seven seasons with the VSO.

Admittedly, Coulthard's music was technically difficult to play and to sing. This was because it explored all ranges of the voice and instrument and thereby demanded accomplished musicians to perform it. She composed many of her works for specific musicians and ensembles.

217. Jean Coulthard cited in Glenn David Colton, "The Piano Music of Jean Coulthard," 20, 21.

Among these were the Canadian contralto Maureen Forrester, the pianists John Ogdon and Lloyd Powell, the violinist Thomas Rolston and the University of Alberta String Quartet and the Purcell String Quartet.

By the time Jean retired from the University of British Columbia in 1973, she and Don were very comfortably off; his business was booming and often took him away on foreign visits. For Jean, loss of an academic income was by now no problem; instead, the relief from her university responsibilities left her, at age sixty-five, with more time and opportunity to develop her own vocation. Don's death in 1985 showed her resilient and self-reliant. She continued to participate in the Shawnigan Summer School of the Arts on Vancouver Island and intermittently at the Victoria Conservatory of Music. She officiated at the Okanagan Music Festival and at the Banff Centre's Composers Workshop. But most of her time was devoted to composition.

Some of the pieces that she wrote after 1973 explored the musical language that she encountered in a younger generation of essentially Romantic composers. She looked to the work of Witold Lutoslawski and another Polish composer, Krzysztof Penderecki, whose shaded masses of sound charged with highly dramatic effects expanded the musical repertoire. Though Coulthard's musical vocabulary became more diverse, she never strayed from her goal: to "reach the heart" of her audience through her music.[218] Instinctive and highly personal—even idealistic—Coulthard's music never appeared to be forced. The shaping of sounds and movement were what mattered to her. And she achieved this through rhythmic variety, divergent themes, harsh contrasts and an intrinsic lyricism that gave her music a sense of excitement and direction.[219]

During the last decade of her career as a composer, Coulthard wrote a commissioned work, *Shelley Portrait* (1988), for the opening of Concordia University's Department of Music. *Symphonic Image: "Vision of The North"* (1989) was composed for London's Guildhall String Ensemble. She revived *Serenade or a Meditation and Three Dances* in 1989 for the

218. Jean Coulthard quoted in *Thirty-Four Biographies of Canadian Composers* (Montreal, 1964), 29.

219.Vivienne W. Rowley, "The Solo Piano Music of the Canadian Composer Jean Coulthard," 13.

Toronto Symphony Orchestra. Coulthard also reworked many other earlier compositions. For example, *When Tempests Rise* (1988) was derived from her opera, *The Return of the Native*, written during her sabbatical in France in 1955–56, but it only came to fruition thirty years later. "I go to great lengths to change everything around," she recalled, "and then in the end I turn back and write my original idea." Though she withdrew earlier works from her oeuvre, she continued to compose new pieces—"so the works just piled up."[220] Until the end of her life Coulthard simply continued to plough her own furrow, professionally somewhat isolated but personally indomitable, in the city that she had always called home.

THOUGH BIOGRAPHICAL FRAGMENTS EXIST among Jean Coulthard's extensive papers, she did not write an autobiography. However, listening to her earlier work enabled Jean to "review my youth for the moment, and the other stages in one's life." Listening to *Autumn Symphony, No. 4 for string orchestra* (1984) in 1989 helped her to recapture "a sort of feeling" in her eighty-first year.[221] Listening to *Aegean Sketches* (1961) recalled the ruins and bone-dry landscape she had encountered in Greece. Listening to *Sketches from the Western Woods* (1969) and *Kalamalka: "Lake of Many Colours"* (1973–1974) evoked British Columbia's luxuriant forests, interior lakes and wildlife. And listening to *The Pines of Emily Carr* (1969), written for soprano and ensemble following the publication of Emily Carr's posthumously published journals *Hundreds and Thousands* in 1966, Coulthard recalled how moved she had been by Carr's passion for British Columbia's forests and sea. Coulthard had celebrated this by seeking a musical metaphor for the mystery, the surging energy and movement inherent in Carr's paintings that, in her view, evoked the painter's vision of death.

Though not self-consciously a nationalist, Coulthard was always proud of being a Canadian composer—indeed, a British Columbia composer. During the early part of her career, Ravel and Debussy had an impact on how Jean composed music. Her music was also informed by her

220. David Duke, "A Conversation with Jean Coulthard," 14.
221. David Duke, "A Conversation with Jean Coulthard," 15.

old teacher Ralph Vaughan Williams and later by Poland's much-younger dramatic composers, Lutoslawski and Penderecki. But throughout her career, the breadth of space and the moods of British Columbia's landscape remained her touchstone. "People are instinctively different," she observed, "and certainly music from different regions should reflect this." That her music had what she called a "western flavour" was one of her fervent beliefs.[222] Just as Aaron Copland had done with the Appalachians, Jean Coulthard tried to make her music reflect her immediate environment. "If one has been born in this land," she pleaded, "where earliest memories of life are walks in the woods, picnics in the bays and coves of its waters—summer vacations in the interior among the lakes and mountains—how could one (if at all sensitive to nature) fail to catch the atmosphere of this country?"[223]

Yet did Coulthard's work intrinsically convey a Canadian, let alone a British Columbian, sound? This question can be answered in more than one way. The Quebec composer and teacher Jacques Hétu had one view: "There are as many kinds of Canadian music as there are Canadian composers, representing as they do the full aesthetic spectrum of our time—and that's as it should be!"[224] When questioned by Murray Adaskin about the uniqueness of Canadian music, Darius Milhaud gave another answer. Yes, Milhaud answered, there was "a Canadian sound, one that was sparse, with great loneliness but which held wonderful optimism."[225]

In 2008, almost ten years after Coulthard's death, a celebration marking her centennial saw the Turning Point Ensemble perform her *Duo Sonata for Violin and Cello* (1989) and *Shelley Portrait* (1987). She would no doubt have been pleased to have the work of a British Columbia composer chosen by the Vancouver Women's Musical Society and by UBC's Department of Music, pleased that they had chosen music in her distinctive idiom and pleased that they had chosen music that she had composed in her late seventies and early eighties.

222. Glenn David Colton, "The Piano Music of Jean Coulthard," 37, 51.

223. Jean Coulthard, "Biographical Sketches" Number IV, 1–2, cited in Vivienne W. Rowley, "The Solo Piano Music of the Canadian Composer Jean Coulthard," 4.

224. Jacques Hétu cited in Colton, "The Piano Music of Jean Coulthard," 34.

225. Ray Chatelin, "Murray Adaskin," 18.

The inescapable fact remains, however, that at the time of Coulthard's death in 2000, the vast majority of her repertoire remained unperformed, unpublished and unrecorded. In this she was not alone, of course. Two other Canadian women of Jean's generation, Barbara Pentland and Violet Archer, though composing in more modernist styles, had equal difficulty in establishing their careers as composers. Like Coulthard, they had studied with prominent male composers in North America and Europe; they had received degrees, won competitions and research fellowships; they had secured teaching positions in newly established university music departments. And, more importantly, they had written extraordinary amounts of music that was only occasionally heard on the CBC, or squeezed between the work of European composers in a concert hall.

Like Coulthard, Pentland and Archer were frequently passed over, ignored or included only as the token female by the musical establishment. "I was naïve enough to believe that if I wrote good music, *that* was what mattered," Pentland later put it. And she offered the obvious explanation: "It only came to me *poco a poco* that others thought differently, and the discrimination was very real."[226] When music composed by women was reviewed in the press, it was often considered to possess a gender-laden voice. A compilation of Coulthard's reviews during the early 1960s found her choral music "very moving" and "beautifully written." Her tribute for Queen Elizabeth's coronation—*Prayer for Elizabeth* (1953)—was, in another critic's view, a "little masterpiece in its moving sincerity." While yet another critic noted the "subtle substance" and "tonal charm" of Coulthard's *Two Sonatinas for Violin and Piano* (1945). Commenting on the predicament of being a female composer, the music critic Chester Duncan noted in *The Canadian Music Journal*: "Either listeners expect you to be nicer and weaker than other people and your music goes all watery with impressionism, or you overcompensate by developing a will like a ramrod and music like iron filings in a steel kaleidoscope." Even so, he went on to insist

226. Barbara Pentland cited in Sheila Eastman and Timothy J. McGee, *Barbara Pentland* (Toronto, 1983), 6.

that Coulthard's *Preludes* retained "their femininity without either embarrassment."[227]

Female folksingers and composers—Alberta-born Joni Mitchell and Cree First Nations songwriter Buffy Sainte-Marie, for example—fared much better. Though a generation younger than Coulthard, Pentland and Archer, they had an international following during the 1960s. And their music was heard repeatedly on the radio. It was readily available on vinyl records and as sheet music. And there were plenty of folk festivals throughout North America at which they were always welcome.

Coulthard's music suffered from *genre*-discrimination as much as from *gender*-discrimination. And the fact that she achieved recognition as British Columbia's most eminent composer of her generation was itself double-edged, given the cultural dominance of Central Canada. From the middle of the 1970s there were indeed plenty of celebrations and awards to let Coulthard know that she would not be forgotten. In 1978 she was awarded the Order of Canada and became a Freeman of the City of Vancouver. In 1984 the Canadian Music Centre made her an associate composer and the Performing Rights Organization elected her the Composer of the Year. On her eightieth birthday, in 1988, Coulthard heard her cantata for voice and orchestra, *When Tempests Rise*, premiered at the Orpheum Theatre in Vancouver. All of this sustained her in writing music into her eighty-fifth year.

Jean Coulthard's old friend, the British composer and conductor Arthur Bliss, once wrote: "Musical reputations seem to move around like the slats on a water mill, first ascending to a peak of admiration, then descending to a depth of neglect, before once more climbing the ascent towards renewed appreciation."[228] He might have been describing the trajectory of Coulthard's career. She was celebrated in her youth. Then she was marginalized as the wave of twelve-note atonal music liberated Canadian composers from Old World styles following the Second World War. Likewise, the reality of her geographical location in British Columbia alienated her from her colleagues in Toronto and from their

227. Canadian Broadcasting Corporation, *Thirty-Four Biographies of Canadian Composers,* 29.

228. Arthur Bliss, *As I Remember* (London, 1970, 1989), 192.

music. Only as she approached old age did she begin to receive her due. Now audiences reacted against atonal music in favour of Coulthard's more accessible style. She was even considered to be a pioneer composer by Postmodernist music theoreticians because, by maintaining her style, she had envisioned the emergence of a more eclectic, tonal-based music. Fortunately, Jean Coulthard lived long enough to see that the slats of the waterwheel were about to come full circle.

A Contested Reputation
BILL REID (1920–1998)

N OCTOBER 1999 British's Columbia's most prominent artist, Bill Reid, was accused of being a fraud. Writing in *Maclean's* magazine, the Toronto journalist Jane O'Hara claimed that Reid had not created all of his own work but had employed others to do it for him while giving them little credit.[229] Grudging and churlish in tone, the article seemed oblivious of the fact that generations of European sculptors had employed assistants, apprentices, technicians and designers to help them create their work. In levelling her charges, O'Hara was fully aware of Bill Reid's status, especially in British Columbia. She would not have been surprised to hear schoolchildren shout as they entered the University of British Columbia's Museum of Anthropology: "Where's Bill Reid's *Raven?*" Or to learn that *Raven and the First Men* had been compared to Michelangelo's *Pietà*. She certainly knew that few Canadians had been given so many accolades upon their death. O'Hara's claim was simple: the public had been sold a false bill of goods.

It was just over a year since Bill Reid's death in March 1998. The *Globe and Mail* had praised him for saving "an artistic tradition that was

229. Jane O'Hara, "Trade Secrets," *Maclean's*, 18 October 1999, 20–29.

in danger of being lost."[230] Writing in the same newspaper, art critic David Silcox claimed that Reid had been the first artist within living memory to raise a three-ton totem pole and to carve a dugout canoe.[231] In the *Vancouver Sun*, journalist Michael Scott told how sculptures like Reid's *Killer Whale* had transformed Vancouver's public spaces. He also maintained that Reid had rescued Northwest Coast Native art from extinction, thereby restoring "a feeling of pride to Native communities up and down the Pacific coast."[232]

Bill Reid's fame crossed many frontiers. One of his best-known works, *The Spirit of Haida Gwaii*—or *The Black Canoe* as it is also known, stood at the entrance of the Canadian Chancellery in Washington, D.C., and his death was a newsworthy item for the *New York Times*. It took longer for *The Times* in London to acknowledge Reid's death, but, when it did so, the editor of "the morgue" gave him the lion's share of the coveted obituary page. Four photographs accompanied a lengthy text that charted the salient features of Reid's life. There were images of him salvaging and re-creating Haida totem poles and protesting against logging on the Queen Charlotte Islands, as Haida Gwaii was called during the era of its Western colonization.

As with O'Hara's diatribe against Reid in *Maclean's*, there was a good deal of exaggeration in the obituary tributes. Thus it was not right to claim that Reid had retrieved a lost tradition, for the simple reason that the creation of Native art had never died out—especially in areas where First Nations people had resisted religious conversion. It was likewise incorrect to claim that Reid had made the first dugout canoe or carved the first pole "within living memory." And if it was wrong to credit Reid with single-handedly restoring the pride of First Nations people, this was surely because they had never lost it.

Myths are a powerful and a dangerous medium because they speak to the emotions rather than to the head. Here, within a year of Reid's death,

230. Miro Cernetig, "Great Canadian Artist Led West Coast Native Art Renaissance," *The Globe and Mail*, 16 March 1998.

231. David Silcox, "Lives Lived: William Ronald Reid, 1920–1998," *The Globe and Mail*, 14 March 1998.

232. Michael Scott, "A Tribute to Bill Reid, 1920–1998," *Vancouver Sun*, 14 March 1998.

Canadians had been presented with two opposing myths. If neither is true, neither is wholly false; and both are understandable. Finding any common ground between them, and understanding how Reid got from there to here, requires going back to the beginning of his life.

BILL REID WAS BORN in Victoria in 1920 to Sophie Reid, née Gladstone, a First Nations woman from Skidegate (*Hlgaagilda 'llnagaay*) in Haida Gwaii. Whether she knew it or not, Sophie's father may have been the Norwegian ethnographic collector Fillip Jacobsen with whom her mother had an affair shortly before marrying William Gladstone, a Haida from Skidegate, in 1895.[233]

Like many First Nations people of her generation, Sophie had spent her formative years in a church-run residential school far from her Native village. In 1905 it had taken her ten days to travel from Skidegate to the Coqualeetza Industrial Institute at Sardis in southern British Columbia. It was there that Sophie learned how to sew and play the piano and received sufficient academic training to gain admission to the Provincial Normal School in Victoria, where she trained as a teacher. Nor was Sophie the only Gladstone to receive post-secondary education. After graduating from high school, Sophie's sister Ella went to Vancouver's Columbia Business College while her brother Percy was the first Native person to graduate from the University of British Columbia (UBC) with a Master of Arts degree.

In 1919, at the age of twenty-three, Sophie got her first teaching job in New Hazelton (*Gitanmaax*) on the Skeena River in northern British Columbia. Shortly after taking up her post, she met William Reid, an American of German-Polish-Scottish ancestry who had moved to Canada following the First World War. "Billy" Reid was a rum runner, a speculator in gold and silver and, when he had accumulated enough money, a hotelier with successive establishments at Stewart in the Cassiar District and at Hyder on the Alaska–Canada border.

There was nothing unusual about a white man marrying a Native woman—especially if he lived in northern British Columbia where

233. Maria Tippett, *Bill Reid, The Making of an Indian* (Toronto, 2003), 20–21.

non-Aboriginal women were scarce. After all, the province's first governor, Sir James Douglas, had formed a successful "country marriage" with Amelia Connolly whose mother was a Native woman. Moreover, women like Sophie Gladstone who had survived the residential school system were exemplary homemakers—partly because they had been co-opted into running the residential school in order to pay for their room and board.

At any rate, by marrying Billy in 1919, Sophie lost her Native status. Now classified as white, she had no claim to federal assistance, no membership in the Skidegate Band and therefore no right to live on the reserve. But Sophie never forgot her roots in Haida Gwaii. She wore silver bracelets made by her father, Charles Gladstone, and by another Haida artist, John Cross. She frequently visited Haida Gwaii, and her relatives visited her in Stewart, in Hyder and later in Victoria.

It was in the provincial capital that Sophie's first son, William Ronald, was born in 1920. She had subsequent children: Margaret was born in 1921 and Robert in 1928. And it was also in Victoria, following the end of her relationship with Billy Reid, who preferred drink, casual sex and poker to his own family, that Sophie set herself up in 1932 as a dressmaker and became a single mother of the three children.

Marrying Billy Reid was the price that Sophie had paid to become legally white. Conversely, the price exacted meant losing her Native status. But while she knew that she occupied a middle ground between the Aboriginal and non-Aboriginal worlds, Sophie was determined to raise her children as white, middle-class Canadians. She made a point of sending them to genteel private schools like Alice Carr's school for infants. And when Sophie's children graduated from high school, she helped them obtain further education. Bill went to Victoria College, Margaret went on to earn a Ph.D. in psychology from London University while Robert attended art school in Toronto.

Bill Reid rarely acknowledged that, until he was twelve, he had spent his formative years in the frontier town of Hyder, in the days when his father owned a hotel there. He claimed, instead, that Victoria was his hometown. Perhaps this was because he had been bullied at the Superior School in Hyder or because he had absorbed the obvious tensions that

existed between his parents at home. But life at home and at school did not significantly improve when Bill, his two siblings, his mother and the family's companion-housekeeper, Mrs. Leah Brown, settled in Victoria in 1932. During his years at Victoria's South Park School, Bill had "a terrible image" of himself. And when he moved on to Victoria High School he was "a most unenthusiastic student."[234]

While Billy Reid was no longer a disruptive influence—the children never saw their father again after the breach—their mother was clearly unhappy. It was not uncommon, as her daughter, Margaret, recalled, for Sophie to spend "the whole weekend screaming, not just lecturing but screaming."[235] Having lived so many years in a residential school far from her own family, Sophie found it difficult to summon the emotional resources required to nurture her children. It is not wholly surprising that young Robert did not care if he drowned when, on one memorable occasion, he was swept out to sea while playing below the cliffs on Dallas Road. Or, despite receiving well-above-average grades, that Bill left Victoria College after completing just one year.

Bill was suffering from the early stages of the bipolar illness that would dog him for the rest of his life. He was also struggling with his ethnic identity. His mother had done everything she could to raise her children as white—indeed biologically they were at least half-white, and maybe three-quarters. None of Bill's boyhood friends suspected that he was Native. And he himself often claimed that he only discovered his ancestral link to the Haida people when he was in his late teens. Yet Bill must have known that he had some Native blood running in his veins. His mother had entertained her Haida siblings wherever the family happened to be living. She wore Native bracelets on her arms. And at the time of her marital crisis, she had taken her twelve-year-old son and his sister, Margaret, back to Haida Gwaii.[236]

234. Edith Iglauer, "The Myth Maker," *Saturday Night* (February 1982), 17; Bill Reid, "Curriculum vitae," *Bill Reid: A Retrospective Exhibition.* Vancouver Art Gallery catalogue (November–December, 1974), n.p.

235. Margaret Kennedy (née Reid), in discussion with the author, 28 July 1998.

236. Bill had been three and Margaret a year and a half on their first visit to Skidegate.

Sophie's father, Charles Gladstone, had been an accomplished boat builder and carpenter. He was also an artist. Despite a law enacted in 1884 forbidding the holding of potlatches and the making of ceremonial objects, Gladstone had studied under his famous uncle-artist Charles Edenshaw (also *Edenso, Tahaygen* or *Da. a xiigang*) in Old Massett (*Rad raci7waas*). Later, working from his base in Skidegate, Gladstone made silver bracelets and carved in wood and in argillite. It was there that Bill met his grandfather in 1932. Viewing Gladstone's bracelets along with those made by Tom Moody, John Cross and Moses Jones stirred Bill to become "sort of interested" in Native art.[237]

According to Margaret, her brother was always a "fiddler."[238] Bill demonstrated his artistic skills as a child by carving a miniature tea set out of blackboard chalk and an Arab dhow out of wood. But he took no formal training until, a year after leaving Victoria College, he enrolled in an evening course in life drawing taught by Allan Edwards. Drawing from the nude model scandalized the prudish citizens of Victoria. It taught Bill how to summarize and condense the salient features of the human figure onto paper with a minimum of charcoal strokes. And it introduced him to fellow students like Sid Barron, later to become an editorial cartoonist, who was experimenting with abstract painting. There was little chance, however, that Bill would be able to support himself as a full-time artist, especially in the less-than-popular abstract mode. Nor could he expect to make a living, if he had wanted to do so at the time, as a silversmith like his accomplished grandfather Charles Gladstone. So when Bill heard that Victoria's radio station CFCT was looking for someone to help them write commercials, to read the news and to spin the records—in fact, to do everything except sweep the floor—Bill applied for the job.

BILL'S SISTER, MARGARET, recalled that her brother had a nice voice and that she liked listening to it. Over the next twenty years—from 1938 to

237. University of British Columbia film, Bill Reid, *Interview.* Filmstrip (1961), Royal BC Museum and Provincial Archives, Victoria.

238. Margaret Kennedy (née Reid), in discussion with the author, 28 July 1998.

1959—Bill Reid earned his living by working as a radio broadcaster. During that time he learned how to wrap his tongue around difficult-to-pronounce words; how to read a script as though he were holding an ordinary conversation; how to fill in dead airtime with idle chat; and how to think quickly on his feet. He also learned how to hold the attention of his listeners with clever but casual, often self-deprecating, conversation. And he became a master at keeping his audience slightly off-guard by jumping from imaginative to more factual modes of discourse, or vice versa. Bill liked the fluid, non-visual medium of radio. He discovered a natural aptitude for stimulating the imagination of his listeners. He enjoyed giving the community a sense of itself by reporting gossip, by sharing confidences and by telling jokes. Rather like the protagonist in Carol Shield's novel *The Republic of Love* (1992), Reid relished having the opportunity to air his own thoughts—without being interrupted.

Working as a broadcaster taught Bill the tricks of the self-marketing trade. Most importantly, it gave him the confidence that he had lacked as a child and a young man. When he began to promote his art a few years later, Bill never hesitated to approach the person at the top, be it the director of an art gallery or a museum, the president of a university or a major art patron or critic or journalist—anyone who might help him to further his career.

As a radio announcer, Bill held down a series of jobs that took him from Victoria to Kelowna within British Columbia, to Rouyn in Quebec, and to Kirkland Lake and Windsor in Ontario. But in 1948 he was drawn back to the West Coast, where he met and married the Vancouver station's receptionist, Mabel ("Binkie") van Boyen. The same year, Bill landed a job with the Canadian Broadcasting Corporation (CBC), which took him to Toronto. It was a good time to be at the head office of the country's first national radio station. The CBC had just launched *Wednesday Night*, a programme devoted to music and literature. And its staff included the legendary broadcasters Harry Mannis and Earl Cameron. Bill was not hired to contribute to the CBC's various arts programmes but to read *Dominion News* and to host *News Round-up*.

Sadly, Billy Reid never got to hear his son on national radio; he died in Stewart in 1942 at the age of sixty-two. However, from 1949 to

1952 practically everyone else in the country heard Bill's rhythmic and declamatory voice introduce the evening news with the words: "This is Bill Reid speaking." Bill's voice even reached Haida Gwaii. "That's Sophie Gladstone's boy!" the residents exclaimed when they heard him read the evening news on the radio. Indeed, Old Massett resident Florence Gladstone liked Bill's voice so much that she was prompted to give him a Haida name: *Kihlguulinbe* "the one who speaks well."

Reading the evening news not only made Bill Reid's name known across the country. It gave him the time, since he worked the night shift, to pursue his artistic interests during the day. Several months after arriving in Toronto, the twenty-nine-year-old Reid embarked on a two-year course of study at Ryerson Institute of Technology with the intention of becoming a jeweller. Bill's hope was that "they might be able to teach me to make jewelry like my grandfather and John Cross had made for my mother in the Queen Charlottes."[239]

Bill spent two years at Ryerson, from 1949 to 1951. There he learned to use hammers and beaders, pushers and punchers, files and fine-tooth cutting saws—indeed all the tools of the jewellery-maker. He was introduced to the work of contemporary jewellers like the American Margaret de Patta, whose precious stones seemed to float above her fragile metal structures. He visited leading jewellery houses like the Dominion Diamond Company and Harry Winston. And since it had become fashionable to incorporate ethnographic motifs into designer jewellery, Bill viewed the ethnographic collection at the Royal Ontario Museum (ROM).

It was during one of his visits to the ROM that Reid discovered a totem pole from Haida Gwaii that had stood in the village where his grandmother, Josephine Ellsworth, had spent her childhood. Removed from Tanu (*T'anúu 'llnagaay*) in the late 1920s by Marius Barbeau, an ethnographer with the National Museum in Ottawa, the pole had been sawn into segments to facilitate transportation to Toronto and covered with an ugly coat of "preservative" black paint. Bill was nevertheless fascinated when he saw the re-assembled pole. At its base was a beaver; halfway up

239. Pat Lush, "A Transformer of Existing Things," *Ryerson Rambler* (Fall 1985), 10.

was a sensitively carved frog; and, at the top, was Bill's ancestral crest, the raven.

Seeing the pole from Tanu at the ROM prompted Bill to do more systematic research. He studied the illustrations in Alice Ravenhill's *A Corner Stone of Canadian Culture: An Outline of the Arts and Crafts of the Indian Tribes of British Columbia* (1944) and Robert Bruce Inverarity's 1950 publication, *Art of the Northwest Coast Indians*. He noted the subtle changes in the width and direction of the formline, the ovoid and other design elements that were fundamental to the overall structure of Northwest Coast art. And when he abstracted a Native motif onto a flat surface in order to make a brooch or a pair of earrings, he immediately appreciated the adaptability of Native art forms to contemporary jewellery.

In 1951 Bill showed his own work to his grandfather, Charles Gladstone, while on a short visit to Haida Gwaii. The Native elder was impressed. Access to power tools and to new jewellery-making techniques had enabled his grandson to produce work that was beyond his own technical capability. Bill was gratified by his grandfather's praise. He was particularly moved because he assumed—wrongly—that Gladstone and his contemporaries were the last generation of artists working within the Native art tradition. After Bill's trip to Haida Gwaii, his jewellery-making suddenly had a purpose: he would keep that tradition alive and he would take it to another level of artistic achievement. Bill knew that if he was to do this, he needed to be closer to the source, which meant moving back to the West Coast. Fortunately the CBC in Vancouver was looking for someone to read the evening news and to host a new programme, *A Man and His Music*. Bill put in his application and was given the job.

BILL REID THUS MOVED back to British Columbia in 1952, accompanied by Binkie and his two-year-old daughter, Amanda. Shortly after settling in Vancouver, he began making connections with officials in the local museum community. His first call was to the Museum of Anthropology, located in the basement of the University of British Columbia. There he found the museum's curator, Audrey Hawthorn. Reid showed her the

Native-inspired jewellery that he had made at the Ryerson Institute of Technology. Impressed, Hawthorn bought a brooch that was based on a tattoo drawing of the man in the moon, which Reid had copied from Alice Ravenhill's book on the traditional art of the Native peoples.[240]

It is not surprising that this notably sympathetic response to Reid's work came from the curator of an anthropological museum, not from the director of an art gallery. Most people still viewed a piece of Native art as either an artifact that belonged in a museum or as a souvenir that could be bought for a few dollars in a handicraft shop. Indeed, Native themes and designs were often more acceptable to the white community in their appropriated form: on the canvases of Emily Carr, as logos or emblems for non-Native societies and clubs or as advertising copy for local businesses. But even in its appropriated form there were problems, as was demonstrated in 1954 when the provincial government was accused of succumbing "to cults and fetishes" by using the totem-pole image on the province's licence plates and removed the motif.

The story would not die. In the same year, a spate of articles appeared in the province's leading newspaper claiming that totem poles were "crude monstrosities" and that the Provincial Museum's attempt to restore and salvage them was misguided.[241] Here was an overt display of racial condescension that Reid was qualified to challenge, both as a professional communicator and, of course, as an artist with Native ancestry. Writing to the editor of the *Vancouver Sun,* Reid set out the difference between the imitation totem poles that Japanese artists had been producing for the tourist trade since the 1920s and the monumental totem poles that were still standing in coastal villages from Alert Bay to Alaska. He insisted that late nineteenth and early twentieth–century Aboriginal carvings were equal to work produced by any other nation or civilization in the world. And he reinforced the sentiment that Kwakwaka'wakw artist Ellen Neel (*Kakaso'las*) had voiced when she told white educators, social workers and museum curators at the Conference on Native Indian Affairs in 1948

240. Bill made at least three brooches with this motif, which he renamed the Woman in the Moon.

241. Harold Weir, "More Totem Nonsense," *Vancouver Sun,* 16 February 1954.

that " . . .our art must continue to live, for not only is it part and parcel of us, but it can be a powerful factor in combining the best part of the Indian culture into the fabric of a truly Canadian art form."[242] As Reid now put it, if contemporary artists were to fuse Western technology with First Nations designs, Canada would have an art form that represented Aboriginals and non-Aboriginals alike.

As well as Audrey Hawthorn, Reid found another useful ally in the white community when he introduced himself to Wilson Duff, the anthropologist at the Provincial Museum in Victoria. Although Duff clung to the view that Native art was dead, he, like Hawthorn, was convinced that it was worth salvaging or replicating. When Reid met him, Duff was in the midst of planning an expedition to Haida Gwaii for the purpose of moving totem poles from abandoned villages to museums in the south.

Reid asked to be included in this expedition. In the spring of 1954 he left for Haida Gwaii, and was to join two further expeditions in 1956 and 1957, also organized by Duff. Reid's participation in these expeditions to Haida Gwaii proved seminal. He wrote and narrated a radio programme about his experience and he produced a film entitled *Totems* (1959). Following their first trip to Haida Gwaii, Duff became Bill Reid's friend and mentor on matters relating to the history of Native peoples' art and culture.

Bill Reid was by now a man with a mission, a vocation—and ultimately a career. He had a lot to learn but was a receptive pupil, and it was within the Aboriginal community that he also attempted to establish his reputation as a jeweller and to promote the production of Native art. In 1954 he offered to help his aunt, Ella Gladstone, and Tsimshian Native Hatti Fergusson organize the *Arts and Handicrafts Show* at the Vancouver Art Gallery.

Though this was another important milestone for Reid, its novelty should not be exaggerated. This was not the only occasion on which the city's leading art gallery had mounted an exhibition of Native art. In 1941 the Vancouver Art Gallery had displayed historic *and* contemporary work

242. Ellen Neel in *Report of Conference on Native Indian Affairs, Acadia Camp, University of British Columbia, April 1–3, 1948* (Victoria, 1948), 12–13.

borrowed from the Provincial Museum's collection. Nor was this the first time that Native peoples' masks and other ceremonial objects had been recognized as works of art. The German ethnographer Franz Boas had done so in his 1927 publication, *Primitive Art*. And several decades before this, it might be noted, the Rev. A.J. Brabant, a Roman Catholic missionary living on the west coast of Vancouver Island, had lauded the artistic quality of masks produced by Nuu-chah-nulth artists.[243] Indeed, Brabant had given several of them to a visiting sea captain, who put them on display in a hotel in Victoria in 1874.

The *Arts and Handicrafts Show* of 1954 was different from these previous exhibitions in two ways. Native peoples had organized the exhibition themselves and contemporary artists had made most of the work on display. There were contributions from artists living as far north as Fort St. James, as well as from Vancouver Island and up and down the mainland coast. Some of the work had been produced for ceremonial activity and was not offered for sale. Other work, clearly made for the tourist trade, was available for purchase. Thus argillite totem poles, silver bracelets, and baskets made from cedar bark and wild cherry root could be bought for twenty dollars or less. By contrast, Bill Reid's 18-carat gold bracelet was priced at the enormous sum of seventy dollars—at least seven hundred dollars in today's money. And unlike most of the work on display, it consciously fused Western technology with traditional Native art forms.

If Reid had hoped to make his name by participating in the *Arts and Handicrafts Show*, he was to be quickly disappointed. There was no opening ceremony to introduce the contributing artists to the public. There was no exhibition catalogue. (Hatti Fergusson had been unable to persuade the gallery to produce even a mimeographed list of the artists.) And because the press had stayed away, there was no critical assessment of the work. "Contrary to what most people think," Fergusson reproached one of the gallery's curators, "Indians appreciate practical criticism."[244]

243. Charles Moser, *Reminiscences of the West Coast of Vancouver Island* (Victoria, 1926), 28–29.

244. Hatti Fergusson to J.A. Morris, 13 November 1954, Box 107, Archives, Vancouver Art Gallery.

The *Arts and Handicrafts Show* was a flop. It did not achieve Reid's ambitions, either for his own work or for that of the other contributing artists. He was disappointed by the public's lack of interest. And he was disappointed by what he felt to be the low standard of work on display. He was particularly critical of Ellen Neel, who since 1949 had been earning a living by carving poles, and making silkscreen prints and souvenirs from her Totem Art Studios in Stanley Park.

Convinced that Native peoples were incapable of promoting their own work and of working to his standards, Bill turned to the white museum and art gallery community and to white patrons and critics. These were the institutions and the people who, in his view, could exhibit and sell his work, write about it and generally help him to establish his reputation as a jeweller.

In 1955 Reid took strategic steps towards achieving this when he volunteered to help the Vancouver Art Gallery mount an exhibition titled *People of the Potlatch*. Though he did not contribute his own work to the show, he covered two large panels with Native motifs that served as a backdrop for the historical work on display. With the assistance of his friend, the designer Robert Reid (no relation), he produced a series of engravings to be sold during the exhibition for two dollars each. Bill also helped the curatorial staff choose the exhibits for the show. He made a point of including silver bracelets made by Charles Edenshaw, John Cross and his recently deceased grandfather, Charles Gladstone. Bill also wrote an essay for the catalogue. In it he ranked Northwest Coast Native art according to his own taste and aesthetic preferences. Kwakwaka'wakw art was "emotional and terrifyingly dramatic." Coast Salish art was "child like" while the art of the Nuu-chah-nulth Nation was "moody and austere." Only the art of the Haida Nation was, in Reid's view, aesthetically pleasing and could be compared to the best art in Europe. This privileging of Haida over any other First Nations group not only challenged the highly popular Kwakwaka'wakw art. It was self-serving for Reid and for any other Haida artist who worked within the stylistic vocabulary of Haida art.

Reid's involvement in *The People of the Potlatch* did not end when the exhibition opened in the spring of 1956. Exploiting his personal skills and

contacts, he conducted visitors around the gallery. He gave talks about the exhibition on the CBC. And he produced and narrated a documentary film based on the show. By working with the exhibition's curators, Audrey Hawthorn and J.A. Morris, Reid was associating with people who believed, like Franz Boas before them, that the objects on display were not curios, souvenirs or handicrafts but works of art. When the Vancouver Art Gallery celebrated the province's centenary by mounting *100 Years of B.C. Art* in 1958, it was Reid who was chosen to oversee the Native section of the exhibition. Reid was thus building a reputation for himself as an advocate of First Nations art, not only through his curatorial activities but also through his writings and his radio and television programmes. In all of this, he was expanding his contacts and friendships within the museum and art gallery community in ways that proved helpful as he embarked on another phase of his career, as a carver.

IN 1951 when Bill made his short visit to the West Coast to visit Charles Gladstone in Haida Gwaii, he had observed Mungo Martin (*Nakapenkem*), a Kwakwa̲ka̲'wakw artist from Fort Rupert (*Ts'axis*), carving a totem pole at the University of British Columbia. Martin and his wife, Abayah, had moved to Vancouver in 1947 in order to help their niece Ellen Neel work on the totem poles that had been moved from villages in northern British Columbia onto the campus several years earlier. Mungo Martin was a known quantity. In the late 1930s the federal government had commissioned him to carve two seventeen-foot totem poles for the Canadian pavilion at the New York World's Fair (1939). The university's decision to bring Martin and Neel to the city over a decade later reversed the policy of keeping First Nations people as far away from the urban centre as possible. It also signalled a step towards acknowledging First Nations people as artists in their own right.

After completing two forty-foot poles for the university, Mungo Martin relocated to Victoria at the invitation of Wilson Duff. During the next few years, Martin, along with his son David and other Kwakwaka̲'wakw artists including Henry and Richard Hunt, restored and replicated the Provincial Museum's totem poles. They also constructed a

large, planked communal longhouse, or "big house," in Thunderbird Park adjacent to the museum.

Learning of Martin's activities in Victoria, Reid proposed that he himself should construct a Haida Native village on the UBC campus. He therefore approached his old friend Audrey Hawthorn and her husband, Harry, also a well-established anthropologist. They both liked the idea and told Bill to put the idea to the university's president, Norman "Larry" MacKenzie.

In a tightly argued letter to MacKenzie, Reid set out the reasons why he felt that he was the best person to create the Haida village. To "expect a modern Indian, uneducated either in the patterns of his ancestors or those of today to recreate what are essentially great artistic achievements was," he told MacKenzie, "an empty hope."[245] The crest totem poles replicated by Mungo Martin and his assistants had "somehow not quite come off." And, in any case, how, Bill continued, could a Kwakwaka'wakw like Martin be expected to work in the Haida style?

In eight pages, Reid thus declared the inferiority of contemporary Native art. He asserted the superiority of traditional Haida carving over that of any other First Nations group. He dissociated himself from the Native community by telling MacKenzie that he had been raised in the non-Aboriginal community, had only discovered his Native ancestry in his late teens and did not produce souvenirs or handicrafts, but instead made jewellery that sold for high prices. Here Reid was disclosing his ignorance of the superbly made ceremonial carvings that had often been called "souvenirs" in order to protect the artists from being arrested for producing ceremonial objects for the banned potlatch.

In his letter to MacKenzie, Reid had put himself in a pivotal position. He was knowledgeable about both modern and "primitive" Northwest Coast art. He was a skilled technician. And he could reproduce "any Haida carving from a fifty foot totem pole or canoe to the finest slate carving."[246] This was a bold claim for a man who had no experience carving a totem pole, let alone making a dugout canoe. Even so, Reid's proposal

245. Bill Reid to Norman MacKenzie, 26 September 1955, Audrey Hawthorn Papers, Museum of Anthropology, University of British Columbia, Vancouver.
246. Bill Reid to Norman MacKenzie, 26 September 1955.

caught MacKenzie's attention. It had the backing of Harry Hawthorn who, as head of the Department of Anthropology at UBC, applied to the Canada Council for a grant to support Reid's re-creation of a Haida village near the university's Totem Park. And it prompted Wilson Duff to arrange for Reid to receive training as a carver from Mungo Martin at the Provincial Museum.

"Professor M. Martin," as Bill called Mungo Martin during his ten-day apprenticeship in the spring of 1956, taught him how to use the D-edge, the elbow adze and the curved knife, along with a wide range of chisels and wedges. Reid was a quick learner. By the time his crash-course had ended, he had progressed to the point where Martin allowed him to carve a small figure on a Haida pole.

The experience of working alongside Mungo Martin not only made Reid realize that he could, as he had claimed, carve on a large scale. It made it difficult for him to return to his broadcasting job at the CBC and even to his jewellery bench. But the possibility of prolonging his apprenticeship was quashed when Martin made it clear to Wilson Duff that he needed no further assistance from Bill Reid.

It took three more years before Harry Hawthorn received a grant from the Canada Council. When it finally came through, it allowed Reid to quit his job at the CBC, to spend less time making jewellery and to begin carving on a grand scale. He thus took up full-time employment as a carver—at a much-reduced salary—in the spring of 1959. Among those with whom he worked was one of Martin's former apprentices, Douglas Cranmer (*Pal'nakwala Wakas* and *Kesu'*), a Kwakwaka'wakw artist from Alert Bay. During the next three years, Reid enjoyed being out of doors among the weather-silvered crest poles that he and Duff had brought to the university from Haida Gwaii. And he enjoyed carving new totem poles.

The legendary artist Charles Edenshaw knew, as every Native artist had known before him, that an artist could push the limits of the art form while working within the vocabulary of the design elements. This is what had given Edenshaw's work a sense of surprise. One day while Edenshaw's great-nephew, Bill Reid, was working at UBC, he "just did something that didn't relate to the old designs." As Bill continued: "It was

quite an amazing experience to look at it and realize that it was not too bad and that I could create, if not new, at least different interpretations of the old forms."[247]

Reid now went ever further than Edenshaw. He combined crests that, he later recalled, "I supposed would never really belong together."[248] He and his assistants increased or scaled down their figures in order to make them more aesthetically pleasing. And they used a chainsaw to rough out a pole before carving it. When a California film crew that had come to capture Reid carving on film heard the buzz of the power-saw as they approached the carving shed, they turned tail. Yet the crew did not leave the province empty handed. In Victoria they found an artist who still did things in the traditional way—Mungo Martin.

Reid made no secret of the fact that he did not envision spending the rest of his career carving totem poles: "It's a never-never land existence spending your time whittling poles and it's not my idea of a permanent occupation."[249] Even so, by creating house posts and mortuary poles that had no story, no ceremonial function, but were made exclusively for museum display, Reid had blurred the distinction between tradition and invention. And by hiring the Kwakwaka'wakw carver Doug Cranmer to help him, he had given future First Nations artists licence to work outside of their tribal affiliation.

Reid justified his participation in the Haida village project by claiming that he had thereby paid a debt to his ancestors. Now forty years old, he had other debts. He had given up his broadcasting job to work on the Haida village. He and Binkie had divorced in 1959 but he had ongoing commitments to his daughter. The Haida village was finished but he discovered that he could not make a living by selling his work through local craft shops and at craft trade fairs. In order to make a true profit, Reid needed another venue and another client. As he told the young art student Einar Vinge in the early 1960s, "It isn't how good you are at what

247. Richard Wright, "The Spirit of Haida Gwaii," *EnRoute* (March 1991), 92.

248. Bill Reid interviewed by Peter Malkin, *Profile of Bill Reid*, Archives, Vancouver Art Gallery, Video, 1974.

249. Olive Dickason, "Off the Haidas," *The Globe and Mail*, 23 January 1960.

you do; it's who you know."[250] Reid now set about finding people who were willing to pay high-end street prices for his bracelets and brooches.

He found some of them through his association with the museum and art gallery community. Audrey Hawthorn had been one of Reid's earliest and most steadfast patrons. From the mid-1950s on, the Museum of Anthropology curator along with her colleagues and friends spent many evenings at Reid's Vancouver studio. He was a consummate host. He treated his guests to his special variety of pancakes, fried oysters and spiked milkshakes, which he mixed in a five-gallon pail and stirred with an electric drill. He entertained them by playing the music of Joan Baez and Leonard Cohen. Then, in a non-aggressive, laidback manner, he summoned his skills as a communicator and entrepreneur to sell them his work. And he was successful. "It was very much like going to some secret society," Hawthorn recalled of the evenings she and her friends spent in Bill's studio, "because all the men and women were wearing Bill's jewelry."[251]

The public had an opportunity to see the extent to which Reid was taking the formal components of Haida art into a new realm when the Vancouver Art Gallery mounted an exhibition entitled *Arts of the Raven: Masterworks by the Northwest Coast Indian* during Canada's centennial year in 1967. As with the Vancouver Art Gallery's two other recent exhibitions of Northwest Coast Native art, Reid helped choose the historic and contemporary exhibits. He grudgingly commissioned the young Haida artist Robert Davidson, who was studying under him at the time, along with his former carving partner Doug Cranmer, to produce five works each for the show. He invited four other artists to submit work—two of whom were non-Native artists working within the Native idiom. And not least of all, Reid contributed his own work.

In the contemporary section of the exhibition Reid exhibited his pendants, brooches, boxes and magnificent bracelets, rendered in gold and silver, and sometimes with abalone or ivory inlay. There was also his argillite platter, model totem pole and panel pipe along with an imposing crouching bear carved out of cedar. Bill thereby showed everyone who visited the *Arts of the Raven* exhibition that he was as comfortable working

250. Einar Vinge, in discussion with the author, 6 August 1999.
251. Audrey Hawthorn, in discussion with Beverley Berger, March 2000.

in silver and slate as he was carving in wood. He also demonstrated that he was capable of producing work on any scale, be it an intricate brooch or a massive sculptural figure.

In his essay for the exhibition catalogue, Reid showed that he could write eloquently about Native art. For example, he wrote about the tension that existed between the rules and the artist's own imagination—a tension that resulted in the latent energy that made every object appear to inhabit its own frozen universe.

By now Reid was accepted at his own valuation. Few questioned why his work dominated the contemporary section of the exhibition; why there were no examples of Reid's recently deceased rivals, Mungo Martin and Ellen Neel; why the most accomplished living First Nations artist, William Seaweed, also Sewid (*Kwaxitola*), himself near death, was excluded from the exhibition; why Reid's contemporaries, Pat Dixon, Rufus Moody, Pat McGuire, Raymond and Howard Williams, were not invited to exhibit their work; and why, above all, Reid had ignored these artists, preferring instead to include two non-Aboriginal carvers.

Indeed, this was surely a manifestation of Reid's ambivalence about his own status. How did he now think of himself: as Aboriginal or non-Aboriginal? But no one now questioned his ethnicity in the glow of success that surrounded the *Arts of the Raven* exhibition, which had conclusively demonstrated that contemporary Northwest Coast art belonged in an art gallery, not in a souvenir shop.

REID WAS CLEARLY at the top of his game in 1967, yet simultaneously more aware of his own shortcomings than many of his new admirers, acolytes and patrons alike. During the course of collecting the historic pieces for the *Arts of the Raven* exhibition, he had been exposed to collections of First Nations art across North America. He had become acquainted with major collectors like Walter Koerner. And at the exhibition's gala dinner, Reid had met the director of the National Gallery of Canada, Vancouver's mayor, the province's lieutenant governor and everyone else associated with the province's and the country's art establishment.

As the Haida scholar Marcia Crosby later pointed out: "most aboriginal people didn't circulate in these circles."[252] But then, most Native people had not been trained as a radio announcer and thereby possessed Bill Reid's communication skills. They were not six-feet-plus in height. Moreover, many carried cultural baggage: Tony Hunt had been in jail, Pat McGuire abused drugs, and even in his youth Robert Davidson manifested some social unease simply because he had been born and raised on a reserve.

However much attention Reid received from his contribution to the *Arts of the Raven* exhibition, he was increasingly uneasy about creating what he called "artifakes."[253] As early as 1959 he told an interviewer that he had "reached a dead end" for himself at least in Haida jewelry.[254] He knew that his bracelets and cuff links meant more to the non-Native peoples who wore them than to him. As one commentator observed in 1959, Reid's art assuaged "the white man's burden of guilt" by creating "a living memory to the arts of the once great nation."[255] Reid himself spoke in a less pompous register. He often talked about his work in a cynical, flippant manner. "He will call himself a 'monument builder' in one sentence," a reporter for *Maclean's* magazine noted in 1980, "and then talk about himself as 'a maker of artifakes' in the next."[256]

Moreover, as Reid revealed in 1965, he was desperate to make jewellery that was "original" and associated with the modern idiom.[257] Aware that he needed to master more skills if he was to compete with local, non-Aboriginal, contemporary jewellers like Toni Cavelti, Reid applied for and received a grant from the Canada Council to study at London's Central School of Art and Design.

252. Marcia Crosby, "The Legacy of Bill Reid: A Critical Inquiry," Bill Reid Symposium, 13 November 1999, University of British Columbia, Vancouver.

253. Margaret Kennedy (née Reid), in discussion with the author, 23 July 1998.

254. Elizabeth Summer, "Have You Met Bill Reid," *Radio Times* (September 1959).

255. "The Totem Carvers," *Radio Times,* 21 May 1959.

256. Thomas Hopkins, "The Happy Rebirth of an Intricate Art," *Maclean's,* 14 April 1980.

257. Bill Reid, "The Indian as Artist," tape, CBC Radio [1965] Royal BC Museum, BC Archives, Victoria.

Within a few weeks of entering the Central School in the autumn of 1968, Reid was borrowing ideas from modernist sculptors and painters. And he was treating everything he produced as a work of art. Under the eye of his instructor David Thomas, Reid also honed his technical skills. He learned how to make a perfect clasp, how to make diamonds float above a delicate tracery of gold, and returning to Native motifs, how to adapt repoussé and chasing techniques to a three-inch-wide gold bracelet decorated in half-relief with his family crests: the raven and the wolf.

When Reid returned to Canada at the end of his year abroad, it was not to British Columbia. Instead he moved to Montreal, where his old friend Robert Reid was working as a book designer. It was there that Bill fell desperately in love.[258] It was also in Central Canada that his old bouts of depression became so frequent and intense that he became an outpatient at Toronto's Clarke Institute of Psychiatry.

After Reid signed off from the Clarke Institute, he moved back to Montreal. Fortified by large doses of lithium, he helped Robert Davidson demonstrate carving at the *Man and His World* exhibition at Expo 67. Dressed in a ceremonial robe, Davidson showed Reid how to stage a mock potlatch.[259] It was in Montreal that Robert Reid remembered his old friend going "all Native."[260] As Bill's girlfriend at that time, Sherry Grauer, later put it, "he became an Indian before my eyes."[261]

From 1968 to 1972 Reid shifted restlessly, back and forth, between Montreal, Toronto and New York, in an effort to market his modernist-inspired jewellery. At the jewellery bench he now moved between the European and Native idioms. He refined the repoussé, casting and soldering techniques that he had learned at the Central School of Art and Design. He opportunely combined the Funk Art of Saskatchewan ceramicists Joe Fafard and David Gilhooly with Haida and Aztec traditions. This hodge-podge of styles made the mythic and animal creatures featured on Reid's Haida bracelets and boxes more naturalistic than

258. For Bill Reid's relationship with the artist Sherry Grauer, see Maria Tippett, *Bill Reid, The Making of an Indian*, 164ff.

259. Robert Davidson, in discussion with Beverley Berger, 7 February 1999.

260. Robert Reid, in discussion with the author, 22 July 1999.

261. Sherry Grauer, in discussion with the author, 27 August 1999.

they were in traditional Native art. The tension that was the hallmark of Charles Edenshaw's work was thus diminished. Even so, what might be called Reid's High Baroque Native jewellery sold much better than his lyrical and organic modernist pieces.

So what had happened to the man who claimed to be tired of adapting Native art forms to his jewellery? Did "becoming an Indian" have something to do with it? Or was it the impact of Reid's short visits to British Columbia in the early 1970s that prompted him to tell Sherry Grauer: "I used to be an assimilationist; I now see that the way to go is to keep this [Native art] alive."[262]

Reid certainly discovered that a lot had happened since he had left British Columbia in 1968. The American civil rights movement and the response to it by British Columbia's First Nations people had made the non-Native public more aware of the social, cultural and economic deprivation of Native peoples. Moreover, Aboriginal peoples were lobbying the government more vigorously for control over their own lives by working through such organizations as the Native Indian Brotherhood and, in British Columbia, the BC Association of Non-Status Indians and the Union of BC Indian Chiefs.

Things had changed on the art front too. Reid's former student Robert Davidson was the most sought after Native artist in the province. Other artists from Haida Gwaii were pushing the margins of the traditional art form. At the Native-run Gitanmaax School of Northwest Coast Indian Art on the Skeena River in Hazelton, Gerry Marks, Freda Diesing, Dempsey Bob and Walter Harris, among others, were merging northern tribal motifs to create a new art. While a few artists, like Nuu-chah-nulth Ron Hamilton (*Ki-Ke-In*), were producing work exclusively for their own people, most were selling their carvings and jewellery through an ever-increasing number of galleries.

Reid not only discovered that there were new styles and more galleries than previously devoted to Native art. The words "salvage" and "decline" had been replaced by "renaissance," "revival" and "rebirth." In addition to this, every level of government was supporting the production and

262. Bill Reid, in correspondence with Sherry Grauer, 14 November 1970, private collection.

marketing of First Nations art. And they were also helping to expand the institutions that displayed it.

During his short visit to Vancouver in the winter of 1971, Reid had learned that the Museum of Anthropology at the University of British Columbia was to get a building of its own. Moreover, the museum's curators and its architect, Arthur Erickson, told Reid that they wanted him to help plan the exhibition space and the museum's long-time patron, Walter Koerner, wanted Reid to scale up his diminutive boxwood carving, *Raven Discovering Mankind in a Clamshell*, into a major work for display in the new museum. Bill accepted Koerner's impressive offer of $125,000 to complete the work, and then returned again to Montreal.

REID DID NOT MOVE BACK to the West Coast until the spring of 1973. When he did so, he returned in triumph, and on his own terms. Just over a year after he resettled in British Columbia, 250 examples of his work went on display at the Vancouver Art Gallery. This was the first time that the gallery had devoted its exhibition rooms to the work of one Native artist. It was the first time that the public had an opportunity to see so much of Reid's work. And it was the first time that Reid had the chance to tell his own story so fully.

Writing in the exhibition catalogue, Reid told of being raised in the white world, of discovering his Native ancestry only as an adult and of becoming an artist with the help of white institutions. Reid's biographical essay fit into the myth of the struggling artist. As in his earlier testimony to Larry MacKenzie, he deliberately dissociated himself from the Native reserve by claiming, quite misleadingly, that his mother, Sophie Gladstone, had concealed her ethnicity from her children. And Reid charted his association with the museums and art galleries, along with the art schools and patrons who had helped make his reputation.

The non-Aboriginal community could thus congratulate itself on its participation in Bill Reid's story. It now appeared that the cultivation, support and promotion of Reid's knowledge of Native culture, along with the technological know-how, had come entirely through non-Native institutions. The University of British Columbia, the Canada Council, the

Ryerson Institute in Toronto and the Central School of Art and Design in London could all bask in pride. At the same time, the public could associate Reid with the last of the great carvers—his great-uncle Charles Edenshaw—whom they naïvely assumed to have lived at a time when First Nations people had been free of the economic and social woes for which non-Native society was largely responsible.

Only one contributor to the exhibition catalogue attempted to grapple with a problem that had preoccupied Bill Reid since he had become involved in Native peoples' art and culture. How, Wilson Duff asked, could Reid create work that combines classical Haida with Western art traditions? Why, he continued, could Reid not stop talking about "artifakery?" And what, he demanded, was the origin of "the haunting doubt in this birth of a new art form from an old style, this birth of new melodies from old rhythms?"[263]

The other contributors to the catalogue—the American anthropologist Edmund Carpenter and UBC's Harry Hawthorn—took another tack. They could not stop talking about how Reid had been responsible for revitalizing a dying art. No wonder the artist himself used one word to describe *Bill Reid: A Retrospective Exhibition* to a friend: "smashing."[264]

When Reid's retrospective exhibition had opened in November 1974, he could already sell a gold bracelet for $4,000. After the exhibition closed, the value of his work rose dramatically. And there was more of it than ever before. *Raven and the First Men*, commissioned by Koerner in 1972, was completed in 1980. In the late 1970s, Reid carved a pole in Skidegate, which was raised in 1978. Other large-scale commissions followed: the *Killer Whale*, or *Chief of the Undersea World*, installed at the entrance of the Vancouver Public Aquarium in 1984; the 8.5-metre-long, low-relief bronze carving for Teleglobe Canada, *Mythic Messengers* (1985); the *Loo Taas* (also *Luutaas* or *Loo-Taa*) created for Expo 86; *The Spirit of Haida Gwaii* (also known as *The Spirit Canoe* or *The Black Canoe*), originally for the Canadian Chancellery in Washington D.C. in 1991, and

263. Wilson Duff, *Bill Reid: A Retrospective Exhibition,* Vancouver Art Gallery, 1974 n.p.

264. Bill Reid, in correspondence with Peter and Sandi Page, January 1975, private collection.

replicated four years later at the Vancouver International Airport for a record-breaking $3,000,000.

All of these works were excitingly innovative. Some were inspired by earlier twentieth-century Haida carvings. Others were adapted from Reid's smaller-scale jewellery and carvings. Much of it, like Reid's *Raven and the First Men*, was a hybrid of styles that combined Native and Western art forms. Anti- modernist and nostalgic, the *Raven* fused classical human anatomy with traditional Native design in a new way. If the concept of Postmodernism had been popular at the time, Reid's *Raven and the First Men* would have fit the bill.

Significantly, all of the large-scale work Reid produced was recognizably based on West Coast Native motifs that had existed in one form or another for five thousand years. Above all, none of the work that he produced had anything to do with salvage anthropology: it had not been appropriated, stolen or bought for a token fee from a Native elder. It was, from the white community's point of view, thus free of any taint of white liberal guilt. But Reid's position was paradoxical. In 1985, the year of his mother's death, Bill applied for, and received, status as a Native person, following an amendment of the Indian Act. Yet the work he was producing had little to do with the ceremonial practices of Native peoples.

Robert Davidson, who has deep roots in the Haida community, was troubled on this score. During the Museum of Anthropology's exhibition *Bill Reid: Beyond the Essential Form* in 1986, Davidson said that it was about time Reid put his work into a ceremonial context. Reid's thoughts on these matters showed a different sensibility. "Robert's main criticism," he observed, "seems to be that I don't whoop and holler." [265]

VIRTUALLY HIS OWN SPIN-DOCTOR, Bill Reid encouraged the public to engage with the production of everything he created. Using his connections with the media, he gave radio and television interviews. He allowed film crews into the carving shed on Granville Island. And he prepared

265. Eve Johnson, "Revivalist Reid and the Indian Image," *Vancouver Sun*, 9 August 1986.

a text that provided his interpretation of the creation myth depicted in *Raven and the First Men*.

When Reid embarked on the *Loo Taas* in the mid-1980s, the press documented every stage of that project. First, there was the fundraising to pay for the project; next, the quest for a suitable log—a 750-year-old, 200-foot-long tree was eventually found; then, upon completion, there was the image of the canoe leading the VIP flotilla at Expo 86. After this, *Loo Taas* was paddled down the Seine River in France from Rouen to Paris to celebrate the eightieth birthday of the internationally celebrated French anthropologist Claude Lévi-Strauss. All of these events were publicized in graphic detail.

But what did Reid's work mean: to himself, and to the public? In 1990 he told the arts reviewer Max Wyman that "the dialogue between me as an urban twentieth-century product of this particular culture and this twentieth-century thing has produced some quite remarkable pieces." This high claim was then modulated. "What they symbolize," Reid continued, "or what their significance is, I don't know. They're just nice things—and that's all they have to be."[266]

But Reid's carvings had more than an aesthetic meaning for him. For example, he conceived the idea for *The Spirit of Haida Gwaii* after observing a fractious family on a Sunday outing to Vancouver's Stanley Park. His preliminary carving, not surprisingly, featured a white steersman standing in the centre of the canoe. In a subsequent version, the white family was replaced with Haida people and mythical creatures. Thus to the political scientist James Tully, *The Spirit of Haida Gwaii* had become a metaphor for the constitutional debate that was dominating Canadian politics at the time, because it represented the country's cultural differences through mutual recognition, continuity and consent.[267] For Robert Davidson the work had a more profound meaning. It showed that the Haida "were all in the same boat" and, Davidson continued, that they had "all come from that

266. Max Wyman, "Modest Artist Wins $100,000 Award," July 1990, Bill Reid clipping file, Archives, Vancouver Art Gallery.

267. James Tully, *Strange Multiplicity, Constitutionalism in the Age of Diversity* (Cambridge, 1995), 1–34.

holocaust."[268] As for Reid himself, the meaning of *The Spirit of Haida Gwaii* had morphed from the image of a family outing in the park to a representation of "the kernel of the founding nations."[269]

But how, one might ask, was Reid physically able to complete his later large-scale commissions? In the early 1970s he was diagnosed with Parkinson's disease, a devastating affliction that promised resting tremors, slurred speech, loss of balance and the horror of being trapped in a pain-racked body, which reduces the sufferer to a shuffling gait. Yet Walter Koerner, who commissioned *Raven and the First Men* in 1971, had been undeterred when Reid informed him of the diagnosis. He simply advised Reid to hire assistants to do the physical work for him. He also told Reid: "I will help support the staff whom you select to carve it."[270]

There was, after all, nothing unusual about a sculptor having assistants. France's Auguste Rodin, Britain's Barbara Hepworth and Henry Moore were simply following the example of Renaissance sculptors of the calibre of Michelangelo, each of them employing help to scale up their maquettes. Native artists likewise customarily had assistants to help them carve a pole or a canoe. And Reid was no exception.

But worse was to come. As his condition deteriorated, Reid's shaking hands made it difficult for him to draw with his mechanical pencil or to carve or to engrave or even to model in clay. This meant, for example, that although he could produce the four-inch maquette of *Killer Whale*, it was the Haida artist Jim Hart who carved the four-foot model that George Rammell subsequently used to make the eighteen-foot-high clay plaster cast, from which the bronze was made at the Tallix Foundry in Beacon, New York. Reid had as many as nine assistants working on his larger projects. Some of the Native artists he hired did not belong to the Haida nation. And he also employed non-Native artists, notably George Rammell, who worked on more than one project. Others came and went.

268. Robert Davidson, "Voyage Through Two Worlds: The Sculpture of Bill Reid," *Border Crossings* 2, no. 4 (December 1992).

269. Christopher Dafoe, "An Odyssey of Mythic Proportions: Bill Reid's *The Spirit of Haida Gwaii,*" *The Globe and Mail,* 16 November 1991.

270. Audrey Hawthorn, interview, March 2000, private collection.

Many of Bill's assistants left their signature on his work. Rammell's curvilinear and animated style, along with his contextual shift from Native to Western high-art conventions, was evident in *Raven and the First Men*.[271] Others, like the goldsmith Jeffrey Miller and the jeweller Grace Mooney, helped Bill make his smaller bronze, gold and silver pieces. And Gitxsan artist Phil Janzé had sole control over the design and execution of the talking staff for *The Spirit of Haida Gwaii*.

But however many hands were involved in the production of the work, and even in some cases the design, Reid's own critical eye scrutinized every stage of a project, be it the making of an intricate piece of jewellery or the carving of a monumental totem pole. And when he was not happy with the work, he acted. During the production of *Raven and the First Men*, for example, Reid was so displeased with how one of his assistants had rendered one of the figures' arms that he took a saw and cut it off. Needless to say, the assistant re-carved the arm, to Reid's satisfaction.

There were problems with acting as what Renaissance artists called the *Capomaestro*, or master builder. The Haida artist Gary Edenshaw (Guujaaw) left a project in a huff when he learned that Reid had hired not just non-Haida artists but non-Natives, like George Rammell, to help him. Gary Edenshaw had no problem with collaboration in itself. Rather, he was displeased with having to follow Reid's carefully worked-out calculations. Edenshaw would have preferred to carve the Skidegate pole intuitively, in the way that the Haida had always worked. But Reid frequently showed as little respect for Aboriginal traditions as for the skills of his Aboriginal assistants. "I almost had to tell the natives which end of the hammer to hold," he told one reporter.[272]

If the process of collaboration was entirely honourable, there was surely nothing to hide here. Yet many of the collaborators wondered why they were given so little credit for doing the lion's share of the work. And why they were deliberately excluded from the public presentation of major pieces. When Rammell was not invited to the unveiling of *The Spirit of*

271. George Rammell, "The Authentic Master, Bill Reid," *Vancouver Sun*, 30 October 1999.
272. Lloyd Dykk, "Arts and the Man," *Vancouver Sun,* 6 August 1983.

Haida Gwaii at the Chancellery in Washington, he commented sourly: "I did most of the work on that and I didn't even get an invitation."[273]

On the other hand, it is notable that Reid showed himself most willing to join forces with the Haida people, even at a cost to himself, when it meant protecting the wilderness landscape. In 1985 he sat in front of the dazzling lights of a logging truck to protest the logging of the south slope of Lyell Island in Haida Gwaii, albeit without immediate effect on the project.

More strikingly, Reid later helped give the Haida Nation political clout when the provincial government, under the premiership of Bill Vander Zalm, refused to settle Haida land claims. In response, Reid dramatically abandoned work on *The Spirit of Haida Gwaii* destined for the Canadian Chancellery in Washington. This time his intervention was successful: the South Moresby archipelago became the Gwaii Haanas National Park. Reid withdrew his protest and work resumed on *The Spirit of Haida Gwaii.*

It was the land rather than the songs or the dances or even the language of the Haida people that mattered to Bill Reid. He had connected with the environment during his visits to Charles Gladstone, during his salvaging expeditions with Wilson Duff and during the carving of the totem pole in Skidegate. This was surely what shaped Reid's sense of Native identity because, unlike cultural traditions, the land had not changed and was, he felt, worth preserving.

In his later years, Reid not only had a group of dedicated assistants. He had the help of Martine de Widerspach-Thor, whom he married in 1981. The young anthropologist possessed a clear vision of the direction in which Bill and his work should be moving. She was conscious of his ancestral link to Charles Edenshaw. And, above all, Martine J. Reid as she became known after their marriage, insisted that her husband was a born maker who could slip into the Native peoples' past with ease.

During the last two decades of Bill's life, Martine became the major entrepreneurial force that helped turn his "artifakes" into a serious financial proposition. Scaled-down gold and silver replicas of his major

273. George Rammell, in discussion with Beverley Berger, 13 November 1998.

carvings and pieces of jewellery were offered in limited editions—at a price. Money was certainly needed. During the last decade of his life, Bill Reid was a very sick man. Care was expensive. And Parkinson's disease made it more difficult for him to create the maquettes on which his larger works were based.

Bill Reid died in his seventy-ninth year in 1998. He was to be remembered in many different ways. While his work was there for all to see in Vancouver's airport, aquarium and museums, some felt uncertain whether his fame would survive in the long run. "He was famous because of himself," suggested Michael Ames, the director of the Museum of Anthropology. "Without the person himself around with that charisma, how much of his work will carry on?"[274] Martine Reid was certainly there to ensure that her husband's reputation lived on. A year after Bill's death she helped establish the Bill Reid Foundation, which is committed to preserving his art. In 2008 she was the force that brought Vancouver's Bill Reid Gallery of Northwest Coast Art to fruition.

Reid's reputation needs no false claims to sustain it. He was not the first twentieth-century Native artist to carve a totem pole or a dugout canoe. Nor did he "revive" winter ceremonies—long before the anti-potlatch law was rescinded in 1951, those who had resisted conversion had continued to hold potlatches. Reid's younger contemporaries, Robert Davidson and Tony Hunt, were certainly better carvers. Douglas Cranmer and William Seaweed were more imaginative. And the next generation after Reid— from Jim Hart, Richard Hunt and Don Yeomans to Dorothy Grant, Ron Hamilton, Susan Point, Lawrence Paul *and* Robert Davidson—would take the Native art form further than anyone could have imagined during Reid's own lifetime. But, as Yeomans put it, it was nevertheless Bill Reid who "made the world fall in love with what we do."[275]

Not that Reid's success guaranteed the success of other First Nations artists. Making and marketing Native peoples' art within the white community could be difficult for those artists who lived on a reserve, who did not have the right clothing or communication skills to make an impression at

274. Michael Ames, in discussion with Beverley Berger, 17 February 1999.
275. Don Yeomans, spoken at "A Bill Reid Tribute," 24 March 1998, Museum of Anthropology, Vancouver.

an opening of their work "down south." Robert Davidson reflected that "Bill had a talent and a connection to a broader audience," seen in his media skills, "whereas people on a reserve are a lot more sheltered, you know, not so trusting because so much trust has been taken away from us because of all of the broken promises, because of losing so much of our culture and who we are."[276] Yet Reid taught Davidson and other First Nations artists how to make connections in the museum and art gallery world and how to market themselves and to get the best price for their work. Through Reid, Davidson came to feel that he could listen to Mozart, drink fine wine and eat good food without losing his credibility as a Native artist.

Reid demonstrated that First Nations art—both past and present—was worth taking seriously because it was comparable to that of any other nation. He was not the first Native artist to combine Western technology and Western motifs and styles with Native peoples' art. But by incorporating non-Native sensibilities and non-Native techniques into Native peoples' art forms—and by doing this within the white community, Reid created an art that spoke to all Canadians. The sheer quantity, calibre and inventiveness of his work shifted the thinking of anthropologists and museum officials and gallery curators alike. After Reid, the words "decline" and "decay," so freely applied to Native peoples' culture and their artistic production throughout most of the twentieth century, had become outdated terms.

It should not be thought that Reid gave Native peoples back their pride: what he gave them was markets, critics, curators and venues for their art in the non-Aboriginal world. Should Reid be seen, then, along with Emily Carr perhaps, as an appropriator of First Nations culture? No. It is simplistic to demand whether or not Bill Reid was "Indian," whether he was born Haida or white, or whether he opportunely remade his identity. Instead, we should listen to what Chief Miles Richardson of the Haida Nation said at Reid's memorial feast in July 1998: "Doctor, lawyer, Indian Chief—at first I used to get annoyed, but after Bill I am used to it."[277]

276. Robert Davidson, discussion with Beverley Berger, 7 February 1999.

277. Miles Richardson, spoken at Bill Reid's memorial feast, Skidegate, British Columbia, 3 July 1998.

Beyond Provincialism
ARTHUR ERICKSON (1924–2009)

O N 14 JUNE 2009, a few weeks after the death of Arthur Erickson, some eight hundred people gathered at Simon Fraser University (SFU) to pay tribute to the architect's life. They assembled under the three-hundred-foot-long glazed roof covering the central mall that Erickson had designed with Geoffrey Massey in the early 1960s. Phyllis Lambert, the founding director of the Canadian Centre for Architecture in Montreal, spoke eloquently about Erickson's beautiful "mind and spirit" and noted how his attachment to the land was "particularly Canadian." Abraham Rogatnick, Erickson's long-time friend who would be dead himself within two months, thought of the architect in more poetic terms: "Arthur was eloquent with words, but he became most renowned as an artist/architect whose life and whose work can be seen as a long, lyrical, but silent poem, a song without words." And landscape architect Cornelia Hahn Oberlander, who had worked on such signature projects as Erickson's three-block Robson Square development in the centre of Vancouver and the Museum of Anthropology at the University of British Columbia, praised him for having stimulated "new thoughts of how we should live and socialize in the city."[278]

278. Cornelia Hahn Oberlander, "A Tribute to Arthur Erickson," *Canadian Architect,* 1 October 2009.

This eulogistic tone was echoed in newspapers and magazines across Canada and around the world. Here was a man, according to a writer for Britain's *Guardian* newspaper, who had rubbed against Canada's "petty, Presbyterian sensibilities that confuse parochialism with patriotism" in order to design buildings that "embodied the Canadian ideal at its most promising: clean, contemporary design, rooted in natural inspiration, open to the world."[279] In *Maclean's* magazine, the writer Nancy Macdonald described Erickson more simply: "A Canadian Icon."[280] And she was right. Erickson was deemed "by far the greatest architect in Canada, and maybe the greatest on the continent," by the doyen of American architects, Philip Johnson, who had advanced the International Style in the United States well before the Second World War.[281]

No other Canadian architect had won so many prestigious design awards. Erickson was the first Canadian to receive the American Institute of Architect's gold medal and France's Auguste Perret Award, fittingly named after the first architect of his generation to explore the potential of ferroconcrete. No other Canadian architect had received so many honorary doctorates, nor been elected an honorary fellow of so many professional institutions—from Mexico and the United States to Scotland and Spain.

David Covo and Barry Johns, both professors from McGill University's School of Architecture where Erickson had received his degree in 1950, thought that it was his "unique" personality that accounted for his success: "Arthur was like his buildings—gentle and dignified, impeccable in manner and dress, eloquent and courageous."[282] Erickson's first biographer, Edith Iglauer, had likewise noted, almost thirty years earlier, how Erickson's architectural style was "unique" and had been variously defined—"as lyrical, cool, daring, romantic, monumental, contemporary,

279. Hadani Ditmars, "Remembering Arthur Erickson's architectural triumphs," *The Guardian*, 2 July 2009.
280. Nancy Macdonald, "A Canadian icon rediscovered," *Maclean's*, 4 June 2009.
281. Edith Iglauer, *Seven Stones* (Madeira Park, 1981), 11, 12.
282. David Covo and Barry Johns, McGill School of Architecture, online article about Arthur Erickson, 1 June 2009.

classical, derivative, original, neo-Inca, timeless, modern—and sometimes as just breathtakingly beautiful." Indeed the extent to which Erickson had worked within and outside of so many styles made one architect exclaim: "Why, Arthur doesn't even follow himself!"[283]

What few commentators had dared to note immediately following his death were things that most people already knew. Erickson's buildings had a reputation for leaking; Toronto's Roy Thomson Hall was acoustically inadequate; Erickson's hostility to Postmodernist styles and to theoretical models had alienated him from the architectural community. Moreover, his indifference to business matters, coupled with his extravagant lifestyle, had led to personal bankruptcy. Unlucky in love as well as in business, Erickson had lost one lover to AIDS and another to suicide.

ARTHUR CHARLES ERICKSON was born in Vancouver on 14 June 1924. His parents, Oscar and Myrtle Erickson (née Chatterson), had been married in Winnipeg in 1919 before moving later that year to Vancouver, where Oscar established the western branch of the Toronto-based dry goods firm, E.H. Walsh & Company. Within a couple of months of their arrival on the West Coast, Oscar and Myrtle began overseeing the construction of a house. Situated on the edge of Shaughnessy Heights, the Erickson residence was not only located in Vancouver's most exclusive district it was purpose-built in a peculiar way for a specific reason.

Oscar Erickson was a First World War veteran who had received the Military Cross from King George V. While serving with the Winnipeg Grenadiers' 78th Battalion in France in August 1918, Oscar had lost both of his legs in the Battle of Amiens. Stairs were a challenge, so the ground floor of his new house was constructed at street level. Driving was easier for Oscar than climbing stairs; he owned one of the first hand-operated vehicles in the country.

Oscar had been a tennis and track champion before the Great War. After it he had to confine himself to less challenging sports. He did not complain about his infliction, least of all to his two sons—Donald was born in 1928. Thus Arthur was brought up to see his father as perfectly

283. Edith Iglauer, *Seven Stones,* 19.

normal and "to think that he could do anything."[284] If Oscar had any regrets it was that his eldest son took no interest in sports or in Boy Scouts or in the Seaforth Cadets. "I can't click my heels fast enough!" Arthur complained to his mother.[285]

Oscar had been born in the United States in 1890. Like many of his Swedish ancestors, he was hard-working, orderly and practical. A successful businessman, he became a staunch royalist and a member of the Anglican Church. Oscar's five-year-younger wife, Myrtle, was different from her husband in virtually every way. She was a Christian Scientist and made sure that her two sons likewise attended her church until they were in their early teens. She was impractical, disorderly, strong-minded, unpredictable and unabashedly optimistic. Decades later, Arthur declared that there had been three influential figures in his life, of whom his mother was the first. "Everything she did," he fondly recalled in 1969, "was very original."[286]

It was amid the mix of chaos and order created within the Erickson household by Oscar and Myrtle's dissimilar personalities that Arthur grew up. Moreover, the boy's world did not just revolve around his immediate family. "My mother," Arthur recalled, "was a great enter-tainer and there were always interesting people about."[287] The stream of visitors included Arthur and Donald's young friends, Oscar's busi-ness acquaintances, one of whom brought the boys exotic gifts from his travels in Japan. Myrtle's artist friends and fellow members of the Women's Auxiliary, who helped establish the Vancouver Art Gallery in 1931, were in and out of the house too.

Every Sunday during his youth, Arthur's flamboyant English-Irish maternal grandparents, Charlie and Sadie, visited the Erickson home. In the afternoon Sadie took Donald and Arthur on long walks during which they collected mushrooms, pebbles, moss and leaves. And when the boys returned home, they listened while Charlie pitched his radical,

284. Arthur Erickson in discussion with Mr. Takahashi, 13 November 1969, in *Speeches by Arthur Erickson* (Vancouver, ca. 1978), 77.

285. Edith Iglauer, *Seven Stones*, 38.

286. Arthur Erickson in discussion with Mr. Takahashi, 13 November 1969, in *Speeches by Arthur Erickson*, 78.

287. Edith Iglauer, *Seven Stones,* 38.

left-leaning views across the dinner table at their politically conservative father. Little wonder that, as Arthur later put it, these conversations marked the "beginning of my education."[288]

It is no exaggeration to suggest that Myrtle—and to a lesser extent, Oscar—indulged their precocious son for whom "the world was a source of endless wonder to be investigated, collected, dissected [and] befriended."[289] Myrtle turned a blind eye to the culture of worms that her son kept in the bread cupboard to provide food for his tropical fish. She tolerated the evil-smelling jars of water that contained the microbes and bacteria to be examined under Arthur's made-for-children microscope. And when the young boy expressed an interest in art, Myrtle encouraged that activity too. Arthur first produced modest watercolour paintings alongside his hobbyist-artist father. But it was his mother, also an amateur painter though in a more modern idiom than her husband, who allowed her son to express himself on a more ambitious scale. Myrtle gave her son licence to cover the walls of his upstairs bedroom with underwater scenes copied from *National Geographic* magazine.

Although Myrtle and Oscar facilitated their son's early interest in painting, it was his Point Grey Junior High School artist-teacher, Jessie Faunt, who introduced Arthur to the work of the Impressionist and Post-Impressionist painters. Faunt also taught Arthur the rudimentary concepts of design. "I *really* began painting then," he claimed in hindsight, "I remember being absolutely overwhelmed by a sudden vision of the grand design that pervades nature, the sense of everything's following a certain rhythm."[290] Faunt not only expanded the boy's artistic horizons, she also encouraged him to exhibit his work. In the autumn of 1941, during Arthur's last year at Prince of Wales High School, he contributed three pastel drawings—*Negro Town*, *Seascape* and *Forest*—to the Vancouver Art Gallery's tenth annual BC Artists' Exhibition.

At seventeen years old, Arthur was not, as is often claimed, the youngest artist to have exhibited his work at the city's leading art

288. Arthur Erickson, *The Architecture of Arthur Erickson* (Vancouver, 1988), 17.

289. Arthur Erickson, *Architecture of Arthur Erickson* (Montreal, 1975), 11.

290. Edith Iglauer, *Seven Stones,* 42.

gallery. A year earlier, Bill Massey, who would soon enter the Jesuit order and become known as Father Dunston, had been given a solo exhibition in the same venue at the age of sixteen. It is highly creditable that Erickson received honourable mention for his work, *Forest*, but he had undoubtedly benefited from the advantages of his home milieu. It was Arthur Erickson rather than Bill Massey who had already received crucial encouragement from one of Canada's best-known painters, the former member of the Ontario-based Group of Seven, Lawren Harris.

In the mid-1930s, Harris and Bess Housser had caused a scandal in Toronto when they left their former spouses in order to marry each other. The couple fled, first to the United States, then to Mexico, where they remained for five years; and in the autumn of 1940 they finally settled in Vancouver. It was shortly after Lawren and Bess arrived on the West Coast that another artist, Nan Cheney, introduced the couple to Oscar and Myrtle Erickson.

Well aware of the fame of the Group of Seven, Arthur anticipated Lawren Harris's first visit to his home with "great excitement." During it he proudly showed Harris his pastel sketches, notably one depicting the Black Tusk in Garibaldi Park. Then the sixteen-year-old boy waited for a response. "I was looking for somebody to say, well, you are a genius, just devote your whole life to it, but they didn't."[291] All that Harris came up with were three words: "swell . . . just swell."[292]

Although Harris was now working almost entirely in the non-objective idiom, he continued to draw inspiration from the landscape. An avid hiker, he revisited his old sketching grounds in the Rocky Mountains. Closer to Vancouver, he climbed the North Shore Mountains with J.W.G. ("Jock") Macdonald, then a teacher at the Vancouver School of Decorative and Applied Arts. Sensitive to the mountainous landscape, Harris thus responded favourably to young Arthur's pastel drawing of Garibaldi Park's majestic sentinel when he first saw it on his visit to the Erickson home.

291. David Stouck, *Arthur Erickson, An Architect's Life* (Vancouver, 2013), 22.
292. Arthur Erickson, "Foreword," in Peter Larisey, *Light for a Cold Land: Lawren Harris's Work and Life—An Interpretation* (Toronto, 1993), vii.

The pencil sketch that formed the genesis of Arthur's Black Tusk pastel had been made during a trip to Garibaldi Park with the Botanical Club. When Arthur returned home, he had transformed his rudimentary drawing into a finished work by adopting an abstract style that owed its inspiration to Paul Cézanne and by choosing a palette redolent of the muted tones employed by Georges Braque. The result was a highly sculptural rendering of the Black Tusk.

Erickson had predecessors who had also sought to capture the imposing monumentality of the mountains in Garibaldi Park. During the 1930s Jock Macdonald and his colleague, another former Group of Seven member F.H. Varley, along with local artists like Paul Rand and W.P. Weston, had sketched in Garibaldi Park's alpine meadows. As Macdonald recalled, the meadows were carpeted with wildflowers. The emerald lakes and glaciers were fractured with rose-madder and turquoise-blue. And, depending on the time of day, the mountains could appear to be black, ochre or Egyptian red.[293] These painters had inspired a younger generation of artists to capture the mood and the feeling of the coastal landscape in their oil sketches and watercolour paintings too.

Erickson was, therefore, far from alone in adapting an abstract style to the West Coast landscape. By 1941 other local artists, including Bea Lennie and Erickson's former teacher, Jessie Faunt, as well as photographer John Vanderpant, and latterly Jock Macdonald, were all working in the abstract mode. Moreover, within a year of arriving in the city, Lawren Harris celebrated this genre by mounting an exhibition of abstract painting at the Vancouver Art Gallery in the late autumn of 1941. It was this *Exhibition of Abstract Art* to which Harris now invited Arthur to contribute his pastel drawing of the Black Tusk.

His inclusion in Vancouver's first comprehensive exhibition of abstract painting made Arthur take himself seriously as an artist. During his last year of high school he enrolled in classes at the Vancouver School of Decorative and Applied Arts so that he might hone his skills. Jack Shadbolt taught him painting and B.C. ("Bert") Binning, drawing. "Bert's course was the most memorable," Erickson later recalled—again

293. J.W.G. Macdonald quoted in *F.H. Varley Paintings, 1915–1954* (Toronto, 1954), 7.

with some hindsight—because it left "an indelible mark on my drawing style, for he taught me the beauty of the less detail, the better."[294] And Arthur became closer to Lawren Harris.

Many people in British Columbia's art community came to resent the enormous influence that Harris wielded at the Vancouver Art Gallery. Some thought that the former member of the Group of Seven and an heir to the Massey-Ferguson fortune lacked critical judgement. (He accepted virtually every work that was put before him for exhibition— with the exception of those depicting the nude.) Harris's most severe critic, however, was the young art teacher Jack Shadbolt. The atmosphere at Bess and Lawren's Saturday evening soirées, or musical evenings as they were also known, struck Shadbolt as rarified, even precious. Harris's answers to his searching questions were "too pat." Harris's commitment to non-representational painting, a form of abstract painting that had no connection to the natural world, grated against Shadbolt's belief that an artist had a duty—especially during the war—to address social issues in his or her work. And Harris's domination of the Vancouver Art Gallery, which Shadbolt claimed, "he practically ruled," was as unpalatable as his esoteric "religion," Theosophy.[295]

Erickson disagreed. The well-mannered neophyte was at an impressionable age and found himself comfortable in the genteel atmosphere of Bess and Lawren's palatial home. He relished listening to Harris's collection of 78-rpm recordings of classical music and he loved hearing Harris expound on his own latest abstract painting, which would be conveniently propped on an easel in the corner of the living room. Arthur enjoyed being introduced to the other guests, among whom were the city's leading writers and artists, musicians and composers. Above all, Arthur was mesmerized when Harris spoke about transcendentalism, the universality of life and other matters relating to Theosophy. Indeed Harris's "non-material approach to the world," enabled Erickson, as his biographer David Stouck has rightly

294. Arthur Erickson, "Introduction," in Abraham J. Rogatnick, *BC Binning* (Vancouver, 2006), x.

295. Jack Shadbolt, "A Personal Recollection," in *Vancouver Art and Artist, 1932–1983* (Vancouver, 1983), 40.

observed, to make "a smooth and logical transition from a Christian Science upbringing to the more subtle, spiritual religions of the East."[296]

Little wonder that Arthur called Harris "a Canadian Titan" and was to put him, alongside his mother, among the three most influential people in his life.[297] Little wonder, too, that Arthur adopted traits of Harris's personality. Erickson began to rely less on analysis and reason and more on his own instinct—what he later referred to as "the unconscious ocean we carry within us."[298] Already detached from his classmates at high school, Erickson became even more aloof. This manifested itself in his tardiness and in indifference to others. Rather like his mother, Myrtle, he now displayed a willful determination to be different from everyone else. Depending on the observer, therefore, Arthur could appear arrogant, mystical or serene. Indeed one commentator could not make up his mind whether he was a poet, a pagan or a priest.[299]

For his part, Harris recognized young Erickson as a sensitive spirit who had the potential to become a fine artist. Even so, Harris never attempted to turn his young protégé into a clone of himself. When Arthur sought the older man's counsel a few years after they first met, he was firmly told that "it would be a mistake to advise about your life."[300] This itself may have been good advice in general, but this particular headstrong, willful boy hardly needed encouragement to rely even more on his own instinct and to go his own way.

OSCAR ERICKSON HAD HIS OWN IDEAS about his son's future. He wanted Arthur to do something practical and vainly suggested studying engineering. If not, then perhaps architecture—but that, in Arthur's later

296. David Stouck, *Arthur Erickson,* 26.

297. Arthur Erickson, "Foreword" in *Light for a Cold Land,* vii.

298. Arthur Erickson, "Thoughts on Architecture: A Personal View," unpublished manuscript, (Montreal, 1999), cited in Nicholas Olsberg and Richard L. Castro, *Arthur Erickson: Critical Works* (Vancouver, 2006), 99.

299. Christopher Thomas, "Reconciling the Universal and the Particular: Arthur Erickson in the 1940s and 1950s," SSAC *Bulletin* no. 2 (June 1996), 36.

300. Arthur Erickson, "Foreword" in *Light for a Cold Land,* viii.

recollection, "didn't seem particularly interesting to me."[301] Though Myrtle hoped her son would pursue a career in art, Arthur was decreasingly confident that he could become an artist. "My painting ideas were original, but I wasn't very good technically."[302] Consequently, after graduating from high school in 1942, Erickson stopped taking lessons at the Vancouver School of Decorative and Applied Arts and enrolled in a general course of study at the University of British Columbia (UBC).

Arthur had a rewarding first year—at least out of the classroom. He joined the university's Players Club, he helped make the sets, and on one occasion he trod the boards as an actor. He indulged his passion for dancing; Blackie Lee, and then Diana Chesterton became his favourite dancing partners. Bandleader Dal Richards often provided the music. Arthur continued to hike in the local mountains and to attend Lawren and Bess Harris's Saturday evening soirées. During the summer vacation, he and a college friend worked in a logging camp located in Quatsino Sound at the northern end of Vancouver Island. And at the beginning of his second year of university—which marked the third year of the Second World War—Arthur joined the Canadian Officers Training Corps in order to prepare himself for military service, naturally as an officer, like his heroic father.

Arthur, along with many of his fellow students, was soon clicking his heels on a military parade ground. This time he was following the commands of the university physics professor, Gordon Shrum, a much-decorated First World War veteran who would play a significant role in Erikson's later career. Halfway through the year, however, this conventional military regime ended when Arthur was singled out for special training as a translator and interpreter of the Japanese language.

In December 1941 Japan's Imperial Forces bombed the American naval base at Pearl Harbor in Hawaii. This brought the United States into the Second World War, more than two years after Canada. It also meant that Japan became Canada's enemy too. While there is little evidence to suggest that anyone in the Japanese-Canadian community posed a threat to the country's security, the Canadian government nevertheless

301. Arthur Erickson, *Architecture of Arthur Erickson* (1975), 12.
302. Edith Iglauer, *Seven Stones*, 42.

interned over twenty-seven thousand Japanese Canadians living in British Columbia, deporting them from the west coast to the interior of the province.

This is the reason why Arthur underwent thirteen months of training in Japanese language and culture. It is also why twenty-one-year-old Lieutenant Erickson then found himself on a military transport aircraft bound for India, where he was seconded to the British Intelligence Forces. After his arrival in Bombay, Erickson was sent to a hill station outside of Poona, before relocating to the outskirts of Calcutta, then to Delhi and, finally, in August 1945, to Kuala Lumpur in Malaya, where he helped run a radio station. During the war Erickson developed a lifelong friendship with a fellow interpreter—and artist—George Swinton, who would become one of Canada's leading scholars of Inuit peoples art and culture. Erickson also formed a close bond with two British officers: Jack Brinkley, a devote Buddhist, and Trevor Leggett, a Zen scholar, thereby expanding his knowledge of and attachment to Eastern religions. His exposure to the exotic landscape and to archeological sites like Fatehpur Sikri on the Indian sub-continent gave him "an even greater curiosity about the world."[303]

Erickson had a good war. He rose honourably to the rank of captain. He escaped military action. But what next? On his return to Vancouver in the spring of 1946, he found that abstract painting—to which he had been previously committed—was now out of fashion and would remain so until the middle of the next decade. Conversely, urban social realism, which celebrated the worker and industry, coupled with exhibitions devoted to urban planning, architecture and modern design, were now in vogue.

The notion that artists, designers *and* architects had a major role to play in the post-war reconstruction of British Columbia had an enormous impact on Erickson. It prompted him to reconsider becoming an architect. However, his destiny was again denied after an encounter with the Viennese-born Richard Neutra. The well-known California-based architect told Arthur that he would first have to study engineering. Fearing that this discipline was too technical and would prevent him from using

303. Arthur Erickson, *Architecture of Arthur Erickson* (1975), 13.

his artistic abilities, Erickson set aside the idea of becoming an architect. Instead, he began to prepare for a career in the diplomatic service. After all, he had enjoyed travelling in India and Malaya, and this was one way to do more of it. During the summer of 1946 he studied economics and history at UBC. But these subjects "failed to arouse" his interest.[304] Indeed, no other profession seemed to catch his attention until, one day that summer, he came across an article in *Fortune* magazine. The article featured the Taliesin West Ranch, also known as the Desert House, which the renowned American architect Frank Lloyd Wright had designed in 1937. Erickson was immediately struck by the building's sensitivity to place—it was situated in Arizona—and by its use of materials. In echoing the landscape's contours and rhythms, Taliesin seemed to hug the parched earth. It made ample use of the local desert rock. And its overall conception and design were clearly products of the architect's artistic skills as much as his knowledge of structural engineering.

Suddenly "everything came into focus," Erickson later recalled thinking: "If an architect can do this, I'm going to become an architect."[305] Thus the third time that his architectural destiny knocked at the door, Arthur was ready to open it. In the late summer of 1946 he applied to several schools of architecture in the United States as well as in Canada. He excluded the recently established school of architecture at the University of British Columbia, most likely on the grounds that he did not want to study in his hometown.

Erickson's applications were late. Only McGill University in Montreal agreed to admit him by bending all the usual rules. Having UBC's president, Norman "Larry" MacKenzie, and also Lawren Harris as his referees no doubt helped him. As did having Arthur Lismer, another former member of the Group of Seven who had become a professor at the school, consider his application. The aspiring young architect, having belatedly discovered his vocation, continued to tread a privileged path.

304. Arthur Erickson, *Architecture of Arthur Erickson* (1975), 13.

305. Arthur Erickson, *Architecture of Arthur Erickson* (1975), 13; Arthur Erickson, in discussion with Jim Donaldson, 17 February 1998, Alumni Interviews, McGill University, Montreal.

McGill University had founded its own school of architecture in 1896, six years after the University of Toronto, Canada's first. Though not as prestigious as institutions in Chicago or Pittsburgh, McGill's school had embraced the Modernist International Style by purging itself of the unfashionable late-nineteenth-century *école des Beaux-Arts* style of architecture. Indeed the professor who taught Erickson the elements of design, Gordon Webber, had studied at the progressive School of Design in Chicago with one of modernism's strongest supporters, the former Bauhaus artist László Moholy-Nagy. Another instructor at McGill, Enrico de Pierro, who was the first architect in Canada to design a building in reinforced concrete, was likewise devoted to another modernist, the Swiss architect Le Corbusier who appreciated the aesthetic possibilities of concrete.

During his four years at McGill, Erickson took courses in design, structural engineering, freehand drawing and even in plumbing. He also got a good dose of architectural history from the school's director, John Bland, who had his students read Sigfried Giedion's *Space, Time, and Architecture* (1941). This important tome, which is still read by architecture students today, introduced Erickson to the concept of space and time. It showed him the extent to which international exhibitions were an important vehicle for introducing new architectural styles. And drawing on the ideas of Germany's former Bauhaus guru Walter Gropius, Giedion demonstrated the close relationship between art, technology and architecture.

Some of Erickson's education also took place outside of the lecture hall. He and his classmates were taken to Boston, where they visited the studios of the German émigrés Gropius and Marcel Breuer. In Montreal itself they viewed the non-representational paintings of Quebec's Les Automatistes, no doubt aware of the group's anti-establishment and anti-religious radical manifesto, *Le Refus Global*, which was published in 1948. Arthur and his fellow students also helped their professors mount two exhibitions. The first introduced Montreal's public to the blond bentwood furniture made by Finnish designer Alvar Aalto. The second exhibition celebrated the architecture of Le Corbusier. The students duly

constructed architectural models and mounted photographs of the Swiss architect's most famous buildings.

It is not surprising that Arthur's four years in Montreal found him "ruthlessly exposed," as he later put it, "to a host of new things—new people—new ideas."[306] His introduction to the work of architects like Walter Gropius, Ludwig Mies van der Rohe, Le Corbusier and other followers of the International Style, made him question the high esteem in which he held the more traditional organic architect Frank Lloyd Wright. Fellow students like Doug Shadbolt (brother of the artist Jack) and Ken Carruthers became lifelong friends. And despite the fact that his teacher Gordon Webber "never explained anything clearly," he gave Erickson the confidence to trust his own instincts. Indeed, it was Webber who was to join Myrtle Erickson and Lawren Harris in Arthur's personal pantheon as the third most influential person in his life. [307]

Erickson had not been easily won over to the International Style of architecture. Prior to embarking on his last year of study at McGill, he had visited Frank Lloyd Wright's apprenticeship school in Wisconsin. During his short stay at Taliesin North, Erickson had been "enchanted" by the school's quasi-monastic lifestyle.[308] And he had immediately succumbed to the charm, wit and mischief of Lloyd Wright himself, who offered to wave the tuition fee if Erickson would join the Taliesin Fellowship. When Erickson returned to Montreal, however, John Bland told him that he was a strong candidate for the department's coveted travelling scholarship. This possible chance of seeing many of the buildings, as illustrated in Giedion's architectural history, as well as exploring Europe, led Arthur to decline Lloyd Wright's generous offer.

Erickson thus remained in Montreal for the final year of his study. He completed his graduating thesis: a design for an arts centre in Vancouver. He saw two of his drawings for a new city hall published in the prestigious *Journal of the Royal Architectural Institute of Canada*. And, at the

306. Arthur Erickson to Mrs. Leslie, 12 March 1947, in *Speeches by Arthur Erickson,* 69–70.

307. Edith Iglauer, *Seven Stones,* 49.

308. Arthur Erickson, in discussion with Jim Donaldson, 17 February 1998.

end of the year, he duly won the travelling scholarship. With over two thousand dollars in his pocket—thanks to additional funds from the Department of Veterans Affairs—Erickson boarded a steamer bound for Europe in the late spring of 1950. He was just twenty-six years old.

The journey did not, however, go as planned. Erickson intended to disembark in England and to partake in the designing of buildings for London's 1951 Festival of Britain. But the steamer diverted its course and its first stop—disconcertingly—turned out to be Egypt. Yet, as ever, Arthur was dogged by good luck. "It was the most important thing that ever happened to me," he later recalled. "It took me back to the beginning of history."[309]

It was an extraordinary trip. Viewing buildings and gardens in the Middle East, then on continental Europe and after that in the British Isles, gave Erickson "a great sense of the way things belonged to a place, and how people belong to a place, and how architecture is an expression, not only of the land, but also of the kind of light, and the kind of climate that a certain part of the world might have."[310] As he also recalled: "I think a lot of my sense of architecture was developed through that experience."[311]

Erickson was able to lengthen his tour of Europe from one to two and a half years by living frugally. In Florence, for example, he rented a bathroom and persuaded his landlord to throw a mattress over the tub, thus giving him a bed. Oblivious of discomfort, he thus remained in Italy's most culturally beguiling city for nine months. And towards the end of his journey, Erickson extended his visit a few weeks by working in London as an assistant to Ernst Freud, the architect son of the renowned psychoanalyst, Sigmund. In fact, until the end of his life, travel would fuel Arthur's ideas. As a young man, it certainly allowed him to maintain his independence from an over-protective family. And by absorbing the culture, landscape and the climate of wherever he happened to be, he was perhaps able to escape from himself.

309. Arthur Erickson, "Arthur Erickson," *Maclean's* 83 (June 1970), 45.

310. Arthur Erickson in discussion with Mr. Takahashi, *Speeches by Arthur Erickson*, 84–85.

311. Arthur Erickson, in discussion with Jim Donaldson, 17 February 1998.

WHEN ARTHUR ERICKSON RETURNED to Vancouver in 1952, he was immediately struck by the extent to which architects were involved in the "rebuilding of a new world."[312] The expanding population, due largely to the baby boom and post-war immigration, prompted a vast investment in infrastructure. All levels of government provided funds for the construction of new buildings, from airport terminals to city halls; and there was a house-building boom in the newly laid-out suburbs of North and West Vancouver and on the outskirts of smaller cities like Victoria.

The architectural profession itself was becoming more institutionalized. There were new professional journals like *The Canadian Architect* and professional architectural photographers, like the British-born photographer Graham Warrington, to provide them with illustrations. There were prestigious awards for notable work. In 1950 the country's first Canadian Governor General, Vincent Massey, established the Massey Medals to honour the country's leading architects. A year after that, the Royal Commission on National Development in the Arts, Letters and Sciences recommended that nation-wide design competitions be held for every major government building. The Royal Commission's *Report* also encouraged the country's architects to develop "a regional architecture adapted to the landscape and climate and also to the material typical of the area."[313]

Before the Second World War, the International Style had come to Vancouver through local architects like C.B.K. Van Norman, Robert Berwick, Peter Thornton and C.E. ("Ned") Pratt. After the war it became the accepted mode of design for many of the city's public buildings. Similarly, a vernacular style of domestic architecture, developed during the hostilities by Ned Pratt and Bert Binning, had created a dialogue between indoor and outdoor space by introducing large plate-glass windows, flat roofs and an open floor plan.[314] Moreover, following the

312. Arthur Erickson, "Convocation Address," University of Manitoba, 26 May 1978, in *Speeches by Arthur Erickson,* 61.

313. *Report of the Royal Commission on National Development in the Arts, Letters and Sciences, 1949–1951,* vol. l (Ottawa, 1951), 216–21.

314. While some commentators insist that Pratt did not design the house, others, including Geoffrey Massey, insist he did. See Abraham J. Rogatnick, *BC Binning,* 59.

Second World War, Erickson's former classmate at the Vancouver School of Art, Ron Thom—along with Victoria architects John Di Castro, John Wade and Alan Hodgson—began using post-and-beam construction and tongue-and-groove cedar planking for decks and roofs. This younger generation of architects borrowed ideas not only from the proponents of the International Style. They also looked to Richard Neutra and Rudolph Schindler in California, as well as to traditional methods of construction practised by architects in Japan. In addition to drawing on these external models, British Columbia's architects exploited the irregular terrain and vegetation of the coastal West Coast landscape, with its shifting moods of light and mist and the pervasive rain. "Unfettered by sentimental or traditional cultural bonds," it was claimed that British Columbia's post-war architects created what was to become known as the West Coast Style.[315]

None of these developments went unnoticed by observers outside of the province. Writers in Ontario began to observe that the modern movement was already a force west of the Rockies. Likewise, Britain's most respected architectural historian, Nikolaus Pevsner, saluted Vancouver's newly arrived status with the dubious sobriquet, "the parvenu of the Dominion cities."[316]

Arthur Erickson had no difficulty partaking in this "rebuilding of a new world." In 1952 jobs were plentiful. He was hired first by the architectural firm McCarter and Nairne. When that job did not work out, he had no problem getting another one. He was taken on by Sharp & Thompson, Berwick and Pratt whose stunning tower for BC Electric Company's Vancouver office would use the innovative "curtain-wall" technology that literally hung a building's façade, enabling it to be continuous over many floors. But Erickson did not fit in to this firm either: "I was a dreamer and not much use."[317] Indeed, within a year of returning to Vancouver from Europe, Erickson had been all too quickly hired, and equally quickly fired, by so many firms that, as he recalled, "nobody

315. Fred Lasserre, "Regional Trends in West Coast Architecture," *Canadian Art* (October/November 1947), 10.

316. Nikolaus Pevsner quoted in Rhodri Windsor Liscombe, ed., *The New Spirit: Modern Architecture in Vancouver, 1938–1963* (Vancouver, 1997), 15.

317. Edith Iglauer, *Seven Stones*, 55.

would hire me in Vancouver."[318] He might very well have remained jobless had he not met Geoffrey Massey in 1953.

Massey, who was the same age as Erickson, had a stunning pedigree. A nephew of Vincent Massey, a cousin of the celebrated Toronto architect Hart Massey and a son of the well-known Hollywood actor Raymond Massey, Geoffrey had been educated wherever his father was making a film, which meant first in England then in the United States. During the Second World War, Geoffrey had moved to Canada where he joined Canada's first paratroop battalion—as a private, with no privileged exemption from the rigours of military action. Following his war service, and following, too, in the footsteps of his architect cousin, Geoffrey entered Harvard's Graduate School of Design. There he was won over to the International Style promoted by Walter Gropius, who was Geoffrey's teacher. Following his "wonderful experience" at Harvard, Massey spent an unhappy year working for a conservative architectural firm in Montreal.[319] Then he travelled to British Columbia, where he landed a job, just as Erickson had done before him, with the architectural firm Sharp & Thompson, Berwick and Pratt. Massey was in the process of designing what he called "a suburbia in the bush" for fourteen thousand residents in the newly created town of Kitimat when he met Erickson— not at work but on a social occasion at artist Bert Binning's home.[320]

Arthur Erickson and Geoffrey Massey became instant friends and flat-mates. Agreeing that neither liked to work for anyone else, Massey quit his job and the two men joined forces. Myrtle Erickson lent them the money to set up their own architectural practice, and their friends and acquaintances provided them with their first commissions. Massey and Erickson designed and oversaw the construction of houses for their artist-friends Charles Stegeman and Gordon Smith, and also for Ruth Killam (who would shortly become Mrs. Geoffrey Massey). The two men also designed a six-storey apartment house in the West End of the city. It was their Egyptian businessman landlord who commissioned this large modernist block known as "The Residency."

318. Arthur Erickson, in discussion with Jim Donaldson, 17 February 1998.
319. Geoffrey Massey, in discussion with the author, 26 September 2013.
320. Geoffrey Massey, in discussion with the author, 26 September 2013.

According to Massey, when he and Erickson set up their partnership, they had no "formal agreement about who was to do what."[321] As it turned out, however, Erickson produced the conceptual designs for which Massey happily did the detailed drawings. Massey also oversaw most of the construction and handled the business side of their practice. This division of labour was significant to the success of their partnership. Not only had Erickson previously shown an inability to work with others, but as he later admitted, he was "ill suited to the dynamics of architecture as a business."[322] Had Massey, who combined personal rapport with business acumen, not taken on such a role, it is difficult to see how Erickson could have established himself as a practising architect.

Building houses on sloping, densely forested lots on the north and west shores of Burrard Inlet offered the young men a challenge. They had to bring the building into harmony with the forest—civilization amid the wilderness. They did this by fusing the organic style of Frank Lloyd Wright and the International Style of Walter Gropius and Le Corbusier, with the post-and-beam tectonics of traditional Japanese architecture. The results were stunning. As one writer said of the first house Massey and Erickson built for Gordon and Marion Smith: it was "lighter and crisper, more skeletal and abstract" than other modernist-inspired houses of its generation.[323] Equally, the one-storey oblong pavilion built for Ruth Killam on a spectacular promontory overlooking Howe Sound "hovered on the rock," as an observer put it, "like a temple to an aerial deity."[324]

Designing their first buildings was, Erickson recalled, not only "overwhelming" but a constant "source of headaches."[325] And the enterprise frequently turned out to be unprofitable. The Egyptian businessman financing "The Residency" apartment building left town without paying Massey and Erickson. Moreover, differences of opinion over construction

321. Geoffrey Massey, in discussion with the author, 26 September 2013.

322. Edith Iglauer, *Seven Stones,* 55.

323. Christopher Thomas, "Reconciling the Universal and the Particular: Arthur Erickson in the 1940s and 1950s," ssac *Bulletin* no. 2 (June 1996), 36.

324. Christopher Thomas, "Reconciling the Universal and the Particular," 36.

325. Arthur Erickson, in discussion with Ramsay Cook, Canadian Broadcasting Corporation, 1973.

costs put a strain on Arthur and Geoffrey's friendship with Gordon and Marion Smith. Even so, these early commissions were a proving ground for subsequent, much larger projects. The Smith and Killam houses, both widely illustrated in magazines, were awarded Massey Medals. This national recognition gave Massey the confidence to set up a formal architectural practice with Ted Watkins in Vancouver's historic Gastown, an area of the city that was once neglected but was soon to become fashionable. Likewise, along with a recommendation from Douglas Shadbolt, it got Erickson a teaching position at the School of Architecture in Eugene, Oregon.

ERICKSON SPENT THE ACADEMIC YEAR of 1955–56 in Oregon. When it ended, Fred Lasserre, who had refused to hire Erickson when he returned from Europe, now offered him an assistant professorship at the University of British Columbia's School of Architecture. Erickson enjoyed teaching at the only Canadian school of architecture west of the Rockies—and was good at it. He relished putting some of the pedagogical methods of his old teacher Gordon Webber into practice himself. In order to unleash his students' creative resources, Erickson told them "not to think."[326] And, following Webber again, he shocked his students "into experiencing things by approaching their cherished precepts in an unexpected way."[327]

Erickson also liked the steady income as much as he liked an attentive student audience. Within a year he had saved enough money to put a down payment on a house near the university. Over the course of the next several years, his West 14th Avenue property underwent several mutations. Arthur replaced the English garden with an informal arrangement of rhododendrons, azaleas, mountain laurels, firs, ferns, reeds, wild grasses and bamboo. He created a small pond, then filled it with carp, and later, after the local raccoons had got the better of them, with black swans. He tore down the existing house and turned the remaining two garages into a modest functional building that combined his sleeping loft and studio

326. Arthur Erickson, in discussion with Leslie Stojsic, "Arthur Erickson: Concrete Poet," *McGill Reporter,* McGill University, Montreal.

327. Arthur Erickson, *Architecture of Arthur Erickson* (1975), 21.

on one side and a living space on the other. And, wanting privacy, he took his cue from the Middle East and surrounded the entire property with a high fence—illegally high indeed.

It was within the privacy of his house and garden that Erickson entertained the city's leading writers, artists, architects and—in due course—one of the country's most charismatic prime ministers, Pierre Elliott Trudeau. It was here, too, that he shared his home, from the early 1960s, with his flamboyant partner, Francisco Kripacz. (The relationship distressed his parents, but Oscar died in 1965 and Myrtle in 1979.) And it was also here that from 1982 Arthur subsequently lived with the American-born Allen Steele until the younger man's death from AIDS. Arthur was to live on West 14th Avenue until shortly before his own death. The fence too remained. He simply faced down its unpopularity in the neighbourhood—and got away with it, because he was "just Arthur."

In 1955 R.H. Hubbard, the Ottawa-based art historian and art critic, noted that the "youthful vigour and originality" of British Columbia's architects and artists was unmatched in the rest of the country.[328] As author Jane Rule justifiably claimed, not only was UBC expanding by the thousands and the CBC entering "a period of regional assertiveness," it was an exciting time to be a writer, a painter, a potter—or an architect—in her adopted city of Vancouver. The American-born writer was hardly exaggerating. The most prominent private art gallery was the New Design Gallery founded by art critic Alvin Balkin and architectural historian Abraham Rogatnick in 1955."[329] The city's leading writers, artists and architects—including Massey and Erickson along with artists John Koerner, Jack Shadbolt and Gordon Smith—also established an Arts Club. This gave them another venue in which to exhibit and to talk about their work.

Although he was a member of the Arts Club, Erickson never let his teaching duties or his participation in the city's cultural life interfere with his own profession as an architect. He set up a drafting table in the

328. R.H. Hubbard, "A Climate for the Arts," *Canadian Art* (Spring 1955).

329. Jane Rule, "The Canadian Climate," *Canadian Literature* (Spring 1984), 259.

corner of his university office and hired his students to turn his rough sketches into finished drawings. Some early commissions were modest: a deck for Lawren and Bess Harris; a garden terrace and moulded fibreglass pool cabana for another acquaintance, the chairman of the BC Electric Company, Del Grauer. And a chance encounter with Robert Filberg led Erickson to a more ambitious project.

The 2,500-square-foot Filberg residential retreat and conference centre that Erickson now designed for the son of a Vancouver Island lumber baron was much larger than the houses that he had designed with Massey. Erickson used the dramatic setting—all twenty-five acres of it on a bluff on the outskirts of Comox—and its abundant light to full effect. Drawing on the International, Islamic and Hellenic architectural styles, Erickson used steel, stone, concrete and wood. The spectacular setting, the fusion of styles and the diversity of materials were in keeping with what Erickson's American contemporaries like Philip Johnson were doing in their buildings. And the results were stunning. The "simple beauty," the "eloquent serenity" along with the house's "compelling sense" seemed to Abraham Rogatnik "to have no reflection in the chaos, insecurity and anxiety said to describe our era."[330] Tragically, Robert Filberg never got to live in the building: he committed suicide in the spring of 1960, just before it was completed. The opening of the building went ahead regardless. It was to be featured in *Canadian Homes*, in *Western Homes and Living*, in *Canadian Art* and in the prestigious pages of the *New York Times*. The Filberg building's North American success, moreover, led to its architect being awarded a Canada Council grant to study in Japan.

Like other architects in British Columbia, notably B.C. Binning, Arthur Erickson had been superficially influenced by the sensibility of Japanese architects towards their use of materials and the location of their buildings. But it was not until Erickson travelled to Japan in the spring of 1961 that he fully came to appreciate the extent to which Japanese art and architecture was based "entirely on the depiction of nature—of rocks and trees and grass" and how, in contrast, Western architecture drew its

330. Abraham Rogatnik, "Filberg House," *The Canadian Architect* (December 1960), 57.

inspiration from the human form.[331] Likewise, Erickson's trip to Japan prompted him to juxtapose Canada's "frontier attitude," which manifested itself in what he called a "brutal indifference to nature," with Japan's "profound communion between building and site."[332] Erickson's exposure to the work of Japanese architects like Maekawa Kunio and Tange Kenzo introduced him to "the textured and opaque poetics inherent in concrete."[333] It also made him aware of how far "an architect [in Japan] could run a horizontal line."[334]

Erickson was eager to pass on his Japanese experience to others. On his return he told his students how he had discovered the discipline of Japanese design by watching an old man prune his garden using only small handmade scissors. In a series of articles he instructed his architectural colleagues on Japanese aesthetics and Japanese building techniques, the use of materials and the organic relationship to the building site. During his rounds as a public speaker, Erickson left his audiences in no doubt that the short time he had spent in Japan "was a decisive experience for me that would influence my work from that time on."[335]

It certainly did. Drawing on Japanese building techniques and aesthetics, Erickson used rough stone for the foundation of his houses. He contrasted dark wood with white panels in their interiors. He brought the natural features of the landscape indoors by installing plate-glass walls and large circular windows. He built houses in concrete and used rough-cut fir and cedar beams direct from the mill. He covered roofs with sod, moss and even with flat, smooth stones. He turned peeled cedar tree trunks on their heads—they became interior posts. He hung heavy chains from the eaves of his houses—they served as drainpipes and drew attention to the "beauty" of the rain. All of this made each building appear as though it had grown out of the surrounding landscape.

331. Arthur Erickson, "The Unmediated Eye," in Neill Archer Roan, *Scale + Timbre: The Chan Centre for the Performing Arts* (London, 2002), 9.

332. Arthur C. Erickson, "The Design of a House," *Canadian Art* (November 1960), 339.

333. Nicholas Olsberg and Ricardo Castro, *Arthur Erickson: Critical Works,* 8.

334. David Stouck, *Arthur Erickson,* 147.

335. Arthur Erickson, "Introduction," Abraham J. Rogatnick, ed., *BC Binning*, xii.

Erickson's well-publicized post-Japanese houses earned him a great deal of attention at home and abroad. In 1963, for example, he received his first international award from the American Institute of Architecture. Even so, until the summer of 1963, Erickson was basically an academic who taught, who wrote articles, who gave public lectures—and who built houses in his spare time. And then, momentously, came the commission for Simon Fraser University.

BY THE EARLY 1960s it had become clear that British Columbia needed a new university to accommodate the growing number of post-war baby-boomers now eligible to enter post-secondary education. The province's premier, W.A.C. Bennett, commissioned a report to suggest how this might be done. The subsequent report offered two suggestions: transform Victoria College into a degree-granting institution and create a new university in the Lower Mainland. Bennett endorsed both recommendations.

Victoria College accordingly became Vancouver Island's first university —the University of Victoria—in 1963. Creating a completely new university was a more challenging proposition. But the premier knew who could do it. In 1963, he asked the co-chairman of BC Hydro (formerly BC Electric Company), Gordon Shrum, to choose a name, to find a location, to raise a portion of the money to pay for it, to hire a president and heads of department, and—not least of all—to select an architect to design the new university and oversee its construction. All of this was to be done within two years.[336] It was a daunting task. For Gordon Shrum, however, it was an opportunity to create an institution where "new ideas could be explored, where new approaches could be tried, where things were not cast in stone."[337] Thus, unlike most universities in North America, senior faculty would be required to lecture to undergraduates; students would be taught in small tutorials as well as in large lecture halls;

336. Six million dollars were raised from the private sector; the other twelve million came from the government.

337. Gordon Shrum with Peter Stursberg, *Gordon Shrum: An Autobiography* (Vancouver, 1986), 112.

interdisciplinary studies would be encouraged; and mature applicants without formal entrance qualifications would nonetheless be considered for admission.

Within a few weeks of being appointed, university Chancellor Gordon Shrum had chosen a site—a thousand acres on the top of Burnaby Mountain to the east of Vancouver. He had found a name— Simon Fraser University—suggested by the province's minister of education. He had decided on the number of students that the new building would accommodate—seven thousand. He had begun raising funds among his business acquaintances. And he had set out guidelines for the competing architects, specifying that all of them had to be residents of British Columbia. According to Shrum's guidelines, there were to be five buildings interconnected by walkways in order to shelter students from the rain. Lecture theatres, embracing all disciplines, were to be located along a single concourse. Ample space was to be allocated for parking. There was to be only one entrance to the university. The buildings should not only look finished but allow for further expansion. And remembering how difficult it had been to raise money at the University of British Columbia for the construction of a theatre, a gymnasium and an indoor swimming pool, Shrum insisted that these amenities be included in the first build.

When Erickson heard about the competition, he asked his old partner Geoffrey Massey to help him prepare a submission. Massey agreed and, significantly, provided half of the submission fee. The two men easily slipped into their former routine: Erickson produced the conceptual design and Massey did the detailed drawings. Within two months they had submitted the required site plan, an aerial view of the campus's layout and drawings indicating the various sections of the buildings. Neither man was yet forty years of age. "Do we try to win the competition," Erickson and Massey asked themselves, "or do we just do what we believe is the right way to design a university?"[338] They opted for the latter. Erickson had strong views about the shortcomings of universities in North America. Most of them, he felt, were factories. Professors and students were "chauvinistic guardians of their intellectual precincts." This

338. Arthur Erickson, in discussion with Jim Donaldson, 17 February 1998.

had turned campus buildings into "fortresses against rival intrusions."[339] Moreover, the physical separation of disciplines had prohibited "the actual mingling of people in a common centre."[340]

In their effort to design a university that brought scholars of every discipline together in one integrated space, thereby fostering the exchange of ideas both in and outside of the classroom, Erickson and Massey looked to the ancient universities of England and to the academies of the classical world and of Islam. They drew as well on Marshall McLuhan's concept of the global village that had recently been expounded in *The Gutenberg Galaxy* (1962).

Erickson also remembered taking part in the interdisciplinary programme of studies at the University of Oregon a decade earlier. He hoped that "unlike any previous university" in North America, Simon Fraser University would be "a direct translation into architecture of the expanding fields of knowledge that defy traditional boundaries, of the vital role of the university as both challenger and conserver of human culture, and of the university community as one in constant intellectual, spiritual and social interchange."[341]

From the outset Erickson and Massey decided to design not five buildings, as Shrum had suggested, but only one. Their one-building concept was informed by the Parthenon in Athens, the colleges of Oxford and Cambridge, the Plaza Major in Salamanca, the spatial and spiritual courtyard spaces in India's Fatehpur Sikri, the ancient Greek city of Pergamon and the terraced rice fields in Bali and Japan—all to be realized on the proposed mountain-top location with its extensive views to the North Shore Mountains and the Fraser Valley. The building proposed by Erickson and Massey spoke to New Brutalism's preference for raw, unadorned, reinforced concrete for both structure and surface. And their decision to design a linear building that followed the contours of the mountain, thereby "allowing the university not just to sit on the

339. Arthur Erickson, "The Architectural Concept," *Canadian Architect* (January–June 1966), 40.

340. Arthur Erickson, "The University—The New Visual Environment," November 1967, in *Speeches by Arthur Erickson,* 21.

341. Arthur Erickson, "The Architectural Concept," 40.

mountain top but to become part of it and extend quite naturally and easily down the slopes," was informed by the hilltop villages Erickson had seen in the Mediterranean on his first visit to Europe and later on his visit to southern Mexico.[342]

According to the Erickson-Massey plan, students and faculty would thus enter the campus at the transportation centre, then begin an ascent that would take them above the tree line. They would walk past classrooms and laboratories, through a three-hundred-foot-long mall with an expansive glass roof, before reaching the academic quadrangle at the summit of Burnaby Mountain. Creating a walkway structure along the spine of the mountain meant that "horizontal masses dominated the composition." Moreover, as Erickson continued, "the combination of horizontal masses with vertical accents" would provide a "pleasing but insistent rhythm throughout the building masses." It was this simple thematic device of linear construction combined with rhythmic facades that gave "the building complex its characteristic of classical repose."[343]

Years later, Massey and Erickson liked to boast that they had defied Shrum's instructions by submitting a one-building design proposal. Shrum might not have agreed that their choice of building material—pre-stressed and pre-cast sandblasted, rough-pebbled, chipped or bush-hammered concrete—was "as noble a material as any limestone."[344] But he liked the fact that concrete was inexpensive, fireproof, easy to maintain and, above all, durable. Indeed, if Shrum had any doubt about concrete's durability, Erickson and Massey only had to point to the world's largest unreinforced concrete dome, the Pantheon in Rome that had been standing since 126 CE.

It was not, however, Shrum himself who chose the winner among the seventy-one submissions. Though he did reserve the right to a veto, it was to be the choice of a panel composed of five architects. Three were from the United States and two from Canada. One of the Canadians, rather conveniently, happened to be Erickson's head of department at the School of Architecture at the University of British Columbia. Erickson felt that

342. Arthur Erickson, "The Architectural Concept," 41.
343. Arthur Erickson, "The Architectural Concept," 41.
344. Arthur Erickson, "The Architectural Concept," 41.

"the other submissions were so backward compared to ours" because they did not really look at education and how it should be conducted.[345] It is certainly true that Erickson and Massey provided spaces in the mall, along the lecture concourse and up and down the indoor and outdoor staircases where students and faculty from all disciplines would meet. And the landscaped garden, or Philosopher's Walk, in the centre of the quadrangle at the summit of the mountain gave anyone who wanted it a place for contemplation.

Erickson and Massey's one-building concept took more advantage of the terrain than any of the other submissions: the building hugged the ridge or spine of the mountain. This allowed for further expansion down the sides of the mountain. And their design, combining elements of Classical architecture with modernism, and their choice of building in concrete, was within the bounds of the long accepted International Style. Even though Erickson and Massey were convinced that they were offering the province "an Acropolis for our time," they did not expect to win the competition.[346] So it was with some sense of detachment that they joined the competing architects and government officials at the Burnaby Mountain pavilion on 31 July 1963—and were astonished when their names came at the top of the list.

In September 1963 Erickson and Massey signed the contract. They and their contractors, along with four other firms shortlisted in the competition—had exactly two years in which to complete the project. The judges had recommended "that every effort be made to see that the first prize-winning design be built without destroying the overall concept."[347] This is broadly what happened. The four runners up—Zoltan Kiss, Robert Harrison, Duncan McNab and Associates, and the partnership of William Rhone and Randle Iredale—were each assigned specific buildings. Although Massey and Erickson were responsible for the Mall, they remained in charge of the entire project.

345. Arthur Erickson, "The Architectural Concept," 41.
346. Arthur Erickson, "The Architectural Concept," 41.
347. Extracts from "Report of the Board of Assessors, Simon Fraser University Architectural Competition," November 1963 in *Canadian Architect* (January–June 1966), 39.

A forty-foot model of the building helped everyone adhere to the Erickson-Massey design. And this is what happened. "It worked out," as Erickson sought to put it in oral recollections, "because the idea was strong enough that . . . it forced a certain consistency and conformity on everyone—because we were all dealing with one single structure."[348] Moreover, the fact that Erickson and Massey were answerable only to Shrum, and not to a board of governors or members of a faculty or to students, meant that decisions could be made quickly. Massey and Erickson were agreed in their later testimony: "As long as we didn't blot our copybook too much he allowed us a free hand."[349]

Under an unrelenting deadline, some problems inevitably proved difficult to resolve. Because they "were thrown almost from a cartoon into working drawings without going into a lot of soul-searching," Erickson felt that he and Massey lacked "time to develop the initial ideas." This is why he told an interviewer in 1964 that the finished product would be "rough" and even "brutal." Even so, he offered the reassurance that it would "be as I think architecture should be in this city," meaning down-to-earth and open, with "no nonsense." He also promised to give the building "as much harmony as possible to its setting and to the climate."[350] Shrum would not accept every idea that the two young architects put before him. They proposed digging a tunnel through the north side of the mountain to provide access to the campus via high-speed elevators. They also wanted to extend the urban complex by creating a new city towards the bottom of the west side of the mountain. They suggested flooding the flat roofs of the buildings to make them look like rice fields, and they wanted to install parking under every building. But Shrum was conscious that the project was already over budget—the final bill was seventeen million dollars, of which a third came from private funds. To him, these bright ideas from Massey and Erickson appeared as frivolous add-ons, and he rejected every one of them.

348. Arthur Erickson, in discussion with Jim Donaldson, 17 February 1998.

349. Arthur Erickson and Geoffrey Massey, 18 October 2006, taped conversation by Archives, Simon Fraser University, Burnaby, British Columbia.

350. "Arthur Erickson: The Lost Interview," 1964, Archives, University of British Columbia.

It was a hectic two years, during which the contractors and five architectural firms often stumbled over one another. Even when SFU admitted its first students—all 2,500 of them—in September 1965, some of the buildings were incomplete. Even so, everyone was happy with what had been done. W.A.C. Bennett got his "instant university"; he received the university's first honorary degree; and he went on to win two more provincial elections. Gordon Shrum, who was to remain Chancellor until 1968, had experienced "the most interesting and important achievement of my career."[351] As for Erickson and Massey who saw *Canadian Architect* devote an entire issue to their building in February 1966, Simon Fraser University made their reputations.

Almost forty years later, architectural historian Nicholas Olsberg still hailed Simon Fraser University as "Canada's Brasilia—a deliberate stretching of faith in the modern out to the frontier—and an homage to the peculiarly Canadian and peculiarly innocent belief in the integrity and continuity of knowledge, nature, and imagination."[352] Erickson could later claim with some justification that he and Massey had launched "a discernible national style."[353] They had done this not by copying International, Brutalist, Classical or even Japanese styles to the letter but by fusing them with the peculiarities of the landscape and climate of the West Coast.

ERICKSON HAD GIVEN UP his teaching position at the University of British Columbia in 1965 and had no intention of returning to the classroom. Even before completing Simon Fraser University, he and Massey had other projects on the go. During the first half of the 1960s, they designed houses for David Catton, Bill Baldwin and David Graham, among other Vancouver residents, in addition to a second house for Gordon and Marion Smith.

351. Gordon Shrum with Peter Stursberg, *Gordon Shrum: An Autobiography*, 123.

352. Nicholas Olsberg, "Canada's Greatest Architect," in Rhodri Windsor Liscombe, ed., *Architecture and the Canadian Fabric* (Vancouver, 2011), 436.

353. David Lasker, "Q&A: Arthur Erickson," *Maclean's*, 15 September 1986, 71.

Following the completion of SFU, Erickson and Massey received more high-profile commissions. There was the Canadian Pavilion for the Trade Fair in Tokyo (1965) and the *Man and His World* national pavilion for Expo 67 in Montreal. There were two further projects that each won Massey Medals: a Canadian Pavilion for Japan's Osaka 70 exhibition and a pair of elegantly coupled, twenty-seven-storey concrete towers for Vancouver known as the MacMillan Bloedel Building (1969). There was also a Faculty Club for the University of British Columbia (1968), a Sikh Temple for the Khalsa Diwan Society (1967) and a university for Lethbridge, Alberta (1972). During these years it was Erickson who exuberantly reaped increasing public and professional acclaim, while it was Massey who was left with increasing headaches about where their business was heading. By the early 1970s they had a Vancouver staff of more than forty and had opened an office in Toronto. But as Massey ruefully recalled forty years later, "We were into the bank for a lot of money."[354]

It is all too clear in hindsight that the business was growing too fast. It suffered from too little supervision and strategic control, given its dependence on an informal understanding between its two original partners. Massey now wanted them to divest their power by making full partners of four of their senior associates who, Geoffrey recalled, "had their own ambitions." Massey called in a facilitator to help them do this. But Erickson "just didn't want partners" and would not hear of it.[355] He felt that it was his, and only his, role to produce the conceptual ideas and everyone else's to provide the detailed drawings and to oversee the construction. As Massey later recalled, "I could see nothing but disaster looming." Conscious of a missed opportunity, he added somewhat wistfully: "We could have established the leading firm in BC."[356]

From the early 1970s Geoffrey found himself steadily written out of the Erickson-Massey narrative. There was clearly only room for one name, and that was Arthur Erickson. It was Erickson not Massey who was given an honorary degree from Simon Fraser University; Erickson

354. Geoffrey Massey, in discussion with the author, 26 September 2013.
355. Geoffrey Massey, in discussion with the author, 26 September 2013.
356. Geoffrey Massey, in discussion with the author, 26 September 2013.

who received the Order of Canada; Erickson who was made Vancouver's Man of the Year; Erickson who was awarded both the Molson Prize and the Royal Bank Award in 1973—which amounted to over $65,000; and Erickson who, in that same year, won the Architectural Institute of BC Award. This was truly an *annus mirabilis* for Arthur Erickson who was showered with every honour that his native city could offer. Wanting more space for his own creative work, and fearing bankruptcy, Geoffrey Massey had left the partnership in 1972. After setting up his own firm, he went on to design residential homes in the West Coast Style and small apartment buildings. During Expo 86 his firm won a contract to design two restaurants. Publicly minded, Massey also served as an alderman, an advisor to the City Planning Commission and a board member of the overwhelmingly successful Granville Island Market. By changing the city's planning laws and by turning an industrial site under the Granville Street Bridge into a thriving market and collection of artisan workshops, Massey helped repopulate and transform the downtown core of Vancouver.[357]

Meanwhile, Erickson focused on building his reputation outside of the country. He knew, as every successful Canadian knows, that fame and acceptance at home can best be achieved through recognition abroad. He sought and won commissions in Kuwait and Saudi Arabia, among other countries in the Middle East. He designed a laboratory in Cambridge, England. And in 1980 he got a contract for one of the largest projects in North America. The One California Plaza (1980–1985) project, covering eleven acres over five blocks in downtown Los Angeles, was aimed at revitalizing the downtown core. It would do so by building a concert hall and art gallery, three large office towers and a hotel. The entire area would be integrated with landscaped areas between the buildings.

Though Erickson might have described himself as shy and retiring, he never refused an invitation to speak, to appear on television or radio, or, of course, to receive an honorary degree. He published several books: the first, *Habitation: Space, Dilemma and Design* appeared in 1965, the last was *The Art of Arthur Erickson* in 1988. And he hired various professional

357. Geoffrey Massey continues to be active. In 2013, along with architectural journalist Adele Weder, he established the West Coast Modern League to protect post-war modernist buildings from demolition.

photographers, like Simon Scott, whose stunning photographs of Arthur's buildings gave them a clarity that suggested to one viewer "an idealism that seems at odds with the vagaries of commercial life."[358] In 1972 the Canadian edition of *Time* magazine had put Erickson on its cover. In 1981 *New Yorker* writer Edith Iglauer published *Seven Stones: A Portrait of Arthur Erickson*. The Vancouver Art Gallery mounted several exhibitions devoted to his work, the best of which was *Arthur Erickson: Critical Works* in 2006. There were films, like Telefilm Canada's *Life and Times of Arthur Erickson* (2004). And there was praise and support from Erickson's fellow architects, notably from Canadian-born Frank Gehry and Moshe Safdie—both of whom had meanwhile moved to the United States. The MacMillan Bloedel building awed Gehry: "So simple. Nobody dared to be that simple."[359] And when Erickson's name did not make it onto the shortlist for the construction of Vancouver's new public library in 1995, the architect who did get the contract, Moshe Safdie, magnanimously called it "outrageous."[360]

Erickson not only received attention from the media and from fellow architects but from the province's and the country's leading political parties. Following the election of British Columbia's New Democratic Party in 1973, he was commissioned to incorporate the Vancouver Art Gallery into the old courthouse designed by Francis Rattenbury and to create a civic centre to include a new courthouse within these three blocks in the heart of the city. The Robson Square complex, as it became known, was completed in 1983.

Arthur Erickson's friendship with Pierre Elliott Trudeau—they had met in 1968—was particularly beneficial to his career. Trudeau initially commissioned Erickson to redesign the prime minister's office in 1971. When costs ran over during the construction of the Museum of Anthropology at the University of British Columbia (1976), the federal government obligingly found another $300,000 to help complete it.

358. Adele Weder, "A Few Words on Simon Scott," *Canadian Architect* (October 2009), 116.

359. Lloyd Dykk, "Erickson on Gehry," *Vancouver Sun,* 16 June 2006.

360. Malcolm Parry, "Winning architect outraged Erickson left out on library," *Vancouver Sun,* 16 February 1993.

(This was justified on the grounds of helping British Columbia celebrate its centenary.) Other federal government contracts followed: the Bank of Canada in Ottawa (1979) and the Chancellery for the Canadian Embassy in Washington, D.C. (1988). This last commission awarded to Erickson by the federal government provoked cries of cronyism. Overriding the jury's selection of another architect in a formal competition, Trudeau insisted on his personal choice: Arthur Erickson. The jury and the public were outraged. Erickson claimed that there was never a formal competition and then, digging himself deeper into a hole, said of the names on the shortlist that "most of the other architects had already received at least one federal government commission and I felt that it was my turn."[361]

The controversy blew over. The flamboyant, vague, even mystical Arthur Erickson remained the country's most famous architect. People listened when Erickson chastised the establishment for creating "trashy" public buildings and "monster" homes in Vancouver.[362] And it seemed that anyone who could meet his fee still wanted Erickson to design their home. Even when most of the country's architects were suffering from the building recession during the 1970s, Erickson had more work than he could handle.

ASKED IN 1998 if any other project had given him as much satisfaction as Simon Fraser University, Erickson replied that, while other projects had given him "different kinds of satisfaction," Simon Fraser University had given him "an opportunity to change the view of people about universities."[363]

Certainly many of the traits evident in that building emerged in his later work. The glass roof crowning the concourse of the Provincial Court of British Columbia in Robson Square and the atrium in the Bank of Canada both echoed the three-hundred-foot-long glazed roof over Simon Fraser University's mall. Equally, Simon Fraser University's unadorned concrete walls, both exterior and interior, made their appearance in

361. David Lasker, "Q & A: Arthur Erickson," 71.
362. Editorial, "Erickson's trashing," *Vancouver Sun,* 3 May 1991.
363. Arthur Erickson, in discussion with Jim Donaldson, 17 February 1998.

domestic buildings like the three-level, sandblasted concrete house he designed for Helmut and Hildegard Eppich (1974). Much the same is true of the cast-in-place, concrete, load-bearing external walls, with their punched-in windows, that became the hallmark of the MacMillan Bloedel Building. Concrete was also the main building material of the University of Lethbridge as well as of Cambridge's Napp pharmaceutical laboratory.

Other trademark features were also evident in Arthur's later work. There are the oversized beams that fly into the air past the exterior walls of the second house that Arthur designed for Gordon and Marion Smith. These reappear in the Canadian Pavilion for the International Trade Fair in Tokyo. Significantly, they were later realized in the fifty-foot-high pre-cast posts and post-tensioned cross-beams—some up to 180 feet long—in the Museum of Anthropology and also in the lodge that Erickson designed at Moraine Lake in Banff National Park (1988). Toronto's Roy Thomson Hall (1982), with its circular glass-sided roof, proved less successful. And the Chancellery in Washington, D.C., remains as controversial in its visual impression today as it was in its original conception. Its colonnade and rotunda obviously echoing I.M. Pei's East Building of the National Gallery of Art and other neoclassical buildings in Washington, flirt uneasily with Postmodernism.

In 1978 Erickson told students at the University of Manitoba that he was "in a continuous state of being airborne," adding that his office was "the cabin of some aircraft or another."[364] His increasingly peripatetic lifestyle saw him maintaining offices, at various times, in Vancouver, Toronto and Montreal, as well as foreign outposts in Saudi Arabia, Kuwait and Los Angeles. In addition to his house in Vancouver, he had residences in Toronto, in both Bel Air and Malibu in California, in Manhattan and on Fire Island in New York State.

While this might have seemed glamorous to the Manitoba students who heard Erickson's convocation address, it was not good for business. The main problem was that Erickson was an absentee boss. And when he did visit the office, he made little impact. As his former associate Bing

364. Arthur Erickson, "Convocation Address," *Speeches by Arthur Erickson*, 2.

Thom complained, "He never told people what to do."[365] Admittedly, this could be seen as a liberating experience for junior architects, stimulating their own development. But another young architect regretted that Erickson never said to his associates: "Hey, I've got an idea, let's discuss it."[366] While it was exciting for his young assistants to hear about their boss's travels and to feel involved in projects that promised to change architectural history, Erickson all too frequently left them wondering what to do next. Above all, they were not told how to deal with the unpaid bills, the promissory notes or the bailiff.

Erickson's vagueness and indecision created even more difficulties than previously for his creative colleagues. He could certainly be faulted, as Geoffrey Massey had good reason to claim, for never giving credit to associates like Bing Thom, Peter Clewes, Bruno Freschi, Keith Loffler, Rudy Wallman, James Cheng and Nick Milkovich. However, the freedom Erickson gave to his associates also enabled a whole new generation of architects to find their own feet—and to make their mistakes under someone else's name before starting their own firms.

By the middle of the 1980s Erickson had a reputation for unreliability. He did not show up for important meetings. He seemed unable to control budgets or meet his expenses. And he simply could not get buildings completed on time. Consequently, many hard-won projects did not come to fruition. Only three of the twenty buildings that Erickson designed in the Middle East were completed. Some of the buildings that he was initially contracted to design for the California Plaza development in Los Angeles were subsequently handed over to other architects, since it became apparent that he was incapable of steering one of the largest building projects in the United States to completion. Closer to home, Canada's most illustrious architect was not awarded the second phase for the University of Lethbridge, where he and Massey had begun the first phase in 1972. Nor was Erickson invited to contribute to new projects: not Vancouver's rapid transit system, nor Expo 86, nor many of the major

365. Lisa Rochon, "Blueprint for Chaos," *Report on Business* (April 1990), 58–65.
366. Lisa Rochon, "Blueprint for Chaos," 58–65.

projects aimed at transforming Vancouver into a "world class" city during the 1980s. And even when he won commissions in Ontario, like the extension to the McMichael Art Gallery in Kleinberg or the civic centre in Markham, Erickson was more than once discreetly removed from the project when it became clear that he was incapable of meeting a budget. The fact was that he was now an absentee boss who had little control over his finances, for which he had never shown any real concern.

So why did things go so badly wrong? Geoffrey Massey was not the only person to claim that Francisco Kripacz was the cause of "Arthur's ruination."[367] Twenty years younger than Arthur, Kripacz was an interior designer, allegedly of Roma ancestry, who claimed to have "extended the architect's idea so much further."[368] Amid much unverifiable posturing, it is indisputable that Kripacz had expensive tastes, that he fostered connections with celebrities and that, when Arthur made him head of the Los Angeles office, he demonstrated that he had even less business sense than his partner. While Arthur understandably sought to keep his relationship with Francisco private—"to be openly gay at that time," he said later, "would not have been good for business"—for many of those who did know, it was an increasing embarrassment.[369]

Throughout the 1980s and 1990s Arthur remained detached from the chaos mounting in his life. Erickson's solution to a crisis was to take an exotic and very expensive trip with Francisco, who, for Arthur, "charged everything with a higher level of intensity."[370] Kripacz also charged everything to Arthur's credit card at higher and higher levels, especially when they threw lavish parties for their celebrity friends, like the film stars Elizabeth Taylor, Rock Hudson and Shirley MacLaine. This was the great architect playing the Great Gatsby. Then financial reality intruded. Things got so bad in 1989 that Erickson was forced to close down his Toronto office, after the failure of a last-minute bailout by his wealthy friends, including Conrad Black and Galen Weston. At age sixty-eight, Erickson was required to declare

367. Geoffrey Massey, in discussion with the author, 26 September 2013.
368. Adele Weder, "Rhapsody in Blue," *Interiors* (May 2001), 116.
369. David Stouck, *Arthur Erickson,* 208.
370. David Stouck, *Arthur Erickson,* 203.

personal bankruptcy and his offices in Los Angeles and in Vancouver were also closed.

Apparently indomitable, Erickson remained optimistic about the future, telling a reporter in 1992 that he fully intended "to continue with vigour."[371] While his erratic business practices prevented him from attracting investors to help him set up a new firm of his own, several of Arthur's former students and employees, including David Aitken, Nick Milkovich and Noel Best, came to his aid. They gave him a perch in their own firms. It was partly charity, and having Erickson's name on their letterhead still helped in winning commissions. In this way Erickson continued working as a design consultant during the 1990s and early years of the next century. He contributed to—but did not have the last word on—designs for Vancouver's magnificent Waterfall Building, renovation of the Portland Hotel, the Koerner Library at the University of British Columbia and the Vancouver Dance Centre in addition to the Museum of Glass in Tacoma, Washington. It was, however, too late to retrieve his personal finances. In 1997 he faced eviction from his home on West 14th. The property developer Peter Wall came to his assistance by issuing a second mortgage on the Point Grey property.[372]

Erickson's public reputation stood up better than some of his buildings. "My projects," he lamented in 2002, "are being destroyed, it is very difficult to see your children wasted."[373] He was not exaggerating. By this time Roy Thomson Hall had undergone a radical interior refit. The Filberg House had been changed beyond recognition.[374] In 2007 the Graham House was demolished. And three years before that, Simon Fraser University had gone vertical when a new extension on the east side of the campus included three eight-storey towers. The new development, called UniverCity, not only replaced the mall as the university's central plaza: it buried the original horizontal concept, as Erickson put it,

371. Anne Gregor, "Arthur Erickson Financial Debacle in California," *Toronto Star,* 26 January 1992.

372. Following Arthur's death on 20 May 2009, the Erickson Foundation repaid the loan to Wall's company, Wall Financial Corporation, with interest.

373. Matt Schudel, "Architect of Controversial Landmark," *Washington Post* (22 May 2009).

374. The Filberg House has been restored to Erickson's original design.

"under a developer's mercantile blanket."[375] And his personal life offered little solace. Francisco Kripacz had committed suicide in 2000, and by 2008 Arthur himself was in the advanced stages of both Alzheimer's and Parkinson's disease.

It is hardly surprisingly that in 2003 Erickson advised future architects to consider another profession: "Architecture is full of heartbreak," he said. "Buildings don't usually last all that long. Most of them come down." And speaking with real poignancy: "When you really put your heart into something, it can be devastating when it all comes apart."[376] Yet Erickson's architecture deserves a better epitaph. It continued to the end to fuse local, national and international cultural ideas and styles, whether it was a log house, a Greek temple or a Japanese teahouse. He helped Canadian architecture to move away from its colonial and classical European-referenced past, which is best seen in the Canadian Pacific Railway's Château-style hotels, and he did so notably by reflecting the country's multicultural sense of itself, as recognized by Trudeau's 1971 Multiculturalism Act. Erickson's buildings thus mirrored the country's bourgeoning national consciousness. Bringing the wilderness into harmony with civilization, he thereby reversed the notion that, as Martin Grainger had observed at the turn of the century in *Woodsmen of the West*, British Columbians were butchering the landscape. Above all, Arthur Erickson contradicted the idea that British Columbia, as Emily Carr thought, was on the edge of nowhere. Though Arthur Erickson had helped put his native province at the centre of the country, the last thing he could be accused of was provincialism.

375. Frances Bula, "Arthur's War: Isolated SFU is about to surround itself with its own mountain village, and Arthur Erickson is very, very worried about what it will look like," *Vancouver Sun* (4 November 2000).

376. Daniel McCabe, "A Fine Balance, The Art and Science of Architecture," *McGill News* (Summer 2003), 2.

EPILOGUE

FOR SEVERAL MILLENNIA, present-day British Columbia was the habitat for the permanent and temporary dwellings of the First Nations people, and for the sacred spaces integral to their culture. After European contact in the late eighteenth century, everything changed for the territory comprising the Cariboo, Kootenays, Northwest Coast, Peace River, Okanagan, Vancouver Island, the Gulf Islands and the Lower Mainland. The land was fought over and plundered. It was possessed. And it was settled. By the middle of the twentieth century "Beautiful British Columbia" had become a catchphrase for licence plates and glossy magazines. The province's dramatic and varied landscape, like its supposed isolation from the rest of the country, was now deeply ingrained in the public imagination. This stylized image of the province became a source of local pride and a lure for tourists and investors alike. More subtly, however, it infused the consciousness of generations of artists, writers, architects, dramatists, musicians, carvers and dancers.

But the story of how British Columbia's culture was shaped during the twentieth century has more than one plot. While it is true that the province's unique geography and its relative isolation from the rest of the country played a significant role, other factors were also at work. Long before European contact, Native styles had been constantly changing

under the impact of inter-tribal trade and warfare. After contact, new tools, new markets and new subject matter influenced how and what Native artists produced, as did the experiences of acute new diseases as well as displacement from, and loss of ownership of, their land. Nor was the non-Native community immune to such effects, albeit with far fewer devastating consequences. Some European settlers found themselves the victims rather than the beneficiaries of economic progress. Others found their resistance to disease weakened in a new continent. And others simply found themselves bewilderingly far from their native lands.

Made in British Columbia has illustrated various ways in which cultural impact came from outside of the province itself. Thus Emily Carr discovered the forest as a subject for her work while studying in the seaside town of St. Ives in Cornwall, England. Francis Rattenbury was introduced to classical European architecture on his grand tour of Europe before ever arriving in British Columbia. And an architect of a much later generation, Arthur Erickson, took his inspiration from the International Style, from Japanese and Arabic architecture, as much as from the rugged coastal landscape that lay within a short drive of his home in Vancouver's West Point Grey neighbourhood.

Travel is part of this story too. But the province's artists, architects, writers, dramatists and musicians did not have to leave British Columbia in order to connect with external ideas and cultural institutions. For example, Jean Coulthard worked her way through the Toronto Conservatory of Music's examination system and thereby prepared herself for study at the Royal Academy of Music in England—and did so while living in Vancouver. George Woodcock built his reputation as one of Canada's finest writers and editors while a resident of British Columbia, though a crucial step towards doing so was winning the Governor General's Award. Woodcock's recognition was also helped by the fact that early in his career he had prestigious publishers who were situated in Toronto. Likewise, it was thanks to the Canadian Broadcasting Corporation (CBC) that the dramatist George Ryga had his short stories and plays aired and televised across the country.

The achievement of cultural recognition during the twentieth century has never been easy. But it was certainly easier for those like Jean

Coulthard and Arthur Erickson who had been born into cultured and middle-class families. They had natural advantages in making connections and thereby establishing their careers. Arriving in British Columbia with a degree from Cambridge University ultimately enabled Martin Grainger to become Chief Forester of the province, but, equally important, he already knew how to make the sort of connections that allowed him to publish his seminal novel *Woodsmen of the West*. Even Emily Carr, who is often talked about as having been poor, was always financially well off. The money she inherited from her middle-class father made it possible for her to study abroad, then to build an apartment house from which she received an income, and also to construct a summer cottage. In contrast to Carr, George Ryga was born in a two-room log cabin on a barely viable farm, one hundred miles north of Edmonton. Proud of his Ukrainian ancestry but scarred by his upbringing—he did not speak English until he was six years old—Ryga's low social status was one of the factors that ensured that he remained both socially and culturally an outsider.

British Columbia offered many cultural opportunities during the twentieth century, but it would be naïve to suppose that they were equal opportunities. Such inequities influence the way that our cultural history is written and who is chosen for attention. There were many talented non-Anglophone artists whose achievements were silently excluded from the narrative. For example, the photographer C.D. Hoy, who lived in the Central Interior from 1905 until his death in 1973, left a comprehensive visual documentation of Chinese Canadians as well as people belonging to other ethnic groups; the collection remains too little known. The same can be said of Arthur Wellington Clah, a Tsimshian from northern British Columbia, who left dozens of diaries charting more than fifty years of his life. Likewise, as a member of the Mennonite community at Yarrow in the Fraser Valley, Heinrich Friesen spent his life making violins that were judged the equal of Stradivarius. These people are seldom heard of today.

Being born in British Columbia was not enough to foster the initial career prospects of Raymond Moriyama as an architect, Takao Tanabe as an artist, Joy Kogawa as a writer. Though they eventually made reputations for themselves, they never had a chance to gain early recognition in British Columbia for the simple reason that they were interned, along

with thousands of other Japanese Canadians, during the Second World War. Likewise, artists belonging to the province's First Nations people were largely ignored until, with a sudden change in fashion among the non-Native cultural elite, the vogue for collecting and exhibiting Native art swept across the province in the 1960s. And even then, a First Nations artist living far from Vancouver might not feel that he or she had the right clothes, the right speech or the right manners to make it in the sophisticated gallery world down south. All of these people—much like George Ryga, brought up on Ukrainian folktales as a child—were both enriched and handicapped by their ethnicity.

But class and ethnicity were not the only factors that determined success. Luck played an important part too. While Emily Carr might have lived in more comfortable circumstances than most artists of her generation, where would she have been if Eric Brown had not walked into her studio in 1927? It was Brown, as director of the National Gallery of Canada, who offered this hitherto unknown female artist the chance to have her paintings prominently displayed in Ottawa. Similarly, George Ryga only came to produce *The Ecstasy of Rita Joe* at the Vancouver Playhouse because the well-connected playwright Beverley Simons—who had happened to see his television play *Indian* on the CBC—magnanimously suggested that this relatively unknown writer have this opportunity instead of herself.

Of course, many of the people in this book made their own luck— that was part of their own talent. Bill Reid used his communication skills, learned during his twenty years as a radio announcer, to make his jewellery and carvings known in the Native and museum communities alike. George Woodcock worked tirelessly to establish his literary credentials, through his association with the University of British Columbia and the CBC, before becoming the founding editor of the journal *Canadian Literature*. But luck and hard work did not always yield results. Despite the overwhelming success of *The Ecstasy of Rita Joe*, Ryga's subsequent politically charged plays raised too many hackles in influential quarters and they were either given short runs or blacklisted altogether.

NOT ALL THE BRITISH COLUMBIANS discussed in these pages achieved this eminence during their own lifetime. Our own perspectives are not always those of contemporaries in the past. Martin Grainger enjoyed being known for helping to establish Manning Park and for being the province's second Chief Forester, following H.R. MacMillan. But it was only after McClelland & Stewart reprinted *Woodsmen of the West* in 1964, almost twenty years after Grainger's death, that the novel became essential reading in literary circles. Francis Rattenbury attracted posthumous notoriety for a different reason: his brutal murder by his wife's lover. And although during Emily Carr's later years her paintings commanded increasing respect, it was not until the centenary of her birth in 1971 that a host of subsequent exhibitions, plays, documentaries, ballets and books made her the focus of more widespread attention. And this came not only from serious-minded scholars, gallery curators, playwrights, choreographers and film producers, but also from naïve devotees often more attentive to their own agenda than to hers.

The cultural context has, of course, changed in recent decades. This raises hypothetical questions about how some of the people discussed in this book would fare in British Columbia's present cultural climate. For example, it would be difficult for a writer like George Woodcock to live solely from his writing today. There are now fewer magazines. The book-review sections in our newspapers are shrinking. And an author like the shy and retiring Woodcock would now have to work as an unpaid member of a publisher's marketing department giving interviews, signing books and making speaking engagements to help promote his new book. Emily Carr would face a different problem if she were beginning her career today. Fifty-six when she was "discovered" by Eric Brown, Carr would look out of place at exhibition openings in commercially minded galleries, where directors like their artists young and attractive, not middle-aged and prone to wearing tent-shaped dresses to hide a generous figure. And what of Bill Reid? His references to his work as "artifakes," along with his virulent criticism of his Native assistants, would surely not be tolerated today. And how would Grainger, Carr or Reid deal with current norms of cultural appropriation and self-censorship?

Further questions are raised by the growth of a grant-dependent culture. Would Carr, Grainger, Woodcock, Coulthard and Ryga have been inhibited from producing their work if they had failed to obtain local or national funding? Would they have spent more of their time promoting their reputations—as many cultural aspirants do today— rather than doing their work? And would they have made a conscious effort to make their work attractive and acceptable in the international community, notably by eliminating every trace of provincialism from their work?

Yet exercises in nostalgia and counterfactual history are surely misplaced. Despite the many changes that have taken place in the cultural community, British Columbians are making more culture, and in more diversified forms, than ever before. Writing groups, both amateur and professional, abound. British Columbia has established its own book prizes. And while we see Toronto-based publishing houses vanishing or becoming parts of conglomerates, some British Columbia publishers are thriving, as is shown by Sono Nis Press, Harbour Publishing, NeWest Press, New Star Books and many others. Symphony orchestras are now to be found in Prince George, Kamloops as well as in the Okanagan Valley and in Nanaimo. Some of these, like the Victoria Symphony Orchestra, have resident composers. Others, like the Fraser Valley Symphony and the Vancouver Philharmonic, devote entire programmes to music written by composers from British Columbia and the rest of Canada. First Nations artists are curating their own art exhibitions and writing the text in the accompanying exhibition catalogues. And the province's art galleries are belatedly exhibiting the work of potters of the calibre of Wayne Ngan, Heinz Laffin and Linda Mackie, and of textile artists like Carole Sabiston.

Admittedly, it is tragic that a city the size of Vancouver was unable to save the Vancouver Playhouse from closing down in 2012. But it would be churlish to belittle the success of Vancouver's seasonal theatre, Bard on the Beach, which is bringing brilliant productions of Shakespeare's plays to more people in Vancouver than ever before. And in a contemporary idiom, theatre companies in British Columbia are featuring plays written by playwrights whose ethnic origin may well be Chinese, Italian

or Indo-Canadian. Moreover, it is not uncommon, as it was during a large part of the twentieth century, for playwrights to deal with homosexuality and with issues relating to collective identity, marginality and isolation. Although dance has not been a focus for historical discussion in this book, it is an area of the arts that is flourishing. This means that, with so many companies from Ballet BC to Ballet Victoria, no dancer now has to leave the province in order to tread the boards.

However, when artists have chosen to make their reputations abroad, photographers like Ken Lum and Ian Wallace and a generation before them the superb linocut printmaker, Sybil Andrews, demonstrated that it is possible to do so. The fact is that British Columbians are now exporting their culture. And it is not just our contemporary photographers who are known around the world. First Nations artists are exhibiting and installing their work in New Zealand, across Europe and throughout Canada. Our authors are being shortlisted for more international book prizes than ever before. And British Columbia's composers, filmmakers, television producers and animators are hearing and seeing their work performed outside of the province—and the country.

While "the great outdoors" might still draw tourists to British Columbia, there are also artists, writers, dramatists, musicians and architects who are making British Columbia's urban landscape as significant as its diverse geography. The buildings designed by Arthur Erickson, particularly Simon Fraser University and the Museum of Anthropology at the University of British Columbia, are attracting visitors from outside of the province and outside of the country. Jeffrey Rubinoff's sculpture park, displaying his seminal modernist sculpture on remote Hornby Island, is another cultural site that is receiving long overdue attention. The landscape and way of life around Lantzville on Vancouver Island, so vividly depicted in Jack Hodgins' short stories and novels, have drawn reverent tourists to the area. Kitanmaax School of Northwest Coast Indian Art in 'Ksan near Hazelton has fostered a new art style and developed a loyal following. The poetry of Paul Yee and Jen Lam has attracted new attention to Vancouver's East Side. British Columbia's diverse wildlife has become better known through the paintings and drawings of Robert Bateman and the late Fenwick Lansdowne. And even the province's bleak

highway underpasses and shabby bedrooms and kitchens have become a popular subject for the internationally acclaimed photographer Jeff Wall.

We can certainly add some of these new cultural sites to the better-known old ones discussed in this book. Yet it would be wrong to forget that although "we have less wilderness, less variety of creatures," as Chief Dan George observed in 1974, "harmony still lives in nature." His warning is still valid: "The wild beauty of the coastline and the taste of sea fog remains hidden behind the windows of passing cars."[377]

Today we need to look through windows of our own upon a cultural landscape that has changed a good deal, not least during the last twenty-five years but is nevertheless *Made in British Columbia.* Looking back over the last century, we can still respect the well-justified eminence of some of the British Columbians who played significant roles during their own era, under very different circumstances from our own. And we can do so without indulging in nostalgia but instead celebrating those who merit similar recognition today.

377. Chief Dan George, *My Heart Soars* (Saanichton, 1974), 67.

ACKNOWLEDGEMENTS

NO AUTHOR WRITES A BOOK without the help of other people. There were many authors and scholars who enriched my understanding and appreciation of British Columbia's cultural history in their books and articles. Libraries and archives from the Victoria City Archives, the British Columbia Provincial Archives, the Vancouver Art Gallery Archives, the Vancouver Public Library Archives, Special Collections at the University of British Columbia, the University of Victoria Library and Special Collections at Simon Fraser University's Archives, Penticton's Archives and Library, the University Library at Cambridge University, among many other institutions, offered help with viewing their resources. Tanya Ryga, Linda Charles and Katherine Beichman, in addition to friends and acquaintances among whom were Paul Delany, David Huitson, Sergei Petrov, Ken Smith, Richard Mackie and Arne Berry gave a word of advice—and sometimes caution—here and there. Tom Berger, Mark Breeze and Fay Bendall read parts of the manuscript. And Stuart Scholefield read it from start to finish. The British Columbia Arts Council provided much appreciated financial support. Tom Berger, who can be considered among the province's culture makers himself, provided the introduction. The team at Harbour Publishing guided the book to fruition. Most thanks, however, go to Peter Clarke who not only gave

moral support throughout the writing of *Made in British Columbia*, but also made time to read my manuscript while completing his own book, *Mr. Churchill's Profession: Statesman, Orator, Writer*.

INDEX

Page numbers in **bold** refer to images

Adams, Donald Marvin, 142, 146, 147, 151

Adams, Frederick, 18, 19–20

Adaskin, Harry, 148, 149–50

Adaskin, Murray, 141, 148

Aikins, Carroll, 121

Alberni Pacific Lumber Company, 47, 48

Allen, Mary Cecil, 72, 74

Andrews, Sybil, 237

Archer, Violet, 158

architecture. *See under* British Columbian culture: architectural scene; Canadian culture: architectural scene

art. *See under* British Columbian culture: art scene; Canadian culture: art scene

Arts and Handicrafts Show, 171, 172–73

Arts of the Raven: Masterworks by the Northwest Coast Indian exhibition, 178, 179, 180

Ashnola: A Legend of Ashnola's Singing Water (Aikins), 121

Authors Anonymous, 91

Baird, Irene, 80–81

Ballade: "A Winter's Tale" (Coulthard), 143, 152

Banff Centre, **xii**, 155

Banff School of Fine Arts, 111–12, 125

Bank of Montreal, 25, 26

Barbeau, Marius, 65, 68

Bard on the Beach, 236

Barron, Sid, 166

Bateman, Robert, 237

Bartók, Béla, 138, 146–47

Barton, Norma, 117, 122, 126

Benjamin, Arthur, 143, 144, 154

Bennett, W.A.C., 108–9, 215, 221

Bennett Lake and Klondyke Navigation Company, 23, 25

Bernardi, Mario, 154

Bill Reid: A Retrospetive Exhibition, 184

Bill Reid Foundation, 190

Bill Reid Gallery of the Northwest Coast, 190

Binning, B.C. (Bert), 90, 142, 152, 198–99, 207

Birney, Earle, 79, 80, 81, 82, 83, 89, 90–91, 93, 144, 152

Black, Malcolm, 122–23

Black Canoe, The (Reid), **xiv**, 162, 184–85, 186–87, 188–89

Bland, John, 204, 205

Bliss, Arthur, 159

Bloomfield, George, 104, 105, 108

Blue Moon Press, 84–85

Bobb, Columpa, **x**

Boulanger, Nadia, 145, 152

Brabant, A.J., Rev., 172

Britain, culture of, 8, 10–11, 42–43, 85–86, 90, 132

British Columbia Institute of Architects (formerly Association of Architects), 13

British Columbian culture
anti-American, 16, 18
architectural scene, 12–13, 14, 28, 29, 207–8, 212
art scene, 45–46, 64, 198, 202, 212. *See also* Modernism in British Columbia: in art; Vancouver Art Gallery
Britain, relationship with, 18, 27, 32, 41–42, 132
Canada, relationship with, 79, 81, 97, 122, 154, 159, 236
dance scene, 57, 237
First Nations culture. *See under* First Nations
grant-dependence, 236
literary scene, 43–45, 79–83, 86, 94, 96, 99–100, 101
music scene, 131–35, 140–41, 142, 150, 157
nature, attitude towards, **iv**, **vii**, 16, 17, 43, 44–45, 46 , 52, 53, 230, 231, 237. *See also* logging in British Columbia; Royal Commission of Inquiry on Timber and Forestry; Commission of Conservation
present cultural climate, 235–36, 238

British Columbian culture (*cont.*)
theatre scene, 106–7, 120–21
women in the arts. *See under* women
See also Vancouver culture
Brough, George, **xii**
Brown, Eric, 67–68, 71
"brutal telling, the" 55–56, 64, 75
Burns, Patrick, 26

Canadian Broadcasting Corporation
(CBC), 78, 117–18, 122, 133–34,
147–48, 167. *See also* Radio Symphony
Orchestra
Canadian culture
architectural scene, 12–13, 193, 203–4,
207, 214, 221
art scene, 45, 58, 191
Britain, relationship with, 128
dance scene, 125
First Nations culture. *See under* First
Nations
literary scene, 79, 80, 81, 82, 92–93,
94–96, 100–101, 125
multiculturalism, 129, 133, 230. *See
also* Chinese Canadians; Japanese-
Canadians; Ukrainian Canadians
music scene, 131, 132–33, 135, 136,
141, 147, 154, 157
radio scene, 117–18
theatre scene, 104–5, 106–7, 112, 121,
123, 125–26, 129
women in the arts. *See under* women
Canadian League of Composers, 130, 153,
154
Canadian Literature, **ix**, 79, 92–94, 95–96,
102
Canadian Mosaic (Coulthard), 144
Canadian Pacific Railway (CPR), 26,
132–33
Captives of the Faceless Drummer (Ryga),
124
Career Woman, 50
Carr, Emily, **v**
caravan, **v**, 74
criticism, reviews and awards, 61, 63,
73, 76–77, 81
death of, 76
education, 53–54, 55
exhibitions, 57–58, 60, 61, 62–63, 66,
67, 69, 71

First Nations, attitude towards, 53,
54, 55–56, 58–64, 68–69, 70–72,
74, 77
forest, perception of, 51–52, 53, 56,
59–60, 71
influences and inspiration, 60, 67,
69–70, 71, 72, 73, 75–76
nervous breakdown, 55, 56
pets, 56, 64–65, 66
romantic relationships, 54, 55, 56, 64
spirituality, 52, 57, 59, 69, 70, 72, 74,
75
style, 52, 56, 58, 60, 61–62, 66, 67,
71, 73–74
teaching career, 57, 64
writing, 74, 76
youth, 52
Carr, Emily (senior), 52, 53
Carr, Richard (senior), 52, 53, 55, 64
Carr siblings, 54, 55, 56–57, 58, 64,
72–73
Carter (character in *Woodsmen of the West*),
36, 38, 39, 40
Cassiar district, 33
Cherniavsky, Jan, 141
Chinese Canadians, 33, 233
Chubb, Frederick, 136, 141
Cizek, Albert Franz, 18
Clah, Arthur Wellington, 233
Coghill, Joy, 105, 106
Collings, Charles John, 45, 57–58
Commission of Conservation, 47
composers. *See under* British Columbian
culture: music scene; Canadian culture:
music scene; women: musicians; First
Nations: music
Conkle, E.P., 112
Contemporary Verse, 81
Copland, Aaron, 142
Coulthard, Jean, **xii**
compositions, 130, 134, 137, 141,
143, 144, 146, 147, 148, 151,
154, 155–56, 157. *See also specific
compositions*
conducting, 139, 141
criticism, reviews and praise, 139, 148,
158, 159
education, 135, 136–38, 141, 146,
148, 153
family life, 131, 146

influences and inspiration, 137–38,
139, 142–44, 145–47, 149,
151–52, 155–57
performances, 140, 141
style, 131, 147, 155, 159
teaching career, 130, 140, 141, 148–51
youth, 134–35
Coulthard, Margaret (Babs), 135, 140
Coulthard, Mrs. Walter, 134–36, 140
Coulthard, Walter, 134, 140
Covo, David, 193
Cranmer, Douglas (Pal'nakwala Wakas,
Kesu'), **xiv**, 176, 177, 178, 190
Cross, James, 124
Cross, John, 164, 173
culture. *See* British Columbian culture;
Canadian culture; Vancouver culture
Cunningham and Hinton, 22

Dart, Thurston, 153
Davidson, Robert, 178, 180, 181, 182,
185, 186–87, 190, 191
Davies, Meredith, 154
de Pierro, Enrico, 204
de Ridder, Allard, 140
Dominion Drama Festival, 106, 125
Dowler, Wellington J., 23
Duff, Wilson, 171, 174, 184
Duke, Daryl, 118

Ecstasy of Rita Joe, The (Ryga)
criticism and reviews of, 107–8, 123,
127–28
National Arts Centre production,
108–9
other productions of, **x**, 123
public reaction to, 105, 107, 109, 128
Vancouver Playhouse production, **xi**,
103–4
Edenshaw, Charles, 166, 173, 176–77,
182, 184
Edenshaw, Gary, 188
Empress Hotel, **i**, 7, 26
Erickson, Arthur, **xv**, **xvi**
art, 196, 197–98
associates, 226–27
buildings, 205, 209, 213, 215, 221–23,
225–26, 227–28. *See also specific
buildings*
criticism, praise and awards, 192–94,
210–11, 221, 222–23, 224, 227

death of, 192–93
education, 196, 198–99, 201, 203–6
employment with architectural firms,
203, 208–9, 226–27, 229
finances, 227–29
house, 211–12, 229
influences and inspiration, 195,
197, 198, 199–200, 204–5, 206,
213–14, 217
Massey-Erickson collaboration, 209,
216–223
military service, 201–2
religion, 195, 200
style, 194, 210, 214, 217, 219
teaching career, 211, 214
writing, 223
youth, 194, 195–96
Erickson, Charlie, 195–96
Erickson, Donald, 194
Erickson, Myrtle (née Chatterson), 194,
195, 196, 200, 201, 209, 212
Erickson, Oscar, 194–95, 196, 200–201,
212
Erickson, Sadie, 195
Erickson Foundation, 229n372
Everyman Theatre, 107, 112
*Exhibition of Canadian West Coast Art,
Native and Modern*, 69

Faunt, Jessie, 196, 198
Fergusson, Hatti, 171, 172
Filberg house, **xvi**, 213, 229
First Nations
appropriation of culture, 76, 127–28,
170, 185, 191, 235
art, 63, 64, 69, 70, 120, 162, 166, 169,
170–72, 173, 179–80, 182–83,
191, 232, 234, 236, 237. *See also*
Vancouver Art Gallery: exhibitions,
First Nations
assimilation of, 62, 68, 108, 131–32,
133
British Columbian attitude towards,
45, 54, 62, 107, 120, 170, 172,
174, 179, 182–83
Canadian attitude towards, 108, 119,
121, 127, 174
death and revival of culture, supposed,
62, 68, 70, 71, 77, 120, 161–62,
169, 170–71, 174, 182–84, 190,
191

literature, 99–100, 121, 233
music, 120, 131–32, 144, 144n199
organizations, 182
theatre, 103–4, 105, 107, 119–21, 127–28. See also *Ecstasy of Rita Joe, The* (Ryga)
totem poles, 168–69, 170
See also specific peoples
First Symposium on Canadian Contemporary Music, 153
Forest Branch, **iv**, 47
Forestry Act, 47, 48
Latham (forester), **iv**
Forster, E.M., 41, 151
Fort Victoria, 13, 14, 22, 37
Frame, Statira, 66
Frank, Sophie, 59
"free classical style," 16–17
Friends of the Indians Society, 119
Friesen, Heinrich, 133, 233
Fripp, Thomas, 45, 57, 65
Front de Libération du Québec, 124

Gage, Pat, 106
Gélinas, Gratien, 93, 123
George, Chief Dan (Tswahno), **xi**, 104, 105–6, 109, 121, 127, 238
Giblin, Lyndhurst Falkiner, 32–33, 34, 35
Giedion, Sigfried, 204
Gladstone, Charles, 164, 166, 169, 173
Gladstone, Ella, 163, 171
Gladstone, Sophie. *See* Reid, Sophie (née Gladstone)
God of Gods, The (Aikins), 121
Gordon, Jan, 67, 74
Gosnell, Richard E., 21, 27
Grainger, Henry William, 31
Grainger, Mabel (née Higgs), 35, 41, 43, 49
Grainger, Martin Allerdale, **iii**, **iv**
British Columbia, move to, 32–33
criticism, reviews and praise, 41–42, 186
death of, 50
education, 31–32
forestry, career in, 46–48, 49
health, 35, 47, 48
influences and inspiration, 32, 49, 80
ju jitsu, 35–36
logging, career in, 35, 36–37, 41
marriage, 35, 41
military service, 34–35

political views, 32, 33, 48, 49
sports, 32, 35–36
teaching career, 41
writing, 34, 36, 49. See also *Woodsmen of the West* (Grainger)
youth, 31
Grass and Wild Strawberries (Ryga), 123
Grauer, Sherry, 181
Grey, Ralph, 35, 49
Grey, Winifred (née Higgs), 35, 43, 49
Group of Seven, 68, 69

Haida House (Reid), **xiv**, 175–77
Haig-Brown, Roderick, 46, 81, 93, 98
Halpern, Ida, 144n199, 149
Harris, Lawren, 69, 70, 71–72, 142, 197, 198, 199, 200, 201, 203
Hawthorn, Audrey, 169–70, 174, 175, 178
Hawthorn, Harry, 175, 176, 184
Hétu, Jacques, 157
Higgs, Leonard, 33, 35, 36, 43
Higgs, Mabel. *See* Grainger, Mabel (née Higgs)
Hodgins, Jack, 237
Home Theatre, 121
Housser, Bess, 69, 197, 199, 201
Housser, F.B. "Fred," 69, 70
Howards End (Forster), 151
Howell, E.C., 18
Hoy, C.D., 233
Hudson, Robert, 9, 10
Hyland, Francis, 104, 106

Iechinihl, **i**, 5–6
Imperial Order Daughters of the Empire (IODE), 111, 113
Indian (Ryga), 118, 119, 120, 121–22
International Style, 204–5, 207, 209

Jacob, Gordon, 153
Jade Canoe, The (Reid), **xiv**, 162, 184–85, 186–87, 188–89
James, Burton, 112, 113, 114
Japanese-Canadians, 80, 81, 201–2, 233–34
Joe, David, **xi**, 104, 105–6, 127
Joe, Rita, **x**, 104, 105, 109
Johns, Barry, 193
Johnson, Pauline, 45, 80
Johnson, Philip, 193

Judge, Grace, 58
Juilliard School of Music, 146

King's College, 31–32, 50
Kirkland, Jack, 107
Klee Wyck (Carr), 76, 81
Koerner, John, 90–91, 212
Koerner, Walter, 135, 179, 183, 187
Kogawa, Joy, 233–34
Kripacz, Francisco, 212, 228, 230
Kropotkin, Peter, 87, 88
Kuthan, George, 93

Laffin, Heinz, 236
Lahr, Charles, 84–85
Lake, The (Pentland and Livesay), 149n208
Lam, Jen, 237
Lamb, Harold Mortimer, **v**, 68
Lament for Confederation (George), 121
Lansdowne, 237
Laporte, Pierre, 124
Lasserre, Fred, 211
Laurier Memorial, 120n161
Lawrenchuk, Michael, **x**
Le Guin, Ursula, 98n116
Le Jeune, Father Jean-Marie Raphael,
 120n161
Le Nigog, 92
Leeds Free Grammar School, 9
Lefolii, Ken, 118
Legislative Building, **ii**, 5, 7, 13–21,
 22–23, 27–28
Lekwammen Coast Salish people, 14, 22,
 37
Les Six, 138, 145
literature. *See under* British Columbian
 culture: literary scene; Canadian
 culture: literary scene
Livesay, Dorothy, 80–81, 90, 91, 99,
 149n208
Lockwood, Henry, 8, 9, 10
logging industry in British Columbia, **iii**,
 vii, 31, 32, 37–40, 44–45
Loo Taas (Reid), 186
Love and Salt Water (Wilson), 121
Lowry, Malcolm, 82, 94, 97, 98
Lum, Ken, 237

Macdonald, J.W.G. (Jock), 65, 197, 198
MacKenzie, Norman (Larry), 150,
 175–76, 203

Mackie, Linda, 236
Maclean's, 118, 161
MacMillan, H.R., 44, 47, 48, 49
MacMillan, Sir Ernest, 141, 143, 147
Man and His World exhibition, 181
Manning Park, 50
Marega, Charles, 27
Marquis, G. Welton, 150
Mart (character in *Woodsmen of the West*),
 30–31, 33, 36, 37, 39–41, 42
Martin, A.G.B, 20
Martin, Mungo (Nakapenkem), 77, 174,
 175, 176, 177, 179
Massey Commission, 154
Massey, Geoffrey, **xv**, 209, 216–223
Mawson, Richard, 9, 10
Mawson, William, 8, 9, 10
Maynard, Joyce, **v**
McFee, Dwight, **x**
Melrose Paint and Decorating Center
 (formerly Melrose Paint and
 Decorating Co.), 23
Milhaud, Darius, 145, 157
Modern French Painters (Gordon), 67
Moriyama, Raymond, 233–34
Morley, Dorothy, **v**
Modernism, in British Columbia
 architecture 204, 208
 art, 60, 66, 90, 181
 music, 130–31, 153, 158, 159–60
 theatre, 121
Moretti, Victor, 18
Morris, R.O., 137
Morrison, Frank, 120
Mortifee, Ann, 104, 105
Museum of Anthropology, **xiii**, **xiv**, **xv**,
 169, 183, 224, 226
music. *See under* British Columbian
 culture: music scene; Canadian culture:
 music scene; women: musicians; First
 Nations: music

National Gallery of Canada, 67, 68–69
Neel, Ellen, 170–71, 173, 174, 179
Neutra, Richard, 202
New, William, 96
New Design Gallery, 212
New Westminster, 44
Ngan, Wayne, 236
Nootka Sound: Or, Britain Prepar'd,
 119–120

Now, 85, 86
Nunn, Florence Eleanor, 5–6

O'Hara, Jane, 161, 162
Oberlander, Cornelia Hahn, 192
Omelchuk, Mike, 115
Orwell, George, 86, 88, 90

Paddon, Mayo, 55, 56
Painters of the Modern Mind (Allen), 72
Pakenham, Alma Victoria Clarke Dolling, 6–7
Paracelsus (Ryga), 126
Parliament Building, ii, 5, 7, 13–21, 22–23, 27–28
Patterson, Ambrose and Viola, 66–67
Paul, Jaimie, x, 104, 105
Pemberton, Sophie, 54, 60
Pentland, Barbara, 149, 149n208, 153, 158
Peoples of the Coast (Woodcock), 99–100
Pinetree Ghetto (Ryga), *The*. See *Indian* (Ryga)
Plaskett, Joe, 77, 152
Playhouse Theatre, 103, 109, 122, 123, 126
playwrights. *See under* British Columbian culture: theatre scene; Canadian culture: theatre scene; First Nations: theatre
Portrait (Coulthard), 141
Potrebenko, Helen, 50
Poulet, Gaston, 152
Pratt, E.J., 95
Prayer for Elizabeth (Coulthard), 148, 158
Preludes (Coulthard), 159
Prior, Edward Gawler, 9, 12

Quv'utsun' people, 120

Radio Symphony Orchestra, 141, 143, 154
Rammell, George, 187–89
Rattenbury & Co. Estates, 23–24
Rattenbury, Florence Eleanor (née Nunn), 5–6
Rattenbury, Francis Burgoyne, 5, 6, 7
Rattenbury, Francis Mawson (Ratz), ii
 addictions and depression, 6, 7
 British Columbia, move to, 12
 buildings, 7, 12, 23, 24, 25–26, 28. *See also specific buildings*

criticism, praise and awards, 10, 21–22
education and apprenticeship, 8–11
influences and inspiration, 8, 11, 16–17, 28
marriages, 5–7
murder of, 5
style, 10, 16–17, 22, 25, 28, 29
youth, 8
Rattenbury, Mary (née Mawson), 5, 9
Raven and the First Men (Reid), xiii, 161, 184, 186, 187, 188
Ravens and Profits: An Account of Journeys in British Columbia, Alberta and Southern Alaska (Woodcock), 89, 99
Read, Herbert, 84, 85, 90
Reforestation (Carr), vi, 51–52, 66, 75
Reid, Amanda, 169, 177
Reid, Bill (William Ronald), xiii, xiv
 criticism, reviews and praise, 161–62, 180, 185, 186, 190–91
 death, 162, 190
 education, 164–65, 166, 168, 176, 180–81
 ethnic identity, 165, 179, 180, 181, 182, 183–84, 185, 186, 189
 exhibitions, 171–74, 178–79, 181, 183, 184
 fraud accusations and assistants, 161, 187–89
 health, 165, 181, 187, 190
 influences and inspiration, 166, 168–69, 170, 181–2
 Native art, views on, 173–74, 175, 188
 radio career, 166–68, 169
 romantic relationships, 167, 177, 181, 189
 self-promotion, 167, 173, 177–78, 185, 191
 style, 176–77, 181–2
 works, 162, 169–70, 183, 185, 187, 190. *See also specific works*
 writing, 171, 174, 179, 183, 185–86
 youth, 163, 164–65
Reid, Mabel (Binkie, née van Boyen), 167, 169, 177
Reid, Margaret, 164–65
Reid, Martine J. (née de Widerspach-Thor), 189, 190
Reid, Robert (designer), 93, 173, 181
Reid, Robert (Bill Reid's brother), 164–65
Reid, Sophie (née Gladstone), 163–5, 183

Reid, William (Billy), 163–4, 165, 167
Ringwood, Gwen Pharis, 112, 118
Risk, Sydney, 107, 112
Robinson, Jean Blake, 134–36, 140
Rogatnick, Abraham, 192, 212
Roy Thompson Hall, 194, 229
Royal College of Music, 136–37
Royal Commission of Inquiry on Timber and Forestry, 46–47
Royal Commission on National Development in the Arts, Letters and Sciences, 154
Rubinoff, Jeffrey, 237
Rule, Jane, 100n123, 101
Ryerson Press, 125
Ryga, Anne, 110, 117
Ryga, Campbell, 122
Ryga, George, x
 British Columbia, move to, 117
 criticism, praise and awards, 106–7, 116–17, 119, 124. See also The Ecstasy of Rita Joe: public reaction to; criticism and reviews of
 cultural activism, 125–26
 death of, 127
 education, 111–13, 114
 employment, 113–14, 116
 First Nations, views on, 119, 121–22, 127
 influences and inspiration, 107, 111–113, 114, 115–16, 118
 political views, 110, 113, 114–15, 116, 124
 production of The Ecstasy of Rita Joe, 104–5
 romantic relationships, 115–6, 117
 writing, 109–10, 113, 114–5, 116–7, 118, 122–24, 125, 126
 youth, 110–11
Ryga, George (senior), 110, 117
Ryga, Mary (née Kolodak), 110, 117
Ryga, Norma (née Barton), 117, 122, 126

Sabiston, Carole, 236
Schafer, R. Murray, 150
Schellenberg, August, 105–6
Schoenberg, Arnold, 130, 138, 145
Scholefield, Ethebert O.S., 27–28
Scorned as Timber, Beloved of the Sky (Carr), vii, 45, 74–75

Sea and Sky, viii
Sea Wolf (Reid), xiv
Seaweed, William (Kwaxitola), 77, 179, 190
Shadbolt, Douglas, 205, 211
Shadbolt, Jack, 90, 98, 142, 152, 198, 199, 212
Shrum, Gordon, xv, 215, 218, 220, 221
Simon Fraser University (SFU), xv, xvi, 215–221, 225, 229
Simons, Beverly, 122–23
Smith, Gordon, 91, 209, 210–11, 212, 221, 226
Smyth, Ethel, 139
Song of my hands: and other poems (Ryga), 116
Songhees Indian Reserve, 13, 14
Sorby, Thomas Charles, 15, 16
Space, Time and Architecture (Giedion), 204
Spalding, Arthur, 35, 43
Spark, Muriel, 79
Spirit of Haida Gwaii, The (Reid), xiv, 162, 184–85, 186–87, 188–89
Stephens, Donald, 95
Stirling, David, 113, 114
Stoner, George Percy, 7
Storm in Yalta, A (Ryga), 126
Stouck, David, 199–200
Sunshine and Tumult (Carr), v
Swinton, George, 202
Symons, Julian, 87, 88

Taliesin North, 205
Tanabe, Takao, 233–34
Teague, John, 15
theatre. See under British Columbian culture: theatre scene; Canadian culture: theatre scene; First Nations: theatre
Thibert Alluvial Gold Company, 33
Thompson, Nancy, 111, 112
Tiedemann, H.O., 13–14
Tobacco Road (Kirkland), 107, 112
Tobey, Mark, 67, 71
Toronto Conservatory of Music, 135, 136
Toronto Symphony Orchestra, 143, 147, 156
Trudeau, Pierre Elliott, 109, 212, 224–25
Two Sonatinas for Violin and Piano (Coulthard), 158

Two Songs of the Haida Indians
(Coulthard), 144
Tzinquaw, 120–21

Ukranian Canadians, 110
University of British Columbia, 82,
148–49
University of Victoria, 215

Vala, Lobat, 115–6
Vancouver Art Gallery
establishment of, 195
exhibitions, 174, 196, 198, 224
exhibitions, First Nations, 171–72,
173–74, 178
Lauren Harris' influence on, 199
refit, **ii**, 224
theatre, 124
Vancouver Courthouse, **ii**, 26
Vancouver culture, 57, 65–66, 133, 135n,
142–43, 202, 212, 228
Vancouver Little Theatre Orchestra, 141
Vancouver Playhouse Theatre, 103, 109,
122, 123, 126, 236
Vancouver Promenade Symphony
Orchestra (VSPO), 143, 144
Vancouver School of Decorative and
Applied Art, 65, 197, 198–99
Vancouver Symphony Orchestra (VSO),
134, 135, 140, 143, 144, 154
Vancouver Women's Musical Club, 135,
136
Varley, F.H., 65, 198
Vaughan Williams, Ralph, 137–38, 139
Victoria College, 215
Victoria in 1892, 11, 15, 16

Wagenaar, Bernard, 146
Wall, Jeff, 238
Wall, Peter, 229
Wallace, Ian, 237
Walsh, Anthony, 120
Webber, Gordon, 204, 205, 211
Weder, Adele, 223n357
West Coast Modern League, 223n357

West Coast style, 207–8, 221
West, Cecil, 120
When Tempests Rise (Coulthard), 156, 159
Wilson, Ethel, 82–83, 91, 93, 94, 121
women
artists, 53, 54, 57, 63, 69, 75
musicians, 138–39, 151, 158–59
writers, 100–101
Woo, **v**
Woodcock, Arthur, 79
Woodcock, George, **ix**
British Columbia, move to, 88–89
CBC career, 89, 91, 97
criticism, praise and awards, 96, 98–99
death, 101
editing career, 79, 86, 87, 95, 97. See
also *Canadian Literature*
education, 83, 87
influences and inspiration, 84–85, 86,
88, 90–91
political views, 78, 84, 85–86, 97
publications, 78, 84–85, 86–87,
88–89, 91, 95, 96–97, 98,
100–101. *See also specific
publications*
reviewing career, 86, 89
teaching career, 78–79, 90, 91
youth, 79, 83–84
Woodcock, Ingeborg (née Linzer
Roskelly), 79, 84–85, 89, 90, 95, 98,
100
Woodcock, Margaret, 79
Woodcock, Sam, 83
Woodsmen of the West (Grainger), 30–31,
32, 33, 37, 38, 40, 41–44, 46, 48, 50
Wright, Frank Lloyd, 203, 205
writers. *See under* British Columbian
culture: literary scene; Canadian
culture: literary scene; women: writers
Wylde, Theresa, 60

Yarrow Mennonite choir, 133
Yee, Paul, 237
Yorkshire College of Science, 9